DIE PARKETT-REIHE MIT GEGENWARTSKÜNSTLERN / THE PARKETT SERIES WITH CONTEMPORARY ARTISTS

Buchreihe mit Gegenwartskünstlern in deutscher und englischer Sprache, erscheint dreimal im Jahr. Jeder Band entsteht mit Künstlern oder Künstlerinnen, die eigens für die Leser von Parkett einen Originalbeitrag gestalten. Diese Werke sind in der gesamten Auflage abgebildet und zusätzlich in einer limitierten und signierten Vorzugsausgabe erhältlich.

Book Series with contemporary artists in English and German, published three times a year. Parkett choses to retain its authors' stylistic variations. Each volume is created in collaboration with artists, who contribute an original work specially made for the readers of Parkett. The works are reproduced in the regular edition and available in a limited and signed Special Edition.

PARKETT NR. 49 ENTSTEHT IN COLLABORATION MIT • LAURIE ANDERSON, DOUGLAS GORDON, JEFF WALL • WILL BE COLLABORATING ON PARKETT NO. 49

JAHRESABONNEMENT (DREI NUMMERN) / ANNUAL SUBSCRIPTION (THREE ISSUES) SFR. 98.– (SCHWEIZ), DM 122,– (BRD), SFR. 115.– (ÜBRIGES EUROPA), US$ 75 (USA AND CANADA ONLY)

Zürichsee Druckereien AG (Stäfa) Satz, Litho, Druck/Copy, Printing, Color Separations

Nachdrucke jeder Art sind nur mit Genehmigung des Verlags erlaubt, bei Besprechungen bitten wir um Belege.
No parts of this magazine may be reproduced without publisher's permission. We appreciate seeing any mention of Parkett in critical reviews.

PARKETT-VERLAG AG, ZÜRICH, DEZEMBER 1996 PRINTED IN SWITZERLAND ISBN 3-907509-98-6 ISSN 0256-0917

HEFTRÜCKEN/SPINE NO. 46–48: EMMA KUNZ (1892–1963)

Umschlag/Cover: Ausschnitte von / Details of GABRIEL OROZCO, PARACHUTE IN ICELAND, 1996 *(front)* & PIPILOTTI RIST, (ENTLASTUNGEN) PIPILOTTIS FEHLER, 1988 *(back)*.

Vordere Umschlagklappe/Front cover-flap: Details von/of GARY HUME, THE POLAR BEAR, 1994 & MORE FUCKING VALUES, 1991. *Photos: Jay Jopling, London, & Matthew Marks, New York.*

Doppelseite/Doublepage: GABRIEL OROZCO, ASPRILLA, 1996, *c-print; Photo: Carol Shadford, Marian Goodman, New York.*

Special thanks to Jeffrey Peabody at Matthew Marks Gallery.

PARKETT Zürich New York Frankfurt

Bice Curiger Chefredaktorin/Editor in Chief; **Jacqueline Burckhardt** Redaktorin/Senior Editor; **Louise Neri** Redaktorin USA/ Senior Editor US; **Susanne Schmidt** Textredaktion und Produktion/Editing and Production; **Trix Wetter** Graphik/ Design; **Hanna Koller** Graphik Assistenz/Design Associate; **Catherine Schelbert** Englisches Lektorat/Editorial Assistant for English; **Frances Richard** Editing and Research US; **Claudia Meneghini** Korrektur/Proof Reading

Beatrice Fässler Vorzugsausgaben/Special Editions; **Beatrice Aschmann** Buchvertrieb, Inserate/Distribution, Advertising; **Vera Tremp** Abonnemente/Subscriptions; **Yvette Brackmann** Administration und Abonnemente USA/Administration, Research and Subscriptions US; **Kareen Bastien** Subscriptions US; **Tricia Lee** Praktikantin USA/Intern US; **Anahita Krzyzanowski** Volontariat/Traineeship; **Adrian Koerfer** Deutsche Verlagsvertretung/German Representative

Jacqueline Burckhardt – Bice Curiger – Dieter von Graffenried Herausgeber/Editorial Board; **Jacqueline Burckhardt – Bice Curiger – Dieter von Graffenried – Walter Keller – Peter Blum** Gründer/Founders

Dieter von Graffenried Verleger/Publisher

PARKETT-VERLAG AG, QUELLENSTRASSE 27, CH-8005 ZURICH, TEL. 41-1-271 81 40, FAX 41-1-272 43 01
PARKETT, NEW YORK, 155 AV. OF THE AMERICAS, N.Y. 10013, PHONE (212) 673-2660, FAX (212) 271-0704
PARKETT-VERLAG AG, TANNENWALDALLEE 17, D-61348 BAD HOMBURG, FAX 06172-937 444

Im Fluss

Falls Sie den Eindruck haben, jemand habe (auf den Seiten 16–35) in ihre Parkett-Ausgabe hineingekritzelt, bevor Sie sie in die Hände bekamen: Es handelt sich um eine geplante Aktion. Gregor Muir beschreibt innerhalb dieser Seiten, wie der Künstler Gary Hume auf Folien, die er über Zeitschriftenbilder legt, Zeichnungen macht, die Ausgangspunkt für seine grossen Lackbilder werden. Als wir mit Gary Hume das Layout seiner Collaboration-Seiten diskutierten, fanden die Folien wie von selbst wieder zurück auf die Seiten einer Zeitschrift. Es ist, als würden sich die Bilder ein weiteres Mal zur Ruhe setzen auf ihrer temporären Reise durch immer wieder neue Realitäts- und Kunstebenen. Die Malerei von Gary Hume zwingt Kunsthistoriker zu einer neuen Terminologie. Wenn Farbe nicht in erster Linie an Pinsel und Leinwand erinnert, sondern an Soft-Eis und Lakritz, erstaunt es nicht, dass dies zu lebensnahen Analogiebildungen auch in ernsthaften analytischen Überlegungen führt. So betrachtet Douglas Fogle die Malerei von Gary Hume vor allem als «Hautphänomen» (Seite 35).

In dieser Ausgabe von Parkett entsteht der Eindruck, dass gewisse Grenzen innerhalb der Kunst sanft in Fluss geraten sind. In Anlehnung an Nancy Spectors Beitrag zu Pipilotti Rist (Seite 88) lässt sich an eine Ästhetik des Flüssigen denken. Sanft fliessend ist auch unser Titelblatt mit der strahlenden Fallschirmblume, einem ephemeren, skulptural-bildlichen Zwitterwesen. Da es Gabriel Orozco ist, der das Phänomen inszeniert und festgehalten hat, erkennen wir auch auf Anhieb eines seiner Lieblingsmotive: Es ist das Schneiden und neu Zusammenfügen, das Orozco immer wieder fasziniert und das er als Tätigkeit in seine Arbeit einführt. So ist die aus Segmenten bestehende weisse Form nicht nur Blume und Fallschirm, Bild und Skulptur, Gestalt und Ereignis, sondern auch der sich für Momente aufblähende, im Wind fliessende Seidenstoff mit den sichtbaren Schnitten und Nahtstellen – ein Symbol des Transitorischen schlechthin.

Pipilotti Rist hat als Videokünstlerin sich selbst ins Fegefeuer versetzt und ihr Publikum durch eine Ritze im Fussboden um Hilfe angefleht. In dieser Arbeit mit dem Titel SELBSTLOS IM LAVABAD wird die Vorstellung vom elektronischen Medium als einem kalten Fluss zunichte gemacht. In diesem Sinn wird in Pipilotti Rists Arbeit in der Schalterhalle einer Bank, FLIEGENDES ZIMMER (Seite 94), das Fernsehgerät für kurze Momente zum Boten einer kleinen sozialen Utopie. Wer beim Warten in der Bank den Blick schweifen lässt, wird hoch über den Köpfen der Anwesenden eine Ansammlung von Möbeln und Einrichtungsgegenständen entdecken, die dank aufgehobener Gravitation irgendwie kopfüber wegzuschweben scheinen. Nicht genug, im davonfliegenden Fernsehgerät hüpfen und tummeln sich die gleichen Bankangestellten, die in der Schalterhalle Kunden bedienen, als Stars niegesehener Videoclips.

Der Zufall will es, dass alle drei Collaboration-Künstler im gleichen Jahr, nämlich 1962, geboren wurden, und zwar in Kent (England), Jalapa (Mexiko) und Grabs (Schweizer Rheintal). Liegt es vielleicht am Jahrgang, dass etwas Fliessendes die drei zu vereinen scheint?

Between Flight and Flux

If you have the feeling that someone scribbled in your issue of Parkett (pp. 16–35) before it was delivered to you, you may rest assured—the effect is intentional. Gregor Muir describes how artist Gary Hume makes drawings on acetate sheets laid on top of magazine images as the basis of his large-format lacquer paintings. When we were talking with the artist about the layout for his collaboration, these films ended up back on the pages of a magazine, as if to return to their own point of departure, coming to rest again on their passing journey through countless layers of art and reality. Gary Hume's paintings force art historians to resort to a new terminology. If paint evokes ice-cream and licorice instead of brush and canvas, it is not surprising for a visceral analogy to make striking sense, even in serious analytical studies. Thus, Douglas Fogle sees Gary Hume's art primarily as a "skin job" (page 31).

In this issue of Parkett, certain artistic canons have gently loosed their moorings. From Nancy Spector's observations on Pipilotti Rist's art (p. 83), one might be led to discover an aesthetics of fluidity. Our cover is also in gentle flux with a luminous parachute-flower, an ephemeral, sculptural hybrid. Gabriel Orozco staged and captured this phenomenon, demonstrating one of his favorite motifs: his fascination with dissection and transformation. The segmented white shape is both flower and parachute, picture and sculpture, image and event, but it is also a piece of silk with visible cuts and seams blowing in the wind—quintessential symbol of transience.

Video artist Pipilotti Rist has put herself in purgatory and begs her audience for help through a crack in the floor. This piece, titled SELFLESS IN THE LAVA BATH, hotly undermines the idea of electronic media as a cold stream of images. Similarly, for a fugitive moment, her FLYING ROOM, suspended in the lobby of a bank (p. 97), transforms the television set into the harbinger of a social utopia. Waiting customers whose gaze wanders will discover a selection of topsy-turvy furnishings that seem to be floating off to nowhere high above their heads. And to top it off, the people cavorting overhead as stars of Rist's video clips are down below on the ground as well, serving clients.

It so happens that all three collaboration artists were born in 1962—in Kent (England), Jalapa (Mexico), and Grabs (Switzerland). Could that have anything to do with the fact that they share a certain preoccupation with things that flow?

Bice Curiger

Back to the Future
Charles Long & Stereolab

Certainly it is possible, if you try hard, to remember what the Future was like. First find something comfortable to sit on—a bean bag, all shiny vinyl and bright color, is good, or maybe something a little more upscale and "moderne," an Eames chair perhaps, if you've got the money for that kind of thing. Then select a little mood music (something made with a Moog is good), settle back, close your eyes, and let yourself drift…

You'll notice the Future out of the corner of your eye first: There'll be a change in the light (whiter and cleaner somehow); kidney-shaped dots in acid greens and Las Vegas-swimming-pool blues will come floating across your field of vision…

MARK VAN DE WALLE

Charles Long and his cohorts at Stereolab have figured it out: At the present moment, nothing could be more compelling than the future, or, at least, our various memories of it; and what better weapon against present dystopias than our recollections, refigurations, of possible utopias? A response to current cries of millennial disaster, the general move towards a revisited future speaks to the hope for a return to a certain innocence (fellow travelers will include Mariko Mori's sublime technotopias, Diesel stores, assorted tribes of rave kids, and cocktail music afficionados). After all, Long's "Amorphous Body Study Center" project, put together with London's No. 1 future-pop group Stereolab, squats, hovers, and burbles out there at the cutting edge of Retro-Futurism, and even as it manages to be a compen-

dium of the movement's tropes, it's about nothing more—or less—than innocent (but not so simple) pleasures. Physical stuff: sitting on squooshy cushions, drinking cold water, listening to music, playing with Silly Putty, looking at bright colors and shiny plastic. This last thing will be the key: All of the works in the "Amorphous Body Study Center" are plastic-based, reminding us that, as in the fifties, sixties, and seventies, the future belongs to plastic.

Plastic is the real stuff of Retro-Futurism, the basic material for its base materialism. At once the most prosaic and most magical of substances, plastic is not so much made as extruded. Extrusion, of course, is the preferred method of production for the Retro-Future: At one end there's nothing much, a connection to a machine, some whirring noises, and at the other end, something appears. The process lends the final "something" its utopian quality of contingency—you get the sense that whatever "it" is, it could just as well be something else, that its plastic body could shift shapes with the force of your polymorphous desires (all of Long's sculpture looks as

MARK VAN DE WALLE writes a regular column about the World Wide Web for *Artforum.* He recently contributed an essay, "A Short History of the Coming Apocalypse," to the anthology *Echoes,* forthcoming from Monacelli Press. He lives in New York City.

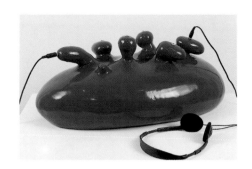

though it's in mid-shift). Indeed, the very name "plastic" refers to the endless possibility for transformation: It's defined by its ability to go from being a heap of nothing much to being anything. Or almost anything, since the one quality plastic always retains is that of fakeness. There is, after all, no such thing as "real" plastic—nothing will ever make it seem like any kind of natural material; it'll never escape the confines of the ersatz. This is, of course, its strength as well: Retro-Futurists have learned to embrace cheeziness as a virtue. As in: "Of course it's fake, it's not even pretending to be a genuine anything; it's itself, it's the stuff of the Future." In another almost magical operation, the qualities that make kitschy junk become the same qualities that produce groovy stuff (the repressed always returns transformed, a fact that the Retro-Futurists take full advantage of).

So, since plastic only seems to come in acid-tinged tones, Charles Long's lava lamp-like amorphous bodies turn up the volume: 3 TO 1 IN GROOVY GREEN (1995) is the brightest, grooviest possible shade of green (a green that never occurred in nature and never will); the plasticine (a kind of plasticized clay, an endlessly squishy merging of the organic and inorganic) at the BUBBLEGUM STATION (1995) is a pink that no flesh ever came in; likewise, CHANGING OUR MIND's (1995) flaming purple body is the kind of purple that only the children of the Space Age have dreamed of. It's no coincidence that Judy Jetson and Barbarella both wore clothes and lived in places that came in these colors: They're the perfect hues for any extruded objects, for the momentary productions of the endless hook-ups and flows of these desiring machines. Which presents the question: What kind of noise do these machines make when they're producing production, when they're in the endlessly ongoing (but here, momentarily frozen) process of plasticity?

The hook-ups that matter most here are headphones, plugged in all over Long's amorphous bodies; you put them on and patch your body into the amorphous body, becoming a conduit for Stereolab's groop sounds of the Future—returning to it, of course. It's a groovy noise, cheeze transformed: "Buloop, buloop." And also, "La, la, la, lala." Even the names of the instruments are groovy (as well as suggestive of plastic): Theremin, Moog, Ondioline. And like everything else in the Retro-Future, the songs travel in little circles, back and forth between the Future and the Past, between kitsch and kool. The best thing to do is settle down on one of the cushions on the floor, plug yourself into GOOD SEPARATION IN SOFT BLUE (1995), and start to listen, let the circular Muzak mantras carry you off into a trance.

The Future will begin to close in, then: Furniture will start to change its shape, shifting and squirming until it echoes the shapes of your body, the shapes of your own internal organs. Your clothes, which have become a gleaming white jumpsuit, will slide pleasantly against the slick plastic and steel. You'll notice that machines are everywhere, except that they don't look like machines at all, they're shiny and bulbous, pointy and curvy, shapes like the furniture, like the buildings.

And finally you're there, you're back in the Future, at once totally strange and just like home, just the way it used to be all those years ago. You'll hear gliding footsteps, and the tinny voice of your robo-butler announcing that a guest has arrived (dressed in another gleaming jumpsuit). You'll reach for the pleasure orb on the table in front of you, and then for your visitor's hand…

Charles Long und Stereolab:

Zurück in die Zukunft

Wenn man sich etwas Mühe gibt, ist es durchaus möglich, sich daran zu erinnern, wie die Zukunft war. Als erstes braucht man dazu einen bequemen Sitzplatz – ein grosser Sitzsack mit glänzendem Vinylbezug in irgendeiner freundlichen Farbe ist geeignet, oder vielleicht auch etwas Stilvolleres und Moderneres, ein Eames-Stuhl, zum Beispiel, sofern man das Geld für so was hat. Sodann wähle man eine stimmungsvolle Musik (etwas mit Synthesizer Produziertes eignet sich bestens), lehne sich zurück, schliesse die Augen und lasse sich treiben . . .

Den ersten Blick auf die Zukunft wird man aus den Augenwinkeln erhaschen: Das Licht wechselt, es wird irgendwie weisser, reiner, und nierenförmige Flecken, in giftigen Grüntönen und einem Blau wie aus einem Pool in Las Vegas, gleiten in dein Gesichtsfeld . . .

MARK VAN DE WALLE

Charles Long und seine Getreuen bei Stereolab haben es herausgefunden: Zur Zeit gibt es nichts Faszinierenderes als die Zukunft. Oder wenigstens unsere Erinnerungen an sie; und welch bessere Waffe gäbe es gegen die heutige Kurzsichtigkeit, wenn nicht unsere Erinnerungen und Neuformulierungen möglicher Utopien? Als Antwort auf das gegenwärtige Weltuntergangsgeschrei zur Jahrtausendwende zeugt die allgemeine Bewegung hin zu einer Wiederbesinnung auf die Zukunft von der Hoffnung auf das Wiedererlangen einer gewissen Unschuld (zu den Mitreisenden werden auch Mariko Moris raffinierte Technoträume, *Diesel-Stores*, verschiedene jugendliche Raver-Stämme und Cocktailmusik-Fans gehören). Schliesslich hockt, gleitet und strudelt da, am äussersten Rand des Retro-Futu-

rismus, Longs *Amorphous Body Study Center (Studienzentrum für amorphe Körper)*, verquickt mit Londons erster Future-Pop-Gruppe, *Stereolab;* und selbst wenn es ihnen dabei gelingt, sämtliche Tropen der Bewegung in sich zu vereinigen, so geht es doch um nichts mehr – oder weniger – als um unschuldige (und das heisst nicht etwa: einfache) Freuden. Körperlich heisst das: auf weichen Kissen sitzen, kaltes Wasser trinken, Musik hören, mit dem *Silly Putty* spielen[1], helle Farben betrachten und glänzendes Plastik. Und letzteres wird zum Schlüssel des Ganzen: Die Arbeiten des *Amorphous Body Study Center* bestehen ausnahmslos aus Plastik und erinnern daran, dass die Zukunft in den 50er, 60er und 70er Jahren ganz diesem Kunststoff gehörte.

Plastik ist das Material des Retro-Futurismus, das Ausgangsmaterial für seinen schäbigen Materialismus. Als zugleich prosaischster und magischster aller Stoffe wird Plastik weniger hergestellt als vielmehr

MARK VAN DE WALLE ist Publizist und lebt in New York.

8

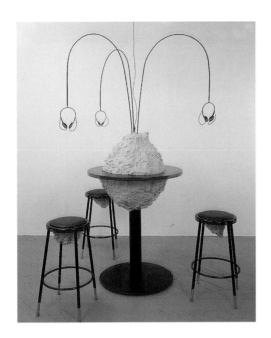

CHARLES LONG, BUBBLE GUM STATION, 1995,
modeling clay, sound equipment and furniture,
91" high, 60" diameter /
KAUGUMMISTATION, Modelliermasse, Sound-Equipment und
Möbelstücke, Höhe 231 cm, Durchmesser 152 cm.

CHARLES LONG, GOOD SEPARATION IN SOFT BLUE, 1995,
flocking over plaster, sound equipment, cushions,
rug, 101 x 67 x 21" /
GUTE AUFLÖSUNG IN HELLBLAU, Textilfaser, Gips,
Sound-Equipment, Kissen, Teppich, 256,5 x 170,2 x 53,3 cm.

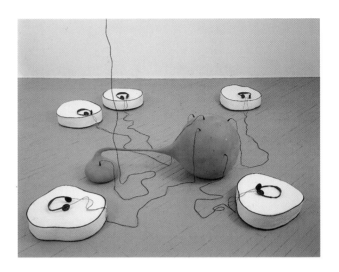

ausgestülpt. Ausstülpen oder -pressen ist natürlich die Lieblingsproduktionsmethode der zurückgekehrten Zukunft: Am einen Ende ist nicht viel, eine Verbindung zu einer Maschine, ein vibrierendes Geräusch, und am anderen Ende kommt etwas heraus. Der Vorgang verleiht dem entstandenen Etwas seine utopische Qualität des absolut Zufälligen – man hat das Gefühl, dass es, was immer «es» ist, genausogut etwas anderes sein könnte, und dass sein Plastikkörper die Form entsprechend unseren vielgestaltigen Wünschen verändern könnte. (Charles Longs Skulpturen sehen alle aus, als befänden sie sich mitten in einem Veränderungsprozess.) Und tatsächlich tönt ja schon der Name endlose Veränderungsmöglichkeiten an. Plastik ist geradezu durch die Fähigkeit definiert, aus einem amorphen Materialhaufen zu allem Möglichen zu werden. Oder zu fast allem, denn die eine Qualität, die dem Plastik immer anhaftet, ist die des Unechten. So etwas wie

echtes Plastik gibt es nämlich nicht. – Nichts wird es je wie ein natürliches Material erscheinen lassen, und den Ruch des Ersatzmaterials wird es nie loswerden. Natürlich ist genau dies auch seine Stärke: Retro-Futuristen haben gelernt, Schäbigkeit als eine Tugend zu begrüssen. Etwa mit den Worten: «Natürlich ist es eine billige Nachahmung, es gibt auch gar nicht vor, etwas Echtes, Ursprüngliches zu sein; es ist es selbst, das Material der Zukunft.» In einer anderen, schon beinahe magischen Operation können genau die Eigenschaften, die den kitschigen Trödelkram zu dem machen, was er ist, auch die echt heissen und gefragten Dinge ausmachen (das Unterdrückte kehrt immer in einer veränderten Form wieder, eine Tatsache, welche die Retro-Futuristen weidlich ausnützen).

Da Plastik nur in den giftigsten Farbtönen zu existieren scheint, wird dies in Charles Longs amorphen Körpern (die den schwebenden bunten

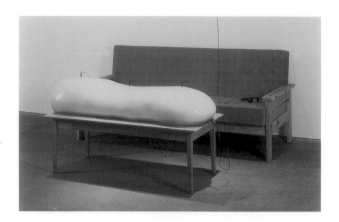

Öltropfen in jenen unsäglichen Lampen und deko-
rativen Glasbehältern von anno dazumal gleichen)
auf die Spitze getrieben: 3 TO 1 IN GROOVY GREEN
(3 zu 1 in irrem Grün) hat den hellsten, herrlichsten
Grünton, den man sich denken kann, ein Grün,
das es in der Natur nicht gibt und nie geben wird;
die Modelliermasse (eine Art plastifizierter Ton, ein
schlüpfriges Gemisch von organischem und anorga-
nischem Material) von BUBBLEGUM STATION ist so
rosa wie kein Fleisch je war; ebenso hat der flam-
mend purpurne Körper in CHANGING OUR MIND
(unsere Meinung ändern) einen Pupurton, von dem
erst die Kinder des Raumfahrtzeitalters zu träumen
wagten. Es ist kein Zufall, dass die Kleider, die Judy
Jetson und Barbarella trugen, und die Räume, durch
die sie sich bewegten, genau diese Farben hatten. Es
sind die idealen Farben für gepresste Objekte und
die kurzlebige Produktion der endlosen Verbindun-
gen und Ströme dieser Wunschmaschinen. Das wirft
folgende Frage auf: Was für ein Geräusch machen
diese Maschinen, wenn sie die Produktion selbst
produzieren, mitten im unendlich dauernden (hier
momentan angehaltenen) Prozess der Plastizität?

Die Verbindungen, auf die es hier ankommt, stel-
len die Kopfhörer her, die überall in Longs amor-
phen Körpern stecken; man setzt sie auf, pflanzt sei-
nen eigenen Körper in den amorphen Sitzkörper
und wird so zu einem Kanal für die irre Zukunfts-
musik von Stereolab – pardon, Zurück-zur-Zukunfts-
musik natürlich. Es sind irre Geräusche, umgewan-
delter Schmalz, «Baluup, Baluup» und auch «La, la,
la, lala». Sogar die Namen der Instrumente tönen
umwerfend (und nach Plastik): *Theremin, Moog, On-*

dioline. Und wie alles andere im Bereich der Re-
tro-Zukunft, bewegen sich die Songs in kleinen
Kreisen, rück- und vorwärts, zwischen Zukunft und
Vergangenheit, Kitsch und Kool. Das Beste, was man
tun kann, ist, sich auf eines der Kissen am Boden sin-
ken zu lassen, sich in GOOD SEPARATION IN SOFT
BLUE (1995) einzustöpseln, zuzuhören und sich von
den kreisenden Muzak-Mantras in Trance versetzen
zu lassen.

*Dann wird sich die Zukunft herabsenken: Möbel werden
ihre Formen verändern, ein Verschieben und Sich-Winden
wird losgehen, bis sie etwas von der Gestalt deines Körpers
widerspiegeln, die Gestalt deiner inneren Organe. Deine
Kleidung, nichts weiter als ein glänzend weisser Jumpsuit,
wird auf dem glatten Plastik- und Stahluntergrund an-
genehm rutschen. Du wirst bemerken, dass überall Ma-
schinen sind, nur sehen sie nicht wie Maschinen aus; sie
glänzen, sind prall, spitz und geschwungen, in denselben
Formen wie die Möbel und Gebäude.*
*Und schliesslich bist du wieder dort, zurück in der Zukunft,
so fremd und doch vertraut wie ein Zuhause, genauso wie
es vor Jahren einmal war. Du hörst gleitende Schritte, und
die blecherne Stimme deines Robo-Butlers meldet einen
Besucher an (im gleissenden Jumpsuit, was sonst). Du
greifst nach dem kugelförmigen Handschmeichler auf dem
Tisch vor dir und dann nach der Hand deines Besuchers.*

(Übersetzung: Susanne Schmidt)

1) *Silly Putty* war ein In-Spielzeug der 70er Jahre. Es ist eine wei-
che modellierbare Gummimasse, die in einem zweiteiligen Pla-
stikei verpackt war. Gleichzeitig sprang es auf wie ein Ball und
konnte Farben annehmen; man rollte es über eine Comic-Abbil-
dung, und das Bild übertrug sich auf das Silly Putty.

Gary Hume, born 1962 in Kent, lives and works in London / geboren 1962 in Kent, lebt und arbeitet in London.

Gabriel Orozco, born 1962 in Jalapa, Mexico, lives and works in New York / geboren 1962 in Jalapa, Mexiko, lebt und arbeitet in New York.

Pipilotti Rist, geboren 1962 in Grabs im Schweizer Rheintal, lebt und arbeitet in Zürich / born 1962 in Grabs, Switzerland, lives and works in Zurich.

GARY HUME, FOUR FEET IN THE GARDEN, 1995, gloss paint on aluminum panel, 87 x 67" / VIER FÜSSE IM GARTEN, Lackfarbe auf Aluminium, 221 x 170 cm. (PHOTO: STEPHEN WHITE)

LIONEL BOVIER

Definitely Something

Just what is it that makes today's painting so different, so appealing?[1]

Über seine «weichen abstrakten Bilder» sagte Gerhard Richter 1970 in einem Interview mit Rolf Gunther Dienst: *Die Bilder unterscheiden sich nicht von den anderen* [d. h. den Photobildern] *oder nur äusserlich, und das ist unwichtig.*[2] Denn, wie er es einige Jahre später formulierte: *Die Voraussetzung meiner neuen Bilder ist die gleiche wie bei fast allen anderen Bildern: dass ich nichts mitteilen kann, dass es nichts mitzuteilen gibt, dass die Malerei nie die Mitteilung sein kann, dass sich weder durch Fleiss, Trotz, Irrsinn noch durch sonstige Tricks die fehlende Botschaft von selbst nur so durch das Malen einstellen wird.*[3] Der Künstler will zwar durchaus «ein Bild von der Welt» vermitteln, aber seine Absicht ist: *nichts erfinden, keine Idee, keine Komposition, keinen Gegenstand, keine Form – und alles erhalten: Komposition, Gegenstand, Form, Idee, Bild.*[4]

Diese Aussagen leuchten uns heute zwar unmittelbar ein, sie sind jedoch zentral, will man den Weg jener Künstler verstehen, die in der zweiten Hälfte der 80er Jahre begonnen haben, aus der Sprache der Malerei selbst heraus wieder einen Bezug zwischen Werk und Realität herzustellen – jedoch ohne diesen in der Form einer subjektiven Aussage ausdrücklich zu vermitteln.

Benjamin Buchloh hat aufgezeigt, wie stark der Satz von Richter mit der Entwicklung der Photographie als Medium der Aufzeichnung des Wirklichen zusammenhängt.[5] Es geht dabei allerdings weniger um eine Frage der Enteignung denn der paradoxen Bestätigung, wie Dave Hickey in seinem Essay «Richter in Tahiti» schreibt: *(...) dass nämlich die Malerei sich nach dem Aufkommen der Photographie nicht wandelte, weil die Photographie deren beschreibende Funktion übernommen hatte, sondern weil die Photographie diese Funktion betonte und damit das Zeichen höher bewertete als das Bezeichnete.*[6]

Gerade dieser Frage des *Was soll ich malen, wie soll ich malen?*[7] geht Gary Hume in der Serie DOORS (Türen, 1988–1992) nach. Tatsächlich han-

LIONEL BOVIER ist freier Kritiker und Ausstellungsmacher. Er lebt in Genf.

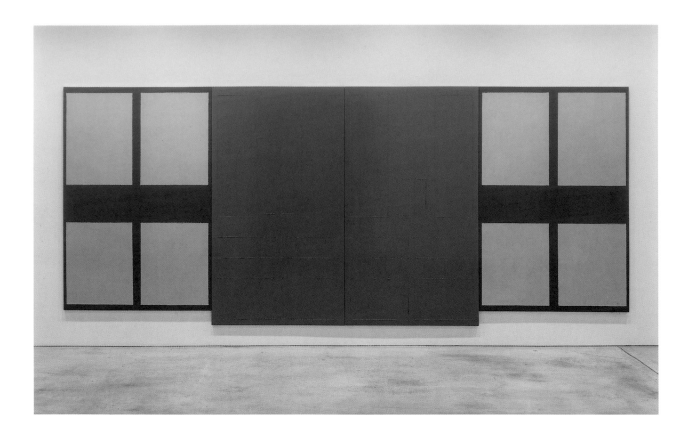

GARY HUME, PRESENT FROM AN OCTOGENARIAN, 1991, oil on formica panel, 82 x 196" /
GESCHENK EINES ACHTZIGJÄHRIGEN, Öl auf Resopalplatte, 208 x 498 cm.
(PHOTO: MATTHEW MARKS GALLERY, NEW YORK)

delt es sich bei diesen spiegelnden, lackierten Oberflächen (die in unwahrscheinlichen Farbvariationen die Schwingtüren eines Londoner Spitals wiedergeben) offensichtlich darum, ein Motiv zu finden, das den Beschränkungen eines flachen Bildträgers und einer Technik des Farbauftrags entspricht, die offensichtlich mehr von der industriellen als von der handwerklichen Malerei geprägt ist. In gewissem Sinn sind die DOORS ein verzögertes Echo der FLAGS von Jasper Johns, die über den Umweg einer grundsätzlichen Auseinandersetzung mit der Moderne einen neuen, mehrdeutig schillernden Gehalt gewonnen haben. Wie der Künstler selbst hellsichtig

feststellt, lag es nun gefährlich nahe, der Verführung einer solchen Ausdrucksweise zu verfallen und sie in unendlichen Variationen auszubeuten.[8] Indem er die Leinwand durch Resopal oder Aluminium ersetzte, fand Gary Hume jedoch eine Lösung für das unlösbare Problem (und persönlich bin ich geneigt, dieses für die darauf folgenden Veränderungen seines Vorgehens verantwortlich zu machen): Nach tatsächlich existierenden Modellen malte er schematisierte Türen, so dass man beinah glauben konnte, sie könnten in Wirklichkeit wieder als solche dienen ...

Wenn man auch auf gewisse, häufig wiederkehrende optische Effekte und die Verwandtschaft der

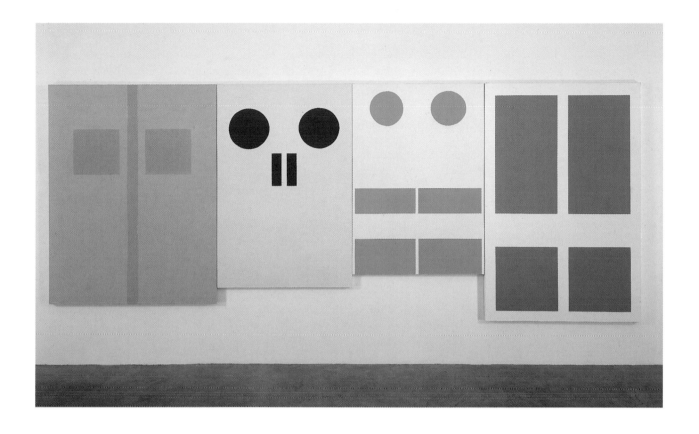

FOUR DOORS I, 1989/90, gloss paint on canvas, 94 x 234" /
VIER TÜREN I. Lackfarbe auf Leinwand, 239 x 594 cm.
(PHOTO: MATTHEW MARKS GALLERY, NEW YORK)

Methode in den Werken dieser Serie und heutigen Werken des Künstlers hinweisen kann, wie das Ulrich Loock[9]) tut, so muss man doch anerkennen, dass sie andrerseits gleich weit voneinander entfernt sind, wie etwa Jasper Johns und Wesselman, um ein möglichst klares und sicher nicht unschuldiges Beispiel zu nennen. Die Verwandtschaft, welche viele zeitgenössische Werke mit den Arbeiten von Wesselman verbinden, ist in der Tat zu auffällig, um nicht eher auf struktureller als auf formaler Ebene erklärbar zu sein. Was Hume von der Pop Art aufnimmt, ist nicht so sehr die allgemeine Reduktion auf die Zeichnung, als vielmehr die Verbindung heterogener Kodes in einem Bild. Während die GREAT AMERICAN NUDES ein bestimmtes Fragment aus einem Werk von Matisse mit Bildern aus der Welt der Massenmedien verbanden, wird die Collage bei Hume zu einer eigentlichen Überlagerung von Schichten, so wie parallel dazu seine Maltechnik eher mit Schichten als mit Pinselstrichen arbeitet.[10])

VICIOUS (1994) etwa zeigt eine Silhouette, die von den faschistischen Statuen des Olympiastadions in Rom inspiriert und von Blumenmotiven umgeben ist, bei denen man nicht weiss, soll man dazu irgendeine kunstvolle Tapete aus *Arts & Crafts* assoziieren oder doch eher Warhols *Flowers.* Unterschiedliche

Gary Hume

Bildkodes sind hier dicht miteinander verwoben, und genau daraus ergibt sich die faszinierende Ambivalenz des Werkes: Da ist einmal das Statuenhafte, ferner das genaue Registrieren von Schatten und Silhouette (dessen Bezüge zu den Anfängen der Photographie bekannt sind) sowie das Dekorative und dessen künstlerische Wiederverwertung usw. Selbstverständlich zielt ein solches Inventar weder auf eine Erklärung des Bildes noch auf Vollständigkeit. Es soll nur das Zusammengesetzte, Kombinierte des Werkes aufzeigen, dass es eher «computiert» als «komponiert» ist, wie Loock richtig bemerkt.[11] Es erstaunt deshalb nicht, dass diesem Bild eine Collage zugrunde liegt, die in Humes Römer Atelier entstanden war, und auch nicht, dass Hume regelmässig Projektionen von Bildern verwendet, die er aus Magazinen oder Filmstreifen ausgeschnitten hat. Denn all diese Prozesse münden schliesslich in ein einziges Bild, das sehr klar erkennbar ist und doch mehrdeutig bleibt. Genau darin besteht eine der grossen Stärken dieser Malerei.

Die folgende Anekdote verrät einiges über Gary Humes Einstellung zur Malerei. Es ist die Geschichte von Tony Blackburn, einem Radio-Diskjockey, dessen Name Hume als Titel für ein Werk von 1993 verwendete. Blackburn erlangte dadurch eine «gewisse Berühmtheit» (um einen Begriff von Gregor Muir[12] zu verwenden), dass er seine tägliche Sendung dazu benützte, seine Freundin nach der Trennung zur Rückkehr zu bewegen. Durch diesen «Missbrauch» des Mediums, in dessen Dienst er vertraglich stand, indem er – gegen die eigene Logik des Mediums – eine streng geregelte Sprachform zu rein persönlichen Zwecken verwendete, verstiess der DJ gegen sämtliche Regeln: Er war nicht mehr bloss Entertainer, sondern eine Art Pirat, der die Gleichförmigkeit des gesellschaftlichen Informationsflusses störte.

Ich erinnere mich, wie bei einem Besuch im Atelier des Künstlers, einige Monate vor der Ausstellung in der Kunsthalle Bern, ein grosses Bild mit dominanten Farbtönen in Schwarz und Violett einen starken Eindruck auf mich ausübte (FOUR FEET IN THE GARDEN, 1995). Es schien mir, als ergebe sich die figürliche Interpretation des Werkes direkt aus seiner «abstrakten» Dimension. Das Gemälde liess den Sinn aufblitzen, ohne dass er sich wirklich fassen

liess. Ich sah natürlich vier Paar nackte Füsse, tendierte aber dazu, ihre Entstehung auf eine zufällige Veränderung der Oberfläche zurückzuführen, auf ein formales Ganzes, das ebensoviel von einem Rorschachklecks wie von der Photographie hatte, die vermutlich als Vorlage diente. Der schwarze Bereich, in dem sich ein unbeholfener Kreis abzeichnete, schien diese Unsicherheit zu bestätigen. Ein Element jedoch irritierte mich zutiefst, denn es brach diese lebendige bewegte Wirkung und lenkte den Blick brüsk auf die Bildebene selbst: Am unteren Bildrand hatte Hume ein paar nonchalante grüne Striche hingesetzt, die eine Wiese andeuteten. Ich wagte es zu jener Zeit nicht, mir einzugestehen, dass dieser Stilbruch, diese «Geschmacklosigkeit» unbedingt notwendig war. Heute ist mir klar, dass es Gary Hume nicht um Bilder als Objekte des Geschmacks oder der Kultur geht, oder mit Godard gesprochen, nicht darum *des images justes*, sondern *justes des images* zu schaffen – als etwas Unvermeidliches und seltsam Endgültiges.

(Aus dem Französischen von Katharina Bürgi)

1) Der Titel dieses Essays (deutsch: Eindeutig etwas) stammt aus dem musikalischen Werk von Gerwald Rockenschaub und lehnt sich an den Titel des ersten Albums der Gruppe «Oasis» an: *Definitely, May Be*. Das Motto (deutsch: Aber was ist denn an der Malerei heute so anders und faszinierend?) nimmt Bezug auf das bekannte Bild von Richard Hamilton mit dem Titel JUST WHAT IS IT THAT MAKES TODAY'S HOME SO DIFFERENT, SO APPEALING (1956).
2) Gerhard Richter im «Interview mit Rolf Gunther Dienst 1970», in: Hans-Ulrich Obrist (Hrsg.), *Gerhard Richter. Text*, Insel Verlag, Frankfurt am Main 1993, S. 58.
3) Gerhard Richter, «Aus einem Brief an Benjamin H. D. Buchloh 23.5.1977», ebenda, S. 80.
4) Gerhard Richter, «Notizen 1986», ebenda, S. 120.
5) Benjamin Buchloh, *Gerhard Richter: Ausstellungskatalog*, vol. II (Essais), Paris 1993. Vgl. auch die Artikel von Gertrud Koch und Luc Lang, in: *Gerhard Richter*, Ed. Dis Voir, Paris 1993.
6) In: *Parkett* 35, Zürich/New York 1993, S. 95.
7) Gerhard Richter, «Notizen 1986», a.a.O., S. 120.
8) Im Interview mit Adrien Dannatt, «The Luxury of Doing Nothing», *Flash Art*, no. 183, Sommer 1995.
9) Ulrich Loock, «Artifizielle Bilder», in: *Gary Hume*, Ausstellungskatalog, Kunsthalle Bern/ICA London, 1995, S. 12–15.
10) «I love the skin of enamel, so mainly I refuse brush strokes (...)», erklärt Hume im Gespräch mit Dannatt, a.a.O., S. 97.
11) Ebenda, S. 15.
12) Gregor Muir in: *Art + Text*, no. 51, 1995, S. 38–43.

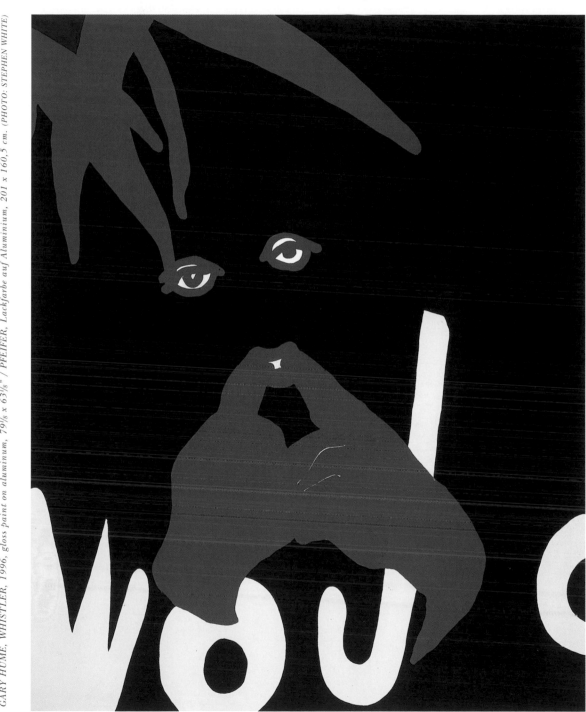

GARY HUME, WHISTLER, 1996, gloss paint on aluminum, 79⅛ x 63⅜" / PFEIFER, Lackfarbe auf Aluminium, 201 x 160,5 cm. (PHOTO: STEPHEN WHITE)

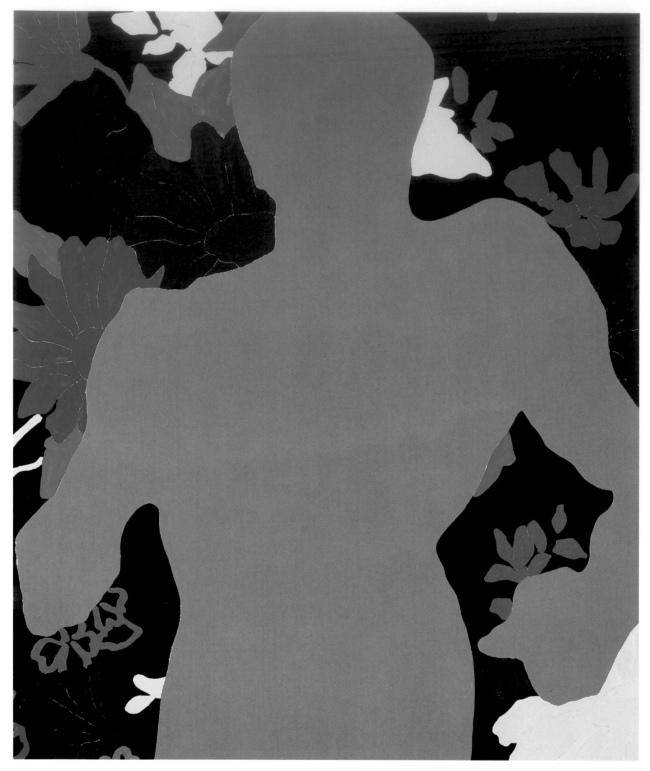

GARY HUME, VICIOUS, 1994, gloss paint on wood panel, 86 x 71" / BÖSARTIG, Lackfarbe auf Holzplatte, 218,4 x 180,3 cm. (PHOTO: JAY JOPLING, LONDON)

LIONEL BOVIER

Definitely Something

Just what is it that makes today's painting so different, so appealing?[1]

In an interview with Rolf Gunther Dienst, Gerhard Richter said that his "soft abstract paintings," were *no different from the others* [his "photo paintings"], *or only outwardly,*[2] and a few years later he elaborated: *The proposition of my new paintings is the same as in almost all of my other paintings: I cannot communicate anything; there is nothing to communicate; painting can never be the message; diligence, defiance, madness or other ruses can never compensate for the lack of message; it never just comes by painting.*[3] Of course the artist wants to convey a "picture of the world" but his intention is *not to invent anything, no idea, no composition, no subject matter, no form—and to engage everything: composition, subject matter, form, idea, picture.*[4]

These remarks certainly seem obvious to us today but they are also central to an understanding of the path pursued by artists in the second half of the eighties, who—within the painting idiom itself—began to re-establish a relationship between work and

reality—but without explicitly conveying it in the form of a subjective statement.

Benjamin Buchloh has demonstrated just how much Richter's proposition was linked to the development of photography as a medium of recording the real.[5] This, as Dave Hickey notes in his essay "Richter in Tahiti," certainly has less to do with dispossession than with a paradoxical confirmation: *Painting changed after the advent of photography, not because photography usurped its descriptive function, but because photography prioritized it, thus valorizing the referent over what it signified.*[6]

It is Richter's question, *What to paint, how to paint?*[7] that Gary Hume develops in his series of DOOR paintings (1988–1992). From all visual indications, these reflecting lacquer surfaces—which reproduce the swinging doors of a London hospital in improbable color variations—seek a motif equivalent to the constraints of a flat support, and a covering technique apparently closer to industrial painting than to craftsmanship. In one sense, the "doors" are a distant echo of Jasper Johns's "flags," sifted through

LIONEL BOVIER is a free lance art critic and curator who lives in Geneva.

GARY HUME, TONY BLACKBURN,
1993, gloss and matt paint on formica
panel, 76 x 54" / Lack- und Mattfarbe
auf Resopalplatte, 193 x 137 cm.
(PHOTO: JAY JOPLING, LONDON)

a filter of fundamental doubt about modernity, and recharged with ambiguous content. The path was wide open, as the artist himself notes,[8] for an infinite series of variations exploiting the undeniable seduction of such a formulation. In other words, by replacing the canvas with Formica or aluminum, Gary Hume reached a skeptical outcome (which, for my part, I tend to link with the subsequent changes in his approach); that is, he painted schematized doors based on an existing model, which could almost be used as such in reality.

But while one can—as Ulrich Loock does in his essay "Artificial Pictures"[9]—underscore recurrent visual effects and similarities of method among the works in the series in question and in his current works, one must recognize that among them, there begins to develop the same distance that—to use as innocent an example as possible—separated Johns from Wesselman. The affinities that many of Hume's recent paintings have with the works of Wesselman are, in fact, too obvious not to be evaluated on a level more structural than formal, since what Hume takes from Pop painting is not so much the generalized flattening of the drawing itself as the combination of heterogenous pictorial codes. And while Wesselman's series GREAT AMERICAN NUDES (1961–1973)

assembles a fragment from a Matisse composition with images from the world of media, the collage in Hume's process becomes superimposition, just as the pictorial technique proceeds in layers rather than strokes.[10]

VICIOUS (1994) thus shows a silhouette inspired by the Fascist statues surrounding the Olympic stadium in Rome, against a floral ground that one hesitates to attribute to a tapestry from the Arts and Crafts Movement or to compare with Warhol's Flowers. Here, different codes are woven together into a skein from which the fascinating ambiguity of the work unwinds: There is the code of statuary; that of the index, the shadow, and the silhouette (which are significantly linked to the origins of photography); of decoration and its artistic recycling; and so on. Such an inventory, of course, intends neither to explain painting nor to exhaust it. It limits itself to indicating the composite, combined nature—"computed," rather than "composed"[11]—of the work. One adds very little, then, by saying that the origin of this painting lies in its being a collage made by Hume in his Roman studio, or that he makes regular use of projected images cut out from magazines or acetates. For all these operations make way in the end—and this is one of the most sucessful aspects of these paintings—for a unique image, strongly individual and totally ambiguous.

There is one anecdote that to me best reveals something of Gary Hume's attitude toward painting: the story of Tony Blackburn, the radio disc jockey whose name gave title to a 1993 work. Blackburn became a minor celebrity[12] when he used his daily program as a personal broadcast in an attempt to bring back his girlfriend after they had broken up. In this cooptation of a medium in which Blackburn was contractually bound to work, this reverse use of media logic in which he appropriated a codified language to his own strictly private ends, a reversal of status takes place: The DJ here is no longer an "entertainer," but, rather, a kind of pirate disturbing the undifferentiated flow of social messages.

I remember how, after a visit to the artist's studio, a few months after his exhibition at the Kunsthalle Berne, I was particularly struck by a large, predominantly black-and-violet canvas (FOUR FEET IN THE GARDEN, 1995). The figurative reading of the work seemed indeed to come directly from its "abstract" dimension. The painting brought the meaning to the surface, without freezing it. I clearly saw four pairs of bare feet, but I could not prevent myself from attributing them to a kind of surface accident, to a formal universe owing as much to Rorschach as to the photograph that had seemingly served as model. No doubt the black area in which a circle had been drawn served as confirmation of this ambiguity. One element, however, continued to irritate me, breaking the effect of the ebb and flow, and acting as an abrupt placing of the focus on the picture plane: At the bottom of the panel, Gary Hume had placed a few nonchalant strokes of green paint to represent grass. At that moment I did not dare admit to myself that this disruption of tone, this "lack of taste," was necessary. Whereas today it seems quite apparent to me that for Gary Hume the point is not to make tasteful or cultured objects, not to make, to quote Godard, *des images justes, mais juste des images*—as something inevitable and singularly definitive.

(Translated from the French by Sophie Hawkes)

1) The title of this essay is borrowed from the musical productions of Gerwald Rockenschaub, and echoes the title of the first album by the British group "Oasis," *Definitely, May Be.*
The subtitle makes allusion to Richard Hamilton's famous collage JUST WHAT IS IT THAT MAKES TODAY'S HOME SO DIFFERENT, SO APPEALING? (1956), the very picture that initiated British Pop Art.
2) Gerhard Richter in "Interview mit Rolf Gunther Dienst 1970" in: Hans-Ulrich Obrist (ed.), *Gerhard Richter. Text* (Frankfurt am Main: Insel, 1993), p. 58.
3) Gerhard Richter, "Aus einem Brief an Benjamin H.D. Buchloh 23. 5. 1977" ibid., p. 80.
4) Gerhard Richter, "Notizen 1986" ibid., p. 120.
5) Benjamin H.D. Buchloh, *Gerhard Richter*, ex. cat. vol. II, *Essays* (Paris: 1993). See also the texts of Gertrud Koch and Luc Lang in: *Gerhard Richter* (Paris: Editions Dis Voir, 1993).
6) Dave Hickey, "Richter in Tahiti" in: *Parkett* No. 35 (Zurich/New York: Parkett Publishers, 1993), p. 87.
7) Gerhard Richter, "Notizen 1986," op. cit., p. 120.
8) Interview with Adrien Dannatt, "The Luxury of Doing Nothing" in: *Flash Art*, No. 183 (Summer 1995), pp. 97–99.
9) In: *Gary Hume*, ex. cat., Kunsthalle Berne and ICA London, 1995, pp. 63–66.
10) "I love the skin surface of enamel, so mainly I refuse brush strokes..." Hume declares in his interview with Dannatt, op. cit., p. 97.
11) Dannatt, ibid.
12) Gregor Muir, *Art + Text*, No. 51, 1995, pp. 38–43.

GREGOR MUIR

LACQUER SYRINGE

In a recent telephone conversation with Gary Hume, I expressed the opinion that the art-going public was beginning to catch up with the work. Whereas Hume's rambunctious aesthetic may once have proved hard to swallow, I sensed a turnaround. Hume's determination to stay one step ahead of the game had me wondering how he might feel about a possible return to easy street. For instance, just when everything seemed to be going well with the door paintings (1988–1992), Hume decided to start over. In 1992, following a brief struggle with sculpture and photography, he adopted a more fluid style of representation noted for its figurative, organic, and biblical motifs. Although they retained his signature medium of household gloss paint, the first of the new paintings were difficult to comprehend. The colour schemes were deranged—swathes of chocolate brown against acid orange—and the subject matter oblique—tell me, is this a lung or a leaf? Anyone could be forgiven for mistaking Hume's transitional work for an accident involving an ice-cream van and a 1970s carpet store. Since then, the paintings have

become increasingly more—there is no better word —beautiful. And, what's more, people now accept their being beautiful. As we talked, the thought crossed my mind that perhaps he never intended his work to be easy on himself or on others. Then he said, "But what about me? How do these paintings relate to me?" Despite all the discussion surrounding his most recent work, Hume seemed to feel overlooked.

Not for the first time, our conversation ended on an awkward note. I felt like a culture vulture, intent on pinning the work to something out there that, at that moment, Hume found irrelevant.

A few days later, I arrived at Hume's studio to learn more about what he meant by "me." It was there, in a former auto-repairs shed where natural light descends through a darkened skylight, that his paintings revealed themselves to me as time-based works, their colours fluctuating with each passing cloud. During the course of a day, each exposed painting conducts its own series of private manoeuvres in the dappled sunlight. This temporal responsiveness in Hume's works brings to bear their quasi-photographic development, in which an overhead projector is used to transfer images onto large alu-

GREGOR MUIR is a writer and curator who lives in London.

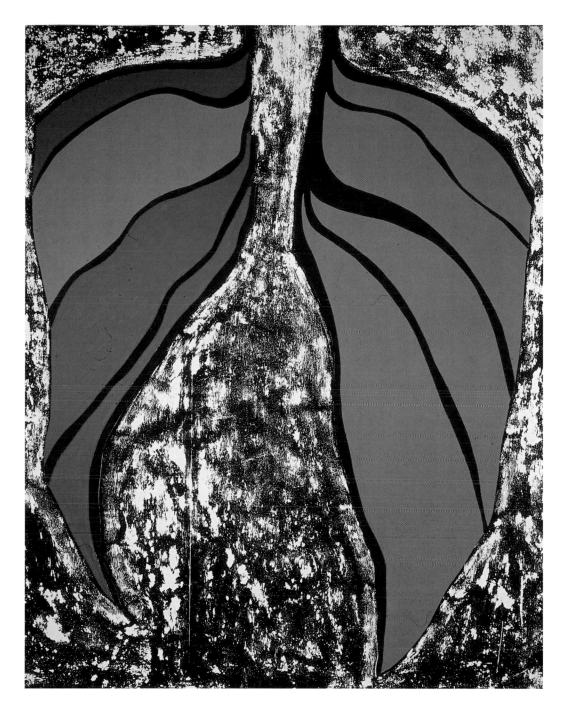

GARY HUME, ROOTS, 1993, gloss paint on formica panel, 86 x 72" / Lackfarbe auf Resopalplatte, 218,5 x 183 cm.
(PHOTO: JAY JOPLING, LONDON)

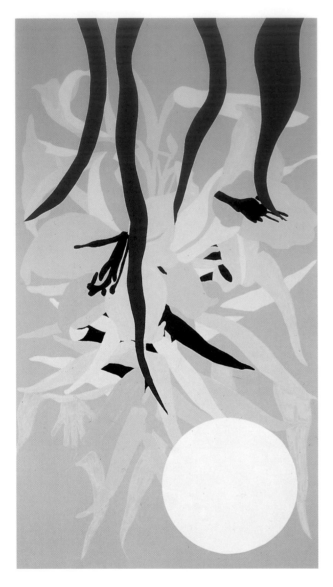

GARY HUME, NARCISSUS' SYMPATHY, 1996,
gloss paint on aluminum, 82 x 46" / Email auf Aluminium,
208,5 x 117 cm.
(PHOTO: STEPHEN WHITE)

minium panels. More often than not, they start out as tracings on sheets of A4 acetate. (Imagine Hume at the breakfast table, flicking through books and magazines until he finds the appropriate image.) These images on acetate sheets constitute Hume's iconic software, stored for future reference in a cardboard box. Unlike conventional drawings, the marker-pen lines—spare, light-handed, telling us all we really need to know—demarcate the paintings' tectonic layout, whereby lakes of pure colour butt up against each other, forming thick, creamy ridges.

Worked up into bold, schematic areas of flat paint, the image becomes increasingly simplified, more sign-like. It is often said that Hume's paintings engage us through simultaneous processes of knowing and not knowing what the subject matter means —owls, teddy bears, icicles, feet, hands, a horse, nothing. Perplexed, we ask ourselves why a painting composed of universally recognised symbols should appear so withheld. To decipher the image, we attempt to unravel Hume's painting process, working backward to some "master" image in the belief that this will reveal the subject's niggling familiarity. Preempting this reasoning, Hume leaves us high and dry. A compositional twist here, a wildly misrepresentative colour there, and the umbilical cord between the painting and its original image is severed. Unable to return to the source, our only option is to become emotionally involved with the subject matter as presented. From here on in, there is no respite, no free ride. The difficulty we experience in locating the imagery forces us to become active observers. Hume's esoteric colour combinations, his edgy composition, those irritating areas of what appear to be unfinished paintwork (not to mention the works' looming identity crisis with sculpture), all conspire to keep us on our toes.

Hume maintains that as soon as we engage with his paintings we become alive—living, thinking individuals, forced to extract a plausible narrative from his ridiculous fiction. Hume and I contemplate the works' emotional "always-ness." As psychoactive mirrors, the paintings force us to identify with them. Such is the generosity of Hume's imagery, a generosity which openly lets us decide what it is, so that the paintings will forever act as ciphers for us. Continu-

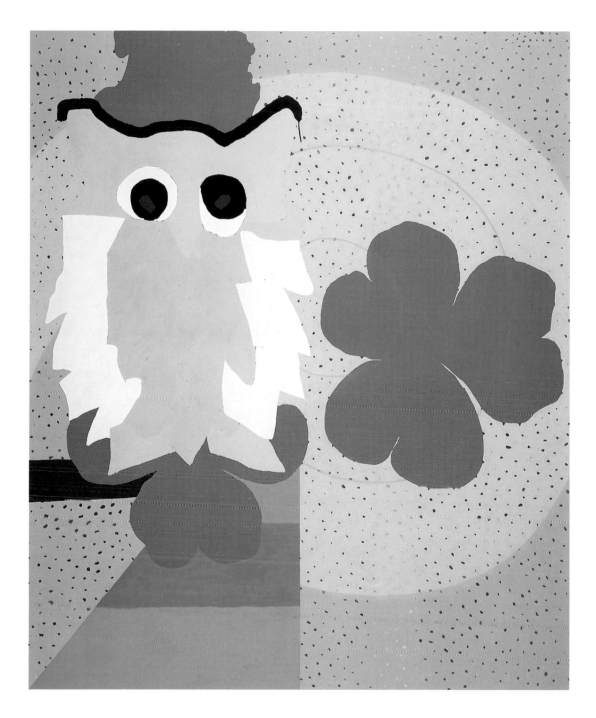

GARY HUME, WISE OWL, 1996, gloss paint on aluminum panel, 86 x 71" /
WEISE EULE, Lackfarbe auf Aluminium, 218,4 x 180,3 cm. (PHOTO: STEPHEN WHITE)

GARY HUME, RABBIT DRAWING, 1996,
ink on paper, 81 x 53" /
Tusche auf Papier, 206 x 135 cm.
(PHOTO: STEPHEN WHITE, LONDON)

ing this line of thought, Hume revisits the "me" of our earlier conversation. What he is getting at is the universal reception of his work. In other words, how do these paintings relate to you? In order to clarify his position, Hume invests certain words with ponderous significance. In this instance, he conflates "me" and "you." Me, as in I AM HE AS YOU ARE HE AS YOU ARE ME AND WE ARE ALL TOGETHER; it's odd how the paintings' narrative structure echoes that of "I Am the Walrus." From this, I imagine a whole host of iconographies inspired by The Beatles: SITTING ON A CORNFLAKE WAITING FOR THE VAN TO COME; CRAB A LOCKER FISHWIFE PORNOGRAPHIC PRIEST-ESS; EXPERT TEXTPERT CHOKING SMOKERS; ELE-MENTARY PENGUIN SINGING HARE KRISHNA.

Our conversation takes another turn when we consider how, deep down, the work is embarrassing. (Consider the moment when, having been humili-ated, you shrink at the sight of seeing yourself through other people's eyes.) Hume's work is a source of embarrassment on two levels. Primarily, there is a tendency to be humiliated by the subject matter. How can we fail to cringe at Hume's juxtaposition of British colloquialisms with pop-folkloric celebrities such as Tony Blackburn (a hackneyed radio disc jock-ey), Patsy Kensit (ex-film starlet presently dating Liam Gallagher of Oasis), and Kate Moss (Über-model), not to mention The Madonna and Child? Bold, emotional, ludicrously overstated, these im-ages make us increasingly self-aware as they probe our memories for a response. But the real killer

occurs when we catch ourselves reflected in the gloss paint. We become instantly self-conscious, and for a split-second we exit ourselves: a form of astral projec-tion akin to embarrassment. Our fear is that we remain in a perpetual state of watching ourselves fall apart. Confronted by the work, we experience our-selves in three possible loci: in front of, behind, and on the surface of the picture plane. Anxious to return to the image, we refocus, but it's too late. The painting has just caught us in the act of trying to determine what it's all about.

Unlike the surface of protective glass associated with framed canvases, household gloss paint reflects a murky, shadowy image whereby we witness our-selves as blurred outlines. Scanning back and forth between reflection and painted image, we succumb to a maddening psychological assault, in the face of which it takes a certain amount of bottle to hold the self together. These paintings are resolute in their outlook, pushy and up-front. They know what they're about, whereas we… What do we know? At the risk of being intimidated, we attempt to possess the image, at which point we enter into a compulsive relation-ship with the subject matter. Without question, these are intrusive paintings; they tease at the very fabric of our identity, demanding that we engage them head-on. Evoking some specific yet unnamed emotional condition, we indulge in their narcotic pleasures and allow them to get us high. All the while, Hume—the beauty terrorist—picks at our souls, curious to see how we rise to the challenge.

GREGOR MUIR

LACK SUBKUTAN

Kürzlich, in einem Telephongespräch mit Gary Hume, hatte ich die Meinung geäussert, dass das Kunstpublikum langsam, aber sicher Zugang zu seinem Werk finde. Gary Humes grelle Ästhetik schien ihm bisher eher sauer aufzustossen, doch jetzt spürte ich eine Kehrtwendung. Da Hume immer gern eine Nasenlänge voraus ist, fragte ich mich, was er wohl jetzt von einer Rückkehr in ruhigeres Fahrwasser hielt. So hatte er zum Beispiel, gerade als mit der DOOR-Serie alles gut zu laufen schien, den Entschluss gefasst, noch einmal von vorne anzufangen. Nach einem kurzen Geplänkel mit der Bildhauerei und der Photographie machte sich Hume 1992 einen flüssigeren Stil der gegenständlichen Darstellung zu eigen, der sich durch figurative, organische und biblische Motive auszeichnete. Obwohl er an seiner mittlerweile vertrauten Verwendung von handelsüblichem Glanzlack festhielt, waren die ersten der neuen Bilder schwer verständlich. Die Farbkombinationen waren abwegig – Schwaden von Schokoladenbraun neben ätzendem Orange, das Sujet undurchsichtig – *war das nun eine Lunge oder ein Blatt?* Man konnte es keinem verübeln, wenn er Humes Werk aus dieser Übergangsphase für einen Unfall hielt, bei dem ein Glacewagen in ein Teppichgeschäft der 70er Jahre gerast und umgekippt war. Seither sind die Bilder zusehends schöner – es gibt kein treffenderes Wort – geworden. Mehr noch, die Leute

akzeptieren, dass sie schön sind. Während unseres Gesprächs ging mir der Gedanke durch den Kopf, dass Hume es wohl nie darauf angelegt hatte, es sich selbst oder anderen mit seinen Arbeiten leicht zu machen. Dann sagte er: «Aber was ist mit mir? In welchem Zusammenhang stehen diese Bilder zu mir?» Trotz aller Diskussionen um seine jüngsten Arbeiten schien Hume sich übergangen zu fühlen.

Nicht zum ersten Mal nahm unser Gespräch einen etwas peinlichen Ausgang. Ich kam mir zwangsläufig vor wie ein «culture vulture», ein besserwisserischer Kulturheini, der die Sachen unbedingt an etwas Objektivierbarem festmachen wollte, was Hume für völlig irrelevant hielt.

Ein paar Tage später besuchte ich Hume in seinem Atelier, um mehr darüber zu erfahren, was mit «mir» gemeint war. Dort, in einer ehemaligen Autowerkstatt, in die durch ein Oberlicht Tageslicht einfällt, offenbarten sich mir seine Bilder erst wirklich als zeitabhängige Werke, deren Farben sich mit jeder vorbeiziehenden Wolke verändern. Im Lauf des Tages durchläuft jedes Bild eine Folge kaum merklicher Farbenspiele unter den wechselnden Lichtflecken. Diese Zeitgebundenheit von Humes Malerei trägt auch ihrer quasifilmischen Genese Rechnung. Die Bilder werden mit Hilfe eines Hellraumprojektors auf grosse Aluminiumplatten übertragen. Meistens erblicken sie das Licht der Welt zunächst als gepauste Konturzeichnung auf einer Acetatfolie im A4-Format. (Man stelle sich Hume vor, wie er am Frühstückstisch Bücher und Illustrierte so lange

GREGOR MUIR ist Kunstkritiker und Ausstellungsmacher. Er lebt in London.

durchblättert, bis er das richtige Motiv findet.) Diese Acetatfolien bilden Humes ikonische Software, abgelegt in einem Pappkarton als Quellenmaterial für die Zukunft. Im Unterschied zu herkömmlichen Zeichnungen bezeichnen die mit feinem Stift gezogenen Linien – sparsam und leichthändig alle notwendigen Informationen vermittelnd – die tektonische Grundstruktur der Bilder, in der Seen reiner Farbe aneinanderstossen, so dass dicke cremige Wülste entstehen.

Zu kühnen schematischen Partien unmodulierter Farbe ausgearbeitet, wird das Dargestellte zunehmend vereinfacht und plakativ. Es heisst oft, Humes Bilder fesselten uns durch ihr Spiel mit der Erkennbarkeit des Dargestellten – Eulen, Teddybären, Eiszapfen, Füsse, Hände, ein Pferd, nichts. Verdutzt fragen wir uns, weshalb ein Gemälde, das sich aus allgemein bekannten Symbolen zusammensetzt, derart unzugänglich wirken kann. Um das Bild zu entschlüsseln, versuchen wir Humes Malvorgang auf ein «Urmotiv» zurückzuführen im Glauben, dadurch werde die detailgenaue Vertrautheit des Gegenstandes zutage treten. Aber als hätte er diese Versuche vorausgeahnt, lässt uns Hume auf dem trockenen sitzen. Ein kompositorischer Dreh hier, eine abenteuerlich verfehlte Farbe dort, und schon ist die Nabelschnur zum ursprünglichen Motiv durchtrennt. Der Möglichkeit beraubt, zur Quelle zurückzukehren, bleibt uns nichts anderes übrig, als uns emotional auf das Dargestellte einzulassen. Und von da an gibt es kein Zurück, jetzt gilt es ernst. Die Schwierigkeit, die es uns bereitet, die Motive zu orten, macht uns notwendig zu aktiven Betrachtern. Humes esoterische Farbkombinationen, seine kantige Komposition, irritierend unfertig wirkende Bildpartien (ganz zu schweigen von der drohenden Identitätskrise der Arbeiten in unmittelbarer Nähe zur Bildhauerei): All das trägt dazu bei, uns in Trab zu halten.

Hume ist der Ansicht, dass wir, sobald wir uns auf seine Bilder einlassen, zum Leben erwachen, zu lebendigen, denkenden Individuen werden, dazu gezwungen, seiner absurden Fiktion einen plausiblen Inhalt zu entlocken.

Hume und ich stellten Betrachtungen über die emotionale *«Allzeitlichkeit»* seiner Arbeiten an. Wie könnten wir uns mit diesen psychoaktiven Spiegeln nicht identifizieren? Die Humesche Bildsprache ist

derart grosszügig – die nähere Bestimmung des Dargestellten bleibt ausdrücklich uns überlassen –, dass die Bilder für uns dauerhaft als Chiffren fungieren können. Diesen Gedankengang weiterspinnend, kommt Hume auf das «mir» in unserem Telephongespräch zurück. Worauf er hinaus wollte, war die universelle Rezeption seines Werkes. Mit anderen Worten: In welchem Zusammenhang stehen diese Bilder zu dir? Um seinen Standpunkt zu verdeutlichen, befrachtet Hume bestimmte Wörter mit gewichtiger Bedeutung. In diesem Fall wirft er «ich» und «du» in einen Topf. «Ich» wie in: I AM HE AS YOU ARE HE AS YOU ARE ME AND WE ARE ALL TOGETHER (Ich bin er wie du er bist wie du ich bist und wir alle zusammen sind). Seltsam, wie sich die narrative Struktur seiner Bilder an die von «I Am the Walrus» anlehnt. Entsprechend lassen sich eine Unmenge von den Beatles inspirierte Bildmotive ausmalen: SITTING ON A CORNFLAKE WAITING FOR THE VAN TO COME; CRAB A LOCKER FISHWIFE PORNOGRAPHIC PRIESTESS; EXPERT TEXTPERT CHOKING SMOKERS; ELEMENTARY PENGUIN SINGING HARE KRISHNA.

Unser Gespräch nimmt eine Wendung, als wir uns überlegen, dass die Arbeiten im Grunde peinlich sind. (Wie wenn man in einer demütigenden Situation zusammenzuckt, beim Gedanken an das Bild, das man in den Augen anderer abgibt.) Humes Werk ist uns auf zweierlei Art peinlich. Erstens wirkt oft schon der dargestellte Gegenstand wie eine Beleidigung. Wir können gar nicht anders als zurückschrecken vor Humes Kombinationen von Sprachfloskeln und Exponenten der Pop-Folklore – Tony Blackburn (abgetakelter Radio-Diskjockey), Patsy Kensit (ehemaliges Filmsternchen) oder Kate Moss (Megamodel) – von der Madonna mit Kind ganz zu schweigen. Frech, emotionsgeladen, absurd überspitzt, werfen uns diese Bilder, indem sie nach einer Reaktion verlangen, immer mehr auf uns selbst zurück. Der eigentliche Todesstoss erfolgt jedoch erst, wenn wir uns selbst im Glanzlack gespiegelt erblicken. Sofort werden wir uns unserer selbst bewusst und für einen Sekundenbruchteil geraten wir ausser uns – eine Art Astralprojektion, die Scham auslöst. Dabei fürchten wir, dass wir aus dem Zustand der Beobachtung des eigenen Auseinanderfallens nicht mehr herauskommen. Wir erfahren uns selbst

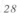

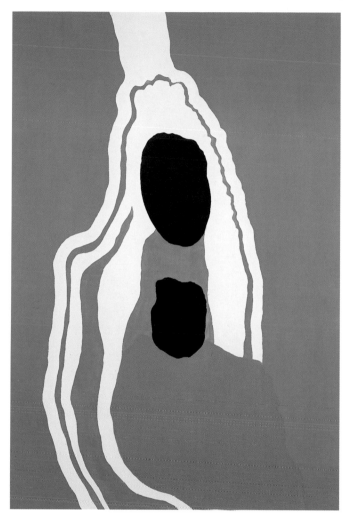

GARY HUME, MADONNA, 1993, gloss
paint on formica panel, 81⅞ x 55⅛" / Lackfarbe
auf Resopalplatte, 208 x 140 cm.
(PHOTO: JAY JOPLING)

dem Werk gegenüber in drei möglichen Positionen: vor, hinter und auf der Bildfläche. Bestrebt, zum Bild zurückzukehren, fokussieren wir den Blick neu, doch es ist zu spät. Das Bild hat uns soeben auf frischer Tat ertappt, beim Versuch, eine Bedeutung aus ihm herauszuklauben.

Anders als die spiegelähnliche Oberfläche von normalem Schutzglas reflektiert der Glanzlack ein trübes, schattenhaftes Bild, durch das wir uns selbst nur als verschwommenen Umriss wahrnehmen. Im ständigen Hin und Her zwischen gespiegeltem und gemaltem Bild sind wir einer entnervenden psychologischen Attacke ausgesetzt. Um der zu widerstehen, braucht das Ich schon einen sehr soliden Rückhalt. Die Bilder wirken resolut, aggressiv und direkt.

Sie wissen, worum es geht, wohingegen wir... Was wissen wir schon? Auf die Gefahr hin, vor den Kopf gestossen zu werden, versuchen wir das Bild in den Griff zu bekommen und gehen so eine zwanghafte Beziehung zu seinem Gegenstand ein. Denn zweifellos sind es aufdringliche Bilder: Sie zerren am Gewebe unserer Identität und fordern uns zum direkten Angriff heraus. Dabei rufen sie einen spezifischen Gemütszustand hervor, in dem wir uns betäubt dem Genuss hingeben und uns berauschen lassen. Aber gleichzeitig stochert Hume, dieser Terrorist des Schönen, in unseren Seelen herum, und beobachtet gespannt, ob und wie wir uns der Herausforderung gewachsen zeigen.

(Übersetzung: Magda Moses, Bram Opstelten)

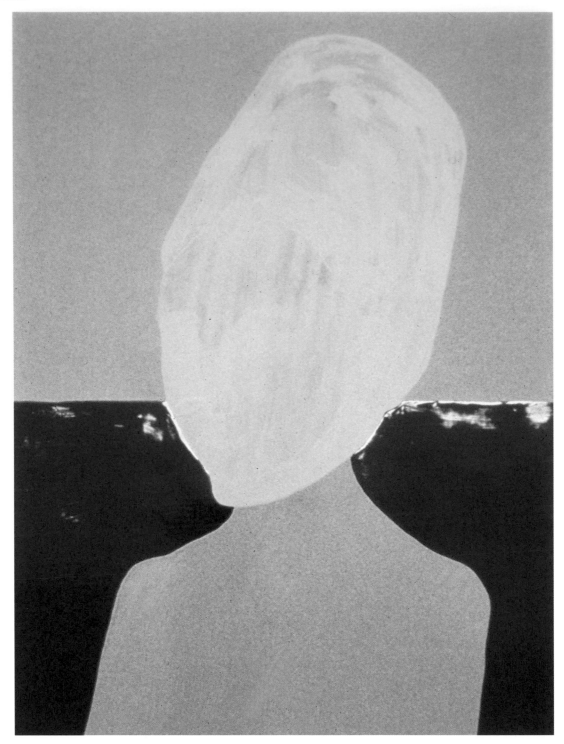

GARY HUME, AFTER PETRUS CHRISTUS, 1995, gloss paint on wood panel, 48 x 30" /
NACH PETRUS CHRISTUS, Lackfarbe auf Holzplatte, 122 x 76 cm. (PHOTO: JAY JOPLING, LONDON)

DOUGLAS FOGLE

Skin Jobs

They say that beauty is only skin deep. So what, we might ask, is the depth of skin? Nothing more than a loosely connected layering of cells just a few millimeters thick, the skin, although an effective barrier, is nonetheless a particularly precarious organ. Its structure incorporates gaps and, despite all its powers of regeneration, its surface tears easily. It is the very tenuousness of our corporeal container that underlies the seemingly paradoxical ambivalence that our culture directs towards its surface. Skin doesn't simply hold our bodies together; it provides a medium for our interface with the world. As the judicial sentencing machine in Kafka's *In the Penal Colony* would seem to suggest, the skin functions as a palimpsest, on which is left the physical traces of social interaction, our traumatic intersection with the world. Whether we obsess over the complexion of a supermodel, express horror at the transmogrifications of plastic surgery, or marvel at tales of ecstatic stigmata, the skin holds us tightly in its grip.

The French psychoanalyst Didier Anzieu devoted an entire volume to the analysis of dermatological paranoia in his patients. In postulating a psychoanalytic explanation for this cultural obsession, Anzieu put forth the notion of a "skin ego," which we might think of as a psychic envelope whose contours are coterminus with the physiological limits of our bodies. In analyzing his patients over the years, Anzieu found a direct correspondence between anxieties concerning imagined violations of the skin and actual dermatological pathologies. These findings were then generalized to suggest the workings of a larger cultural paradigm in which the blurring of the skin ego with the social ground against which it appears produced an anxiety in the subject. The symptoms varied from hysterical numbness to compulsive self-mutilation, but Anzieu was confronted by the common fear of "a flowing away of vital substance through holes," which he identified as "an anxiety not of fragmentation but of emptying."[1]

Something of this paradoxical fascination with the skin can be identified in the surface of Gary Hume's paintings. In fact, the artist himself has likened his canvases to flesh, suggesting that the underpainting takes on the function of skin in relation to the surface paint's role as makeup. Like skin, these paintings act as interfaces between the realm of subject and object, viewer and viewed, drawing us into the orbit of their saccharine sheen while at the same time maintaining a high-gloss barrier to any unwelcome entry. From the earlier geometric paintings of doors to recent forays into more figurative terrain, Hume's paintings are encased in a cocoon of gelatinous pigment, like insects caught in amber. In PATSY KENSIT (1994), the minor denizen of pop stares at the viewer, her taunting gaze frozen in shimmering layers of pink and ochre hues. Like skin, the pigment's glistening surface is at first seductive. But then Kensit begins to resonate with a wholly different kind of energy, her surface curdling like milk left out too long. As figure and ground mutate into a single prophylactic envelope, one begins to feel dizzy, a phenomenon which, as Ulrich Loock suggests in his recent essay "Artificial Pictures,"[2] destabilizes any attempts at resolving the historical tensions produced between figure and ground, between the physicality of the paintings—their material opacity—and

DOUGLAS FOGLE is a writer, and a curator at the Walker Art Center in Minneapolis.

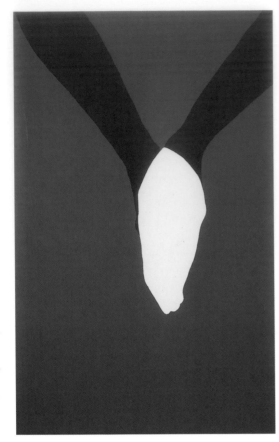

GARY HUME, FALLING, 1995, gloss paint on aluminum panel, 79 x 49″ / FALLEN, Lackfarbe auf Aluminium, 200,7 x 124,5 cm. (PHOTO: STEPHEN WHITE)

the clone's Romantic predecessor, provoked an existential questioning of the soul through an uncanny doubling of the subject, the replicant operates according to a decidedly different genetic paradigm, which we might term viral. The replicant has left Plato's cave behind, being far more interested in exact cellular mitosis than in the shadowy realm of mere simulacra. In this viral model, the idealistic bifurcation of representation and reality evaporates on the seamless membrane of Hume's paintings.

Nowhere is this evaporation more evident than in a series of paintings based on photographs of the Fascist figure sculptures that surround Mussolini's Olympic stadium in Rome.[3] In VICIOUS (1994) we see a heroically posed male figure rendered in disquieting brown paint against a flattened floral background. Its contours taped off in a hard-edged outline, its forward motion arrested by viscous pigment, this Fascist monument towers over us on its enormous aluminum surface, a body sealed against any possible leakage of its skin ego into the ground that offsets its silhouette. More human than human, the Fascist "soldier-male" (as Klaus Theweleit calls it) fully embodies the pathological characteristics ascribed by Anzieu to his patients. But in Hume's high-gloss monumentality, the virile hygiene of the figure is transformed into a viral contamination of its skin ego. Hardened, yet strangely porous, these hypermasculine skin jobs become infected with the same vertigo that destabilizes the coquettish PATSY KENSIT. The dominating perspectival tilt from which we see the figure in VICIOUS suggests the Romantic apotheosis of Leni Riefenstahl's athletic *Übermensch*, but Hume's affectless urgency gets under the skin of this fascinating Fascism and mutates it. Against such an infection Romanticism has no recourse. Hail the new flesh.

their illusionistic references. In labeling these paintings "hybrids" and "hermaphrodites," Loock claims for them a new phylum within the taxonomy of artistic production. Rather than overcoming all dissonance through a dialectical resolution of opposites, the paintings produce an endless disturbance, a precarious if insistent insurgency which short-circuits the logic of modernism. But while Loock's characterization of Hume's paintings might be summed up in the figure of the clone, we might also consider them more in relation to Anzieu's sense of the pathological anxiety of the skin ego.

If both characterizations are correct, we might then call Hume's paintings "skin jobs," a term used to describe the replicants in Philip K. Dick's novel *Do Androids Dream of Electric Sheep?* In Dick's novel the skin job is described as "more human than human," inspiring a mixture of admiration and revulsion in the human imagination. Whereas the *doppelgänger*,

1) Didier Anzieu, *The Skin Ego* (New Haven: Yale University Press, 1989), pp. 38–39.
2) Ulrich Loock, "Artificial Pictures," in *Gary Hume: Paintings* (Bern: Kunsthalle Bern, 1995), pp. 63–66.
3) With titles like VICIOUS (1994), MANLY (1994), and HERO (1993), one might be tempted to read these paintings as a continuation of the questioning of artistic hubris begun in Hume's short single-channel video ME AS KING CNUT (1992), in which the artist sits in his backyard in a bathtub full of water, a paper Burger King crown on his head, telling the story of King Canute.

Gary Hume

GARY HUME, KATE, 1996, gloss and paper on aluminum panel, 46 x 81⅞" / Lack und Papier auf Aluminium, 117 x 208 cm. (PHOTO: STEPHEN WHITE)

GARY HUME, PATSY KENSIT, 1994, gloss paint on formica panel, 81⅞ x 46" / Lackfarbe auf Resopalplatte, 208 x 117 cm. (PHOTO: JAY JOPLING, LONDON)

DOUGLAS FOGLE

Hautphänomene

Man sagt, Schönheit sei eine Frage der Oberfläche, sie reiche nicht tiefer als die Haut. Aber wie tief reicht denn die Haut selbst? Eine lediglich wenige Millimeter dicke Lage lose miteinander verbundener Zellschichten, bildet die Haut zwar eine wirksame Barriere, ist im Grunde aber ein äusserst verletzliches Organ. Ihre Struktur ist mit Poren durchsetzt, und obwohl sie enorm regenerationsfähig ist, reisst die Oberfläche leicht auf. Die Fragilität unserer körperlichen Hülle ist der tiefere Grund für die scheinbar so widersprüchliche Ambivalenz, mit der unsere Kultur deren Oberfläche betrachtet. Die Haut hält ja nicht nur den Körper zusammen, sie ermöglicht auch den Kontakt zur Aussenwelt. Wie die Urteilsvollstreckungs-Maschine in Kafkas Erzählung *In der Strafkolonie* es anzudeuten scheint, gleicht die Haut einem Palimpsest, auf dem die soziale Interaktion unentwegt Spuren hinterlässt, ein traumatischer Berührungspunkt von Ich und Welt. Der Haut sind wir erbarmungslos ausgesetzt, ob wir den makellosen Teint der Supermodels vergöttern, ob es uns angesichts der Verwandlungskünste der plastischen Chirurgie schaudert oder ob wir fasziniert irgendwelchen Wundergeschichten von aufbrechenden Stigmata lauschen.

Der französische Psychoanalytiker Didier Anzieu hat der Untersuchung der dermatologischen Paranoia seiner Patienten einen ganzen Band gewidmet. Er fordert und versucht eine psychoanalytische Erklärung für die Hautbesessenheit unserer Kultur und führt den Begriff des «Haut-Ichs» ein; dieses können wir uns als eine Art psychische Schutzfolie vorstellen, deren Umrisse mit den Grenzen unseres Körpers zusammenfallen. Während der jahrelangen Analyse seiner Patienten stiess Anzieu auf einen direkten Zusammenhang zwischen den Angstphantasien über mögliche Hautverletzungen und tatsächlichen Erkrankungen der Haut. Diese Befunde wurden dann verallgemeinert in der Annahme, dass ein umfassenderes kulturelles Paradigma wirksam sei, wo immer die drohende Auflösung des «Haut-Ichs» im sozialen Umfeld, von dem es sich normalerweise deutlich abhebt, im Subjekt Ängste auslöst. Die Symptome reichten vom hysterischen Verlust des Empfindungsvermögens bis zur zwanghaften Selbstverstümmelung, aber Anzieu sah sich einer allgemeinen Angst gegenüber, «dass lebenswichtige Substanz durch die Löcher und Lücken entweiche», was er mit «nicht Angst vor Zerstückelung, sondern vor Entleerung» umschrieb.[1]

Etwas von dieser paradoxen Faszination durch die Haut findet man auch in den Oberflächen von Gary Humes Bildern. Tatsächlich brachte der Künstler selbst seine Leinwände mit dem Körper in Verbindung, als er das Verhältnis von Grundierung und darüberliegender Farbe mit jenem von Haut und Make-up verglich. Wie die Haut fungieren diese Bilder als Schaltstellen zwischen Subjekt und Objekt, Betrachter und Betrachtetem, indem sie uns in den Dunstkreis ihres süssen Scheins hineinlocken und zugleich eine Hochglanz-Barriere gegenüber jedem unwillkommenen Eindringen aufrechterhalten. Von den frühen geometrischen Bildern von Türen bis zu seinen neueren Vorstössen ins Gebiet des Figürlichen: Humes Bilder liegen in einem Kokon zähflüssigen Pigments wie in Bernstein eingeschlossene Insekten. In PATSY KENSIT (1994) starrt das Pop-Sternchen dem Betrachter entgegen, wobei ihr

DOUGLAS FOGLE ist Publizist und Kurator im Walker Art Center in Minneapolis.

Gary Hume

verächtlicher Blick durch leuchtende Schichten von Pink und Ocker schillert. Wie die Haut wirkt auch die glänzende Pigmentoberfläche zunächst verführerisch. Aber dann beginnt Kensit plötzlich in einem völlig andersartigen Energiefeld zu schwingen, die Oberfläche gerinnt wie abgestandene Milch. Und wenn Figur und Hintergrund zu einer einzigen Schutzschicht werden, fühlt man sich schwindelig, ein Phänomen, das (laut Ulrich Loock) jeden Versuch zur Lösung der historischen Spannungen vereitelt, die zwischen Figur und Hintergrund entstehen, zwischen der Körperlichkeit der Bilder – ihrer materiellen Opazität – und ihren illusionistischen Referenzen. Indem er diese Bilder als «Hybriden» und «Hermaphroditen» bezeichnet, fordert Loock für sie ein neues Vokabular innerhalb der Taxonomie künstlerischer Produktion. Statt alle Dissonanzen in einer dialektischen Auflösung der Gegensätze zu überwinden, bewirken die Bilder eine andauernde Störung, ein gewagtes, aber nachdrückliches Aufbegehren, das die Logik des Modernismus unterläuft.[2] Loocks Charakterisierung von Humes Bildern lässt sich in der Metapher des Klons zusammenfassen, aber wir könnten sie im Licht von Anzieus Verständnis der krankhaften Ängste des «Haut-Ichs» noch etwas näher betrachten.

Wenn beide Auffassungen zutreffen, könnten wir Humes Bilder auch *Skin Jobs* (Hautphänomene) nennen. Diese Bezeichnung verwendet Philip K. Dick in seinem Roman *Do Androids Dream of Electric Sheep?* In diesem Roman wird der *Skin Job* (ein Replikant, eine Art Haut- oder Hüllen-Wesen)[3] «menschlicher als menschlich» genannt und löst in der Vorstellung der Menschen eine Mischung von Bewunderung und Abscheu aus. Während der Doppelgänger, ein romantischer Vorläufer des Klons, durch eine einfache Verdoppelung des Subjekts ein existentielles Hinterfragen der Seele auslöste, funktioniert der Replikant nach einem grundverschiedenen genetischen Programm, das man als viral bezeichnen könnte. Der Replikant hat Platons Höhle verlassen und interessiert sich weit mehr für die Zellkernteilung als für das Schattenreich der Bilder. Nach diesem Modell der viralen Replikation würde die idealistische Trennung von Zeichen und Wirklichkeit durch die nahtlose Membran von Humes Bildern aufgelöst.

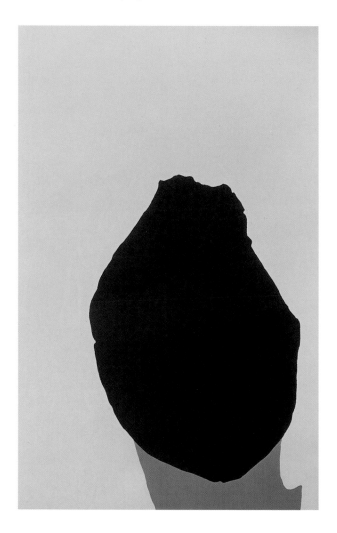

GARY HUME, YELLOW HAIR, 1995, gloss paint on wood panel, 81⅞ x 46" / GELBES HAAR, Lackfarbe auf Holzplatte, 208 x 117 cm. (PHOTO: JAY JOPLING, LONDON)

Nirgends wird diese Auflösung deutlicher als in einer Bilderserie, die auf Photographien faschistischer Skulpturen aus Mussolinis Olympiastadion in Rom beruhen.[4] In VICIOUS (1994) sehen wir eine männliche Silhouette in heroischer Pose und bestürzend brauner Farbe vor einem flach wirkenden geblümten Hintergrund. Mit überdeutlichen, hart umrissenen Konturen, die Vorwärtsbewegung in zäher Pigmentfarbe erstarrt, überragt uns dieses faschistische Monument auf einer riesigen Aluminiumplatte, ein Körper, der absolut dicht und versiegelt ist gegen jede Durchlässigkeit zwischen «Haut-Ich» und Hintergrund. Menschlicher als menschlich, weist dieser faschistische oder «soldatische» Mann (wie Klaus Theweleit ihn nennen würde) alle Krankheitsmerkmale auf, die Anzieu seinen Patienten zuschreibt. Aber in Humes Hochglanzmonumentalität verwandelt sich die übertrieben virile «Reinheit» der Figur in eine virale Infektion seines Haut-Ichs. Verhärtet und doch merkwürdig porös, werden diese hypermaskulinen Skin Jobs vom selben Schwindelgefühl infiziert, das auch die kokette PATSY KENSIT aus dem Gleichgewicht bringt. Die erhabene Perspektive, in der die menschliche Figur in VICIOUS erscheint, erinnert an die romantische Apotheose des athletischen Übermenschen bei Leni Riefenstahl. Aber Humes unpathetische Eindringlichkeit durchdringt die Oberfläche dieses verführerischen Faschismus und verwandelt ihn durch und durch. Gegen eine solche Infektion kennt der Romantizismus keine Medizin. Es lebe der neue Körper.

(Übersetzung: Susanne Schmidt)

GARY HUME, TWO EGGS, 1995, gloss paint on aluminum, 49¼ x 82⅝" / ZWEI EIER, Lackfarbe auf Aluminium, 125 x 210 cm. (PHOTO: STEPHEN WHITE)

Die dem Text unterlegten Zeichnungen geben (teilweise leicht verkleinert) die Folienzeichnungen wieder, mit denen Gary Hume arbeitet. / The drawings (some of them slightly reduced) underneath the text show the drawings on film that Gary Hume works with.

1) Didier Anzieu, Das Haut-Ich, Suhrkamp, Frankfurt am Main 1991.
2) Ulrich Loock, «Artifizielle Bilder» in: Gary Hume. Paintings, Kunsthalle Bern, 1995, S.12 ff.
3) Für die Bandbreite von Bedeutungen des englischen Job – von Arbeit, Auftrag, Angelegenheit, Produkt, Typ . . . bis unangenehmer Kerl (tough job) – gibt es im Deutschen keine genaue Entsprechung.
4) Durch Titel wie VICIOUS (1994), MANLY (1994) und HERO (1993) könnte man sich dazu verführen lassen, diese Bilder als Fortführung der Infragestellung der künstlerischen Hybris zu verstehen, die Hume in seinem Einkanalvideo ME AS KING CNUT (1992) begonnen hat; darin erzählt der Künstler, in einer Badewanne in seinem Hinterhof sitzend, eine Burger-King-Pappkrone auf dem Haupt, die Geschichte von King Canute.

EDITION FOR PARKETT

GARY HUME
SNOWMAN, 1996
Silkscreen on pink felt,
printed by Print Workshop, London,
12 x 12"
Edition of 55, signed and numbered

SCHNEEMANN, 1996
Siebdruck auf rosa Filz,
gedruckt bei Print Workshop, London,
30,5 x 30,5 cm
Auflage: 55, signiert und numeriert

(PHOTO: MANCIA/BODMER)

Gabriel Orozco

Back in Five Minutes

FRANCESCO BONAMI

Gabriel Orozco finished rolling his plasticine ball, YIELDING STONE (1992), and set it to rest next to one of the massive pillars in the Corderie, the long, cavernous rope factory where "Aperto '93" was about to open at the Venice Biennale. This first piece "installed," it was now time for him to work on the second sculpture, EMPTY SHOEBOX (1994), he had chosen to present in the exhibition—a white, empty shoebox, just as the title suggests. He opened his knapsack, pulled out the box, chose the spot on the stone pavement, and put the piece down.

As I wanted to do my curatorial job the best I could, protecting as flesh of my flesh the works of the artists I'd selected, I suggested to Orozco to glue the box to the floor. It was clear to me that the poor, ephemeral piece would not survive the milling throngs during the opening. People would crush the thing, distractedly seeking more evident signs of contemporary art. As it was, they were already sticking their fingers into YIELDING STONE; someone had even stabbed it with a plastic fork, perhaps as an act of pure vandalism, or maybe on an irrepressible impulse to interact, as much of the exhibition encouraged. So why should people spare that one box, born to be destroyed? Ungrateful feet, whose shoes may have once rested in that very same box, would have abused it without pity. Not to mention the Biennale's installation crew—they would have thrown it into a trash bag early in the morning. After all, at the 1978 Biennale they painted PORTE 11 RUE LARREY, Duchamp's famous door, which shut when it was opened and vice versa. Yes, they painted it, meaning to do their job quickly and dutifully, while normally you need to petition the president of the Italian Republic to get a screwdriver.

Orozco looked at me calmly, if a little worried. I understood right away that my suggestion was not only silly, but showed quite awkwardly that I didn't get anything about his work. Pondering, I left him and his empty box, and found myself in front of another work I'd selected for my section of the show. It was Charles Ray's 7½ TON CUBE (1990), a cube of solid steel painted so white as to look almost weight-

FRANCESCO BONAMI is a writer and curator, and the U.S. Editor of *Flash Art*. He lives in New York City.

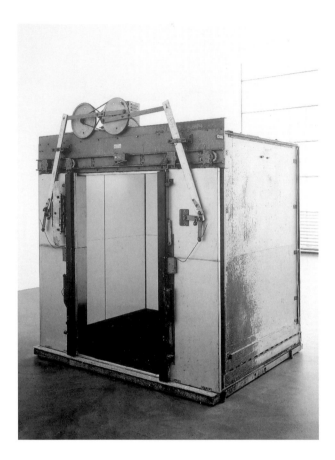

GABRIEL OROZCO, ELEVATOR, 1994,
altered elevator cabin, 8 x 8 x 5' /
LIFT, umfunktionierte Liftkabine, 244 x 244 x 152,5 cm.
(PHOTO: MARIAN GOODMAN GALLERY, NEW YORK)

less. Suddenly that little box by Orozco became an ironic comment on the cube that was in front of me, which no one could have moved an inch.

In the space between those two works, the shoe-box and the steel cube, the collapse of contemporary sculpture was consumed. The language of those pieces, which at first seemed incompatible, appeared to be complementary after a second analysis. Ray assimilated the minimalist discourse into the latent psychopathy of Californian art: The obsession of minimalism materialized in the weight of the cube, maintaining only a deceptive surface of lightness and simplicity. Orozco's shoebox, however, digested the minimalist heritage so easily as to become its ideal, never risking being reduced to a mere "thing." Ray sealed the language of sculpture definitively; Orozco laid it open to a whole spectrum of possibilities and deep perspectives.

But the real comparison was not this one, but the one between EMPTY SHOEBOX and YIELDING STONE. These two works were a meeting point in Orozco's long, slow tasting of the sculptural syntax laid out by art history. Extracting every possible technique adopted by sculpture through the course of centuries and applying them to simple things, Orozco transformed these things, making them "sculptures" in the most classical sense, yet without the loss of their "thing-ness." The plasticine ball was quintessential of the "To Put On," while the shoebox was a sublimation of the "To Pull Off," two of the most common techniques used by classical sculptors: the indefinite which grows toward formalism, and the block of matter from which the form is extracted. But we must keep in mind that Orozco is a classical extremist, and so his ball is nothing but the indefinite growing indefinitely, and the extracted form is nothing but the shoes themselves, whose absence can be imagined as being present elsewhere—maybe even on the feet of the artist himself.

We are looking at an artist who analyzes the alphabet created by sculpture in art history, and then mixes it with the alphabet created by things in reality. Inside Orozco's work, a series of threads are woven, but along those threads the communication flow is interrupted by knots of meaning. These knots are, simply, those things—transformed into sculpture—

which break the circuit of artistic language. The logical and historical consequences of the artwork are subverted or, at least, diverted.

Coming back to the shoebox: This is the container, the signifier of a form that is nothing but the shape of the feet. If we were to empty the box, it would be clear enough that it is a complete sculpture, and the upside-down cover is its base: Thus does Orozco solve one of the "problems" of classic sculpture (look at Brancusi), by applying the classical grammar to the ordinary object.

The idea of the empty container waiting to be filled is one of the most well-trodden paths in Orozco's activity. So this "void" is again one of the many materials used by the artist to compose the work, to compress it, to cut it, to sew it, to weld it. To be more clear, we could say that the "void" is the knot that is tied in the rope of language. HAMMOCK HANGING BETWEEN TWO SKYSCRAPERS, presented in 1993 at the Museum of Modern Art in New York, is a perfect example of the "void" sculpted and molded, underlining that the "Putting On" and the "Pulling Off" of classical sculpture are recurring elements in the language of objects. Grasping these elements as constant references to the traditional idea of sculpture and its dispersal into the accidental realm of things, Orozco reestablishes the instability of the space in relation to the materials which fill it. He takes away where we expect it to be occupied, and he fills where we expect to find an empty corner. The hammock between two trees in the garden of the MoMA is not just empty, it's deflated; even the air that the body would have squashed in laying itself down is gone. Yet beyond the walls of the garden, on the window ledge of a building facing the museum, some oranges appear, exactly where we would not expect to find anything. The person who put those oranges there is the same person who disappeared from the hammock, isn't he?

The actions of taking away and putting on are overlapping, creating a continuity of movement, an existential loop which erases much of the recent insistence on the physicality of art and the presence of the artist. As viewers, we are taken off-guard. We must mentally fill that empty space with something. We do not ask ourselves "Who did it?" but rather,

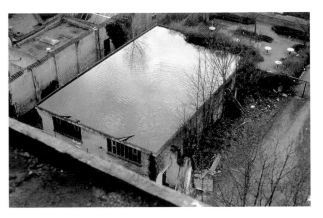

GABRIEL OROZCO, FROM ROOF TO ROOF, 1993,
c-print, 9⅛ x 13½" / VON DACH ZU DACH, 23,2 x 34,3 cm.

GABRIEL OROZCO, UNDER THE TABLE, 1993,
c-print, 9⅛ x 13½" / UNTER DEM TISCH, 23,2 x 34,3 cm.

GABRIEL OROZCO, SAND ON TABLE, 1992,
c-print, 12⁷/₁₆ x 18⅝" / SAND AUF TISCH, 31,6 x 47,3 cm.

GABRIEL OROZCO, BREATH ON PIANO, 1993, c-print, 12⁷/₁₆ x 18⁵/₈″ / ATEMHAUCH AUF KLAVIER, 31,6 x 47,3 cm.

GABRIEL OROZCO, BIG BANG, 1995, c-print, 12⁷/₁₆ x 18⁵/₈" / 31,6 x 47,3 cm.

"Who was here?" (the hammock), "Who put this here?" (oranges).

"Where is it?" was the question at the core of Gabriel Orozco's first solo show in New York in 1994. The shoebox was enlarged to become the gallery itself. The huge room appeared to be empty, a receptacle for the viewers which behaved as a kind of architectonic gauge of the viewer's presence and conscience. There was nothing in the space except four clear yogurt container-lids rimmed in blue. A seemingly relentless landscape—but there was more than first met the eye.

The yogurt caps were at the same time the show and its absence. On this occasion the space was filled mentally, not physically, by the viewer. The obligation that this placed upon the people in the space to be present and share the "emptying" created the intentional "disappointment" that Orozco often communicates in his work; that is, we are not disappointed by something that we wish was better, but because we are forced to suspend any judgment, to freeze our reactions in the void. We are not shocked by something outrageous, but we are pissed because we are missing the point which would give us reason to stay or go. The absence of things creates great discomfort. Here, nothing happened, which goes against the logic and rules of a work of art.

Not that Orozco means to desecrate the artistic experience; rather, he moves it constantly from one point in our panorama of knowledges and references to another. Just like Duchamp's door, Orozco's door opens when it closes and closes when it opens, at the same time making it possible to enter and exit. Actually, if in the empty gallery nothing happens, in other of Orozco's works what is happening, or what has already happened, creates for the viewer a similar state of anguish and disappointment to that produced by the clear, blue-rimmed yogurt caps.

Inside the LA DS—the sculpture that Orozco extrapolated from the famous car designed and produced by Citroën in the fifties by taking away a central slice and pasting the remaining two thirds perfectly back together—the passenger gets squeezed into the space that has been removed, much as a body might grow thinner to get into a hammock rather than the hammock expand to receive the person. ("What happened?" "What's happening?") Apparently, this slicing intervention is minimal—actually, the idea is—but the result and the process of understanding it are quite baroque. The destruction of a sophisticated spatial concept, like that of the original Citroën design, corresponds to a meticulous reconstitution of totally new dimensions yet is able to refer, even if in total derangement, to the object's original message. (As if Fontana's cut was patiently stitched back together and painted over, but still showed the altered proportions of the canvas.) In a way, the gesture that wounds is also the gesture that heals, giving

GABRIEL OROZCO, PINCHED BALL, 1993, c-print, 9⅛ x 13½" / GEQUETSCHTER BALL, 23,2 x 34,3 cm.

back to the object its emotional function, if not its practical one.

Going back to the early comparison of Orozco's work with Duchamp's door, we could say that Orozco's method is very similar to the door swinging on its hinges. In its transit from one function toward another it remains ambiguous, but it maintains its functionality throughout.

The title of this text, "Back in Five Minutes," is like the note we find pasted to a shop door. These five minutes could be an eternity, or they may be only a few seconds—their real purpose is to stress a simultaneous presence and absence: "I am not here but soon I will be here." So I feel that Gabriel Orozco is inviting the viewer to wait, to be patient with any artwork, to observe its hidden meanings or suspended functions, like those of his chessboard inhabited only by knights, HORSES RUNNING ENDLESSLY (1995). In this work, the game consists of only one possible move, from one place to another, again and again and again.

So absence has become just another of the materials used by the sculptor. But it is not what St. Augustine calls "the nothing enriched with space," the emptiness. Absence implicates the presence of something or someone elsewhere. We often confuse something absent with something missing. Something missing is something or someone that no longer exists, but what is absent is something moved away

from one place, or someone who took his or her presence away from somewhere. Once again, Duchamp's door explains the idea, joining absence and presence in its hinged trajectory. All of Orozco's work is this back-and-forth impulse, as in, for example, SIX SOCKS (1995), where the sock is absent but is survived by its own space stuffed with papier-mâché.

Like the protagonist of Italo Calvino's great tale, *The Baron in the Trees*, Orozco moves ceaselessly from one branch to another in his creative tree. He underlines his absence from the normal routine by staying present in the same reality of things, only above the ground. In Calvino's story, tension inhabits the space created by expectation. We expect that the baron will soon come down from the tree up which he climbed when he was a kid—it's simple logic that we climb a tree just to come down again. But this character will not come down, ever. And I believe that Gabriel Orozco, who climbed the tree of things some time ago, also will never come down. But still we wait patiently for him to do so, because this is the logic of life to which we have been sentenced. We will keep watching him from down here, and he will keep watching us from up there. "Sooner or later he will climb down," is our hope, and in this endless expectation we will notice a little "or" in between the "sooner" and the "later," and within these two letters we will finally catch most, if not all, of the meaning.

47

Bin in fünf Minuten zurück

FRANCESCO BONAMI

Gabriel Orozco rollte seine Knetgummikugel YIELD-ING STONE (1992) in Form und plazierte sie dann neben eine der massiven Säulen in den *Corderie*, jenem langgestreckten Gewölbebau der Seilerei, in der die «Aperto 93» zur Biennale Venedig eröffnet werden sollte. Nachdem dieses erste Stück «installiert» war, machte er sich an die Vorbereitung der zweiten Skulptur, EMPTY SHOEBOX (1994), die er in dieser Ausstellung präsentieren wollte – ein leerer weisser Schuhkarton, wie schon der Titel sagt. Er öffnete seinen Rucksack, zog den Karton heraus, suchte einen Punkt auf dem Steinboden aus und stellte das Stück da hin.

Da ich meine kuratorische Aufgabe so gut wie möglich erfüllen und die Arbeit der von mir ausgewählten Künstler wie meinen eigenen Augapfel hüten wollte, schlug ich Orozco vor, die Schachtel auf dem Boden festzukleben. Ich war sicher, dass das karge, ephemere Stück die während der Eröffnung durchziehenden Menschenmassen nicht über-

leben würde. Auf der hektischen Suche nach deutlicheren Zeichen zeitgenössischer Kunst würden die Leute das Stück zertreten. Immerhin hatten schon einige ihre Finger in YIELDING STONE gebohrt; jemand hatte sogar eine Plastikgabel hineingesteckt, aus purer Zerstörungslust, vielleicht aber auch in einem unwiderstehlichen Partizipationsdrang, der ansonsten in der Ausstellung ja durchaus gefördert wurde. Warum also sollten die Leute eine einzelne Schachtel verschonen, die zum Zerstören wie gemacht erschien? Unbarmherzige Füsse, deren Schuhe vielleicht einst in dieser Schachtel gelegen hatten, würden sie wohl bald gnadenlos misshandeln. Ganz zu schweigen von den Aufbauhelfern der Biennale, die sie wahrscheinlich bereits frühmorgens in den Mülleimer werfen dürften. Immerhin hatten sie bei der Biennale 1978 Duchamps berühmte Tür PORTE 11 RUE LARREY, die sich beim Öffnen schloss und umgekehrt, angestrichen. Ja, a n g e s t r i - c h e n, weil sie's besonders schnell und gründlich machen wollten, während man gewöhnlich für jeden Schraubenzieher einen Antrag beim Präsidenten der Republik stellen muss.

FRANCESCO BONAMI ist Autor und Kurator sowie US-Redaktor von *Flash Art*. Er lebt in New York.

GABRIEL OROZCO, CRAZY TOURIST, 1991, c-print, 12⁷/₁₆ x 18⅝" / VERRÜCKTER TOURIST, 31,6 x 47,3 cm.

Orozco schaute mich ruhig an, wenngleich ein wenig besorgt. Ich begriff, dass mein Vorschlag nicht nur dumm gewesen war, sondern auch peinlich klarmachte, dass ich seine Arbeit nicht verstanden hatte. Nachdenklich verliess ich ihn und seine leere Schachtel; dann stand ich vor einer anderen Arbeit, die ich für meinen Teil der Ausstellung ausgewählt hatte: Charles Rays 7½ TON CUBE (1990), ein Würfel aus massivem Stahl, der so weiss angestrichen war, dass er fast schwerelos schien. Und plötzlich sah ich Orozcos kleine Schachtel als ironischen Kommentar zu dem Würfel vor mir, den kein Mensch auch nur einen Zentimeter hätte verrücken können.

In der Spanne zwischen diesen beiden Arbeiten, dem Schuhkarton und dem Stahlwürfel, schien der Zusammenbruch der zeitgenössischen Skulptur auf. Die Sprachen dieser beiden Stücke, die einander zunächst zu widersprechen schienen, erwiesen sich nach einer zweiten Analyse als gegenseitige Ergänzung. Ray übernahm den minimalistischen Diskurs in die latente Psychopathie der kalifornischen Kunst. Die Obsession des Minimalismus nahm Gestalt an im Gewicht des Würfels, dessen leichte und schlich-

te Oberfläche trügerisch war. Orozcos Schuhkarton hingegen griff das minimalistische Erbe mit solcher Leichtigkeit auf, dass es darin geradezu seine Idealform gefunden zu haben schien, ohne jedoch Gefahr zu laufen, auf ein blosses «Ding» reduziert zu werden. Ray besiegelte die Sprache der Skulptur endgültig; Orozco öffnete sie für ein ganzes Spektrum an Möglichkeiten und Einsichten.

Aber der wesentliche Vergleich war nicht dieser, sondern jener zwischen EMPTY SHOEBOX und YIELDING STONE. Diese beiden Arbeiten waren ein zentraler Punkt in Orozcos langdauernder, vorsichtiger Auslotung der skulpturalen Syntax, wie sie sich im Laufe der Kunstgeschichte herausgebildet hat. Indem er jede nur mögliche Technik, die in der Bildhauerei über die Jahrhunderte entstanden ist, isolierte und sie auf simple Gegenstände anwandte, verwandelte er diese in «Skulpturen» im klassischen Sinn, ohne dass sie dabei ihre «Dinghaftigkeit» einbüssten. Die Knetgummikugel war das sichtbar gemachte Prinzip des «Hinzufügens», während der Schuhkarton eine höchste Steigerung des «Wegnehmens» war; denn das sind ja die beiden Grund-

GABRIEL OROZCO, MOON TREE, 1996, *plastic leaves and branches, trees, plastic pots, bark chips, paper discs, 100 x 78¾ x 78¾" /*
MONDBAUM, Plastikblätter und -zweige, Bäumchen, Plastiktöpfe, Baumrinde, Papierscheiben, 254 x 200 x 200 cm.
(PHOTO: CAROL SHADFORD & MARIAN GOODMAN GALLERY, NEW YORK)

verfahren der klassischen Bildhauerei: das Unbestimmte, das zunehmend Form gewinnt, und der Materieklotz, aus dem die Form herausgeschält wird. Aber wir dürfen nicht vergessen, dass Orozco ein klassischer Extremist ist, und so ist seine Kugel denn auch nichts anderes als ein Unbestimmtes, das ins Unbestimmte wächst, und die herausgeschälte Form ist nichts anderes als das Paar Schuhe, aus dessen Abwesenheit sich schliessen lässt, dass es anderswo präsent ist, vielleicht sogar an den Füssen des Künstlers selbst.

Wir haben es mit einem Künstler zu tun, der das im Laufe der Skulpturgeschichte entstandene Alphabet analysiert und es dann mit dem Alphabet der einfachen Dinge des Lebens vermischt. Orozcos Werk spinnt eine Reihe von Fäden, doch entlang dieser Fäden wird der Kommunikationsfluss durch Bedeutungsknoten unterbrochen: Diese Knoten sind einfach jene – in Skulptur verwandelten – Dinge, die den Kreislauf der künstlerischen Sprache aufbrechen. Die logischen und historischen Bedeutungen des Kunstwerks werden über den Haufen geworfen, oder doch wenigstens durcheinandergewirbelt.

Kommen wir zum Schuhkarton zurück: Er enthält eine und verweist auf eine bestimmte Form, nämlich jene der Füsse. Wenn wir den Karton leeren müssten, würde sofort klar, dass es sich um eine vollständige Skulptur handelt, mit dem umgedrehten Deckel als Sockel. Auf diese Weise löst Orozco eines der «Probleme» der bildhauerischen Tradition (etwa bei Brancusi) – indem er die klassische Grammatik der Skulptur auf den alltäglichen Gegenstand anwendet.

Die Idee des leeren Behälters, der darauf wartet, gefüllt zu werden, gehört zu Orozcos Lieblingsmethoden. Diese «Leere» ist also eines der vielen Materialien, mit denen der Künstler sein Werk komponiert, komprimiert, beschneidet, zusammenfügt und -schweisst. Tatsächlich können wir sagen, dass diese Leere der Knoten im Seil der Sprache ist. HAMMOCK HANGING BETWEEN TWO SKYSCRAPERS, ein Stück, das 1993 im New Yorker Museum of Modern Art gezeigt wurde, ist ein perfektes Beispiel für die geformte Leere und zeigt deutlich, dass das «Hinzufügen» und das «Wegnehmen» der klassischen Bildhauerei häufig wiederkehrende Elemente in der Sprache der Gegenstände sind. Indem Orozco diese

Elemente als feste Bezugspunkte im traditionellen Verständnis von Skulptur und deren Auflösung in der Zufallsherrschaft der Dinge begreift, verhilft er der Instabilität des Raumes hinsichtlich der Materialien, die ihn füllen, zu neuer Bedeutung. Er nimmt weg, wo wir Massives vermuten, und er füllt, wo wir eine leere Ecke erwarten. Die Hängematte zwischen zwei Bäumen im Garten des MoMA ist nicht einfach leer, sie fällt in sich zusammen. Selbst die Luft, die ein darinliegender Körper verdrängt hätte, ist weg. Und dann liegen da hinter der Gartenmauer auf dem Fenstersims eines Hauses gegenüber dem Museum ein paar Orangen, genau da, wo wir überhaupt nicht damit rechnen, etwas vorzufinden. Derjenige, der die Orangen da hingelegt hat, ist derselbe, der auch aus der Hängematte verschwunden ist, nicht wahr? Wegnehmen und Hinzufügen überlagern sich und schaffen eine Kontinuität der Bewegung, eine existentielle Schleife, welche das herkömmliche Beharren auf der körperlichen Fassbarkeit des Kunstwerks und der Gegenwart des Künstlers weitgehend liquidiert. Der Betrachter ist überrumpelt. Er oder sie muss den leeren Raum geistig ausfüllen. Wir fragen uns nicht «Von wem ist das?», sondern «Wer war hier?» (Hängematte) oder «Wer hat das da hingelegt?» (Orangen).

«Wo ist es?» war die Frage, die Gabriel Orozcos erste Einzelausstellung 1994 in New York aufwarf. Der Schuhkarton war zur Galerie aufgeblasen. Der riesige Raum schien leer zu sein, ein Behälter für die Besucher, der die Aufmerksamkeit für die Gegenwart und das Bewusstsein der Besucher im Raum weckte. Sonst war nichts im Raum, ausser vier transparenten Joghurtbecherdeckeln mit blauem Rand: ein ziemlich unwirtlicher Ort.

Die Joghurtdeckel waren zugleich die Ausstellung und deren Abwesenheit. So wurde der Raum in diesem Fall nicht nur geistig, sondern auch physisch von den Besuchern ausgefüllt. Die Aufgabe, die den Leuten im Raum dadurch zukam – präsent zu sein und an der «Entleerung» mitzuwirken –, schuf jene beabsichtigte «Enttäuschung», die Orozco oft in seiner Arbeit anstrebt; das heisst, wir sind nicht enttäuscht von etwas, das wir uns besser wünschen, son-

dern weil wir gezwungen sind, uns jeden Urteils zu enthalten und weil unsere Reaktionen in der Leere erstarren. Wir sind nicht schockiert durch irgend etwas Empörendes, sondern angeschmiert, weil sich weder ein Grund findet, den Raum zu verlassen noch dazubleiben. Die Abwesenheit von Gegenständen erzeugt grosses Unbehagen. Und wenn nichts passiert, widerspricht das der Logik und den Regeln eines Kunstwerks.

Nicht dass Orozco die künstlerische Erfahrung in den Dreck ziehen wollte; vielmehr verschiebt er sie unentwegt innerhalb der uns vertrauten Begriffe und Bedeutungen. Wie bei Duchamp schliesst auch bei Orozco die Tür, wenn sie geöffnet wird, und öffnet sich, wenn sie geschlossen wird. So kann man zugleich hinein- und hinausgehen. Wenn in der leeren Galerie nichts passiert, so erzeugt auch in seinen anderen Werken das, was passiert oder bereits passiert ist, genau wie die blaugeränderten Joghurtdeckel, beim Betrachter ein Gefühl des Unbehagens und der Enttäuschung.

Bei LA D.S. (1993) schnitt Orozco aus dem erfolgreichen Citroënmodell der 60er Jahre in der Mitte ein Stück heraus und setzte dann die beiden äusseren Drittel wieder perfekt zusammen. Der Passagier musste sich nun in den frei gewordenen Raum quetschen, als ob ein Körper dünner würde, wenn er sich in eine Hängematte legt und nicht, umgekehrt, die Hängematte sich dehnte, um den Menschen aufzunehmen. («Was ist geschehen?» «Was geschieht?») Der schneidende Eingriff ist augenscheinlich minimal(istisch) – die Idee zumindest ist es –, aber das Ergebnis und der Erkenntnisprozess sind durchaus barock. Die Zerstörung eines ausgeklügelten Raumkonzepts, wie des von Citroën entwickelten, entspricht einer exakten Rekonstruktion völlig neuer Dimensionen und verweist zugleich selbst in der völligen Demontage noch auf die ursprüngliche Botschaft des Objekts (wie wenn Fontanas Schnitt in der Leinwand sorgfältig wieder zusammengenäht und übermalt würde, dabei aber weiterhin die veränderten Proportionen der Leinwand zeigte). Auf gewisse Weise ist die verletzende Geste auch die heilende, indem sie dem Gegenstand zwar nicht seine praktische, dafür aber seine emotionale Funktion zurückgibt.

Kommen wir noch einmal auf unseren anfänglichen Vergleich von Orozcos Werk mit Duchamps Tür zurück, so lässt sich feststellen, dass Orozcos Methode der in ihren Scharnieren schwingenden Tür gleicht. Im Übergang von einer Funktion zur anderen verharrt sie für einen Augenblick in einem Zustand der Ambivalenz, behält aber ihre Funktionalität uneingeschränkt bei.

Die Überschrift dieses Textes, «Bin in fünf Minuten zurück», ist wie ein Zettel, den man an die Ladentür klebt. Die fünf Minuten können eine Ewigkeit dauern oder nur ein paar Sekunden; ihre eigentliche Absicht ist jedenfalls, Anwesenheit und Abwesenheit zugleich zum Ausdruck zu bringen. «Ich bin zwar nicht da, werde aber bald wieder dasein.» In meinen Augen lädt Orozco auf gleiche Weise den Betrachter dazu ein zu warten, mit jedem Kunstwerk geduldig zu sein, dessen verborgene Bedeutung und ausgesetzte Funktion in Betracht zu ziehen, etwa bei seinem Schachbrett, auf dem nur Springer stehen: HORSES RUNNING ENDLESSLY (1995). Bei dieser Arbeit besteht das Spiel aus einem einzigen, noch und noch zu wiederholenden Zug.

Die Abwesenheit ist zu einem der Materialien geworden, mit denen Bildhauer arbeiten. Aber diese Abwesenheit ist nicht das, was Augustinus «das mit Raum angereicherte Nichts» nennt, die Leere. Abwesenheit impliziert die Anwesenheit von jemand oder etwas an einem anderen Ort. Oft verwechseln wir Abwesenheit mit Verschwundensein. Wenn etwas oder jemand verschwunden ist, bedeutet das, dass er oder es nicht mehr existiert. Aber wenn etwas abwesend ist, dann ist es von einem Ort entfernt worden bzw. hat seine Gegenwart woandershin verlegt. Auch diese Idee lässt sich mit Duchamps Tür erläutern, die Anwesenheit und Abwesenheit gleitend ineinander übergehen lässt. Orozcos gesamtes Werk schwingt in dieser Pendelbewegung, vor und zurück, so auch in SIX SOCKS (1995): Zwar ist die Socke abhandengekommen, der Raum jedoch, den sie innehatte, hat überlebt, ausgefüllt mit Pappmaché.

Wie der Protagonist in Italo Calvinos berühmter Geschichte, *Der Baron auf den Bäumen*, wechselt auch Orozco in seinem schöpferischen Baum unablässig von einem Ast zum andern. Er betont sein Wegbleiben von der normalen Routine, indem er sich zwar

PAUL TONGE

Crews battle to establish an early advantage at the start of the boys junior eights, which was won by Westminster, at Holme Pierrepont

GABRIEL OROZCO, CREWS BATTLE, 1996, 3 part computer-generated print, plastic coated, 78¼ x 105¾" /
MANNSCHAFTSWETTKAMPF, dreiteiliger computergenerierter Druck mit Plastikfolie überzogen, ca. 199 x 269 cm.
(PHOTO: CAROL SHADFORD & MARIAN GOODMAN GALLERY, NEW YORK)

in derselben dinglichen Realität bewegt, aber immer mit Abstand zum Boden. In Calvinos Geschichte wird die Spannung durch Erwartung erzeugt. Wir erwarten, dass der Baron endlich von dem Baum herunterkommen wird, auf den er als Kind geklettert ist – denn es ist einfach logisch, dass wir, wenn wir auf Bäume klettern, auch wieder herabsteigen. Aber dieser Typ kommt nicht herunter, nie. Ich glaube, auch Gabriel Orozco, der vor geraumer Zeit auf den Baum der Dinge geklettert ist, wird nie wieder herunterkommen. Aber noch immer warten wir geduldig dar-

auf, dass er es doch tut, denn das ist die Lebenslogik, auf die wir geeicht sind. Wir werden ihn weiter von hier unten beobachten, und er uns von da oben. «Früher oder später kommt er schon herunter», denken wir. In dieser fortwährenden Erwartung wird uns das kleine «Oder» zwischen dem «Früher» und dem «Später» entgehen. Aber schliesslich werden wir in diesen vier Buchstaben wenn nicht den ganzen Sinn, so doch einen guten Teil davon entdecken.

(Übersetzung: Nansen)

GABRIEL OROZCO, YOGURT CAPS, 1994, four yogurt caps /
JOGHURTDECKEL, vier Joghurtdeckel.
(PHOTO: MARIAN GOODMAN GALLERY, NEW YORK)

THE OS OF OROZCO

M. CATHERINE DE ZEGHER

It is not surprising that Pope Boniface VIII, who proposed to have certain pictures painted for St. Peter's, heard of Giotto's fame and sent a courtier to investigate him and his works. On his way to visit Giotto the messenger spoke with many artists in Siena and collected designs from them. He proceeded to Florence and called one morning on Giotto in his workshop. He told his errand and asked for a drawing to take to His Holiness. Giotto, who was very courteous, took a paper and a brush dipped in red. Then, resting his elbow on his side, with one turn of his hand he drew a circle so perfect and exact that it was a marvel to behold. He turned to the courtier, smiling, and said, "Here is your drawing." "Am I to have no more than this?" asked the latter, thinking it a joke. "That is enough and to spare," replied Giotto. "Send it with the rest and you will see if its worth is recognized." The messenger went away very dissatisfied. But he sent Giotto's drawing in to the Pope with the others. The Pope instantly perceived that Giotto surpassed all other painters of his time.

Vasari's *Lives of the Artists*, 1550

New York, September 12th to October 15th, 1994: four circular plastic yogurt caps on the four blank walls of the Marian Goodman Gallery. That is all. Transparent on top, rimmed in blue, and marked with expiration date and price, each cap from a Dannon yogurt container is placed at eye level in the center of the main gallery walls. Following rather poetic and auspicious solo exhibitions in 1993 at the Kanaal Art Foundation in Kortrijk, Belgium, and at the Museum of Modern Art in New York, the spare YOGURT CAPS was the first work to be installed by Gabriel Orozco in a major commercial gallery in

New York. Since his spectacular trichotomy and reassemblage of the glorified Citroën LA D.S. at the gallerie Crousel in Paris nine months earlier, expectations had begun to build concerning this artist. Emerging into the pontifical center, inevitably he was expected to demonstrate proof of his mastery, the direct trace of the inspired individual: *In painting, a single line which is not labored, a single brush stroke made with ease, in such a way that it seems that the hand is completing the line by itself without any effort or guidance,*[1] No wonder that Orozco's YOGURT CAPS, with its small objects O, was received by some as an aggressive and gratuitous gesture, while others considered it as yet another resolute act defying the institutional art market system.

The trivial, fractional, throwaway object "drawn" as a blue circle onto the white gallery wall might be interpreted as Orozco's response to current demands for authorial charisma in art centers given to sudden enthusiasms for multiculturalism which, on

M. CATHERINE DE ZEGHER is the director of the Kanaal Art Foundation in Belgium, where Gabriel Orozco made his first European solo exhibition in 1993. Her most recent exhibition project, "Inside the Visible: an elliptical traverse of 20th century art; in, of, and from the feminine," opened at the ICA Boston earlier this year.

GABRIEL OROZCO, FOUR BICYCLES (THERE IS ALWAYS ONE DIRECTION), 1994, bicycles, 78 x 88 x 88" /
VIER FAHRRÄDER (ES GIBT IMMER EINE RICHTUNG), Fahrräder, 198 x 224 x 224 cm.
(PHOTO: MARIAN GOODMAN GALLERY, NEW YORK)

the political and economic level, goes hand in hand with multinationalism. The artist seems to succeed in returning these exotic projections and neo-primitivist aspirations by toying with the notion of enforced consumption in our hegemonic culture and, at the same time, debunking the modernist cliché of artistic (painterly) virtuosity. While this strategy reveals the fallacies of the political instrumentalization of artistic practice and identity formation, it is also a witticism aimed at the real dangers of global economic exploitation and ecological destruction. At a glance, the pristine gallery's interior space becomes one big healthy yogurt, the product advertised all over America as being good for you. Even in the eye of a connoisseur, the dated and priced yogurt caps, when abstracted from a domestic register, dismiss the false neutrality of the white walls of public artistic domain. The institutionally sustained and underscored orders of seeing (such as by the gallery, the museum...) are questioned, as is the paradigm of the readymade as uninterrupted continuity in aesthetic object experience.

In a striking way the installation of YOGURT CAPS implies three distinct, yet interconnected, as well as exclusive, modes of object experience: cult value, exhibition value, and exchange value. The mere act of entering the white cube induces in the contemplative viewer an intimation of "the sublime void," here tagged by four blue rings. Perhaps this curious sample of minimalism could be explained as the collision between a purely perceptual experience of the yogurt caps with a reading of the letter/number O as a transcendental sign. Much as the circle of Giotto may be read as the O of God the Father or of infinity in religious symbolic language, Orozco's O could point to eternity (or nothingness).[2] However, as I get close to the small blue circles, instantly the ritualistic status of the transparent object disappears beneath the black letters and numbers, "SELL BY SEPT 11 B" printed on it and the "99 c" sticker. There, in the twinkling of an eye, on the dot, to the letter, occurs a transformation of the exalted nothingness of the work: the "sublime void" (the cult value) into four tiny, minimal geometric circles in a wide white space (the exhibition value), to be then displaced by the artwork of Orozco (the sign exchange value). But

can this plastic object, shown and seen in a gallery, really ever slip from the divine, mythicized space of the masterpiece back into the logic of serialization, industrial reproduction, and mass consumption?

Literally approaching Orozco's Os, it also becomes clear to me that the blue circular fragment is not outlined by the artist, but shows itself as "automatic" writing/drawing performed by mechanical devices on a plastic cap. Or is it a painted line extruded into relief as braille for the blind to touch? Or does it constitute the empty frame of a lost image? The thing seen is only a thing written and drawn through my own eyes; more, the thing seen dissolves into the status of the material trace/tracing left by the artist (as in EXTENSION OF REFLECTION, 1992). In that passage the O seems to be a clearly legible, typographic readymade, one which corresponds to the arbitrary and institutionalized dichotomies of writing and picture, of drawing and readymade. Upsetting in the most "spectacular" way obsolete imperatives of differentiation between the readable and the visible, the disdained plastic disks—the recovered traces of what has been eliminated and thrown away—take possession of a space and force us to look at it in a different way.

Using the ambivalent medium of a mechanically produced image, Orozco allows us to perceive that reading and seeing are not opposed to one another, but ultimately are linked to the oscillation of images between touch and sign, between immediacy and mediation. *The trace no longer speaks except to signal, deceive, supplement the presence of the one who has become only its referent. The traced line has become art, the technical mediation of the thing. And what henceforth it gives access to is no longer the thing but itself, that is, ultimately, the painter.*[3] In this sense, the plastic O of Orozco brings to mind the I-BOX (1963) of Robert Morris, whereby *the viewer is confronted with a semiotic pun (on the words I and eye) just as much as with a structural sleight of hand from the tactile (the viewer has to manipulate the box physically to see the I of the artist) through the linguistic sign (the letter I defines the shape of the framing/display device: the 'door' of the box) to the visual representation (the nude photographic portrait of the artist) and back.*[4] Except for a very different conceptual title, this tripartite division of the aesthetic signifier—its

GABRIEL OROZCO, YELLOW, 1996, garden hose /
GELB, Gartenschlauch.

ISLAND WITHIN AN ISLAND, 1993,
c-print, 12⁷/₁₆ x 18⁵/₈" / INSEL AUF EINER INSEL,
31,6 x 47,3 cm.

ORANGES, 1993, installation at the MoMA,
New York / ORANGEN.

 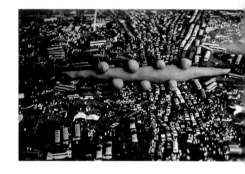

COINS IN WINDOW, 1994, c-print, 12⁷/₁₆ x 18⁵/₈" /
MÜNZEN IM FENSTER, 31,6 x 47,3 cm.

YOGURT CAPS, 1994, detail /
JOGHURTDECKEL.

TRAFFIC WORM, 1993, c-print, 2⁷/₁₆ x 18⁵/₈" /
VERKEHRSSCHLANGE, 31,6 x 47,3 cm.

 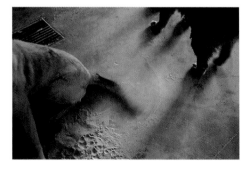 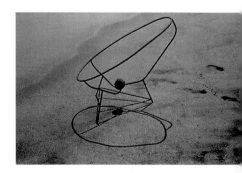

LIGHT SIGNS (KOREA), 1995, plastic sheet with
acrylic paint in light box, 39³/₈ x 39³/₈ x 7³/₄" /
LICHTZEICHEN (KOREA), Acryl auf Plastiktuch
in Lichtvitrine, 100 x 100 x 19,7 cm.

DOG CIRCLE, 1995, c-print, 12⁷/₁₆ x 18⁵/₈" /
HUNDEKREIS, 31,6 x 47,3 cm.

SANDBALL AND CHAIR I, 1995,
c-print, 12⁷/₁₆ x 18⁵/₈" /
SANDKUGEL UND STUHL I, 31,6 x 47,3 cm.

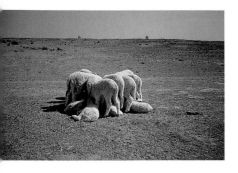 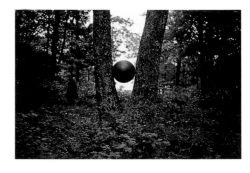

COMMON DREAM, 1996, c-print, 2⁷⁄₁₆ x 18⁵⁄₈" /
GEMEINSAMER TRAUM, 31,6 x 47,3 cm.

RECAPTURED NATURE, 1990,
rubber, 37³⁄₈ x 37³⁄₈ x 37³⁄₈" /
WIEDERGEWONNENE NATUR, Gummi,
95 x 95 x 95 cm.

GREEN BALL, 1995, c-print, 12⁷⁄₁₆ x 18⁵⁄₈" /
GRÜNE KUGEL, 31,6 x 47,3 cm.

 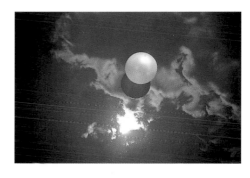

CATS AND WATERMELONS, 1992,
c-print, 12⁷⁄₁₆ x 18⁵⁄₈" / KATZEN UND WASSER-
MELONEN, 31,6 x 47,3 cm.

MOON TREE, 1996, installation detail /
MONDBAUM, Detail.

BALL ON WATER, 1994, c-print, 12⁷⁄₁₆ x 18⁵⁄₈" /
KUGEL AUF WASSER, 31,6 x 47,3 cm.

YIELDING STONE, 1992,
plasticine and dust, 60 hg /
NACHGEBENDER STEIN,
Knetgummi und Strassenstaub.

HORSES RUNNING ENDLESSLY, 1995,
wooden chessboard, knights / ENDLOS RENNENDE
PFERDE, Schachbrett und -pferde aus Holz.

COMEDOR EN TEPOZTLAN /
DINNER TABLE IN TEPOZTLAN, 1995, c-print,
2⁷⁄₁₆ x 18⁵⁄₈" / MITTAGSTISCH IN TEPOZTLAN,
31,6 x 47,3 cm.

GABRIEL OROZCO, WET WATCH, 1993, c-print, 2⁷/₁₆ x 18⅝" /
NASSE UHR, 31,6 x 47,3 cm.

(PHOTO: MARIAN GOODMAN GALLERY, NEW YORK)

separation into object, linguistic sign, and (lost or voided) photographic reproduction—is restated in Orozco's work. However, as to the auto-portrait in the round (*portrait en ronde bosse, portrait en miniature*), the blue frame is empty and recalls singularly the photographic self-portrait of Edward Steichen, SELF PORTRAIT, MILWAUKEE (1898), which shows the artist next to a small, empty, rectangular frame on the wall, as if the nonvisible inscribed itself as latent, imaginary, hidden, unconscious, or past. In the same way, the small object O as an "expandable" trace becomes Orozco's self-portrait; at the same time the first letter of his name might be read for the Other. Or, is the O a sly narration of the American dream "From zero to hero?" For Orozco knows better than anyone that this dream's spectral inversion is the hidden policy of an art scene perpetually obsessed by the new.

Situated at the intersection of identity and anonymity, when we look closely into the plastic Os, a pellucid mirror image partially reflects the viewer: In a shared borderspace auto-portrait and allo-portrait, subject and object, fade and emerge, together but differentiated. According to Jacques Derrida *the self-portrait would first consist in assigning, thus in describing, a place to the spectator, to the visitor, to the one whose seeing blinds; it would assign or describe this place following the gaze of a draftsman who, on the one hand, no longer sees himself, the mirror being necessarily replaced by the destinatory who faces him, that is, by us, but us who, on the other hand, at the very moment when we are instituted as spectators in (the) place of the mirror, no longer see the author as such, can no longer in any case identify the object, the subject, and the signatory of the self-portrait of the artist as a self-portraitist.*[5] In this way, although the minimal exactness of YOGURT CAPS apparently intensifies the geometrization of space and the objectivity of perspective, Orozco's work, paradoxically, challenges the sense of mastery of space—the spectator in the center and the artist in the margins. This shift in spatial awareness also occurs whenever the reader attempts to control the scene of drawing and the scopic field, to locate a viewpoint from which s/he can capture the complete work. All attempts fail. Like a blind spot, one of the four Os stays always out of sight, out of reach, invisible. Meanwhile, the other three Os, like monocular prostheses for the reader/viewer, supplement both sight and scopic pulsion. Art verges on becoming a total experience, limitless, resisting all attempts to stabilize it. A similar strategy is deployed in FOUR BICYCLES (THERE IS ALWAYS ONE DIRECTION)/CUATRO BICICLETAS (SIEMPRE HAY UNA DIRECCION) (1994), and in HORSES RUNNING ENDLESSLY/ CABALLOS CORRIENDO INFINITAMENTE (1995)— *what consciousness does not see it does not see for reasons of principles; it is because it is consciousness that it does not see* (Maurice Merleau-Ponty).

Out of sight out of mind? It seems that YOGURT CAPS never constitutes a whole but is consigned to oblivion, since at least one of the Os always stays behind the viewer. Might one construe a subtle assonance between this missing O and the Lacanian *objet a*—the nonobject, the unattainable Other?[6] Lacan's strange formulation *petit a, an archaic psychic trace, or a primary mental inscription of the residue... of the originary part-object or the real archaic m/other,* refers to what

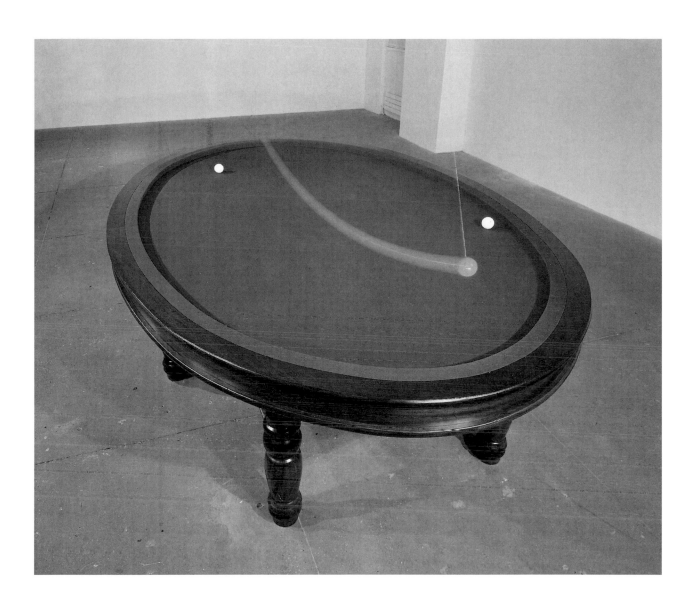

GABRIEL OROZCO, OVAL BILLIARD TABLE WITH PENDULUM, 1996, wood, slate, mixed media, 35 x 121¾ x 90" /
OVALER BILLIARDTISCH MIT PENDEL, Holz, Schiefer, verschiedene Materialien, ca. 89 x 310 x 229 cm.
(PHOTO: CAROL SHADFORD & MARIAN GOODMAN GALLERY, NEW YORK)

GABRIEL OROZCO,
installation at Kanaal Foundation, Kortrijk, 1993.

SOFT BLUE, 1993, plasticine and Letraset,
$4\frac{1}{2}$ x $4\frac{1}{2}$ x $4\frac{1}{2}$"/ *SANFTES BLAU, Knetgummi und Letraset,*
ca. 11,5 x 11,5 x 11, 5 cm.

remains for the subject of the part-object after its separation from it, but which is yet not integrated into the "whole" body—that is, the remnants of the schism. The lacking *objet a* always stays "behind" the desire, and in itself has no form.[7] In the mental, visual dimension, the lost *objet a* is the gaze (associated with the m/other's look), the cause of desire in the scopic field. Negotiating this scopic drive, however, it seems that Orozco's O—in contradistinction to the gaze presented by Lacan as phallic and beyond communication—concerns the near loss of the object, its network of links and the process of creating meaning itself. *The object as an absence and not as an existence, is hinted at in an imaginary way in phantasy in which an 'impossible meeting,' on the level of the part-object from which the subject had already separated may take place. By means of the phantasy, the subject can come into contact with what had been 'removed' from him/herself during the process of inscribing the body within the framework of the symbolic order by a subjectivising discourse.*[8] Thus, the O rather relates to the matrixial *objet a*, in Bracha Lichtenberg Ettinger's theory of "the matrixial gaze," a shared and hybrid object in a composite subjectivity, beginning in the feminine/prenatal encounter. In a matrixial perspective, the becoming-together precedes the being-one. Relations without-relating and distance in proximity preserve the co-emerging Other as both subject and object, rather than reducing it to mere object. Borderlines between subjects and objects become thresholds. Through this process, the matrixial gaze *escapes the margins and returns to the margins. Conceived borderlines and thresholds are continually transgressed or dissolved allowing the creation of new ones.*[9]

This shifting focalization materializes in an earlier project at the Kanaal Art Foundation (1993), where Orozco plots four points through the stories of a dilapidated brewery tower. The four colored dots—a white spot on a table from UNDER THE TABLE/BAJO LA MESA, a blue from SOFT BLUE/SUAVE AZUL, a yellow from GRAPEFRUIT/TORONJA, and an orange from ORANGE WITHOUT SPACE/NARANJA SIN ESPACIO—are propelled into space on an axis through holes in the tower floors, as if following the vertical trajectory of the brewing process from top to bottom. Drawing the spectator's eyes into the deep shaft, the

plasticine piece at the bottom, ORANGE WITHOUT SPACE—like a huge old teddy bear's eye—looks at us looking at it, and thus returns the othering gaze to the viewer caught in the act. These colored points, like the balls in the OVAL BILLIARD TABLE WITH PENDULUM (1996) and, perhaps even more, YOGURT CAPS, coordinate the possibilities of seeing, touching, and moving (see also LIGHT SIGNS, 1995, and THE ATOMISTS, 1996). Since in these pieces the viewer can never focus on all circular "drawings" at once, Orozco succeeds in avoiding the single-point perspective of things in space, and at the same time effects an Augenblick, equating the present of visual perception with drawing's reliance on memory. In YOGURT CAPS, the O reminds us that *in order to be absolutely foreign to the visible, and even to the potentially visible, to the possibility of the visible, this invisibility would still inhabit the visible, or rather, it would come to haunt it to the point of being confused with it, in order to assure, from the specter of this very impossibility, its most proper resource.*[10] This work brings to mind yet another piece by a Belgian contemporary of Orozco's, Joëlle Tuerlinckx, ZERO: IT IS THE NUMBER OF THINGS YOU HAVE WHEN YOU DO NOT HAVE ANYTHING (1996). An overhead projector throws the handwritten definition on the unretouched exhibition wall; stains from evaporated water bubbles left after a cleansing wipe of the overhead projector's plastic writing surface, together with the marks of filled-in holes from the former exhibition accrochage, create a pattern of irregular spots. These points oscillate between projection/illusion and reality, between memory/absence and presence. Like the sculptural cast, adhering to but differing each time from the mold (positive into negative), both works have the capacity to conflate opposites, embodying the Duchampian concept of infra-mince. This exchange of properties is exemplified in Orozco's MY HANDS ARE MY HEART/MIS MANOS SON MI CORAZON (1991) and MANI MARINE (1995).

Roland Barthes's elucidation of the relationship between art and politics in *Writing Degree Zero* has an obvious corollary in Orozco's O. Barthes is not claiming that literature does or should exist in a social, historical, or ethical vacuum: The notion of zero-degree, neutral, colorless writing (or *l'écriture*

ORANGE WITHOUT SPACE, 1993, orange and plasticine /
ORANGE OHNE RAUM, Orange und Knetgummi.

GABRIEL OROZCO, BLUE SANDALS, 1996, c-print, 12⁷⁄₁₆ x 18⁵⁄₈" / BLAUE SANDALEN, 31,6 x 47,3 cm.

GABRIEL OROZCO, HAMMOCK AT MOMA GARDEN, 1993, c-print, 13 x 34" / HÄNGEMATTE IM MOMA-GARTEN, 33 x 86,4 cm.
(PHOTO: MARIAN GOODMAN GALLERY, NEW YORK)

blanche, a term coined by Sartre in his famous review of Camus's *L'Etranger*) enters his argument as the *last episode of a Passion of writing, which recounts stage by stage the disintegration of bourgeois consciousness, and again at the end as one solution to the disintegration of literary language.*[11] Exploring changes in the reception and distribution of the artwork, some artists from Orozco's generation presuppose—in an agonized suspension between contradictory goals—both the effort to abolish the aesthetic object and the effort to confine an artistic experience to ethical communication. Is there a noninstrumentalized or nonreified side to the social object of language, or not? In Orozco's work, "writing degree zero" appears literally in the automatic writing/drawing of O shapes, as seen in YOGURT CAPS, LOST LINE/LINEA PERDIDA (1993), HAMMOCK at MOMA (1993), and figuratively in the mechanized handwriting/drawing of repetitive lines such as in DIAL TONE/ TONO DE MARCAR (1992) and PARKING UNTITLED (Nos. 1–18, 1996). The latter serial project consists of pencil tracings on paper, arbitrary gestures which endlessly enunciate both the daily routine and, hence, the "sense and sensibility" of the artist. In order to trace in a clear, objective, and impersonal way the parallel, vertical lines on a piece of paper, Orozco uses a ruler but encounters resistance from his own finger/eye in attempting to draw those straight lines. Between instrumentalization and impulse, he follows his fingertip and thus incorporates the erroneous disconti-

nuity as a chink in the perfectly straight line. Again and again, within the poetry, precision, and spareness of Orozco's work, the irrational seems to pierce through the "objective" order. Courting objectivity, he incorporates its subjective opposite and nonlogical pole, challenging devotion to geometric laws and the idea of *perspective as doubly objective—on the one hand a system, made objective by means of its mathematical grounding, through which to order and organize objects, and on the other, the possibility of those objects displaying themselves in their very objectivity: as a set of stereometric bodies, 'variations or compounds of spheres, cylinders, cones, cubes, and pyramids,'*[12] as in SANDBALL AND CHAIR I (1995).

In Orozco's oeuvre, the roundness of being, or of experience, is very pervasive: to name a few, RECAPTURED NATURE/NATURALEZA RECUPERADA (1990); CRAZY TOURIST/TURISTA MALUCO (1991); PINCHED BALL/PELOTA PONCHADA (1993); HOME RUN (1993); STOPPER IN MOMA (1993); GREEN BALL/BOLA VERDE (1995); LIGHT SIGNS (1995). In particular YIELDING STONE/PIEDRA QUE CEDE (1992) could be yet another self-portrait of the artist in the round, since this black, solid lump of plasticine corresponds to Orozco's body weight and, while being rotated in the street, absorbs every single anonymous indexical imprint of particles and accidental debris on its skin.[13] Gaston Bachelard's phenomenological meditation on roundness here suggests itself, *since images of full roundness help us to collect ourselves, permit us to confer an initial constitution on ourselves, and to con-*

firm our being intimately, inside. For when it is experienced from the inside, devoid of all exterior features, being cannot be otherwise than round.[14] And although, *when a thing becomes isolated, it becomes round, and assumes a figure of being that is concentrated upon itself ... everything round invites a caress.* It is precisely in this interspace between self-constituting isolation and caress that Orozco's work exists and manifests a different relationship to the spherical, reverberating its permanent contact with the other. He considers that one can only physically survive the pressures and frictions of real life by becoming "round," by accepting the frottage of contact—much like a planet in the universe or a stone in the river. Challenging the square and static objects of Minimalism, Orozco addresses the roundness of, say, a human belly or an organic shape as a container or a "matrix" for continuous exchange and encounters in difference between subjects. His work concerns disposition towards, not imposition on, otherness.

In the same manner, inner and outer space are correlated in Orozco's open-ended "drawing" of blue plastic circles. Unlike in painting, where color tends to subordinate and conceal the canvas, a line traced on paper, or in this case on the wall, simultaneously divides and interconnects space. Like the paper under a drawing, the white wall under the transparent yogurt caps remains one continuous space in which the areas to each side of the rim interact. But *preceding any reading or interpretation, Giotto's O is in the first place a drawing. 'Drawing' is that which, before it is sign in the sense of 'sign of,' is a sign of itself. 'Drawing,' before being a sign of 'something else than itself,' sketches itself, engraves or draws or writes itself in its own space; 'drawing,' before signifying anything, signifies itself. In technical terms one can state that a drawing moves on or at the borderline of semiosis, and that it, even more than any other sign, plays on the ambiguity of mimetic desire. In an image the line that we draw on the edge of our rational abilities intersects between mimesis and semiosis.*[15]

Reading and seeing YOGURT CAPS, I realize that Orozco's rebus unfolding behind and in front of my eyes is riddled at once with ludicrous rigor and logical randomness, as its title and display suggested all along. Is the O a thin blue line between statement and joke? Looking at his recent "drawing" series, THE ATOMISTS, it would seem that the story of Orozco's Os still has to be told...

1) Baldesar Castiglione, *The Book of the Courtier*, first published in Venice, 1528 (New York: Penguin Books, 1967), p. 70.
2) Paul De Vylder notes in his essay "De Ö van Giotto" that "serious historians could indicate the Neoplatonic background of the period in which Vasari's anecdote is told, and argue that Giotto's O is a material token of a higher reality, of a pure idea." *Jarg Geismate: Personal Drawings* (Düsseldorf and Sint-Niklaas, 1992), p. 15.
3) Bernard Vouilloux, "Drawing Between the Eye and the Hand: (On Rousseau)" in: *Yale French Studies* 85, p. 182.
4) Benjamin H.D.Buchloh, "Conceptual Art 1962–1969; From the Aesthetic of Administration to the Critique of Institutions" in: *October* 55, Winter 1990, pp. 116–117.
5) Jacques Derrida, *Memoirs of the Blind. The Self-Portrait and Other Ruins* (Chicago: The University of Chicago Press, 1993), p. 62. Translated by Pascale-Anne Brault and Michael Naas in a volume of the Parti-pris series from the Louvre.
6) Jacques Lacan, *The Four Fundamental Concepts of Psychoanalysis*, translated by Alan Sheridan (New York: Norton, 1981).
7) "The *petit a* could be said to take a number of forms, with the qualification that in itself it has no form, but can only be thought of predominantly orally or shittily. The common factor of *a* is that of being bound to the orifices of the body. What repercussions, therefore, does the fact that the eye and the ear are orifices have on the fact that perception is spheroidal for both of them?" Jacques Lacan, "Le Séminaire de Jacques Lacan, 21 janvier 1975" in: *Ornicar* No 3, (Paris: University of Paris VIII, 1975) pp. 164–5. Translated by Jacqueline Rose in *Feminine Sexuality* (New York: W.W. Norton & Company, 1982), pp. 163–171.
8) Concerning the reading of the *objet a*, I am indebted to Bracha Lichtenberg Ettinger's "Woman as *objet a* Between Phantasy and Art" in: *Complexity—Journal of Philosophy and the Visual Arts* (London: Academy Press, 1995), pp. 57–77.
9) Bracha Lichtenberg Ettinger, *The Matrixial Gaze* (Leeds: University of Leeds, Feminist Arts and Histories Network, 1995), pp. 1–30.
10) Derrida, ibid., p. 51.
11) Susan Sontag in her preface to Roland Barthes, *Writing Degree Zero* (New York: Hill and Wang, 1968).
12) Rosalind Krauss, "The LeWitt Matrix" in: *Sol LeWitt Structures 1962–1993* (New York: The Museum of Modern Art and London: The Oxford University Press, 1993), pp. 25–33.
13) For a more detailed discussion of YIELDING STONE, see Benjamin H.D. Buchloh, "Refuse and Refuge" in: *Gabriel Orozco*, ed. Catherine de Zegher (Kortrijk: The Kanaal Art Foundation, 1993).
14) Gaston Bachelard, *The Poetics of Space*, (Boston: Beacon Press, 1994), pp. 232–241. Originally published as *La poétique de l'espace* (Paris: Presses Universitaires de France, 1958).
15) Paul De Vylder, op. cit.

Making strides: Pollock, who took five Derbyshire wickets, provided further evidence of his potential yesterday. Photograph: Ian Stewart

GABRIEL OROZCO, MAKING STRIDES, 1996, 3 part computer-generated print, plastic coated, 78¼ x 115" /
GROSSE SCHRITTE MACHEN, dreiteiliger computergenerierter Druck, mit Plastikfolie überzogen, ca. 200 x 292 cm.
(PHOTO: CAROL SHADFORD & MARIAN GOODMAN GALLERY, NEW YORK)

DIE OS DES OROZCO

M. CATHERINE DE ZEGHER

Deshalb ist es nicht verwunderlich, dass dieses Werk dem Giotto in Pisa und an anderen Orten einen solchen Ruf verschaffte, dass Papst Bonifatius VIII., der einiges in St. Peter malen lassen wollte, einen seiner Hofleute in die Toskana schickte, um zu erkunden, was für ein Mann Giotto sei und wie seine Arbeiten wären. Da dieser Höfling vorerst hören und sehen wollte, welch andere Florentiner Meister noch in der Malerei und im Mosaik Vorzügliches leisteten, sprach er in Siena mit vielen Künstlern und ging, nachdem er Zeichnungen von ihnen erhalten hatte, nach Florenz. Dort trat er eines Morgens in die Werkstatt Giottos, der eben an der Arbeit sass, eröffnete ihm den Willen des Papstes, erklärte, in welcher Weise sich dieser seiner Kunst bedienen wolle, und bat ihn endlich, etwas zu zeichnen, was er Seiner Heiligkeit schicken könnte. Giotto, der sehr höflich war, nahm ein Blatt und einen Pinsel mit roter Farbe, legte den Arm fest in die Seite, damit er ihm als Zirkel diene, und zog, indem er nur die Hand bewegte, einen Kreis so scharf und genau, dass es in Erstaunen setzen musste. Darauf sagte er lächelnd zu dem Hofmann: «Da habt Ihr die Zeichnung.» Sehr erschrocken, fragte dieser: «Soll ich keine andere als diese bekommen?» «Es ist genug und nur zuviel», antwortete Giotto. «Schickt sie mit den übrigen hin, und Ihr sollt sehen, ob sie erkannt wird.» Der Abgesandte, der wohl sah, dass er sonst nichts erhalten könnte, ging sehr missvergnügt fort und zweifelte nicht daran, dass er gefoppt worden sei. Als er jedoch dem Papst die Zeichnungen und die Namen derer sandte, die sie verfertigt hatten, schickte er auch diejenige von Giotto und berichtete, wie er, ohne Zirkel und ohne den Arm zu bewegen, den Kreis gezogen habe. Hieran erkannten der Papst und viele sachkundige Hofleute, wie weit Giotto die Maler seiner Zeit übertraf.

Giorgio Vasari, *Die Lebensbeschreibungen der berühmtesten Maler, Bildhauer und Architekten* (1550)

New York, 12. September bis 15. Oktober 1994: Vier runde Joghurtdeckel aus Plastik an den vier leeren Wänden der Marian Goodman Gallery, das ist alles. Durchsichtig, blau eingefasst, mit aufgeprägtem Verfallsdatum und aufgeklebtem Preisschild, ist jeweils ein Joghurtdeckel der Marke Dannon auf Augen-

höhe in der Mitte jeder der vier Wände angebracht. Nach seinen eher poetischen und vielversprechenden Einzelausstellungen 1993 in der Kanaal Art Foundation im belgischen Kortrijk sowie im New Yorker Museum of Modern Art war das karge YOGURT CAPS (Joghurtdeckel) das erste Werk Gabriel Orozcos, das in einer der grossen Privatgalerien in New York gezeigt wurde. Seit Orozcos spektakulärer Dreiteilung und Neuzusammensetzung des legendären Citroën D.S. in der Galerie Crousel in Paris, neun Monate zuvor, waren die Erwartungen des Publikums naturgemäss hoch. In der Kunstmetropole New York wurde von ihm nun ein Nachweis seines

M. CATHERINE DE ZEGHER ist Direktorin der Kanaal Art Foundation in Kortrijk, Belgien, wo Gabriel Orozco 1993 seine erste Einzelausstellung in Europa hatte. Ihr jüngstes Ausstellungsprojekt, «Inside the Visible: an elliptical traverse of 20th century art; in, of, and from the feminine», wurde dieses Jahr im ICA Boston gezeigt.

Könnens erwartet, der seine inspirierte Handschrift trüge. Kein Wunder also, dass Orozcos YOGURT CAPS mit den kleinen, objekthaften Os von manchen als aggressive und willkürliche Geste aufgefasst wurde, während andere das Werk als weiteren resoluten Akt des Widerstandes gegen die Mechanismen des etablierten Kunstmarkts ansahen.

Das triviale Wegwerfobjekt, das als blauer Kreis auf die weisse Galeriewand «gezeichnet» ist, liesse sich als Antwort auf den gegenwärtig herrschenden Bedarf an Schöpfercharisma in einer Kunstszene verstehen, welche einer plötzlichen Begeisterung für den Multikulturalismus frönt, der wiederum auf politischer und wirtschaftlicher Ebene mit dem Multinationalismus Hand in Hand geht. Orozco gelingt es, diese exotischen Projektionen und neoprimitivistischen Bestrebungen umzukehren, indem er mit dem Begriff des Konsumzwangs in unserer hegemonischen Kultur spielt und gleichzeitig das mit der Moderne verbundene Klischee der künstlerischen (insbesondere maltechnischen) Virtuosität entmystifiziert. Während diese Strategie die Trugschlüsse der politischen Instrumentalisierung künstlerischer Praxis und Identitätsbildung aufdeckt, beinhaltet sie zugleich eine geistreiche Anspielung auf die realen Gefahren globaler wirtschaftlicher Ausbeutung und ökologischer Zerstörung. Schon beim ersten Hinsehen mutiert das makellose Innere der Galerie zu einem einzigen grossen, gesunden Joghurt, jenem landesweit gepriesenen Produkt, das gut für dich ist. Selbst in den Augen eines Kunstkenners stören die mit Datum und Preis versehenen Joghurtdeckel, aus ihrem häuslichen Kontext herausgelöst, die trügerische Neutralität der weissen Wände des öffentlichen Kunstraums. Die von Institutionen (wie der Galerie, dem Museum u. a. m.) emphatisch geförderten Massgaben des Sehens werden ebenso in Frage gestellt wie das Paradigma des Ready-made als durchgehende Grösse in der Erfahrung des ästhetischen Objektes.

In eindrucksvoller Art und Weise vereint die Installation YOGURT CAPS drei verschiedene, gleichzeitig zusammenhängende und für sich stehende Formen des Objekterlebens: Kultwert, Ausstellungswert und Tauschwert. Der blosse Akt des Eintretens in den weissen Kubus des Galerieraums erzeugt im kontemplativen Betrachter ein Gefühl «erhabener Leere», die in diesem Fall von vier blauen Ringen markiert wird. Vielleicht liesse sich diese kuriose Minimalismusprobe als Kollision zwischen dem blossen Wahrnehmen der Joghurtdeckel und dem Lesen des Buchstabens oder der Ziffer O als transzendentales Zeichen erklären. Ganz so, wie Giottos Kreis in der religiösen Symbolsprache als das O Gottvaters bzw. der Unendlichkeit gedeutet werden kann, so könnte auch Orozcos O auf die Ewigkeit (oder das Nichts) verweisen.[1] Sobald man jedoch näher an die kleinen blauen Kreise herantritt, verschwindet der ritualistische Status des durchsichtigen Objektes umgehend hinter den aufgeprägten schwarzen Buchstaben und Ziffern «SELL BY SEPT 11 B» und dem aufgeklebten «99c»-Preisschildchen. Und dort, in diesem Augenblick, vollzieht sich die Verwandlung dieses hehren Nichts: zunächst von der «erhabenen Leere» (dem Kultwert) zu vier winzigen, minimalistisch-geometrischen Kreisen im weiten weissen Raum (dem Ausstellungswert) und schliesslich zum Kunstwerk Orozcos (dem symbolischen Tauschwert). Aber kann dieses in einer Galerie ausgestellte und bestaunte Plastikobjekt wirklich jemals wieder aus dem sakralen, mythisierten Raum des Meisterwerks in die Ordnung des Serienmässigen, der industriellen Reproduktion und des Massenkonsums zurücksinken?

Beim Nähertreten wird zudem sichtbar, dass die blaue Kreislinie nicht vom Künstler stammt, sondern eine maschinell erzeugte Beschriftung oder Zeichnung ist. Handelt es sich vielleicht sogar um eine auch für Blinde ertastbare Linie, die auf den Deckel geprägt wurde? Oder um den leeren Rahmen eines verlorengegangenen Bildes? Was wir sehen, wird erst in unseren Augen zur Schrift oder zur Zeichnung, mehr noch, was wir wahrnehmen, folgt der vom Künstler gelegten materiellen Spur, seiner Vorgabe – wie in EXTENSION OF REFLECTION (Erweiterte Spiegelung, 1992). In diesem Übergangsprozess erscheint das O wie ein deutlich lesbares typographisches Ready-made, eines, das der willkürlichen, institutionalisierten Dichotomie von Schrift und Bild, von Zeichnung und Ready-made entspricht. In «spektakulärster» Manier obsolete Imperative der Differenzierung zwischen Les- und Anschaubarem über den Haufen werfend, ergreifen diese lächer-

GABRIEL OROZCO, LA DS, 1993, detail.

lichen Plastikdeckel – einsame Überbleibsel von bereits Ausgemustertem und Weggeworfenem – vom Raum Besitz und zwingen uns, ihn auf neue Art zu betrachten.

Durch den Rückgriff auf das ambivalente Medium eines mechanisch erzeugten Motivs ermöglicht Orozco uns die Einsicht, dass Lesen und Anschauen einander nicht entgegengesetzt sind, sondern letztlich beide mit dem Oszillieren von Bildern zwischen Berührung und Zeichen, zwischen Unmittelbarkeit und Vermitteltem zusammenhängen. *Die Ausdruckskraft des Gezeichneten beschränkt sich nur mehr darauf, die Gegenwart eines zu seinem blossen Referenten Gewordenen zu signalisieren, zu simulieren, zu ergänzen. Die gezeichnete Linie ist nunmehr zu Kunst, zur technischen Vermittlung dessen, wofür sie steht, geworden. Und worauf sie fortan verweist, ist nicht länger das, wofür sie steht, sondern eben sie selbst, das heisst letztlich der Maler.*[2)] So besehen, erinnert Orozcos Plastik-O an I-BOX (1963) von Robert Morris, der *den Betrachter zugleich mit einem semiotischen Spiel (mit den homophonen Wörtern «I» und «Eye») konfrontiert wie mit einem spielerischen Wechsel vom Taktilen (der Betrachter muss an dem Kasten physisch herumhantieren, um des Ichs des Künstlers ansichtig zu werden) über das Sprachzeichen (der Buchstabe «I» bildet die Grundform der Rahmen- beziehungsweise Schauvorrichtung: die «Tür» des Kastens) hin zur bildlichen Darstellung (das photographische Aktporträt des Künstlers) und wieder zurück.*[3)] Sieht man vom gänzlich anders gearteten, konzeptuellen Titel ab, so greift Orozcos Arbeit eben diese Dreiteilung des ästhetisch Signifikanten auf: in Objekt, Sprachzeichen und (verlorengegangenes bzw. entferntes) photographisches Abbild. Allerdings ist der blaue Rahmen, im Gegensatz zum als Tondo oder Medaillon angelegten Selbstbildnis, leer und erinnert an das photographische Selbstbildnis von Edward Steichen, SELF PORTRAIT MILWAUKEE (1898), wo der Künstler neben einem kleinen, leeren, rechteckigen Rahmen an der Wand steht, als habe sich das Unsichtbare als latente, imaginäre, unbewusste oder vergangene Spur eingeschrieben. Auf gleiche Weise geraten die kleinen O-Objekte als «erweiterbare» Zeichnungen zu einem Selbstporträt Orozcos, während der Anfangsbuchstabe seines Namens sich gleichzeitig als Abkürzung für «the Other», das Andere, lesen lässt. Oder ist das

O eine raffinierte Anspielung auf den amerikanischen Traum «From zero to hero» (Von Null und Nichts zum Helden)? Denn keiner weiss besser als Orozco, dass die gespenstische Umkehrung dieses Traums die heimliche Strategie einer unablässig nach dem Neuen gierenden Kunstszene darstellt.

Wer aus der Nähe in eines der Plastik-Os hineinschaut, sieht – im Schnittpunkt von Identität und Anonymität – das eigene, transparente Spiegelbild. Im gemeinsamen Grenzbereich verflüchtigen und materialisieren sich, zusammen und dennoch deutlich unterscheidbar, Autoporträt und Alloporträt, Subjekt und Objekt. Nach Jacques Derrida *besteht das Selbstporträt zunächst darin, dem Betrachter, dem Besucher, dem, dessen Sehen blind macht, einen Platz zuzuweisen und diesen mithin zu beschreiben; es weist diesen Platz zu oder beschreibt ihn gemäss dem Blick des Zeichners, der, einerseits, sich selbst nicht mehr sieht, ist doch an die Stelle des Spiegels zwangsläufig der Adressat getreten, das heisst wir – freilich wir, die wir anderer seits im gleichen Augenblick, da wir als Zuschauer an (die) Stelle des Spiegels getreten sind, den Urheber nicht länger als solchen wahrnehmen, jedenfalls das Objekt, das Subjekt und den Signierenden des Selbstporträts des Künstlers als Selbstporträtisten nicht länger identifizieren können.*[4)] Obwohl ihre minimalistische Präzision die Geometrisierung des Raums und die Objektivität der Perspektive noch zu verstärken scheint, stellen Orozcos YOGURT CAPS den Eindruck der Raumbeherrschung – Betrachter im Mittelpunkt, Künstler am Rand – paradoxerweise in Frage. Diese Veränderung der räumlichen Wahrnehmung tritt auch immer dann ein, wenn der Lesende versucht, den Ort der Zeichnung und das Blickfeld zu kontrollieren, einen Blickwinkel zu finden, aus dem er das ganze Werk erfassen kann. Alle Bemühungen schlagen fehl. Wie ein blinder Fleck bleibt eines der vier Os immer ausserhalb des Blickfeldes, ausser Reichweite. Indes verstärken die anderen drei Os – wie eine Art Monokel für die Leser/Betrachter – sowohl das Sehvermögen wie den Impuls, unsere Wahrnehmungsfähigkeit zu erweitern. Kunst ist hier nahe daran, zur totalen Erfahrung zu werden, grenzenlos und nicht mehr zu bändigen. Ähnlich verhält es sich mit FOUR BICYCLES (THERE IS ALWAYS ONE DIRECTION)/CUATRO BICICLETAS (SIEMPRE HAY UNA DIRECCION) (Vier

GABRIEL OROZCO, LA DS, 1993, 55⅛ x 189 x 44⅞" / 140 x 480 x 114 cm.

Gabriel Orozco

GABRIEL OROZCO, EXTENSION OF REFLECTION, 1992, c-print, 12⁷⁄₁₆ x 18⅝" / ERWEITERTE SPIEGELUNG, 31,6 x 47,3 cm.

Fahrräder [Es gibt immer eine Richtung], 1994) und HORSES RUNNING ENDLESSLY/CABALLOS CORRIEN-DO INFINITAMENTE (Endlos rennende Pferde, 1995) – *was das Bewusstsein nicht wahrnimmt, nimmt es aus grundsätzlichen Gründen nicht wahr; eben weil es Bewusstsein ist, kann es manches nicht wahrnehmen.* (Maurice Merleau-Ponty).

Aus den Augen, aus dem Sinn? Es hat den Anschein, als sei YOGURT CAPS nie wirklich ein Ganzes und müsse uns auf immer zu einem Teil entzogen bleiben, weil zumindest eines der Os sich immer hinter dem Betrachter befindet. Liesse sich gar eine Verbindung zwischen diesem fehlenden O und dem Lacanschen *Objekt a* – dem Nichtobjekt, dem unerreichbaren Anderen – herstellen?[5] Lacans seltsamer Begriff des *klein a – eine archaische psychische Spur oder eine primäre mentale Prägung des Überrestes ... des originären Teil-Objekts beziehungsweise der/s realen archaischen Mutter/Andern* – bezieht sich auf das, was dem Subjekt nach der Trennung vom Teil-Objekt bleibt, was aber gleichwohl noch nicht in den «ganzen» Körper integriert ist, das heisst also auf die Überreste des Schismas. Das fehlende *Objekt a* steht immer «hinter» dem Begehren zurück und hat selbst keine Form.[6] Im geistigen, visuellen Bereich ist das verlorengegangene *Objekt a* der (mit dem Blick der Mutter/des Andern verbundene) Blick als Ursache des Begehrens im Bereich des Sichtbaren. Indem jedoch dieser Trieb des Sehenwollens ins Spiel gebracht wird, scheint es bei Orozcos O – anders als beim von Lacan als phallisch und jenseits der Kommunikation dargestellten Blick – um den Beinahverlust des Objektes, um dessen Geflecht von Beziehungen und um den Sinnschaffungsprozess als solchen zu gehen. *Das Objekt als Abwesendes statt als Seiendes wird auf imaginäre Weise in der Phantasie angedeutet, in der eine «unmögliche Begegnung» auf der Ebene des Teil-Objektes, von dem sich das Subjekt bereits abgespalten hat, stattfinden kann. Durch die Phantasie kann das Subjekt in Kontakt treten mit dem, was ihm im Zuge des durch einen subjektivierenden Diskurs erfolgenden Einschreibens des Körpers in den Bezugsrahmen der symbolischen Ordnung «abhanden gekommen» war.*[7] Mithin steht das O bis zu einem gewissen Grad dem *matrixbestimmten Objekt a* in Bracha Lichtenberg Ettingers Theorie des «matrixabhängigen Blickes» nahe – ein gemeinsames, zwitterhaftes Objekt innerhalb einer komplex zusammengesetzten Subjektivität, mit der weiblich-pränatalen Begegnung als Ausgangspunkt. So betrachtet ist das Zusammen-Werden dem Eins-Sein vorgeordnet. Beziehungen ohne Bezugnahme und Distanz in der Nähe lassen das zugleich entstehende Andere als Subjekt wie als Objekt fortbestehen, statt es zum blossen Objekt zu degradieren. Die Grenzen zwischen Subjekten und Objekten werden zu Schwellen. Durch diesen Prozess «entzieht sich» der matrixbestimmte Blick den Rändern und kehrt wieder zu ihnen zurück. Die Grenzen und Schwellen der Wahrnehmung werden unablässig überschritten oder verwischt, so dass neue entstehen können.[8]

Diese wechselnde Fokussierung wird in einem früheren Projekt für die *Kanaal Art Foundation*, 1993, konkret fassbar: Orozco verteilte vier farbige Punkte über die Stockwerke eines baufälligen Brauereiturms. Die vier farbigen Punkte – ein weisser Punkt auf einem Tisch aus UNDER THE TABLE/BAJO LA MESA (Unter dem Tisch), ein blauer Punkt aus SOFT BLUE/SUAVE AZUL (Sanftes Blau), ein gelber aus GRAPEFRUIT/TORONJA und ein orangefarbener aus ORANGE WITHOUT SPACE/NARANJA SIN ESPACIO (Orange ohne Raum) – werden, entsprechend dem Verlauf des Brauprozesses, entlang einer Achse durch Löcher in den Böden der Turmgeschosse in den Raum katapultiert. Den Blick des Betrachters in die Tiefe des Schachtes ziehend, blickt das dort unten plazierte Werk, ORANGE WITHOUT SPACE, den es betrachtenden Betrachter an, wie das Auge eines riesigen alten Teddybärs, und wirft so den das Betrachtete vergegenständlichenden Blick wieder zurück auf den «auf frischer Tat ertappten» Betrachter. Wie die Bälle in OVAL BILLIARD TABLE WITH PENDULUM (Ovaler Billardtisch mit Pendel, 1996) und, vielleicht mehr noch, die Deckel in YOGURT CAPS, vereinigen diese farbigen Punkte die Möglichkeiten des Sehens, Ertastens und Bewegens in sich (vergleiche auch LIGHT SIGNS, 1995, und THE ATOMISTS, 1996). Da der Betrachter bei diesen Arbeiten nie alle kreisförmigen «Zeichnungen» auf einen Blick erfassen kann, gelingt es Orozco, die auf einen einzigen Fluchtpunkt ausgerichtete Zentralperspektive zu umgehen, und gleichzeitig schafft er einen Augenblick, der das Gegenwärtige der optischen

Wahrnehmung mit dem Erinnerungsgebundenen der Zeichnung vereint. Zugleich werden Erinnerungen an ein Werk der belgischen Gegenwartskünstlerin Joëlle Tuerlinckx wach, ZERO: IT IS THE NUMBER OF THINGS YOU HAVE WHEN YOU DO NOT HAVE ANYTHING (Null: Das ist die Anzahl der Dinge, die man hat, wenn man nichts hat, 1966). Ein Hellraumprojektor projiziert die handschriftliche Definition auf die roh belassene Ausstellungswand; eingetrocknete Wasserflecken auf der Schreibfläche des Projektors und an der Wand zurückgebliebene Löcher von der letzten Ausstellung ergeben ein Muster aus unregelmässigen Punkten. Diese Punkte oszillieren zwischen Projektion/Illusion und Realität, zwischen Erinnerung/Abwesenheit und Gegenwart. Wie ein bildhauerischer Abguss der Gussform entspricht, sich aber gleichzeitig von ihr unterscheidet (positiv zu negativ), vermögen diese beiden Werke Gegensätze zu verschmelzen und verleihen somit dem Duchampschen Begriff des *infra-mince* konkrete Gestalt. Exemplarisch für diesen Austausch von Eigenschaften sind Orozcos MY HANDS ARE MY HEART/MIS MANOS SON MI CORAZON (Meine Hände sind mein Herz, 1991) und MANI MARINE (Meereshände, 1995).

Orozcos O stimmt mit Roland Barthes Beleuchtung des Verhältnisses zwischen Kunst und Politik in *Le degré zéro de l'écriture* überein. Barthes behauptet nicht, dass Literatur in einem gesellschaftlichen, historischen oder ethischen Vakuum existiert oder existieren sollte: Der Begriff des Nullpunktes, des neutralen, farblosen Schreibens findet Eingang in seine Ausführungen als *letzte Episode einer Passion des Schreibens, welche Station für Station vom Zerfall des bür-* gerlichen Bewusstseins erzählt, und dann am Ende wieder als eine Lösung für das Problem des Zerfalls der literarischen Sprache.[9] Im Zuge der Analyse von Veränderungen in der Rezeption und Verbreitung des Kunstwerkes setzen manche Künstler der Generation Orozcos – in einem qualvollen Schwebezustand zwischen entgegengesetzten Zielen – gleichzeitig auf den Versuch zur Abschaffung des ästhetischen Objektes und darauf, künstlerische Erfahrung auf ethische Kommunikation zu beschränken. Gibt es eine nichtinstrumentalisierte oder nichtverdinglichte Seite des sozialen Objektes der Sprache oder nicht? In Orozcos Schaffen manifestiert sich das «Schreiben am Nullpunkt» konkret im automatischen Schreiben/Zeichnen von O-Formen – neben YOGURT CAPS auch in LOST LINE/LINEA PERDIDA (Verlorene Linie, 1993) und HAMMOCK AT MOMA (Hängematte im MoMA, 1993) – und im übertragenen Sinn im mechanisierten Von-Hand-Schreiben/Zeichnen von sich wiederholenden Linien, etwa in DIAL TONE/TONO DE MARCAR (Wählton, 1992) und PARKING UNTITLED (NOS 1–18) (Parken Ohne Titel, Nr. 1–18, 1996). Das letztgenannte, serielle Projekt besteht aus Bleistiftlinien auf Papier – willkürliche Gesten, die unaufhörlich die alltägliche Routine und folglich auch «Gefühl und Verstand» des Künstlers artikulieren. Um die parallelen, vertikalen Linien möglichst klar, objektiv und unpersönlich aufs Papier zu bringen, benützt Orozco ein Lineal, stösst dabei aber auf das Hindernis seines eigenen Fingers/Auges. Die Mitte zwischen Instrumentalisierung und Spontaneität haltend, folgt er seiner Fingerspitze und lässt so den fahrigen Ausrut-

GABRIEL OROZCO, SLEEPING LEAVES,
1990, c-print, 12⁷/₁₆ x 18⁵/₈" /
SCHLAFENDE BLÄTTER, 31,6 x 47,3 cm.

scher als Abweichung in der sonst vollkommen geraden Linie zu. Immer wieder blitzt in der Poesie, der Präzision und der Kargheit von Orozcos Werk das Irrationale durch die «objektive» Ordnung hindurch. In seinem Flirt mit der Objektivität bezieht er deren subjektiven, alogischen Gegenpol mit ein und stellt die Ergebenheit gegenüber geometrischen Regeln ebenso in Frage wie die Vorstellung, dass die «Perspektive doppelt objektiv» sei: *auf der einen Seite ein durch seine mathematischen Grundlagen objektiviertes System, um Objekte zu ordnen und zu organisieren, und auf der anderen die Möglichkeit, dass sich diese Objekte in eben ihrer Objektivität darbieten – und zwar als eine Reihe von stereometrischen Körpern, «Variationen oder Verbindungen von Kugeln, Zylindern, Kegeln, Würfeln und Pyramiden,*[10)] wie in SANDBALL AND CHAIR I (Sandkugel und Stuhl I, 1995).

Die Rundheit der Dinge beziehungsweise der Erfahrung durchwaltet Orozcos Œuvre. Um nur einige Beispiele zu nennen: NATURALEZA RECUPE-RADA (Wiedergewonnene Natur, 1990), TURISTA MALUCO (Verrückter Tourist, 1991), PELOTA PON-CHADA (Gequetschter Ball, 1993), HOME RUN (1993), STOPPER IN MOMA (Stöpsel im MoMA, 1993), GREEN BALL/BOLA VERDE (Grüne Kugel, 1995), LIGHT SIGNS (Lichtzeichen, 1995). Insbesondere dürfte YIELDING STONE/PIEDRA QUE CEDE (Nachgebender Stein, 1992) ein weiteres, als Rundbild angelegtes Selbstporträt des Künstlers sein. Denn dieser schwarze massive Klumpen einer formbaren Masse entspricht Orozcos Körpergewicht und nimmt, wenn er durch die Strassen gerollt wird, jedes beliebige namenlose Schutt- und Müllpartikel als Abdruck in seine Oberfläche auf.[11)] An dieser Stelle drängt sich allerdings Gaston Bachelards «Phänomenologie des Runden» auf, wo es heisst: *Die Bil-*

der der vollen Rundung verhelfen uns dazu, uns um uns selbst zu versammeln, uns selbst eine ursprüngliche Verfassung zu geben, unser Dasein innerlich zu bestätigen, von drinnen aus. Denn von drinnen aus erlebt, ohne Aussengestalt, kann das Dasein nur rund sein.[12)] Und während einerseits gilt: *Was sich isoliert, das rundet sich, nimmt die Form des Daseins an, das sich um sich selbst konzentriert,* ruft andererseits *alles, was rund ist, bekanntlich nach Liebkosung.* In eben diesem Bereich zwischen autarker Isolierung und Liebkosung ist Orozcos Werk angesiedelt und manifestiert seine enge Beziehung zum Kugelförmigen, in der wiederum die ständige Tuchfühlung mit dem Andern anklingt. Seine Überlegung ist die, dass man den Druck und die Spannungen des wirklichen Lebens nur aushalten kann, indem man sich «rundet», indem man die Reibung der Berührung akzeptiert – ganz wie ein Planet im Weltall oder ein Stein im Fluss. In einer eigentlichen Kampfansage an die quadratischen und statischen Objekte des Minimalismus thematisiert Orozco die Rundheit eines menschlichen Bauchs oder einer organischen Form als Gefäss oder «Matrix» des fortwährenden Austauschs und der Begegnung der Subjekte in ihrer Verschiedenheit. Gegenstand seines Werkes ist die Öffnung zum jeweils Anderen hin, nicht dessen Vereinnahmung.

Genauso stehen in Orozcos offener «Zeichnung» der blauen Plastikkreise in YOGURT CAPS Innen und Aussen in einer Wechselbeziehung. Anders als in der Malerei, wo die Farbe in der Regel die Leinwand beherrscht und verdeckt, bewirkt eine auf Papier – oder in diesem Fall an die Wand – gezeichnete Linie gleichzeitig eine Teilung und eine Verbindung im Raum. Wie das Papier unter der Zeichnung, bleibt die weisse Wand unter den durchsichtigen Joghurtdeckeln als durchgehende Fläche erhalten, deren

GABRIEL OROZCO, UNTIL YOU FIND
ANOTHER YELLOW SCHWALBE, 1995,
4 of 40 photographs / BIS DU NOCH EINE
GELBE SCHWALBE FINDEST,
4 von 40 Photographien.

Partien beidseits der Trennlinie interagieren. Allerdings: *Vor jeder Deutung oder Interpretation ist Giottos O zuallererst eine Zeichnung. «Zeichnung» meint hier das, was, noch bevor es ein Zeichen im Sinne eines «Zeichens für etwas» ist, zuerst einmal ein Zeichen seiner selbst ist. Ehe sie ein Zeichen für «etwas anderes als es selbst» ist, skizziert, graviert, zeichnet oder schreibt sich die «Zeichnung» selbst in ihren eigenen Raum ein; ehe sie überhaupt irgend etwas bezeichnet, bezeichnet sie sich selbst. Um im Fachjargon zu reden, kann man sagen, dass eine Zeichnung sich an (oder auf) der Grenze der Semiosis bewegt und dass sie, mehr noch als irgendein anderes Zeichen, mit der Doppeldeutigkeit des mimetischen Impulses spielt. In einem Bild ist die Linie, die wir am Rande unserer rationalen Fähigkeiten zeichnen, eine Schnittlinie zwischen Mimesis und Semiosis.*[13]

Wenn ich YOGURT CAPS lese und anschaue, wird mir klar, dass Orozcos Bildrätsel, das sich hinter und vor meinen Augen entfaltet, gleichzeitig von absurder Strenge und von logischer Beliebigkeit durchdrungen ist, wie es der Titel und die Art der Präsentation schon die ganze Zeit suggeriert hatten. Ist das O vielleicht die schmale blaue Trennlinie zwischen Statement und Scherz? Betrachtet man seine jüngste Serie von «Zeichnungen», THE ATOMISTS, so hat es den Anschein, als warte die Geschichte von Orozcos Os immer noch darauf, erzählt zu werden...

(Übersetzung: Magda Moses, Bram Opstelten)

1) In seinem Aufsatz «De O van Giotto» schreibt Paul de Vylder: «Ernsthafte Historiker könnten auf den vorherrschenden Neoplatonismus in der Zeit, in der Vasari die Anekdote erzählt, verweisen und behaupten, Giottos O sei ein materielles *Zeichen* einer höheren Wirklichkeit, einer reinen *Idee*.» Vgl. dazu *Jarg Geismate: Personal Drawings*, Ausstellungskatalog, Düsseldorf und Sint Niklaas 1992, S. 15
2) Bernard Vouilloux, «Drawing Between the Eye and the Hand: (On Rousseau)», in: *Yale French Studies*, Nr. 85, S. 182.
3) Benjamin H.D. Buchloh, «Conceptual Art 1962–1969: From the Aesthetic of Administration to the Critique of Institutions», in: *October*, Nr. 55 (Winter 1990), S. 116 ff.
4) Jacques Derrida, *Memoirs of the Blind The Self-Portrait and Other Ruins*, University Press, Chicago, 1993, S. 62. Ursprünglich unter dem Titel *Mémoires d'aveugle*, 1990 in Paris erschienen. (Das Zitat wurde aus dem Englischen übersetzt.)
5) Jacques Lacan, *Die vier Grundbegriffe der Psychoanalyse* (Das Seminar von Jacques Lacan, Buch XI), dt. hrsg. v. Norbert Haas, Walter Verlag, Olten und Freiburg i.B. 1978.
6) «Das *klein a* kann verschiedene Formen annehmen, mit der Einschränkung, dass es selbst an sich keine Form hat, sondern nur in einem vorwiegend oralen oder skatologischen Sinn verstanden werden kann. Der gemeinsame Nenner des *a* ist, dass es an die Öffnungen des Körpers gebunden ist. Welche Auswirkungen hat also die Tatsache, dass das Auge und das Ohr Öffnungen sind, auf die Tatsache, dass die Wahrnehmung für beide sphäroidisch ist?» Jacques Lacan, «Le Séminaire de Jacques Lacan, 21 janvier 1975», in: *Ornicar No 3*, Université de Paris VIII, Paris 1975, S. 164–165. (Das Zitat wurde aus dem Englischen übersetzt.)
7) Meine Ausführungen zum *Objekt a* stützen sich auf Bracha Lichtenberg Ettingers Aufsatz «Woman as *objet a* Between Phantasy and Art», in: *Complexity–Journal of Philosophy and the Visual Arts*, London 1995, S. 57–77.
8) Bracha Lichtenberg Ettinger, *The Matrixial Gaze* (Leeds: University of Leeds, Feminist Arts and Histories Network, 1995), S. 1–30.
9) Susan Sontag in ihrem Vorwort zu Roland Barthes, *Writing Degree Zero*, New York 1968.
10) Rosalind Krauss, «The LeWitt Matrix», in: *Sol LeWitt Structures 1962–1993*, Ausstellungskatalog, The Museum of Modern Art, New York und London 1993, S. 25–33.
11) Für eine eingehendere Betrachtung zu YIELDING STONE, siehe Benjamin H. D. Buchloh, «Refuse and Refuge», in: *Gabriel Orozco*, hrsg. v. Catherine de Zegher, Ausstellungskatalog, The Kanaal Art Foundation, Kortrijk 1993.
12) Gaston Bachelard, *La poétique de l'espace* (1958), zit. nach der dt. Ausg., *Poetik des Raums*, übers. v. Kurt Leonhard, Frankfurt am Main, Berlin und Wien 1975, S. 265, 270, 267.
13) Paul de Vylder, op. cit.

EDITION FOR PARKETT

GABRIEL OROZCO
LIGHT THROUGH LEAVES, 1996
Iris computer print,
archival water-based ink on paper
(500g sm Somerset Satin 100% cotton rag),
produced by Cone Laumont Editions, New York,
20 x 30$\frac{1}{8}$" (image size),
22 x 32$\frac{1}{8}$" (paper size),
Edition of 60, signed and numbered

LICHT DURCH LAUB, 1996
Iris-Computerprint,
lichtechte Druckfarbe auf holzfreiem Somerset
Satin-Papier (500 gm^2),
gedruckt bei Cone Laumont Editions, New York,
50,8 x 76,5 cm (Bildgrösse),
55,9 x 81,6 cm (Papierformat),
Auflage: 60, signiert und numeriert

(PHOTO: CONE LAUMONT EDITIONS)

Pipilotti

Rist

NANCY SPECTOR

The Mechanics of Fluids

The sea is everything... Its breath is pure and healthy.
It is an immense desert, where man is never lonely, for
he feels life stirring on all sides. The sea is only the
embodiment of a supernatural and wonderful existence.
It is nothing but love and emotion.

Jules Verne, *20,000 Leagues Under the Sea*

Hidden within the labyrinthine basement of Denmark's seaside Louisiana Museum, Pipilotti Rist's projected video installation SIP MY OCEAN (1996) mesmerized its viewers with scenes of maritime pleasure. It was featured this past summer in the exhibition "Get Lost," a subsection of the sweeping, multi-curator affair entitled "NowHere."[1] The overriding theme of this show—that an expansion of perceptual boundaries can lead to personal transcendence—was embodied by the relentless, hypnotic techno-beat that rocked its subterranean setting and permeated the spaces between art works. In marked contrast to this droning, digitalized soundtrack, SIP MY OCEAN exuded a tranquil sensuality. Bracketed by room after darkened room of other film and video installations—one more conceptual than the next—Rist's aquatic playland was accompanied by her own rendition of Chris Isaak's hit love ballad "Wicked Game."[2]

Taped almost entirely underwater, Rist's video offers a "fish-eye" view of swaying seaweed gardens and coral kingdoms. Wafting sybaritically over the ocean beds, the camera records trajectories of household objects as they sink to the depths of the sea; kitsch coffee mugs with heart-shaped patterns, a bright yellow teapot, a plastic toy truck, and an old

LP settle into the sand. Schools of tropical fish whizz in and out of this ever-shifting marine vista, while a bikini-clad woman cavorts in the waves. In Denmark, the video was projected in duplicate as mirrored reflections on two adjoining walls, with the corner between them an immobile seam around which psychedelic configurations radiated and swirled. This kaleidoscopic imagery was choreographed to Rist's cover version of "Wicked Game," which she alternately crooned and hysterically shrieked throughout the loop, leaving one to wonder if there might be trouble in Paradise:

The River was on fire and no one could save me but you
Strange what desire will make foolish people do
I never dreamed that I'd meet somebody like you
I never dreamed that I'd lose someone like you
Oh, I don't want to fall in love...with you.

Rist's video works are often double-edged in their delivery, being at once coquettish and rebellious. Her aesthetic reference is not so much the real-time, task-oriented video of the 1970s (which is the case for many young video artists working today) as the slickly packaged porno-pop of MTV. In particular, her 1986 single-channel piece I'M NOT THE GIRL WHO MISSES MUCH—a spectacle of frenzied rock-and-roll dancing glimpsed through deliberate technical dis-

NANCY SPECTOR is Associate Curator at the Guggenheim Museum, New York.

ruptions—playfully satirizes the commodified eroticism of television's music videos, while exposing their sexist underpinnings. For her projection pieces, which tend to be environmental in scale and immersive in feeling, Rist manipulates the technology of video to emulate cinematic effects. These hybridizations of film and video emit a profusion of captivating audio and visual stimuli that invite corporeal, if not libidinal, identification. Far from being "politically correct," these installations problematize feminism's interrogation of visual pleasure as it is manifest in the cinema.[3]

If Rist claims a feminist agenda for her work, which I believe to be the case, her theoretical sources lie in the lyrical writings of Hélène Cixous and Luce Irigaray, who each espouse pure female embodiment as the vehicle for psychological and sexual emancipation from the inequities inherent to heterosexual gender difference. Cixous's poetic call for women to inscribe their own history with "milk" instead of ink, and Irigaray's directive for women to employ a science based on the "mechanics of fluids" as a methodology for self-analysis, resonate in the leitmotif of aqueous imagery running throughout many of Rist's videos. Visions of water—and the metaphors of mutability and transformation they invoke—abound in the work: from the swimming pool shots in (ENTLASTUNGEN) PIPILOTTIS FEHLER (Absolutions: Pipilotti's Mistakes, 1988), to the floating, interpenetrating bodies in PICKELPORNO (Pimple Porno, 1992), to the scenes of the deep blue sea in SIP MY OCEAN.

Rist's saturated, ever-mutating imagery imparts a polymorphous pleasure in the physical. The pervasive sensuality of SIP MY OCEAN, with its multiple screens and hallucinogenic mirroring effects, sug-

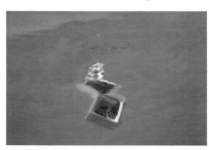

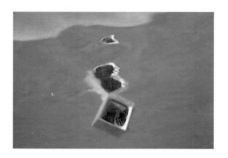

gests the elusive state of *jouissance*—unadulterated, boundless, pre-Oedipal pleasure. Associated with the female, this metaphoric realm imagines a body with no boundaries, a body with multiple and autonomous erotic zones, a body in full possession of its own desire. However, Rist's erratic vocals—which range from sweetly lyrical to maniacal screaming—disrupt these utopian dreams of total gratification. For desire always demands an "other," one who may or may not yield to the seduction, one who may or may not return the favor. As the soundtrack to this deliriously enchanting waterworld, Rist's version of Isaak's tune expresses the dangers (and pleasures) of desire; it also suggests a person trying to maintain control against the rising tides of passion. "Sip my ocean" is Rist's invitation to participate in this game of desire and fulfillment; yet it is also a dare to survive its perilous undertow.

1) "Get Lost" was organized by Louisiana curators Anneli Fuchs and Lars Grambye; the five part exhibition "NowHere" was held at the Louisiana Museum of Modern Art in Humlebaek from May 15 to September 8, 1996. A version of SIP MY OCEAN was also shown at the Museum of Contemporary Art in Chicago from July 2 to August 25, 1996. See the catalogue accompanying its presentation for an insightful essay on the work by Dominic Molon. Both museums have acquired the piece for their permanent collections.
2) Warner Chappell Ltd., 1989.
3) In her study of women's performance work from the 1960s and 1970s, Amelia Jones examines the polemics of pleasure and desire in contemporary art. She situates feminism's call to disown representations of bodily desire in Laura Mulvey's highly influential article, "Visual Pleasure and Narrative Cinema" from 1975 and argues that feminism's refusal to perpetuate the codes associated with male visual pleasure effectively dismissed (and still dismisses) the significance of women's art involving corporeal performance. See her "Postfeminism, Feminist Pleasures, and Embodied Theories of Art," in *New Feminist Criticism, Art, Identity, Action*, Joanna Freuh, Cassandra L. Langer, and Arlene Raven, eds. (New York: Harper Collins, 1994), pp. 16–41.

PIPILOTTI RIST, GROSSMUT BEGATTE MICH, 1994, & SIP MY OCEAN, 1996, Videostills aus den Installationsbändern / video stills of installation tapes.

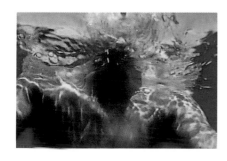

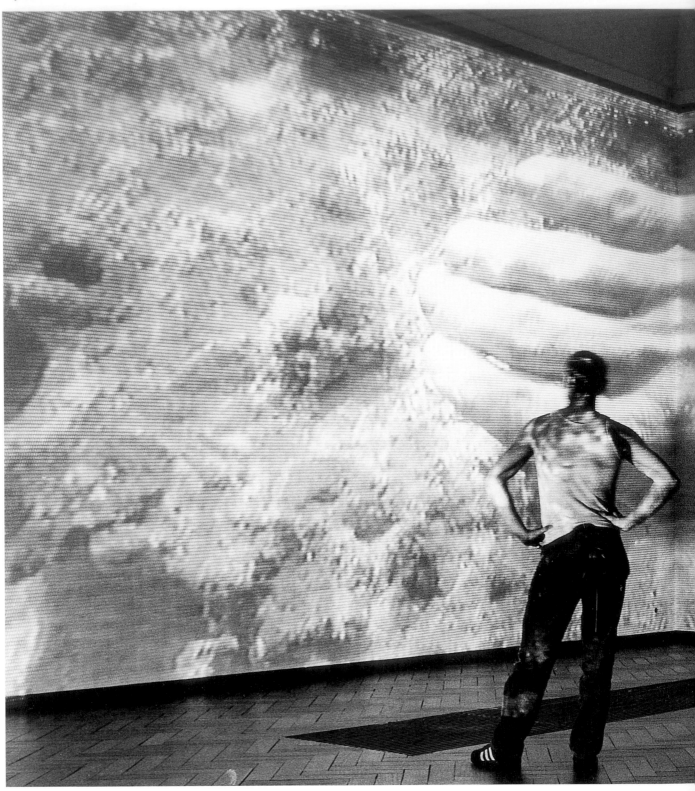

PIPILOTTI RIST, GROSSMUT BEGATTE MICH & SEARCH WOLKEN (Vorstufe von SIP MY OCEAN), 1995, Videoinstallation mit 3 Projektionen, 2 players, audio system and 2 video tapes. (PHOTO: CARY MARKERINK, AMSTERDAM)

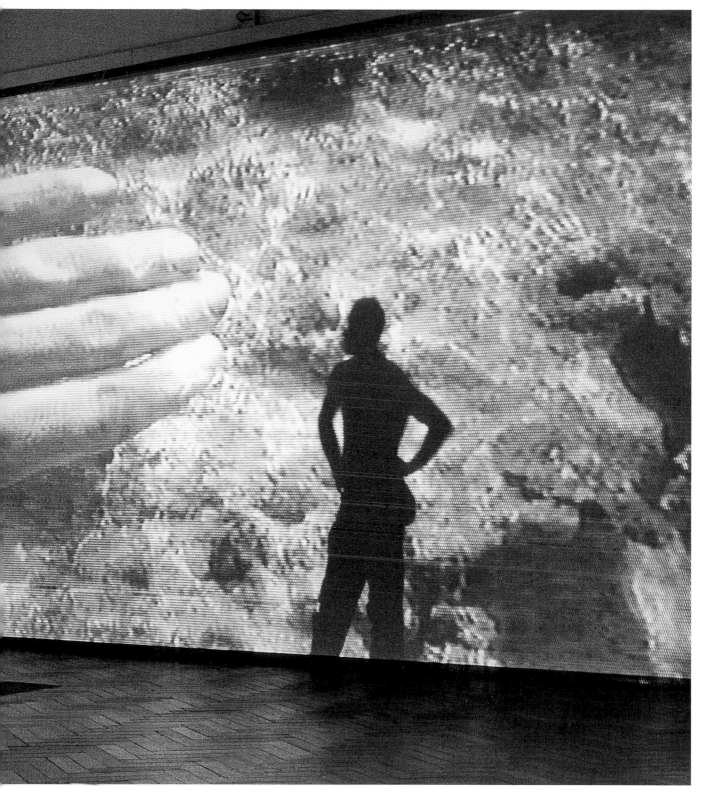

NANCY SPECTOR

Die Dynamik des Fliessenden

Das Meer ist alles... Sein Wind ist rein und gesund.
So unermesslich diese Einöde auch ist,
fühlt sich der Mensch dennoch nie einsam,
denn er spürt, wie das Leben um ihn wogt.
Ein übernatürliches wunderbares Dasein rührt sich im Meer;
es ist nur Bewegung und Liebe, lebendige Unendlichkeit...

Jules Verne, *20 000 Meilen unter Meer* [1]

Pipilotti Rists Videoinstallation SIP MY OCEAN (1996), versteckt im labyrinthisch verzweigten Untergeschoss des (in der Nähe von Kopenhagen, direkt am Meer gelegenen) Louisiana Museums, verzauberte Besucherinnen und Besucher mit ihren Bildern reiner Meereslust. Die Installation wurde diesen Spätsommer, im Rahmen der Ausstellung «Get Lost» gezeigt, einer Unterabteilung des gigantischen Projektes «NowHere».[2] Der schonungslose, hypnotische Techno-Beat, der die unterirdische Szenerie erschütterte und den Raum zwischen den Kunstwerken ausfüllte, brachte das dominierende Thema der ganzen Ausstellung auf den Punkt: nämlich, dass die Erweiterung der Grenzen der Wahrnehmung das Individuelle aufzulösen und zu transzendieren vermag. Ganz im Gegensatz zu diesen dröhnenden, digitalisierten Tönen verströmte SIP MY OCEAN eine stille Sinnlichkeit. Rists verspielte Wasserwelt war von einer beinah endlosen Reihe verdunkelter Räume umgeben, die mit konzeptuellen Film- und Videoinstallationen vollgepackt waren, und wurde von ihrer eigenen Interpretation des Hits *Wicked Game* von Chris Isaak begleitet, einer Ballade über die Liebe.

Das Video ist fast vollständig unter Wasser gedreht und zeigt sanft bewegte Seegraslandschaften und Korallenwelten aus der Fischperspektive. Während das Auge der Kamera genüsslich über dem Meeresboden umherschweift, verfolgt es, wie einige Haushaltgegenstände zum Grund hinuntersinken; kitschige Kaffeetassen mit Herzmuster, ein leuchtend gelber Teekrug, ein Spielzeuglastwagen aus Plastik und eine alte Langspielplatte landen im Sand. Schwärme tropischer Fische flitzen immer wieder durch diese, sich ständig verändernde Meereslandschaft, während eine Frau im Bikini in den Wellen herumtanzt. In Dänemark wurde das Video übereck auf zwei Wände zugleich projiziert, als wäre das eine die Spiegelung des anderen. Die Ecke dazwischen bildete eine ruhige Nahtstelle, um die herum der psychedelische Strom der Bilder floss und wirbelte. Die kaleidoskopische Bildfolge war auf Rists Version von *Wicked Game* abgestimmt, das die ganze Zeit – bald als ein leises Summen, bald als hysterisches Geschrei – ab Band ertönte, so dass man sich fragte, ob im Paradies wohl etwas schiefgelaufen war.

NANCY SPECTOR ist Co-Kuratorin im Guggenheim Museum, New York.

The River was on fire and no one could save me but you
Strange what desire will make foolish people do
I never dreamed that I'd meet somebody like you
I never dreamed that I'd lose someone like you
Oh, I don't want to fall in love… with you.[3]

PIPILOTTI RIST, PICKELPORNO, 1992,
Videotape (12 Min.) / PIMPLE PORNO.

Pipilotti Rists Videoarbeiten wirken in der Art ihrer Wiedergabe oft zwiespältig, kokett und rebellisch zugleich. Und ihr ästhetisches Umfeld ist weniger das engagierte Echtzeit-Video der 70er Jahre (wie bei vielen der heutigen jungen Videokünstler), sondern der geschickt verpackte Porno-Pop von MTV. Insbesondere ihr Einkanal-Video I'M NOT THE GIRL WHO MISSES MUCH (1986) – ein verrücktes Rock 'n' Roll-Tanzspektakel, das durch bewusst eingesetzte technische Störungen verfremdet wird – ist eine spielerische Satire auf die platte Erotik der Musik-Videoclips im Fernsehen und enthüllt deren sexistischen Hintergrund. Bei ihren zur Projektion bestimmten Arbeiten, die meist weit in den Raum ausgreifen und äusserst gefühlsintensiv wirken, macht Rist mit ihrer Videotechnik dem Kino Konkurrenz. Die dabei entstehenden Kreuzungsformen von Film und Video strahlen ein Gemisch faszinierender akustischer und optischer Reize aus, die zu einer körperlichen, wenn nicht gar libidinösen Identifikation einladen. Weit davon entfernt, «politisch korrekt» zu sein, machen diese Installationen die feministische Diskussion um die Lust am Visuellen im Kino zum Thema und stellen sie in Frage.[4]

Wenn Pipilotti Rists Werk ein feministisches Programm beinhaltet, was, wie ich glaube, der Fall ist, so wären dessen theoretische Grundlagen bei Hélène Cixous und Luce Irigaray zu finden. Denn sie beide sehen in der spezifisch weiblichen Körperlichkeit den Ansatz zur psychologischen und sexuellen Befreiung, die den geschlechtsbezogenen Ungerechtigkeiten ein Ende setzen soll. Cixous' poetischer Aufruf an die Frauen, ihre Geschichte mit Milch statt mit Tinte zu schreiben, und Irigarays Maxime, dass Frauen ihre wissenschaftliche Tätigkeit auf einer «Dynamik des Fliessenden» als Methode der Selbstanalyse begründen müssten, schwingen im Leitmotiv der Wassermetaphorik in vielen von Rists Videofilmen mit. Ihr Werk strotzt nur so von Wasserbildern und allen damit verbundenen Metaphern der Veränderlichkeit und der Veränderung: von den Swimmingpool-Aufnahmen in (ENTLASTUNGEN) PIPILOTTI'S FEHLER (1988) über die schwebenden und einander durchdringenden Körper von PICKELPORNO (1992) bis zur tiefblauen Meeres-Szenerie in SIP MY OCEAN.

Rists üppige, sich immer wieder verändernde Bildsprache vermittelt Sinnenfreude in zahllosen

PIPILOTTI RIST, (ENTLASTUNGEN)
PIPILOTTIS FEHLER, 1988,
Stills aus Videoband (12 Min.).

Varianten. Die überwältigende Sinnlichkeit von SIP MY OCEAN mit seiner mehrfachen Projektion und den halluzinogenen Spiegelungen erinnert an die Abgehobenheit im Sinnenrausch: an unverfälschte, grenzenlose, präödipale Freuden. Zu dieser Bilderwelt, die unwillkürlich mit dem Weiblichen in Verbindung gebracht wird, gehört die Vorstellung eines grenzenlosen Körpers mit zahlreichen, voneinander unabhängigen erotischen Zonen, kurz ein Körper im Vollbesitz seines Begehrens. Allerdings stört Rists unberechenbarer Gesang, in seiner ganzen Bandbreite von sanft lyrisch bis zu besessen schreiend, diese utopischen Träume ungetrübten Genusses. Schliesslich verlangt das Begehren immer ein «Anderes», eines, das der Verführung nachgibt oder auch nicht, das die Gunst erwidern kann oder nicht. Als Soundtrack zum entrückenden Zauber dieser Wasserwelt verleiht Rists Version von Isaaks Lied den Gefahren (und Freuden) des Begehrens Ausdruck; es wirkt auch, als ob jemand, angesichts der steigenden Fluten der Leidenschaft, versuchte, die Kontrolle zu behalten. «Sip my ocean» ist eine Einladung, an diesem Spiel von Begehren und Erfüllung teilzunehmen; gleichzeitig ist es aber auch eine Herausforderung, dem verhängnisvollen Sog zu widerstehen.

(Übersetzung: Susanne Schmidt)

PIPILOTTI RIST, (ABSOLUTIONS)
PIPILOTTI'S MISTAKES, 1988,
stills of video tape (12 min.).

1) Nach der Übersetzung von Peter Laneus, erschienen im Diogenes Verlag, Zürich 1966, Kapitel 10, «Der Mann des Meeres».
2) «Get Lost» wurde von Anneli Fuchs und Lars Gramberg organisiert, beides Kuratoren des Louisiana Museums; «NowHere» fand vom 15. Mai bis 8. September 1996 im Louisiana Museum of Modern Art in Humlebaek statt. Im Museum of Contemporary Art in Chicago wurde ebenfalls eine Version von SIP MY OCEAN gezeigt (2. 7. bis 25.8.1996); vgl. dazu den aufschlussreichen Essay von Dominic Molon im Katalog zur Ausstellung. Beide Museen haben SIP MY OCEAN in ihre Sammlung aufgenommen.
3) *Der Fluss stand in Flammen und nur du konntest mir helfen*
Seltsam, wozu die Sehnsucht leichtsinnige Menschen treibt
Nie hätte ich mir träumen lassen, jemanden wie dich zu finden
Nie hätte ich mir träumen lassen, jemanden wie dich zu verlieren
Ach, ich will mich nicht verlieben... in dich.
Chris Isaaks *Wicked Game* ist 1989 bei Warner Chappell Ltd. erschienen.

4)In ihrer Studie über die Performance-Arbeit von Frauen in den 60er und 70er Jahren, untersucht Amelia Jones die Polemik um Lust und Begehren in der zeitgenössischen Kunst. Sie führt die Forderung der Feministinnen, auf die Darstellung körperlichen Begehrens überhaupt zu verzichten, auf einen einflussreichen Artikel von Laura Mulvey aus dem Jahr 1975 («Visual Pleasure and Narrative Cinema») zurück, und sie vertritt die Auffassung, dass die feministische Weigerung jene Ausdrucksformen weiterzuführen, die bisher mit der männlichen Lust am Sehen assoziiert wurden, in Wirklichkeit die Bedeutung der Kunst all jener Frauen, die mit dem Körper arbeiten, übersah und immer noch übersieht. Vgl. dazu ihren Artikel «Postfeminism, Feminist Pleasures, and Embodied Theories of Art» in: *New Feminist Criticism, Art, Identity, Action,* hrsg. von Joanna Freuh, Cassandra L. Langer, and Arlene Raven, Harper Collins, New York 1994, S. 16–41.

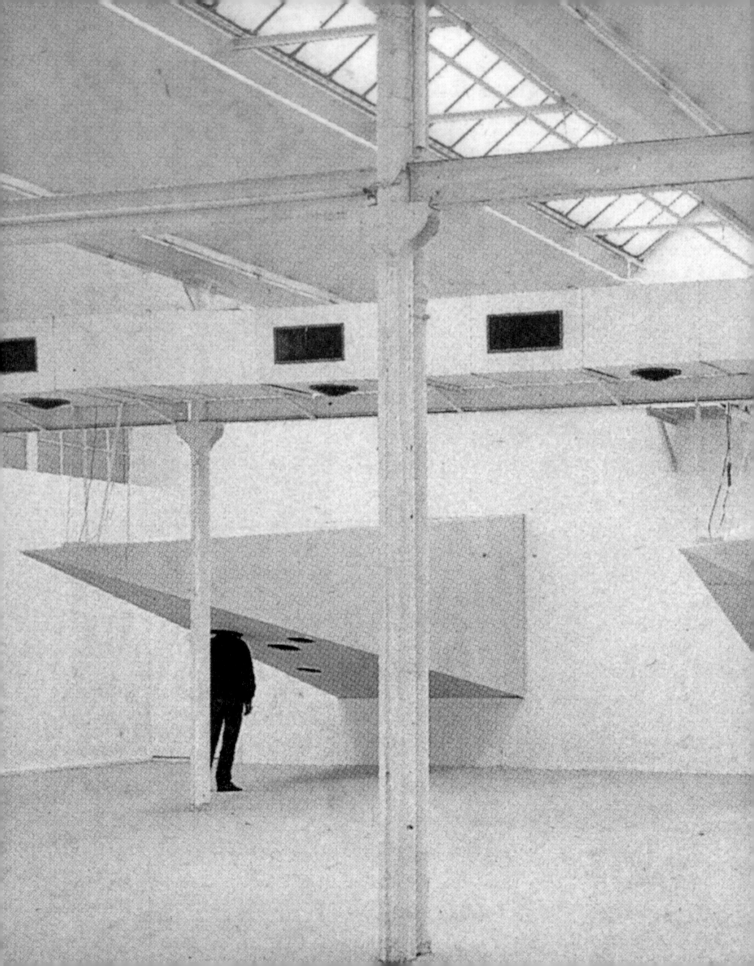

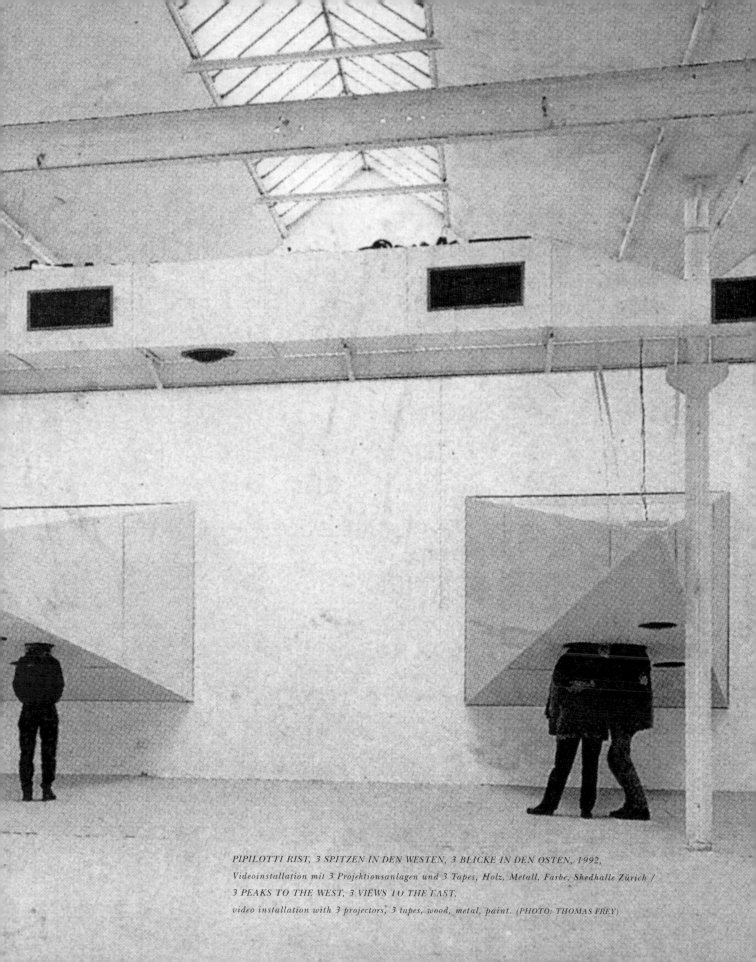

PIPILOTTI RIST, 3 SPITZEN IN DEN WESTEN, 3 BLICKE IN DEN OSTEN, 1992,
Videoinstallation mit 3 Projektionsanlagen und 3 Tapes, Holz, Metall, Farbe, Shedhalle Zürich /
3 PEAKS TO THE WEST, 3 VIEWS TO THE EAST,
video installation with 3 projectors, 3 tapes, wood, metal, paint. (PHOTO: THOMAS FREY)

PHILIP URSPRUNG

Pipilotti Rists
Fliegendes Zimmer

Wer vor dem Bankschalter im ostschweizerischen Buchs plötzlich aus der Warteschlange ausbrechen und weit weg fliegen möchte, nach Hause in die gute Stube oder noch besser hinaus in die weite Welt, der braucht nur den Blick zu heben – er wird nicht enttäuscht sein. Hoch oben in der Schalterhalle schwebt kopfüber die Einrichtung eines Wohnzimmers. Die einzelnen Requisiten wie Stuhl, Tisch, Teppich, Lampe, Globus, Gemälde usw. sind mit Stahlseilen fixiert und scheinen im Flug erstarrt zu sein. In einer Vitrine steht das Modell eines riesigen, rätselhaften Herzens. Und im obligaten Fernseher laufen Videoclips, deren Akteure die Mitarbeiterinnen und Mitarbeiter der Bank sind: Der zum Däumling geschrumpfte Direktor beispielsweise fliegt nach Büroschluss mit flatternder Krawatte und ausgebreiteten Armen wie Superman über die Einöden der Computertastaturen, die Abgründe von Büromöbeln und die Gebirgszüge aus Akten. Der Kassier nimmt statt Geldbündeln ein zappelndes Lamm entgegen, das ihm eine sparsame Kundin über den Bankschalter reicht. Der Lehrling hüpft übermütig, nur in Hose und Schlips gekleidet, durch ein blühendes Tulpenfeld. Eine Kreditkarte mutiert in der Hand der Buchhalterin zum Kaleidoskop, durch das die Welt als Folge bunter Farbschlieren gesehen wird. Und zwei elegante Anlageberater tummeln sich wie Satyr und Nymphe in den Wäldern über dem nebelverhangenen Rheintal.

Pipilotti Rist hat mit dieser Arbeit bereits zum zweitenmal das schwierige, im Lauf des 20. Jahrhun-

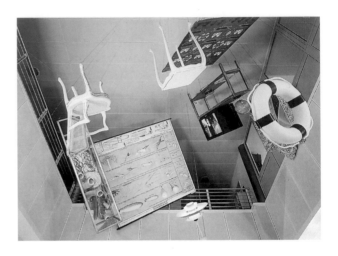

PIPILOTTI RIST, FLIEGENDES ZIMMER, 1995,
Videoinstallation mit Monitor, Laserdisk-Player, Ölbild, Objekten
und Möbeln, Schweizerische Bankgesellschaft Buchs SG /
FLYING ROOM, *video installation with monitor, laser-disc player,*
oil painting, objects and furniture, Swiss Banking Corporation,
Buchs, Switzerland. (PHOTOS: THOMAS CUGINI)

derts verkümmerte Medium der Kunst am Bau aufgegriffen.[1]) Anstatt die Angestellten als Sujets in Form eines Gruppenbildes zu fixieren oder ihnen eine bestimmte Art von Kunst aufzuzwingen, bezieht die Künstlerin sie in den erzählerischen Zusammenhang ihrer Kurzfilme ein, als Darsteller ihrer eigenen Phantasien und Halluzinationen. Das Resultat, ein Bild eines kollektiven Tagtraums im buchstäblich abgehobenen Ambiente eines kleinen Luftschlösschens, hält mühelos der trostlosen Umgebung der Buchser «Innenarchitektur» stand. Denn zum Tragen kommen weniger die objekthaften, an Ausstellungskontexte wie den weissen Museumskubus oder

PHILIP URSPRUNG ist Kunsthistoriker und unterrichtet am Institut für Geschichte und Theorie der Architektur (GTA) der Eidgenössischen Technischen Hochschule ETH, Zürich. Von 1990 bis Herbst 1996 war er Mitkurator der Kunsthalle Palazzo in Liestal, Schweiz. Er lebt in Zürich.

die Industrieruine gebundenen Eigenschaften der Kunst als deren dekoratives und spielerisches Potential. Die offene Struktur des Mobiliars lädt zum imaginären Verweilen ein, und der Rhythmus der Videoclips wird der zerstreuten Aufmerksamkeit des wartenden Publikums gerecht.

Das Zentrum der Installation bildet natürlich der Fernseher. Rists Einstellung zu diesem Gerät unterscheidet sich vom kulturpessimistischen Klagelied der «Reizüberflutung» ebenso wie von der neoliberalen Feier der «Kommunikationsgesellschaft». Sie schlüpft als Künstlerin sozusagen in die Rolle eines Kindes, für das der Fernseher eine Wunderkiste voller Versprechen ist. Schliesslich gehört sie selbst zur Generation der in den 60er Jahren Geborenen, die als erste das schnelle Altern der elektronischen Medien und der Hochtechnologie parallel zum eigenen Aufwachsen miterlebten und entsprechend eine besondere Sympathie für Maschinen entwickeln konnten. Ein vergilbtes Schulwandbild mit der «Geschichte des Menschenflugs» erinnert daran. Die Wahl dieser Rolle ermöglicht ihr als Künstlerin eine gewisse Distanz zum gegenwärtigen Diskurs zur «Videokunst», eine flexible, ironische Haltung sowie ein unbefangenes, experimentelles Arbeiten auf dem angestammten Terrain von Modernisten wie Nam June Paik, ihrem, wie sie ihn nennt, «medialen Grossvater»[2]). Die Situierung innerhalb einer fiktiven Kindheit erschliesst ausserdem ein schier unerschöpfliches Reservoir an Themen, Requisiten und Methoden. Die Assoziation des FLIEGENDEN ZIMMERS mit Erich Kästners Kinderbuch *Das fliegende Klassenzimmer*, die neugierige, scheinbar undisziplinierte Führung der Kamera und die bewusst grellbunte, an die Palette der 60er Jahre erinnernde Farbgebung stehen in diesem Zusammenhang.

Nicht nur das Spiel, auch die Dekoration gehört zu den Funktionen der Kunst, die im Lauf des Modernismus verdrängt worden waren und von deren neuerlichen Verfügbarkeit Pipilotti Rist profitiert. In ihren Händen wird der Fernseher zur Kristallkugel, in der sich die verschiedensten Dinge und Vorstellungen brechen und zerstreuen. Die Störungen des elektronischen Bildes, welche sie so virtuos provoziert und verformt, sind weniger als ideologiekritische Subversion des «Apparates» zu verstehen, son-

dern vielmehr als ein Festhalten jener Momente, in welchen die Flimmerkiste alle ihre Fähigkeiten entfaltet. Die schönsten Sequenzen der kurzen Filme sind denn auch diejenigen, in welchen die Kamera die Kontrolle verliert, ihre Aufnahmen wie schillernde Seifenblasen platzen und zu einem feinen Nebel zerstieben oder in welchen die einzelnen Farbfelder wie Magmaströme unmittelbar unter der physischen Oberfläche der Mattscheibe zu fliessen scheinen und sich das Dargestellte und die Darstellungsart – also abstrakte und figurative Repräsentationsarten – zu Arabesken verbinden.[3])

Und wofür steht das Herz, das fremd und geheimnisvoll in dem eklektisch zusammengewürfelten Wohnzimmer in seiner Vitrine steht? Pipilotti Rist meint, es könne vielleicht das «Gemüt» des Zimmers verkörpern. Dieses hatte bekanntlich im Modernismus ebensowenig zu suchen wie das Spiel und das Ornament. Adolf Loos hat es seinerzeit durch den Satz «Ich brauche keine Gemütlichkeit, gemütlich bin ich selber» ins Abseits verbannt. Dort steht es noch immer, seit bald hundert Jahren. Pipilotti Rist wäre die letzte, die «es» – was immer darunter zu verstehen ist – voreilig aus seinem Gehäuse holen, das schützende Glas zerbrechen und die für die Kunst so fruchtbare ästhetische Distanz aufheben würde. Aber sie gehört zu den Mutigen, welche es aus dem Dunkel hervorzuholen gewagt haben, welche die Scheiben putzen, es zeigen, es immer neu und immer näher umkreisen.

1) 1994 hat Pipilotti Rist im Ausbildungszentrum des Schweizerischen Bankvereins in Basel unter dem Titel KAFFEEMEER eine Cafeteria gestaltet. Beim Bedienen des Kaffeeautomaten werden die Benutzer mit kurzen Videoclips belohnt, die aus zwei Monitoren über den Armaturen sprudeln. Die Installation FLIEGENDES ZIMMER im Neubau der Filiale Buchs (St. Gallen) der Schweizerischen Bankgesellschaft wurde 1995 auf Einladung der Generaldirektion dieser Bank ausgeführt.
2) Zitiert in: Konrad Bitterli, «I'm Not the Girl Who Misses Much oder Lotti im globalen Dorf», in: *I'm Not the Girl Who Misses Much. Pipilotti Rist, 167 cm*, Ausstellungskatalog St. Gallen, Graz, Hamburg, Oktagon Verlag, Stuttgart 1994, o. S.
3) Auf die Methode der Unmittelbarkeit und «Oberflächlichkeit» als spezifisch feministische Kritik einer Distanz haltenden modernistischen Kunsttradition in Judy Chicagos Arbeiten der 70er Jahre wies jüngst Amelia Jones hin: «The Sexual Politics of ‹Dinner Party›», in: *Judy Chicago's «Dinner Party» in Feminist Art History*, hrsg. von Amelia Jones, UCLA at the Armand Hammer Museum of Arts and Cultural Center and University of California Press, Los Angeles und Berkeley 1996, S. 82–118.

Pipilotti Rist

PIPILOTTI RIST, DAS ZIMMER, 1994, Videoinstallation mit 10 Playern und Bändern, einem Fernseher, überdimensioniertem Sofa, Sessel, Lampe, Bild und Audioboxen in den Sessellehnen / THE ROOM, video installation with 10 players and tapes, TV-set, oversize sofa, armchair, lamp, painting and audio boxes in the arms of the chair. (PHOTO: HELGE MUNDT)

Pipilotti Rist's

PHILIP URSPRUNG

Flying Room

In case you should ever be waiting in line in a bank in Buchs, Switzerland, and are suddenly overcome by the wish to skip it all and fly away—home to a comfortable living room or better yet, out into the great wide world—all you have to do is look up at the ceiling; you will not be disappointed. High up in the bank lobby, living-room furniture has been suspended upside down: chairs, table, rug, lamp, globe, painting, all hanging from steel cables and looking as if they had been arrested in flight. In a display case there is the model of a huge, enigmatic heart. And on the inevitable video-monitor, we see video-clips whose actors are bank employees. After banking hours, the bank director, shrunk to Tom-Thumb-size, his tie blowing in the wind and his arms spread out like Superman, sails over a computer-keyboard wasteland, office furniture abysses, and mountain ranges of files. The teller finds herself saddled with a wriggling lamb, handed over by a customer in lieu of bundles of bills. The trainee, wearing only trousers and a tie, hops exuberantly across a field of tulips in bloom. The bookkeeper is holding a credit card that mutates into a kaleidoscope through which the world is seen as a series of colorful streaks. And two elegant financial advisers, satyr and nymph, cavort together in woods above the fog-ridden Rhine valley.

For the second time in her career, Pipilotti Rist has tackled the difficult medium of art in public spaces, a field that has atrophied in the course of the twentieth century.[1] Instead of immortalizing the employees in the form of a group photo, or forcing a

PIPILOTTI RIST, KAFFEEMEER, 1994, *Interaktive Video-installation mit Kaffeeautomaten, Monitörchen, Laserdisk-Playern und Zufallsgeneratoren, Schweiz. Bankverein, Basel /* SEA OF COFFEE, *interactive video installation with coffee automats, little monitors, laser-disc players and a random-generator.* (PHOTO: LILLI KOHL)

certain kind of art on them, the artist incorporates them in the narrative context of her film clips as actors in their own fantasies and hallucinations. The outcome—a collective daydream in the literally elevated ambience of a castle in the air—effortlessly holds its own in the rather bleak interior architecture of the bank in Buchs. It does not foreground the object-like quality of art, which depends on exhibition venues such as the white cube or the industrial ruin, but instead exploits its decorative and playful potential. The open-ended structure of the furnishings encourages imaginative reverie, and the rhythm of the video-clips dovetails with the wandering attention of the waiting public.

PHILIP URSPRUNG is an art critic who teaches at the Institute of Architectural History and Theory at the Federal Institute of Technology, Zurich, and co-curator of Palazzo, a new exhibition space for contemporary art in Liestal, Switzerland. He lives in Zurich.

PIPILOTTI RIST, FLIEGENDES ZIMMER, 1995, Videostill aus dem Installationstape, die Mitarbeiterinnen der Bank in Aktion / FLYING ROOM, video still of installation tape, the bank's employees in action.

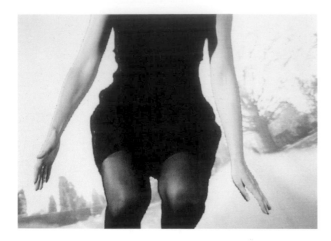

The heart of the installation is, of course, the television set. Rist does not join in the pessimistic chorus that bemoans "sensory overkill," nor in the neoliberal celebration of a "new communications society." As an artist, she simply slips into the role of a child for whom the TV machine is a magic box full of promise. After all, Rist herself belongs to the generation of those born in the sixties, who were the first to experience the swift aging of electronic media and high technology as they themselves grew up, and thus felt a special sympathy for machines. A yellowed educational poster on "The History of Human Flight" reminds us of this. Rist's choice of role allows her to sidestep the current discourse on "video art," to take a flexible, ironic stand, and to engage in uninhibited experimentation on the time-honored terrain of modernists like Nam June Paik, "our medium's grandfather."[2] Her placing it within the fiction of childhood also provides a virtually inexhaustible reservoir of themes, properties, and methods. Among them is the association with Erich Kästner's children's book, *The Flying Classroom*; the curious, seemingly undisciplined camera work; the intentionally garish, sixties palette of colors.

Both play and ornament belonging to the functions of art have been suppressed in the wake of modernism; their renewed availability is now exploited by Pipilotti Rist. In her hands, the television set becomes a crystal ball in whose facets untold things and ideas are refracted and projected. Her virtuosic disruption and distortion of the electronic image are not to be read as ideological critique and subversion but rather as a grasp of the very moments in which the medium unfolds its greatest potential. The most beautiful sequences in her film clips are, indeed, those in which the camera loses control so that her shots burst like iridescent soap bubbles into the finest mist, or when fields of color, streams of magma seem to flow directly under the physical surface of the screen, until, finally, representation and the mode of representation—that is, abstract and figurative subject matter—form arabesques.[3]

But what does the heart stand for, deposited so strangely and mysteriously in its glass display case into the eclectic jumble of the living room? Pipilotti Rist suggests that it might embody the room's "soul," which, along with play and ornament, has also been given the cold shoulder by modernism. Adolf Loos's comment, "I don't need soul, I have one of my own," clearly relegated it to oblivion, where it has been cellared for almost a hundred years. Pipilotti Rist would be the last one to precociously remove it—whatever "it" means—from its casing; she would be the last one to break the protective glass covering and bridge the aesthetic distance that has been so fruitful for art. But she does belong to the courageous few who dare to bring it out into the open again, polish the glass, and show it, moving in on it in ever new and closer circles.

(Translation: Catherine Schelbert)

1) In 1994, in the training center of the Swiss Banking Corporation in Basel, Pipilotti Rist designed a cafeteria entitled COFFEE LAKE. When diners turn on the coffee machine, they are rewarded with short video clips burbling out of two monitors above. The installation FLYING ROOM in the new branch of the Union Bank of Switzerland in Buchs, Canton of St. Gall, was made at the invitation of the bank's executive management.
2) Quoted in: Konrad Bitterli, "I'm Not the Girl Who Misses Much or Lotti in the Global Village" in *I'm Not the Girl Who Misses Much. Pipilotti Rist, 167 cm*, ex. cat., St. Gall, Graz, Hamburg (Stuttgart: Oktagon, 1994), n.p.
3) In her essay on "The Sexual Politics of 'The Dinner Party'" Amelia Jones comments on immediacy and superficiality as a specifically feminist critique of the detached modernist tradition of art in Judy Chicago's works of the seventies, in: Amelia Jones, ed., *Judy Chicago's "Dinner Party" in Feminist Art History* (Los Angeles and Berkeley: UCLA at the Armand Museum of Arts and Cultural Center and University of California Press, 1966), pp. 82–118.

Risikofaktor Rist

Wenn Träume

wie sterbende Fische

zucken

MARIUS BABIAS

Spät aufgestanden, Samstagnachmittag, draussen findet das Wetter statt. Der Schlaf entweicht allmählich aus dem Körper, die Träume zucken wie sterbende Fische, zum Einkaufen keine Lust. Man lauscht dem eigenen Atmen, justiert den fahrigen Blick und summt ein Lied, das zur Tonlawine anschwillt, in deren Gefolge physiologische Partikel, die das Strandgut des Psychosozialen mit sich tragen, aufgewirbelt und endlich zum Wahrnehmungsmosaik ornamentiert werden. Aus Situationen der Selbstvergewisserung wie dieser, wenn das kurzzeitig ausgeblendete Bewusstsein von geringsten Reizen reaktiviert und zurück in die Selbstkontrolle überführt wird, filtert Pipilotti Rist ein filmisches Anwendungsmodell, wie in I'M NOT THE GIRL WHO MISSES MUCH (1986): Die Protagonistin – in ihren Videos oft Pipilotti selbst – tanzt und singt den leicht abgewandelten Refrain von John Lennons Song *Happiness is a Warm Gun*. Die Körperbewegungen rhythmisieren den Gesang, wie umgekehrt das Lied eine Parodie auf den Tanz ist. Bild, Ton und Bewegung geraten aus der Balance und erzeugen einen psychotischen

Treibhauseffekt. Der Tanz steigert sich zum hysterischen Zappeln, je schneller das Bild abgespult wird, und gefriert zur Zeitlupe, je langsamer die Bildgeschwindigkeit wird. Die Darstellerin erscheint in Abhängigkeit von der Technik und wird zum Reflex des Mediums. Ihre zur Schau gestellten weiblichen Attribute – knallrot geschminkter Mund und nackter Busen – lösen sich aus dem grotesk verzerrten Körper und flattern geisterhaft durch das Bild. Der analog zum Bild beschleunigte oder verlangsamte Ton unterstreicht den Vorgang der Selbstauflösung. Die Stimme geht in schrille Unverständlichkeit über. Was als flotter Musik-Clip begann, endet als Bildsalat mit Geräuschkulisse. I'M NOT THE GIRL WHO MISSES MUCH – diese formelhaft wiederholte Refrainzeile verwandelt sich in einen monotonen Hilferuf, der die Zuschauerinnen und Zuschauer aus dem passiven Konsum herausreisst.

Die Kurzfilme und Videos von Pipilotti Rist geben dem an die Grenzen der digitalen Technologie stossenden *Expanded Cinema* verloren geglaubte Aktualität zurück. Die aus den Materialbedingungen und der Medienspezifität abgeleitete Emanzipation von Video und Super 8 als eigenständige Kunstformen war kurzzeitig wieder in Frage gestellt worden, da Bilder und Töne fortan in einer gemeinsamen digitalen Form grammatikalisiert und an unterschied-

MARIUS BABIAS ist Autor und Kunstjournalist und lebt in Berlin. Er ist Herausgeber von *Im Zentrum der Peripherie. Kunstvermittlung und Vermittlungskunst in den 90er Jahren*, Berlin/ Basel 1995.

liche Ausgabegeräte weitergegeben werden konnten. Der klassische Experimentalfilm zeichnete sich dadurch aus, dass die aus den spezifischen Eigenschaften des Mediums konstruierte ästhetische Erfahrung in einen Rezeptionsbereich verlagert wurde, in dem «das Kunstwerk eine Komponente der in Entwicklung begriffenen Welt ist und nicht so sehr deren passive Reflexion»[1]. Die von Medientheoretikern wie Vilém Flusser prognostizierte Vorherrschaft der ideographischen Bilder über das Alphabet («Die digitalen Codes synthetisieren etwas vorher bereits völlig Durchkritisiertes, Durchkalkuliertes. Kritik im alten Sinn würde bei diesen Bildern nichts anderes herausfinden können, als dass sie aus Elektronen komputiert sind.»)[2] ist deshalb nicht eingetreten, weil sich die Digitaltechnologie zwar auf Produktionsprozesse wie den Videoschnitt und auf Animationen, die man gemeinhin Computerkunst nennt, aber nicht so sehr auf das Stabilitätskonzept des Experimentalfilms ausgewirkt hat – auf die Konfrontation mit dem Filmischen als körperliche Erfahrung, auf die Kritik symbolischer Systeme im Kontext der realen Welt und auf die Anordnung der realen Welt als Interpretation. Das *Expanded Cinema* ist angesichts der symbolischen Instabilität von Unterhaltungskino, Privat- und Digitalfernsehen, die nur noch den Widerspruch zur Wirklichkeit abzubilden vermögen, wieder aktuell geworden.

Die Pioniere der Videokunst, die sich aus der Fernsehkultur entwickelte, hatten ein Problem: die fehlende Tradition. Dass das Fernsehen als Abfallprodukt der V2-Raketenversuche in Peenemünde entstanden war, brachte keine Credits ein, ebensowenig die Tatsache, dass das Fernsehen – als eine Art visuelle Waschmaschine des Wirtschaftswunders – dem Alltagsgebrauch entstammte. Der an die Kunst gestellte Exklusivitätsanspruch und der Glaube an einen progressiven Kunstbegriff, der stets eine formale Erneuerung mit sich tragen sollte, verhinderten mangels historischer Vorläufer lange Zeit die Anerkennung des Videos als Kunstform. Mittlerweile unterhält jedes Museum eine Video-Abteilung. Pipilotti Rist, die zunächst Zeichentrickfilme drehte und Bühnenbilder für Musik-Bands baute (was ihre «Clip»-Ästhetik entscheidend prägte), profitiert von der allgemeinen Akzeptanz des Videos als eine Art Ersatz-

medium des Tafelbildes, vor allem aber von dessen Einsatzmöglichkeit in raumgreifenden Installationen. Der spezifische Appeal des Videos, wie ihn Rist einsetzt, absorbiert zudem Schattendisziplinen wie Musik-Clips, Commercials und Trailer. Rist ergänzt ihre am *Expanded Cinema* geschulte Bildsprache um einen zeittypischen Aspekt, den Unterhaltungswert. Das Rhema der Kunst ist zu ihrem Thema geworden und mündet in die Selbstinszenierung, die sowohl die Produktionsmittel (Rist ist Produzentin, Regisseurin, Kamerafrau und Hauptdarstellerin in einem) als auch die existentielle Selbstvergewisserung als soziales Subjekt, Frau und Künstlerin umfasst.

Die im rasanten Tempo geschnittenen und in poppige Farben getauchten Videos vermessen das psychosoziale Feld zwischen Bild und Text, Anarchie und Ordnung, Erotik und Technik. Risikofaktor Rist: Weil sie das alphabetische Prinzip den Erosionen eines Denkens in Bildern aussetzt, geht der Klassenkampf zwischen Begriff und Bild zugunsten der Bilder aus, ein Prozess der visuellen Alphabetisierung. Ihre Videos konstruieren – in prägnanter Abweichung von der Bildsprache der Massenmedien – ein intimes Bildreservoir des Emotiven, in dem Kommunikationsformen und Gefühle des Alltagslebens gespeichert sind. Wer richtig liest, erlebt eine kurzzeitige Drogenerfahrung in Bildern. Die Konfrontation mit dem Filmischen als körperliche Erfahrung wird durch die installative Präsentation im Inneren einer Holzkonstruktion, die nur vier Zuschauerinnen oder Zuschauer zulässt, unterstützt. Man ist aber nicht nur mit dem Filmischen, sondern auch mit der eigenen Situation des Schauens konfrontiert, mit sich selbst als Empfänger und Generator der Sendung zugleich.

Rist streift die Konstruktion der Geschlechter am Rande des Nervenzusammenbruchs, in einem Bereich, wie sie es nennt, der «angewandten Frauenkultur»: Schminken, Schmücken, Verhüllen. Allerdings kommen sie nicht als Vehikel geschlechterspezifischen Rollenverhaltens zum Einsatz. Rists Selbstinszenierung markiert die Distinktion des Starkults aus der Perspektive der Fans. Jede und jeder kann ein kleiner Star werden; diese naive Losung übt auf eine von den Medien kontrollierte Gesellschaft grossen Reiz aus. Rist greift ihn oppositionell auf:

Ihre Konstruktion des Selbst ist zwar an allgemeinen Geschmacksvorgaben und Schönheitsidealen ausgerichtet, wird aber zum filmischen Delirium des Zweckmässigen verzerrt, der eigene Körper als Prisma des Personality-Appeals: wenn Selbstinszenierung, dann in der Opposition des Psychotischen.

Leslie A. Fiedler hat in seinem berühmten Aufsatz «Cross the Border – Close the Gap», der bezeichnenderweise zuerst im *Playboy* erschien, die Verschmelzung von Populärkultur und Kunst gefordert: *Aus der Welt des Jazz und der Rockmusik, aus Zeitungsschlagzeilen und politischen Karikaturen, aus alten Filmen, die durch ihr Wiedererscheinen im Fernsehen Unsterblichkeit erhalten, aus dem idiotischen Geschwätz, das aus den Autoradios dringt, erwachsen neue Antigötter und Antiheroen.*[3] Populärkultur und Kunst sind zwar nicht deckungsgleich geworden, aber sie haben sich in den letzten Jahren angenähert – bis hin zum Missverständnis. Die Kritik symbolischer Systeme – wie der Film eines ist – im Kontext der realen Welt stumpft am Widerspruch ab, mit einem analogen Massenmedium wie dem Video nur die Minderheit des Kunstpublikums zu erreichen. Anleihen aus der Populärkultur machen die Kunst zur sozialen Diaspora.[4] Die Kunst – im kulturellen Überbau für die ästhetische Wegbereitung gesellschaftspolitischer Entwicklungen zuständig – übernimmt meist freiwillig die Aufgabe, die jeweils herrschende Interpretation der Welt abzubilden. Ein Film aber, der die Schrauben dieser Mechanik lockert und die Ventile zischen lässt, beginnt so: Samstagnachmittag, die Träume zucken wie sterbende Fische, man lauscht dem eigenen Atmen und summt ein Lied, vielleicht John Lennon, vielleicht LL Cool J.

1) Malcolm Le Grice: «Mapping im Multi-Space – Vom Expanded Cinema zur Virtualität», in: Sabine Breitwieser (Hrsg.): *White Cube/Black Box*, EA-Generali Foundation, Wien 1996, S. 242.
2) Vilém Flusser: *Die Schrift. Hat Schreiben Zukunft?*, Göttingen 1989, S. 149.
3) Leslie A. Fiedler: «Überquert die Grenze, schliesst den Graben!», in: Wolfgang Welsch (Hrsg.), *Wege aus der Moderne. Schlüsseltexte der Postmoderne-Diskussion*, Weinheim 1988, S. 71.
4) Günther Jacob: «Kunst, die siegen hilft! Über die Akademisierung des Pop-Diskurses: Kritische Betrachtungen zwischen High & Low Culture», in: *Kunstforum International*, Bd. 134, Mai–September 1996, S. 133.

PIPILOTTI RIST, (ENTLASTUNGEN) PIPILOTTIS FEHLER, 1988, Videotape (12 Min.), Videostill aus der «Van-Gogh-Serie» /
(ABSOLUTIONS) PIPILOTTI'S MISTAKES, video tape (12 min.), still from the «Van Gogh» series.

103

The Rist Risk Factor

When Dreams
Twitch Like Dying Fish

MARIUS BABIAS

Saturday afternoon. You rise late. Outside, the weather is happening. Sleep gradually drains away from your body; dreams twitch like dying fish; shopping does not appeal. You listen to your own breathing, focus your straying gaze, and hum a song that swells into an avalanche of sound. In its wake, a trail of physiological particles, laden with the flotsam and jetsam of psychosocial life, is whirled aloft and settles decoratively into a perceptual mosaic. From moments of self-definition like this, when the consciousness, having been briefly obliterated, is reactivated by minute stimuli and restored to full control, Pipilotti Rist distills a cinematic model—as in I'M NOT THE GIRL WHO MISSES MUCH (1986). The protagonist—who in Rist's videos is often the artist herself—dances and sings the (slightly modified) refrain from John Lennon's song, *Happiness is a Warm Gun*. The bodily movements supply the rhythm for the singing, and at the same time the song is a parody of the dance. Image, sound, and movement are tipped off-balance to generate a psychotic greenhouse effect. The dance builds into an hysterical wriggle as the picture rolls faster and faster, and it freezes into slow-motion as the picture speed drops. The performer has become dependent on technology; she has turned into a reflection of her medium. Her displayed female attributes—bright red lipstick and bare breasts—detach themselves from her grotesquely distorted body and flutter, ghostlike, across the screen. The sound, which speeds up and slows down in sync with the picture, underscores the process of self-dissolution. The voice skids into shrill incomprehensibility. What began as a jaunty pop video ends up as a pictorial mess with sound effects. I'M NOT THE GIRL WHO MISSES MUCH: this formulaic, repetitive refrain turns into a monotone cry for help, forcing the viewer out of the role of a passive consumer.

Pipilotti Rist's short films and videos restore to the "Expanded Cinema," as it reaches out to the frontiers of digital technology, an immediacy and relevance that seemed lost. The emancipation of video and Super 8 as autonomous, technologically defined, and medium-specific art forms was momentarily undermined by the discovery that pictures and sounds could be incorporated within a single digital grammar and routed to a variety of different output devices. Classic experimental film was distinguished by the

MARIUS BABIAS is a writer and art journalist who lives in Berlin. He has edited a book on the presentation of art in the 1990s: *Im Zentrum der Peripherie. Kunstvermittlung und Vermittlungskunst in den 90er Jahren* (Berlin and Basel, 1995).

way in which it took the aesthetic experience based on the specific properties of the medium and transposed it into an area of viewer response in which "the work of art becomes part of the evolving world, rather than its passive reflection."[1]

Media theorists such as Vilém Flusser have predicted that ideographic images will prevail over the alphabet. "The digital codes synthesize something already entirely worked through, critically and mathematically. Criticism in the old sense would get nothing out of these images beyond the fact that they are made by computer out of electrons."[2] This prediction has not come true, because, although digital technology has affected such production processes as video editing and animation (which are now commonly classified as Computer Art), the central concept of the experimental film has been left more or less intact. It still confronts the viewer with the filmic essence as a physical experience, it still sets out a critique of symbolic systems within a real-world context, and it still classifies the real world as interpretation. The symbolic instability of mainstream cinema and of cable TV, which can no longer depict anything but the contrast between themselves and reality, has made the Expanded Cinema topical and relevant once more.

Video art evolved out of the culture of television—with the result that its pioneers had a problem: the absence of a tradition. They could hardly count among its credits the fact that television evolved as a by-product of the V2 rocket experiments at Peenemünde—or the medium's everyday, utilitarian history in the years of Germany's Economic Miracle, when it was a kind of visual washing machine. The recognition of video as an art form was long delayed by the assumption that art had to be exclusive, and by the belief in a progressive definition of art which was inseparable from perpetual formal innovation. Now, by contrast, every museum maintains a video department. Pipilotti Rist, who started out making animated cartoons and building stage sets for bands (which had a defining influence on her "pop video" aesthetic), exploits the general acceptance of the video medium as a kind of substitute for the easel painting—and, above all, its role as a component of spatial installations. The specific appeal of video, as

employed by Rist, also incorporates such shadow disciplines as the pop video, the television commercial, and the trailer. Here, Rist's idiom, schooled in Expanded Cinema, receives a highly contemporary infusion of entertainment value. The rheme of art has become her theme; hence the self-dramatization that encompasses not only the means of production (Rist herself is producer, director, camera operator, and theatrical lead) but also her existential self-definition as a subject within society, as a woman, and as an artist.

Edited to a cracking pace, steeped in Pop colors, the videos chart the psychosocial field that spans picture and text, anarchy and order, eroticism and technology. The Rist Risk Factor is this: she erodes the alphabetical principle by thinking in images, and so the class conflict between concept and picture is won by the picture in a process of visual alphabetization. Forcefully deviating from the mass-media "image," her videos construct an intimate reservoir of emotive imagery that stores both communicative forms and everyday emotions. Rightly read, they deliver a brief drug experience in pictures. The viewer's confrontation with film as a bodily experience is reinforced by the installation, housed in a wooden construction with room for just four viewers at a time. The confrontation is not only with film but with one's own situation as a viewer: with oneself as simultaneously the receiver and the source of the transmission.

Rist touches on gender constructs in an area on the brink of nervous breakdown—the area of what she calls "applied feminine culture": makeup, self-adornment, masquerade. Not that these are used as vehicles of gender-specific role-playing. Rist's self-imagery is all about the fan's-eye view of the star cult. Female or male, anyone can become a star of sorts— a naive slogan that has an enormous appeal in a media-controlled society. Rist picks up on this and confronts it: Her construction of self refers to generally accepted givens of taste and ideals of beauty, but is distorted into a delirious filmic travesty of its function—"personality appeal" refracted through the prism of her own body. If this is self-dramatization, it takes place in the alternative world of the psychotic.

In his celebrated essay, "Cross the Border—Close the Gap"—which, significantly, first appeared in

und 3 in Handtaschen eingelassenen LCD-Monitörchen, 6 Players, 6 Tapes, Metallstelen, Samtkissen, Kabel, programmierbare Discolichtanlage, Neue Galerie am Joanneum, Graz, 1995 / video installation with 6 little LCD monitors, 3 of them installed in sea shells, 3 in handbags, 6 players and tapes, metal pillars, velvet cushions, electric wiring and programmable disco light equipment.

PIPILOTTI RIST, BLUTCLIP, 1994, Video (4 min.).

Playboy—Leslie A. Fiedler called for a merger between popular culture and art: *Out of the world of Jazz and Rock, of newspaper headlines and political cartoons, of old movies immortalized on T.V. and idiot talk shows carried on car radios, new anti-Gods and anti-Heroes arrive...*[3] Popular culture and art have not actually become identical, but over the past few years they have drawn closer, to the point where misunderstandings arise. The critique of symbolic systems—which is what films are—within a real-world context is blunted by the anomaly that a mass-medium analog such as video reaches only a minority art public. Borrowings from popular culture turn art into a social diaspora. Art—a part of the cultural superstructure which has the responsibility for aesthetically paving the way for sociopolitical change—most

often voluntarily assumes the task of recording the currently accepted interpretation of the world. But one film that loosens the nuts and bolts of this mechanism, and sets the valves hissing, begins like this: Saturday afternoon; dreams twitch like dying fish; you listen to your own breathing and hum a song, maybe John Lennon, maybe LL Cool J.

(Translation: David Britt)

1) Malcolm Le Grice, "Mapping in Multi-Space—Vom Expanded Cinema zur Virtualität" in: Sabine Breitwieser, ed., *White Cube/ Black Box* (Vienna: EA Generali Foundation, 1996), p. 242.
2) Vilém Flusser, *Die Schrift. Hat Schreiben Zukunft?*, Göttingen 1989, p. 149.
3) Leslie A. Fiedler, "Cross the Border—Close the Gap," first published in *Playboy* (December 1969), reprinted in: *Cross the Border—Close the Gap* (Essays) (New York: Stein and Day, 1972), pp. 81–82.

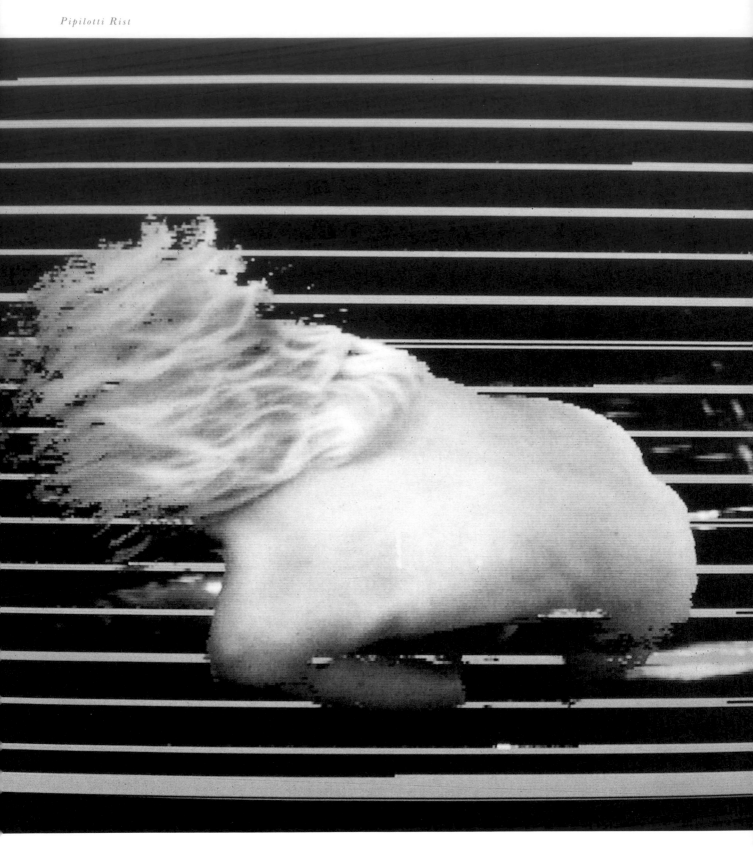

PIPILOTTI RIST, SELBSTLOS IM LAVABAD, 1994, Videostill des Installationstapes /
SELFLESS IN THE LAVA BATH, video still of installation tape.

Shooting Divas

PAOLO COLOMBO

Am Anfang von SHOOTING DIVAS, der bisher grössten Produktion von Pipilotti Rist, standen zwei Texte der Künstlerin und zwei Kompositionen von ihr und Andreas Guggisberg. Im Centre d'Art Contemporain in Genf bot sich dann – von Ende Mai bis Ende September 1996 – die Gelegenheit zur Realisierung des ganzen Projektes, in Form einer zweiteiligen Ausstellung. Deren Kern bildete die – von der Künstlerin sorgfältig inszenierte – Interpretation der beiden Songs durch zehn speziell ausgewählte Sängerinnen, eben die im Titel genannten «Divas».

Die Ausstellung «Shooting Divas» bestand aus zwei zeitlich aufeinanderfolgenden Abschnitten: Auf eine *Work in progress*-Phase folgte eine Video-Installation. Der erste Teil (28. Mai bis 8. Juni) bestand aus den öffentlichen Dreharbeiten für zehn Videos. Jeden Tag wurde ein Video gedreht, das die Interpretation eines Liedes durch eine der zehn Diven aufzeichnete. Gleichzeitig filmten drei Assistenten und Assistentinnen der Künstlerin das anwesende Publikum und bezogen es so – in einer Doppelrolle als Voyeur und Darsteller – in den fortschreitenden Arbeitsprozess mit ein. Die Arbeit am Mischpult erfolgte jeweils sofort nach Drehschluss, einmal öffentlich, tagsüber, manchmal am Abend, oder auch bis in die Nacht hinein. Der Geist dieses *Work in progress* war gemeinschaftlich interaktiv und schloss die kleine perfekt eingespielte Equipe der Künstlerin ebenso mit ein wie die Sängerinnen, die Angestellten des Centre d'Art Contemporain und das Publikum.

Die Video-Installation (9. Juni bis 29. September), deren Rohmaterial im Laufe der ersten zwei Arbeitswochen täglich um das jeweils neu gedrehte Material gewachsen war, wurde nun von der Künstlerin aufgebaut. Dazu gehörten die für die Dreharbeiten verwendeten szenischen Ausstattungselemente, die un-

verändert im Raum stehenblieben, sowie eine «rote Zone», die ihren Namen dem dort plazierten übergrossen roten Sofa und einem ebensolchen Lehnstuhl verdankte. In dieser Zone standen gegenüber von Lehnstuhl und Sofa am Boden zehn Videogeräte, auf denen je einer der zehn Filme lief. Das Publikum konnte mit einer Wahltaste den zum ausgewählten Videoband passenden Soundtrack einschalten. Ein weiterer Monitor vor einer Esszimmer-Szenerie zeigte ungeschnittenes Material von den gemeinsamen Mahlzeiten, einem täglichen Ritual, das zum *Work in progress* gehört hatte und an dem auch das Publikum teilgenommen hatte. Am Eingang schliesslich zeigte ein Monitor das ungeschnittene Material mit den Zuschauerinnen und Zuschauern, die beim Besuch der Ausstellung während der Dreharbeiten gefilmt worden waren.

Die Settings selbst waren bewusst einfach gehalten und wirkten provisorisch; sie waren grell bemalt und konnten leicht verändert und transportiert werden. Sie spiegeln Pipilotti Rists Ästhetik (wie auch die Kameraführung, die absichtlich knapper ist als in früheren Arbeiten) und entsprechen der Fabrikatmosphäre, in der gedreht wurde. Das natürliche Licht im Raum dominierte, ergänzt durch einige Scheinwerfer und leicht verändert durch farbige Folien an den Fenstern. In der definitiven Installation fehlten lediglich die technischen Apparate, etwa die Mischpulte für Bild und Ton, die entfernt wurden, um die Szenerien, in denen gedreht worden war, besser zur Geltung zu bringen.

Zum Verständnis des ganzen, komplexen Werkes ist es wichtig, seine Struktur genau zu analysieren. Die syntaktische Zweideutigkeit des Titels ist programmatisch. Es bleibt unklar, ob die «Divas» Subjekt oder Objekt sind, und auch «shooting» ist mehrdeutig, kann «schiessen» meinen und «filmen». Auch der Ausdruck «shooting stars» klingt an, vielleicht eine Anspielung auf den Status der Sängerin/

PAOLO COLOMBO ist Kunstkritiker und Direktor des Centre d'Art Contemporain in Genf.

Schauspielerin und ein Hinweis auf das Kurzlebige, das im Begriff des *Work in progress* enthalten ist: eine zeitlich begrenzte Form des Kunstwerks, die aber gerade in ihrer Begrenzung den lichtesten und faszinierendsten Augenblick zu erfassen vermag. Die zeitliche Begrenzung des Prozesses wird also bereits im Titel angesprochen, aber er vermittelt auch eine Vorstellung von dem Glanz, der Tragik, ja der Ironie, die jeder Selbstdarstellung und besonders dem traditionellen Rollenbild der Diva innewohnt. Insofern der Titel ein geschlechtsspezifisches Rollenbild anspricht, kann er auch als Hommage an die Frau verstanden werden, und im besonderen als Hommage an die zehn Frauen, welche die beiden Lieder voll Eigensinn, Leidenschaft und ganz ihren musikalischen Neigungen entsprechend interpretieren.

Das eine der beiden Lieder aus SHOOTING DIVAS, «Watermelon», ist schneller und mehr *upbeat*, das andere, «Swan», ist langsamer. Sie sind die beiden Pole eines breiten emotionalen Spektrums. Das erste ist eine Zelebration des Körpers und des Selbst, eine Hymne der Lebensbejahung:

Where it smells of shit
it smells of life
We could choose not to shit
not to open the asshole
but we choose to shit

It's a flower, it's sunshine
it's everything you want…

Das andere ist zugleich eine Beschwörung der Liebe und eine Klage, voll von jener Melancholie, die mit der körperlichen und gefühlsmässigen Hingabe einhergeht:

The blood of your shaving wounds
let me sip it like holy water

Your penis around my neck
like a necklace of diamonds

My boy, my horse, my dog
my man, my diva, my swan…

Beide Lieder enthalten eine klare Aussage; sie stehen für einen Akt der Selbstentblössung, der zwar in wenigen einfachen Zeilen daherkommt, hinter denen sich jedoch ein emotional bestimmter, psychischer Automatismus verbirgt. Diese Konstellation bietet den Sängerinnen einen fruchtbaren Boden, auf dem sie ihre persönliche Interpretation aufgrund ihrer eigenen Erfahrungen und Neigungen entwickeln können. Der Vielfalt dieser Interpretationen entspricht wiederum die Virtuosität, mit der Pipilotti Rist – mittels Kamera und Mix – die Töne und Bilder in neuer Vielfalt ordnet. Sie schneidet dabei die extremsten Stimmresonanzen der «Divas» heraus und kombiniert sie mit Bildern, die sie ihrem eigenen raffinierten und sinnlichen Repertoire entnimmt.

Die Frage nach dem Feminismus im Werk von Pipilotti Rist, die von der Kritik immer wieder aufgeworfen wird, kann für SHOOTING DIVAS dahingehend beantwortet werden, dass die feministische Haltung der Künstlerin sich vor allem in ihrem Blick für die Erfahrung der Frauen und ihre Fähigkeit, die

Welt zu interpretieren und zu verändern, zeigt, und nicht im Rückgriff auf eine Ideologie als Instrument der Kritik. Wie die Künstlerin kürzlich in einem Interview mit Caroline Walther in der Sen-

dung «Aspekte» im ZDF meinte: «(...) für mich ist der Feminismus Ehrensache, eine Frage von *noblesse oblige*.» So ist es denn auch kein Zufall, dass sich dieses Werk ausschliesslich auf die emotionalen Erfahrungen von Frauen bezieht, dass es von Frauen aufgeführt wird und dass die Elemente des Dekors, vom Boudoir zum Wohnzimmer über das Esszimmer zum Garten, aus der häuslichen Umgebung stammen.

Pipilotti Rists Projekt ist demnach eine Anerkennung des Status der Diva als Sängerin von Liedern mit höchst emotionalem Gehalt. Zu dieser Anerkennung eines Rollenbildes kommt das Vertrauen in das individuelle Talent der Sängerinnen und ihre schöpferische Begabung hinzu, deren Resultate sie mit aufmerksamem und kritischem Blick aufnimmt und rasend schnell weiterverarbeitet, damit ja die Frische und Lebendigkeit der Beziehungen zwischen ihr, der Equipe und dem Publikum nicht verlorengeht. In diesem Sinn ist auch die politische Absicht von SHOOTING DIVAS zu verstehen; sie tut sich im Entscheid kund, den Produktionsprozess öffentlich zu machen. Dieses Vorgehen entmystifiziert das «Magische» der Film- und Fernsehbilder und zelebriert gleichzeitig den Glauben an das Wunder des Unvorhersehbaren in der Kunst sowie an deren Macht, das Publikum zu fesseln und zu bewegen.

Alle diese Elemente machen SHOOTING DIVAS zu einem Werk, das voller Anspielungen und Assoziationen ist, die sich laufend aus seiner fliessenden, wechselhaften Form ergeben. Der interaktive Aspekt des Werkes rechtfertigt dabei vollauf die Entscheidung der Künstlerin für die «offene Werkstatt» als Arbeits- und Ausstellungsform. SHOOTING DIVAS wurde in Genf während vier Monaten zu einer lebendigen gemeinschaftlichen Erfahrung aller Beteiligten. Natürlich experimentiert die Künstlerin mit der Faszination des Publikums durch das Medium Video und seine Anwendung, aber darüber hinaus untersucht sie auch die Psychologie ihrer Figuren. Pipilotti Rist taucht tief in die menschliche Psyche

PIPILOTTI RIST, SHOOTING DIVAS, 1996, Work-in-progress & Videoinstallation, Centre d'Art Contemporain, Genf.
Mitarbeiter Miriam Schlachter, Diego Zweifel, Sängerin Pier Angela Compagnino, Pipilotti Rist und Karin Sudan (oben/above), Pier Angela Compagnino (unten und links/below and left hand page).
S.113: Saadet Türkös und Pipilotti Rist. (PHOTO: ZOE STÄHELI)

ein, stellt aber gleichzeitig eine künstlerische Distanz her. Dabei gelingt es ihr, den Isolationismus und Narzissmus, der uns alle prägt und erst recht jede Diva, in eine Anschauung und einen Stil umzusetzen. *(Übersetzung: Katharina Bürgi & Wilma Parker)*

PAOLO COLOMBO

Shooting Divas

SHOOTING DIVAS, Pipilotti Rist's largest production to date—a two-part exhibition which took place at the Centre d'Art Contemporain in Geneva between June and September of this year—was born of two written texts by Rist and two original music scores by her and Andreas Guggisberg. The two songs that resulted from this collaboration were then interpreted by ten singers—the "divas" of the title—who were specifically chosen, and then directed, by Pipilotti Rist.

SHOOTING DIVAS is divided chronologically into two parts, a work in progress and a video installation. The first part of the show (May 28 to June 8) consisted of the shooting, in public, of ten videos, each made in a day and devoted to one diva's interpretation of one song. Three of Rist's young assistants filmed the spectators, turning them into voyeur-actors in the unfolding work. For this part of the show, the mixing was done under pressure, both on the set and at the end of each day. The work in progress was thus developed in a collaborative, interactive spirit by the small and perfectly integrated team of the artist's collaborators, the singers, the gallery staff, and the public.

The video installation, which grew day by day during the first two weeks of taping, was presented by Rist from June 9 to September 29. It comprised the original sets where the taping was done, and a viewing corner or "red zone," so called because of the color of the sofa and the oversized armchair furnishing it. On the floor of this "zone," in front of the armchair and sofa, were ten television monitors, each broadcasting one of the video channels. Spectators could choose the sound corresponding to the selected channel using a remote control. In addition, a monitor outside the set serving as a dining room broadcast unedited footage of the communal meals, a daily ritual that was an integral part of the work in progress, and in which the public could also be

involved. Yet another monitor, at the entrance to the room, broadcast unedited footage of spectators who had been filmed on the visits to the show during the taping.

The sets themselves were deliberately simple and provisional, colorful, portable, and easily transformed; in this they—like the camerawork, which was purposefully more reductive than in former works—reflected the aesthetics of Pipilotti Rist and respected the industrial atmosphere in which the work was filmed. Natural light dominated the space, though it was supplemented by floodlights and modified by applying color gels over a number of the windows. In the final installation, only the technical apparatus—such as the tables for sound-mixing and image-editing—were eliminated, to enhance the spaces in which the videos were filmed.

The elaborate structure of SHOOTING DIVAS thus articulates the work's complexity. The title was chosen for its syntactical ambiguity—since it is unclear whether the "divas" are the subject or the object—and for the multiple significances of "shooting." The title also recalls the expression "shooting stars"—alluding perhaps to the status of the singer-actresses—as well as the ephemerality implicit in the notion of the work in progress, a form limited in time, but able to capture in its limitations the most luminous and compelling of moments. Thus on a programmatic level, there is in the exhibition's title already an allusion to the temporary nature of the process, and an inference of how much brilliance, tragedy, even irony, exists in self-representation and in the traditional image of the diva. Inasmuch as the title refers to a gendered role, it can be considered an homage to women, in particular to the ten performers who interpret the two songs, infusing them with their own subjectivities, passions, and musical inclinations.

The two theme songs of SHOOTING DIVAS—one faster and more upbeat, entitled "Watermelon," and

PAOLO COLOMBO is the director of the Centre d'Art Contemporain, Geneva.

the other slower, entitled "Swan"—span a broad spectrum of emotions. The first celebrates the body and the self, a hymn to the acceptance of life:

Where it smells of shit
it smells of life
We could choose not to shit
not to open the asshole
but we choose to shit

It's a flower, it's sunshine
it's everything you want...

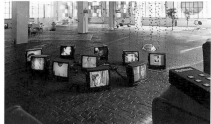
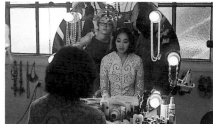

emotional experience of women, has women as its interpreters, and that the decor—ranging from boudoir to living room to dining room to garden—represents a domestic setting.

The other is at once a call for love and an elegy, hinting at the melancholy that exists in abandoning oneself physically and emotionally to the other:

The blood of your shaving wounds
let me sip it like water

Your penis around my neck
like a necklace of diamonds

My boy, my horse, my dog
my man, my diva, my swan...

Both declarative, the songs are born of a process of self-divestment that is expressed in simple lyrics, but which hides a psychological automatism directed by an emotive will. This terrain offers the singers the most variegated of surfaces on which to build a personal interpretation informed by their own experiences and inclinations. Such variety finds its counterpart in the virtuosity of Pipilotti Rist, who, through the camcorder's eye and the mix, dissects the most extreme resonances of the divas' voices and superimposes them on video images that all derive from the artist's own elaborate and sensual repertoire.

In SHOOTING DIVAS, the question of Rist's feminism, often raised by critics, is answered by the artist's focus on the experience of women and their ability to interpret and transform the world, rather than on the use of ideology as an instrument of criticism. As the artist stated recently, "Feminism, for me, is a question of honor, of *noblesse oblige.*"[1] It is therefore no accident that this work refers solely to the

Pipilotti Rist's project is thus an appreciation of the diva—singer of subjects of high emotional content—and this appreciation is accompanied by her faith in the individual qualities and creative abilities of the singers. She registers their efforts with an attentive and discriminating eye, reworking them in unusually rapid fashion so as to respect the freshness of the relationships among herself, the troupe, and the public. It is in this sense that we should understand the political intent of SHOOTING DIVAS, an intent realized in Rist's decision to make the production process public. This strategy demystifies the "magic" of film and video, and at the same time celebrates a faith in the wondrous unpredictability of artistic creation and in the power it has to involve and move the spectator.

Given all these elements, it is evident that SHOOTING DIVAS is rich in allusions that spring from its fluid, changing form. Moreover, the interactive aspect of the work evidences Rist's open-studio approach. While her attention to the video medium and its use as a means of attracting and involving the public are part of Rist's work in general, it is also true that her project goes beyond the nature of the medium itself to encompass the psychology of the people it portrays. Pipilotti Rist delves deep into the human psyche, but at the same time she establishes an artistic distance that transforms the isolationism and narcissism inherent in us all—and particularly in the entity of the divas—into a vision and a style.

(Translated from the Italian by Stephen Sartarelli)

1) Interview with Caroline Walther in *Aspekte*, a cultural program on the German TV channel, ZDF, 1996.

Laurie Anderson and Pipilotti Rist
Meet Up in the Lobby of a Hotel in
Berlin on September 9, 1996.

L: Did you come to Berlin because the sky's so beautiful here?

P: Sure, but I also got a DAAD (Deutscher Akademischer Austauschdienst) grant for a year. I've been going nonstop and have done a lot of really demanding and exhausting video installations. I wanted to take a break and work on a screenplay that I started a while ago. I've got so many ideas floating around in my mind that I have yet to do something with. But now my body's giving me a hard time, forcing me to deal with other things first. Maybe it's saying: do your homework, sweetie pie, and then you can go out and play.

L: You think that works? A subconscious message?

P: I think deep inside us we always know what's up. I just want to take stock. I've always felt so responsible for everything and now I just have to accept the fact that you can't please everybody. Besides, I didn't want to deal with my function as an artist in society in my work because I didn't think it was of general interest.

L: Don't you think we all have this feeling of having to prove ourselves—and that the world is our audience? Unfortunately a lot of people know how it feels to be for sale. Not only artists feel that way. People are always trying to sell themselves. It just becomes more extreme when you do it in a profession. But it's sort of a shock when people come and say: You, OK, you're for sale now. And all of a sudden you think, maybe that's not what you wanted to do.

P: It's comforting to hear you say that. I remember, in connection with the modern cliché of "finding yourself," you once told a story about friends who used to try on different wigs during their coffee breaks. Identity is an important issue for me, for instance, how we use multiple personalities that change from situation to situation. The question is finding a healthy core.

L: There is a lot of pressure to find yourself and then create a constructive and consistent personality. But that's a very strange thing to do. It's a work of art, of fiction. We all create ourselves. And often, when you create your model, it's consistent, but it's too small and too restrictive. I wish I had made a bigger, more flexible drawing of who I am. Once you choose your role, your artistic role or style as an artist, it's hard to escape it. The most helpful thing for me is to forget that anybody cares about what I do.

P: That's what's so wonderful about children. As adults we waste so much time and energy analyzing our behavior, even when we just do something for fun. The piece I did in Graz with the oversized red living room had visitors sinking back into something they weren't really aware of anymore; sitting in that huge armchair made you remember the time when everything used to be too big and too high, but it was also a time when you knew: it's all mine. For children the whole world belongs to them. People acted as if the museum was an extended living room. I like that.

L: Your installation was a good solution, quite immediate.

P: I like installations that really get you involved, that make you part of them, or that even work like a lullaby. When I do projections, I want people to go inside them so that colors, movement, pictures are reflected on their bodies.

L: I agree. I don't really like pieces that define where the edge of the stage is supposed to be and demand that you stand in a certain place. It means you're just part of a more or less passive audience. But then again, it's hard to involve people without getting into fake control systems. What I mean by that is the kind of piece where you're just more or less pushing buttons. There's the illusion that you're doing something—interacting—but mostly you're just switching things on and off.

P: Pushing buttons probably isn't the best way to make people overcome their quasi-religious inhibitions about works of art. In general, I have a hard time with works that scare me.

L: You would have had a problem yesterday with the late night show in the parochial church—Matt Heckert's Spine-Sound-Machines Performance. You know, those big machines with those big sounds. You can't miss it. But because it was in a church, it had a little extra thing to it, you know the huge cross up there. The last time I was in Berlin, I performed in a church under a cross of Jesus hanging up there. So my reaction was to tell a really stupid joke: It's a good thing that Jesus was born in the New Testament, because in the Old Testament the usual death sentence was by stoning, not crucifixion. So instead of Christians making the sign of the cross they'd have to mime dodging a lot of stones. Imagine what that would have done to religion and art history... What's the next thing you would like to do?

P: Recently, when people ask me what I'm doing, I've been saying, "Nothing." I've come to realize that talking about my next work could be one of the reasons why I got sick.

L: That makes perfect sense to me. I really think work can save your life, but talking about it makes it much more difficult.

P: Yes, because people take off a little bit of your skin.

L: But it's not their fault if you let them do that.

P: When you talk to the press...

L: ...you can always lie...

P: ... and they write whatever you want.

L: But you can't do this with your friends.

P: The main thing for me at this point is to get rid of the pressure.

L: And just do things for fun. I wish it wasn't true, but deadlines are so helpful for me, panic helps. I'd love to be able to spend a few hours on one thing, then on another thing, just happily working in a reasonable sort of pleasurable way.

P: If you always work under pressure, then you have a hard time finding a rhythm of your own when the pressure is off. You begin having doubts and anxiety sets in. And so you have to learn to exploit these things in order to produce what you really want to: the success that comes of urgent necessity. But you still want the audience to understand, to appreciate your work, and to praise it.

L: Yes, the eternal desire to please people. But you risk paralysis that way.

P: When you do things that everybody likes and you like them yourself, then you risk being called opportunistic. And if you intentionally undermine expectations, you're just conforming to a long tradition. The only way out is to set your own standards, which also shows that you respect your audience. I was in an all-woman band for six years. I played the flute, percussion and bass—all equally badly. We were professional dilettantes. Naturally, we wanted to please, and we each came up with little tricks to seduce the audience. I left the group two years ago after I had learned how to make the sound for my videos myself. But the band is still going strong. They're called *Les Reines Prochaines*.

L: Oh, that's a good name.

P: We attracted an odd audience—nurses, social workers, intellectuals.

L: Nurses? That's bizarre.

P: Yes, nurses. You know, very progressive, left-wing, feminist…

L: I just had this great picture of all these nurses in their uniforms.

P: No, no, they change their clothes before they go to concerts. Too bad…

L: That is unfortunate. It would be nice to do concerts for specific professions, where the audience would have to wear their professional outfit. Like a performance just for firemen. If you really think about your audience, it's awfully hard to imagine who they might be. There's the question of why you're doing something, but who you're doing it for is a big question, too.

P: It struck me in Zurich last year that your audience is the intelligentsia, artists and musicians…

L: I always try to find out who these people are. I did that once in an installation. It was really silly. The audience had to fill in a form, write what they were doing and how much money they made. We had an instant evaluation of the forms and then seated people on either side of the aisle. One side had beautiful monitors, champagne, and really nice chairs; the other side crummy old chairs, popcorn, and black-and-white monitors. People didn't know why they were sent there instead of to the other side. It was pretty irritating.
Is Pipilotti your real name?

P: My family called me Lotti and my nickname was Pipi, after Astrid Lindgren's Pippi Longstocking Viktualia Pepperminta Rollgardina. I was proud of the nickname because I always wanted to be like her.

L: She's a great character.

P: Yes, she is. She waters the flowers in the rain and she rides a bike without wheels. As a child I didn't realize that they did this with a lousy bluebox technique and with just a crappy old chromakey. They used the simplest tricks to have Pippi Longstocking lift her horse, and the horse's spots were painted, too.

L: Can you imagine people looking at your work in 500 years?

P: Let's see wether laser discs will last that long.

L: Somebody once asked me what I would do differently if I knew I was going to live for 150 years? That's really an interesting question because you pace yourself: I will do that, and then I'll do that, you know…

P: And what did you say?

L: I didn't have an answer. I like to think I might be more socially responsible but I'm not sure I would. I might just see more vacation time.

P: Now, at the age of 34, I'd probably be more relaxed and wiser and would still work with the same intensity. Or maybe, like a child, I'd believe the world was mine again—all mine.

(Ed. Jakobett)

L: Bist du wegen dem schönen Himmel nach Berlin gekommen?

P: Natürlich. Es hat mich aber auch der DAAD (Deutscher Akademischer Austauschdienst) für ein Jahr hierher eingeladen. In den letzten Monaten habe ich mich extrem angestrengt, viele Videoinstallationen eingerichtet, die einen unverhältnismässig grossen Aufwand forderten. Jetzt wollte ich eine Pause machen und an einem begonnenen Drehbuch weiterschreiben, in dem sich alle angestauten und brachliegenden Ideen niederschlagen sollen. Aber nun streikt mein Körper und will, dass ich zuerst andere Dinge kläre. Der Körper sagt mir: Löffle zuerst diese Suppe aus, und danach kannst du nach draussen gehen und spielen.

L: Glaubst du, dass das so funktioniert? Eine Mitteilung des Unterbewusstseins?

P: Ich denke, tief drinnen wissen wir, wo der Has im Pfeffer liegt. Ich muss jetzt einfach mal eine Bestandesaufnahme machen. Beispielsweise fühlte ich mich bisher immer zu sehr für alles verantwortlich. Jetzt muss ich einsehen, dass ich es nicht allen recht machen kann. Zudem wollte ich die Fragen zu meiner Funktion als Künstler in der Gesellschaft nicht in meine Arbeit einfliessen lassen, weil ich sie nicht von allgemeinem Interesse fand.

L: Glaubst du nicht, dass wir alle das Gefühl haben, uns beweisen zu müssen, und dass die ganze Welt unser Publikum sei? Aber nicht nur die Künstler, sondern ganz viele Leute wissen, was es heisst, sich zum Kauf anzubieten. Immer versuchen sich die Leute zu verkaufen. Es wird nur dann besonders extrem, wenn du dies in deinem Beruf tust. Hingegen ist es wie ein Schock, wenn jemand kommt und sagt: O.K. du da, dich kann man jetzt kaufen. Und du denkst plötzlich, das ist ja eigentlich nicht das, was du tun wolltest.

P: Dass du hier sitzt und mir das sagst, tönt sehr beruhigend. In einer deiner Geschichten erzählst du von Freunden, die sich zur Erholung in der Kaffeepause verschiedene Perücken aufsetzten. Damit sprichst du das moderne Klischee des «Sich-selber-Findens» an. Mich interessiert die Frage der Identität extrem und wie wir als multiple Persönlichkeiten, die sich von Situation zu Situation verwandeln, die gesunde Mitte finden können.

L: Es gibt diesen starken Druck, sich selber zu finden und dann daraus eine Persönlichkeit zu kreieren, die schöpferisch und konsequent ist. Das zu tun ist eine eigentümliche Sache, denn es bedeutet, man muss ein Kunstwerk, eine Fiktion schaffen. Alle kreieren wir uns selbst. Aber oft ist das Modell, das wir von uns geschaffen haben, zwar konsequent, aber zu klein, zu einengend. Ich wollte, ich hätte ein grosszügigeres und flexibleres Bild meiner selbst entworfen. Hast du mal deine Rolle gewählt, deine künstlerische Rolle oder deinen Stil als Künstler, ist es schwierig, daraus auszubrechen. Am besten geht es, wenn ich vergesse, dass irgend jemand sich darum schert, was ich tue.

P: In dieser Hinsicht sind die Kinder so wunderbar. Bei den Erwachsenen verschleisst die dauernde Kontrolle über das eigene Verhalten und das Hinterfragen jeder lustvollen Handlung so viel Kraft. In meiner Arbeit mit dem überdimensionierten roten Wohnzimmer, die du in der Grazer Ausstellung gesehen hast, lasse ich die Besucher in etwas zurücksinken, das ihnen nicht mehr so ganz bewusst ist. Tief und klein im riesigen Fauteuil sitzend, sollen sie sich an das Selbstverständnis erinnern, das sie als Kinder hatten: Das alles gehört mir. Denn jedes Kind glaubt, es sei der Mittelpunkt der Welt, und alles gehöre ihm. In dieser Installation verhielten sich die Leute so, als wäre das Museum ihr verlängertes Wohnzimmer. Das mag ich.

L: Deine Installation war eine gute Lösung und wirkte ganz direkt.

P: Ich mag Installationen, in die du so richtig einbezogen bist, Arbeiten, von denen du ein Teil wirst, die dich einlullen. Ich will zum Beispiel auch, dass die Leute in die Projektionen reingehen, so dass sich die Bilder, Bewegungen und Farben auf ihren Körpern reflektieren.

L: Ich mag jene Installationen auch nicht besonders, die klar festlegen, wo die Bühne aufhört, und einen zwingen, an einem bestimmten Ort zu stehen. Du bleibst dabei lediglich ein passiver Zuschauer. Andererseits ist es auch schwierig, die Leute einzubeziehen, ohne ihnen bloss vorzugaukeln, sie hätten die Kontrolle über irgend etwas. Ich meine diese Arbeiten, wo einfach Knöpfe gedrückt werden können, wo die Interaktion nur eine Illusion ist, weil man letztlich nichts anderes tut als etwas ein- und auszuschalten.

P: Dieses Knöpfedrücken ist sicher nicht der beste Weg, um diese allgemeine, fast religiös angehauchte Hemmschwelle vor dem Kunstwerk abzubauen. Generell mag ich jene Arbeiten nicht, die mir Angst einflössen.

L: Da hättest du gestern Probleme gehabt mit der Late Night Show in der Parochialkirche, mit Matt Heckerts Metal-Spine-Klangmaschinen-Performance, mit den riesigen Maschinen und ihrem irre lauten Sound. Weil die Sache aber in einer Kirche stattfand, kam ein ganz bestimmtes Etwas dazu; weisst du, dieses Kreuz dort oben. Als ich das letzte Mal nach Berlin eingeladen wurde, trat ich auch in einer Kirche auf unter einem Kreuz, an dem Jesus hing. Da fiel mir ein dummer Witz ein: Zum Glück ist Jesus im Neuen Testament zur Welt gekommen, denn im Alten Testament wurde das Todesurteil meistens durch Steinigung, und nicht durch Kreuzigung vollzogen. Andernfalls müssten heute die Christen statt sich zu bekreuzigen mimen, wie sie dem Steinhagel ausweichen. Man stelle sich vor, welche Folgen dies für die Religion und die Kunstgeschichte gehabt hätte.
Pipilotti, was willst du als nächstes tun?

P: Neuerdings, wenn ich gefragt werde, was ich zu tun gedenke, sage ich: Ich tue nichts. Ich habe begriffen, dass über die nächsten Arbeiten zu reden mit ein Grund war, weshalb ich krank wurde.

L: Das scheint mir vollkommen logisch. Ich glaube fest daran, dass die Arbeit einem das Leben retten kann; aber darüber zu reden macht es viel schwieriger.

P: Ja, weil die Leute dir ein bisschen Haut abreissen.

L: Es ist nicht ihr Fehler, wenn du das zulässt.

P: Wenn du mit der Presse sprichst . . .

L: . . . kannst du immer lügen . . .

P: . . . und die schreiben alles, was du willst.

L: Ja, aber mit Freunden kannst du das nicht tun.

P: Hauptsache für mich ist jetzt, dass ich den Druck los werde.

L: Um die Dinge aus Lust zu tun. Ich wünschte, es wäre nicht wahr, aber Deadlines helfen mir, die Panik hilft. Es wäre schön, wenn ich einige Stunden an einer Sache bleiben könnte, dann ein paar Stunden an einer anderen, wenn ich einfach zufrieden in einer vernünftigen und angenehmen Art und Weise arbeiten könnte.

P: Wenn du dauernd unter Druck arbeiten musst, fällt es dir schwer, in der Freiheit den eigenen Rhythmus zu finden. Denn wenn der Zeitdruck wegfällt, melden sich die Zweifel und der Weltschmerz. Und diese musst du dann wieder so zu nutzen wissen, dass entsteht, was du dir ja wirklich wünschst: das Gelingen einer Arbeit aus einer dringlichen Notwendigkeit. Und diese Arbeit soll dann erst noch vom Publikum verstanden, begehrt und sogar gelobt werden.

L: Ja, dieses ewige Gefallenwollen. So riskiert man, völlig gelähmt zu werden.

P: Wenn du das tust, was allen gefällt und auch dir selbst gefällt, dann riskierst du, als Opportunist zu gelten. Und wenn du absichtlich Erwartungen unterläufst, verhältst du dich einer langen Tradition gemäss auch konform. Aus dieser Zwickmühle kannst du nur hinausfinden, wenn du deine eigenen Ansprüche erfüllst und dem Publikum zugestehst, dass es diese zu erkennen weiss. Während sechs Jahren war ich in einer Frauen-Musikgruppe, spielte Querflöte, Schlagzeug und Bass, alles

sehr schlecht. Wir waren die professionellen Dilettanten. Natürlich wollten wir gefallen, und jede fand Tricks heraus, mit denen sie das Publikum bezirzen konnte. Vor zwei Jahren bin ich ausgestiegen, nachdem ich gelernt hatte, auch den Sound für meine Videos selber zu machen. Die Gruppe existiert aber immer noch und heisst *Les Reines Prochaines*.

L: Oh, das ist ein guter Name.

P: Wir hatten ein spezielles Publikum – Krankenschwestern, Sozialarbeiter, Intellektuelle ...

L: Krankenschwestern?

P: Ja, Krankenschwestern, weisst du, sehr progressive, linke, Feministinnen ...

L: Ich stelle mir dieses wunderbare Bild vor mit all diesen Krankenschwestern in ihren Uniformen.

P: Nein, leider haben die sich vor dem Konzert umgezogen. Schade ...

L: Wirklich zu schade. Es wäre schön, wenn man Konzerte für bestimmte Berufe geben könnte, und alle im Publikum müssten in ihrer professionellen Bekleidung erscheinen – eine Vorstellung nur für Feuerwehrmänner. Wenn du an dein Publikum denkst, ist es wirklich schwierig, sich vorzustellen, wer da drin sitzt. Schon die Frage, weshalb du etwas tust, ist schwierig; aber die Frage, für wen du etwas tust, ist ebenso wichtig.

P: Dein Publikum ist die Intelligenzija, Künstler und Musiker. Das ist mir letztes Jahr in Zürich aufgefallen.

L: Ich versuche immer rauszukriegen, wer die Leute sind. Und einmal tat ich dies in einer Installation. Jeder und jede im Publikum musste einen Fragebogen ausfüllen, den Beruf sowie den Lohn angeben. Die Fragebogen wurden dann sofort ausgewertet und den Leuten entsprechende Plätze zugewiesen, entweder auf der einen oder anderen Seite des Mittelgangs. Auf der einen Seite gab es wunderbare Monitore, Champagner und richtig gute Stühle; auf der anderen Seite zerschlissene Stühle, Popcorn und Schwarzweissmonitore. Keiner begriff am Anfang, weshalb er auf die eine oder andere Seite geschickt wurde. Das war recht irritierend. – Ist Pipilotti dein richtiger Name?

P: Meine Familie nannte mich Lotti, und mein Spitzname war Pipi. Das hat mit Astrid Lindgrens Pippi Langstrumpf Viktualia Peperminta Rollgardina zu tun. Ich war immer stolz auf diesen Spitznamen, weil ich wie sie sein wollte.

L: Sie ist eine wunderbare Figur.

P: Das kann man wohl sagen. Sie tränkt die Blumen auch bei Regen und fährt ein Fahrrad, das nur aus Lenkstange und Sattel besteht. Als Kind hatte ich nie bemerkt, dass dies im Film mit einer lausigen Bluebox-Technik realisiert wurde, und erst noch mit einem technisch hundsmiserablen Chromakey. Mittels billigster Aufnahmetricks kann Pippi Langstrumpf auch ihr Pferd in die Luft stemmen, und die Flecken auf dem Schimmel sind ohnehin aufgemalt.

L: Kannst du dir vorstellen, dass Leute in 500 Jahren deine Arbeiten anschauen?

P: Erst mal schauen, ob die Laserdisks das so lange bringen.

L: Jemand fragte mich neulich, was ich anders machen würde, wenn ich wüsste, dass ich 150 Jahre alt würde. Das ist eine wirklich interessante Frage, denn man plant doch in gewisser Weise sein Tempo: Ich will das tun, dann das, du weisst ja ...

P: Und was hast du gesagt?

L: Ich wusste keine Antwort. Vielleicht würde ich mehr soziale Verantwortung übernehmen, aber darin bin ich mir nicht sicher. Vielleicht gönnte ich mir auch einfach ein bisschen mehr Ferien.

P: Ich wäre wohl mit meinen 34 Jahren gelassener, weiser und würde trotzdem intensiv arbeiten. Oder vielleicht würde ich wie als Kind wieder glauben, dass die Welt mir gehört, mir ganz allein. *(Übersetzung und Bearbeitung: Jakobett)*

EDITION FOR PARKETT

PIPILOTTI RIST
ICH HABE NUR AUGEN FÜR DICH – (PIN DOWN JUMP UP GIRL), 1996
Dreidimensional erscheinendes Bild, Farbphotographie unter Lenticularrasterfolie,
auf flexiblen Kunststoff aufgezogen, rückseitig vier Saugnäpfe, mit denen das Bild am «schlafenden»
Fernsehschirm befestigt werden kann.
Photographiert von Rita Palanikumar, 21 x 28 cm.
Auflage: 80, signiert und numeriert

I 'VE ONLY GOT EYES FOR YOU — (PIN DOWN JUMP UP GIRL), 1996
3-D image, color photograph under lenticulated film, mounted on flexible plastic with four suction cups,
to be attached to TV screen when not in use.
Photograph by Rita Palanikumar, $8\frac{1}{4}$ x 11".
Edition of 80, signed and numbered

Up Above My Head CONSCIOUSNESS AND HABITATION IN THE GRAPHIC WORK OF Bruce Conner

FAYE HIRSCH

In an old Jewish text we read, "Man ought to know and should remember that the space between heaven and earth is not empty, but is filled with troops and multitudes. Some of these are pure, full of grace and goodness; but others are unclean creatures, tormentors and doers of harm. They all fly to and fro in the air. Some of them want peace, others seek war; some do good, some evil; some bring life, but others bring death."

Elias Canetti, *Crowds and Power*

On the first page of DENNIS HOPPER ONE MAN SHOW (1971–72)—a book in three volumes of etchings by Bruce Conner after collages he made a decade earlier—is an image of a commemorative statue. The statue has one big eye at the center of its shaggy head and other eyes stare from its pedestal and from a wrought-iron fence. Throughout DENNIS HOPPER ONE MAN SHOW disembodied human eyes, a hand, or a whole head, signal consciousness even in the midst of the most impersonal, machine-like assemblages. Conner has said, "When I do these collages, and those little eyes appear, they're…this undifferentiated field that has imposed itself on us. It pops up and looks around."[1] By the third volume, small figures appear in icy, sublime landscapes as if in contemplation—in the manner of Caspar David Friedrich—but what they are looking at is already inhabited: At the horizon a head is sinking into the sea, forehead first, chin aflame, a Victorian sun god. Gardens peering with eyes and teeming with insects,

or deserts navigated by hybrids of people and animals, look like progeny of Goya and Ernst. Conner's collages assert that consciousness is somehow expelled into nature, to dwell there in a fractured but ubiquitous state. At the end of the first volume of DENNIS HOPPER ONE MAN SHOW, the statue is gone; shreds of collage lie at the foot of the empty pedestal. Among the shreds is an eye.

The diminutive viewer in a Romantic landscape is singular; his special sensibility, it is implied, suffuses the whole grand spectacle. But in Conner's work consciousness has been sundered into a mosaic of glittering bits. As has authorship. Famous for elusiveness and pranks, Conner always seemed intent on thwarting the formation of an artistic identity for which the marketplace clamored. He began in the late forties as a painter, then moved restlessly through assemblage, collage, film, and photography. Dennis Hopper was invited to the opening when the original collages comprising DENNIS HOPPER ONE MAN SHOW were finally exhibited in 1972, but that was the extent of the "collaboration"—a complete surprise to Hopper. Conner has submitted photographs of other people to appear in publications as Bruce Conner and even entered himself as dead in *Who Was Who in American Art;* in 1965 he refused to sign prints made at Tamarind with a regular signature, and used his thumbprint instead, with its unique rivulets, a paradoxically anonymous moniker. A lithograph of his thumbprint alone followed. Then, in the same year, he printed his hand inked in human blood. Conner seemed willing to "expose" himself only in this curiously veiled form metonymically linked to his actual body.

FAYE HIRSCH is a writer and editor at *On Paper*. She lives in Brooklyn.

That immutable identifier, the fingerprint, also became the substance of a whole body of drawings in the sixties. Magnified, disembodied, and decontextualized, its meandering contours expand into entire topographies—even a globe. The implication is a limitless habitation of the earth by numbers of unidentifiable people. Looking closely at the felt-tip markings in these drawings, one gets the impression of a druggy compulsion to fill every bit of empty space, not to compose it, but to draw out the potential energy in every inch of blank paper. Conventional signposts are absent—no formal devices to facilitate the formation of hierarchies or an extension into depth; the eye roves over pure surface, shifting direction as if blown by a gentle, changeable wind.

Habitation has been conceived as a crowd in Conner's INKBLOT DRAWINGS. The blots, each unique, blanket the sheet without hierarchy; they are symmetrical, like bodies or faces that return the viewer's gaze. The manner in which they are made, obsessively dropped into light, indifferent folds, suggests that the inkblots are capable of appearing anywhere and everywhere, like a rampant immigration. "They favor perhaps arcane, mysterious hieroglyphics, or images of insects, or collections of objects."[2] Sometimes he organizes the blots in shapes, like that Masonic archetype of mystery and infinity, the pyramid (PYRAMIDS: MAY 29, 1995); but rather than lapsing into signification, this overdetermined choice serves to render them oddly decorative, like garlands on Christmas trees. Sometimes, as in APRIL 30, 1995, Conner singles out a few of the blots for special notice, faintly circling them as if they are being viewed under a lens. Such an action seems to do no more than to exhort the viewer to look ever more closely, an absurdist hermeneutics that will come to no meaningful reading. The Rorschach test was developed as a template from which a diagnostician might "neutrally" derive the particular psychology—even the pathology—of a patient. By multiplying the singular blot into a swarm, Conner in turn neutralizes the propensity of any one blot to become a complete organism generating definitive interpretations. With this proliferation comes a loosening of control. Although Conner's blots may at first appear rather tidily regimented, in fact they are not an army

in thrall to a state, but rather bands of guerrillas sabotaging the certitudes of identity and interpretation.

Conner's works demand close-up scrutiny. His collages, comprised of shreds of imagery taken from turn-of-the-century offset steel and wood engravings, imply with their crosshatch *chiaroscuro,* the creation of an optically consistent, rational space.

But the collaging of these fragments undermines the consistent ordering of the image at every turn. In RELIGIOUS INSTRUCTION (1990–91), bits chosen for their iconographic and formal affinities to the image onto which they are grafted, make that image the more inscrutable by subtly estranging it from itself. In this triptych of ovals, the left presents symbols of measurement and comprehension—a ruler, the egg of the universe, a mandala, a stairway, a geometric figure—ironically displayed against a backdrop of immeasurable clouds or waves. At the center, a hand pointing upward, the paradigmatic gesture of Platonic revelation, indicates a sky in which a circled portion is a similar detail of sky from another source, a small "view" from elsewhere. The heavenly throne in the third oval is likewise grafted with bits of decoration not unlike its own, implying coextensivity, but again stemming from another source. Paradoxically, the closer the collage is examined the more comprehensibility diminishes.

As in the inkblot drawings, the bits within those little circles, "lenses" of a sort, simply exaggerate the mystery by offering the mirage of a more accurate and probing detail. Revelation is the subtle but infinite modulation of consciousness, the process of scrutiny that becomes one with the object of contemplation. The act of looking seems itself to be gobbled up by the work of art, which is animated by this act of assimilation. Whether collage or inkblot drawing (or even the photograms he made in the seventies, with their "angel" apparitions), Conner's work seems permeable, subject to visitation by blots and markings and shreds, a host intent on denying the blankness of the sheet.

1) In Greil Marcus, "The Gnostic Strain," *Artforum* (December 1992), p. 72.
2) With Paul Cummings, *Drawing*, vol. XVI, no. 3 (September–October 1994), p. 57.

BRUCE CONNOR, INKBLOT DRAWING, 1995, ink on Bristol paper, 9⅝ x 8⅜" / TINTENKLECKS-BILD,
Tinte auf Papier, 24,4 x 21,3 cm. (PHOTO: ORCUTT & VAN DER PUTTEN/CURT MARCUS GALLERY, NEW YORK)

*BRUCE CONNOR, PORTRAIT, 2/19/92, engraving-collage with Yes Glue 14½ x 12" /
PORTRÄT, 19.2.92, Radierungscollage mit Leim, 36,8 x 30,5 cm.*

Die Luft über unseren Köpfen BEWUSSTSEIN UND BEWOHNT-SEIN IN BRUCE CONNORS GRAPHISCHEM WERK

FAYE HIRSCH

«An dem Menschen ist es zu wissen», heisst es in einem alten jüdischen Text, «und er sollte es sich merken, dass es keinen freien Raum gibt zwischen Himmel und Erde, sondern ist alles voll von Scharen und Mengen. Ein Teil von ihnen ist rein, voller Gnade und Milde; ein Teil aber sind unreine Geschöpfe, Schädiger und Peiniger. Alle fliegen sie in der Luft herum: welche von ihnen wollen Frieden, welche suchen den Krieg; welche stiften Gutes, welche richten Böses an; welche bringen Leben, welche aber den Tod.»

Elias Canetti, *Masse und Macht* [1]

Auf der ersten Seite von DENNIS HOPPER ONE MAN SHOW (1971–72), einem dreibändigen Werk mit Radierungen von Bruce Conner, nach eigenen, zehn Jahre zuvor entstandenen Collagen, sehen wir das Bild einer Denkmalskulptur. Die Statue hat ein grosses Auge in der Mitte des struppigen Kopfes, weitere Augen starren vom Sockel und aus einem zerschlissenen Eisenzaun. Ständig begegnen wir in DENNIS HOPPER ONE MAN SHOW körperlosen menschlichen Augen, einer Hand oder einem ganzen Kopf; sie zeugen von Bewusstsein, auch in zutiefst unpersönlichen, mechanischen Ansammlungen von Dingen. Conner meinte, «Wenn ich diese Collagen mache und diese kleinen Augen erscheinen, sind sie… dieser Bereich des Unbestimmten, dem wir nicht entrinnen. Plötzlich steht es da und schaut sich um.» [2]

FAYE HIRSCH ist Publizistin und Redaktorin von *On Paper*. Sie lebt in Brooklyn.

Im dritten Band erscheinen kleine Gestalten in eisigen, entrückten Landschaften, wie um diese zu betrachten – ähnlich wie bei Caspar David Friedrich –, aber was sie betrachten, ist bereits bewohnt: Am Horizont sinkt ein Kopf ins Meer, Stirn voran, das Kinn in Flammen, ein viktorianischer Sonnengott. Gärten, die mit Augen schauen und von Insekten wimmeln, oder Wüstengegenden, die von hybriden Menschentypen und Tierarten durchstreift werden, wirken wie späte Sprösslinge von Goya oder Ernst. Conners Collagen behaupten, dass das Bewusstsein sozusagen in die Natur verbannt wurde und dort verharren muss, in Fragmente zerstückelt, aber allgegenwärtig. Am Ende des ersten Bandes ist die Statue verschwunden; Fetzen einer Collage liegen um den leeren Sockel herum. Einer der Fetzen ist ein Auge.

Der winzige Beobachter in einer Landschaft der Romantik ist einzigartig; denn seine besondere Sensibilität durchdringt das ganze grossartige Schauspiel. In Conners Werk dagegen ist das Bewusstsein zu einem Mosaik glänzender Splitter zerbrochen. Wie Autor und Urheberschaft. Berühmt für seine Ausweichtaktik und seine Tricks, schien Conner unentwegt darauf versessen zu sein, sich genau jene falsche künstlerische Identität zu schaffen, nach der der Markt verlangte. In den späten 40er Jahren begann er als Maler, verwendete dann ständig wechselnde Techniken wie Assemblage, Collage, Film und Photographie. Als die Original-Collagen zusammen mit DENNIS HOPPER ONE MAN SHOW 1972 schliesslich ausgestellt wurden, war Dennis

Hopper eingeladen. Das war aber auch schon die ganze «Collaboration» – eine totale Überraschung für Hopper. Conner hat Photographien anderer Leute genommen und sie als Bruce Conner veröffentlichen lassen, und er hat sich selbst sogar als verstorben in *Who Was Who in American Art* eintragen lassen. 1965 weigerte er sich, seine bei Tamarind Press gedruckten Arbeiten normal zu signieren, und verwendete statt dessen seinen Daumenabdruck mit seinen einmaligen Linienverläufen, ein paradox anonymer Künstlername. Bald folgte eine Lithographie seines Daumenabdrucks allein. Dann, im selben Jahr, druckte er seine Hand mit menschlichem Blut als Druckerfarbe. Nur auf diese merkwürdig verhüllte, metonymisch mit seinem Körper verbundene Art, schien Conner bereit, sich als Person zu exponieren.

Der Fingerabdruck, dieses unverwechselbare Kennzeichen der Identität, wurde auch zum Gegenstand eines ganzen Korpus von Zeichnungen in den 60er Jahren. Vergrössert, entkörperlicht, aus allen Zusammenhängen gelöst, weiten sich seine mäandrischen Linien zu ganzen Landschaften, schliesslich zum

Globus. Das impliziert das totale Bewohntsein der Erde durch unzählige nicht identifizierbare Menschen. Schaut man den Filzstiftstrich dieser Zeichnungen genauer an, entsteht der Eindruck eines zwanghaften Drangs, jedes Quentchen leeren Raums auszufüllen, und zwar nicht um der Komposition willen, sondern um die potentielle Energie des weissen Papiers aus jedem Zentimeter herauszuholen. Konventionelle Hinweise fehlen – es gibt keine formalen Mittel, welche eine hierarchische Ordnung oder ein Eindringen in die Tiefe erleichtern würden; das Auge streift über reine Oberfläche, dabei wechselt es die Richtung, als würde es von einem sanften, launischen leichten Wind getragen.

In Conners INKBLOT DRAWINGS (Tintenklecks-Bilder) tritt das Bewohntsein als Masse auf. Die Kleckse, jeder für sich einzigartig, bedecken das Blatt wahllos, symmetrisch wie Körper oder Gesichter, die den Blick des Betrachters erwidern. Die Art, wie sie entstanden sind, dass sie wie besessen in irgendwelche kleine Papierfalten getropft wurden, vermittelt den Eindruck, dass die Kleckse,

gleich einer unaufhaltsamen Invasion, überall und jederzeit auftauchen könnten. «Sie bevorzugen vielleicht geheimnisvolle, unentzifferbare Hieroglyphen oder Insektenbilder oder Sammlungen merkwürdiger Gegenstände.»[3] Manchmal ordnet er die Kleckse, bringt sie in eine Form, etwa in jenen architektonischen Archetypus des Geheimnisvollen und Unendlichen, die Pyramide (PYRAMIDEN: 29. MAI 1995). Aber statt nun der entstandenen Bezeichnung zu entsprechen, wirken die Kleckse durch die allzu bewusste Bestimmung der Form seltsam dekorativ, wie Christbaumgirlanden. Manchmal hebt Conner, wie in 30. APRIL 1995, einige wenige Kleckse besonders hervor, indem er sie fein einkreist, als betrachtete man sie durch eine Lupe. Ein solches Vorgehen scheint nichts anderes zu bezwecken, als den Betrachter zu erhöhter Aufmerksamkeit zu ermahnen, eine absurde Hermeneutik, die nie ein Verstehen von Sinn erreicht. Der Rorschachtest wurde im Sinn eines allgemeinen Rasters entwickelt, aus dem ein Diagnostiker in «neutraler» Weise auf den besonderen psychologischen – wenn möglich sogar pathologischen – Befund seines Patienten sollte schliessen können. Anders Conner, der, indem er den einzelnen Klecks vervielfacht und zu Horden vermehrt, dessen Neigung unterläuft, sich zu einem vollständigen Organismus auszubilden und bestimmte Interpretationen zu erzeugen. Die Vermehrung bedeutet einen Verlust an Kontrolle. Obwohl Conners Kleckse zunächst fein säuberlich geordnet erscheinen mögen, gleichen sie keineswegs einer Armee, die einem zentralen Befehl unterstellt ist, sondern eher Guerillabanden, welche die Sicherheit der Identität und Interpretation sabotieren.

Conners Arbeiten verlangen ein genaues Hinschauen. Seine Collagen, die auch Fragmente von Motiven aus Stahl- und Holzstichen der Jahrhundertwende enthalten, vermitteln durch ihr Rasterstrich-*Chiaroscuro* den Eindruck eines optisch einheitlichen, rationalen Raums. Das Verarbeiten der Fragmente zur Collage unterläuft jedoch unentwegt das Entstehen einer geschlossenen Bildordnung. In RELIGIOUS INSTRUCTION (Religionsstunde, 1990–91) machen Bildfetzen, die wegen ihrer ikonographischen und formalen Nähe zu dem als Grund dienenden Bild ausgewählt wurden, gerade dadurch dieses

Bild besonders unkenntlich, dass sie es aufs Subtilste sich selbst entfremden. Dieses Triptychon ovaler Formen zeigt links Symbole des Messens und Verstehens – einen Massstab, ein das Universum symbolisierendes Ei, ein Mandala, eine Treppe, eine geometrische Figur – in ironischem Gegensatz zu einem Hintergrund ganz und gar nicht fassbarer Wolken oder Wellen. In der Mitte zeigt eine Hand nach oben – die typisch platonische Offenbarungsgeste – und deutet auf einen Himmel, in welchem ein kreisförmiger Ausschnitt ein ähnliches Stück Himmel aus einem anderen Zusammenhang zeigt, eine kleine «Aussicht» in ein Anderswo. Dem himmlischen Thron im dritten Oval wurden ebenfalls dekorative Elemente verpasst, die seinen ursprünglichen durchaus ähnlich sehen: Sie fügen sich in denselben Raum, sind aber völlig anderer Herkunft. Es ist paradox, aber je länger man die Collage betrachtet, desto geheimnisvoller wird sie.

Wie bei den Tintenklecks-Bildern steigern diese kleinen runden, lupenartigen Ausschnitte das Geheimnisvolle, indem sie in einer Art Fata Morgana einen Blick auf genauere, verlockende Details erlauben. Offenbarung ist nicht mehr und nicht weniger als das unmerkliche, aber unendliche Spiel mit der Wahrnehmung, mit einem genauen Hinschauen, das sich im Gegenstand der Betrachtung verliert und schliesslich ganz und gar in ihm aufgeht. Der Akt des Betrachtens selbst, so scheint es, wird vom Kunstwerk einverleibt, und dieses wiederum erwacht erst durch diese Assimilation zum Leben. Gleich ob Collage oder Tintenklecks-Bild (oder sogar eines der Photogramme aus den 70er Jahren mit ihren «Engel»-Erscheinungen), Conners Werk erscheint durchlässig, es unterliegt den Besuchen und Heimsuchungen durch Heerscharen von Kleck sen, Zeichen und allerlei Fetzen, die darauf aus sind, der Weisse des Papiers radikal zu Leibe zu rücken.

(Übersetzung: Susanne Schmidt)

1) Elias Canetti, *Masse und Macht*, Düsseldorf 1960; zitiert nach der Ausgabe im Fischer Taschenbuch, Frankfurt a. M. 1980, S. 44.
2) Aus: Greil Marcus, «The Gnostic Strain», *Artforum*, Dezember 1992, S. 72.
3) Mit Paul Cummings, *Drawing*, Vol. XVI, Nr. 3, September/Oktober 1994, S. 57.

INSERT

RUDY

BURCKHARDT

VINCENT KATZ

RUDY BURCKHARDT
A Short Biographical Sketch

Rudy Burckhardt was born in Basel, the son of a ribbon manufacturer related to the eminent Renaissance art historian, Jacob Burckhardt. He was the product of a rigorous Swiss education coupled with a childhood where his freedom to dream was guaranteed by ribbons. Rudy studied Latin and Greek and was preparing to become a doctor. At that time, he was already taking photographs sporadically around Basel.

A trip to London in 1933 changed everything. Ostensibly, he went to study, but after a few lectures, he never went back. What he did instead was to wander around London, taking photographs. These turned out to be his first "city series," of which many more were to follow. Rudy is essentially a city person. He thrives on the heat a city gives off, the energy of collective desire. Even when he started spending summers on Deer Isle, Maine, in the fifties,

VINCENT KATZ is a poet and translator who lives in New York City.

he would often leave his wife and baby there to make the long trip back to hot New York. I believe he did that for no other reason than to stand on a street corner, hear cars honk, and watch people walk past.

The early London photos have not been seen much. I myself saw most of them only for the first time this year. (Rudy is nonchalant about his work, leaving negatives in drawers for years, printing only a scattering of his shots from time to time). In these photos, he catches London off-kilter. Except for one shot of Piccadilly Circus, the rest are of obscure streets, grim lines of brick row houses or lonely intersections. In them, one becomes involved with the hulking forms of buildings or bridges, rather than with the pathetic stories behind their facades. Rudy has it both ways—he shows the real world without limiting it by social critique. He reveals the multiplicity of the mundane, the beauty of ugliness. The inconspicuous makes its presence felt in

the work of the nineteen year-old Rudy, and he himself is revealed as a frequenter of offbeat solitude, a straying boulevardier. During a visit to Paris in 1934, Rudy advanced his photographic ambitions. For the first time, he shot people close-up—Parisian women in trams, on a carousel. By this time, the rudiments of his mature style were already evident: an unaffected fluency in the textures of his streets and skies and a discerning humanism that allowed him to depict people from all walks of life in their best possible light.

Returning to Basel, Rudy was discovered by Edwin Denby, the American dance critic and poet, who came to him one winter day to get a passport photo taken. They remained friends for almost fifty years, living, traveling, and working together. Denby introduced Burckhardt to the sophisticated world of the cultural elite—among Denby's friends were Jean Cocteau, Virgil Thomson, Aaron Copland, Kurt Weill, Lotte Lenya, and the New York art world. In

RUDY BURCKHARDT, SIRACUSA II, 1951.

the fifties, Denby and Burckhardt collaborated on a book, *Mediterranean Cities*, which paired Denby's terse, difficult sonnets with Burckhardt's expansive and arresting photographs, such as the almost-choreographical series of people "suspended" in white space on a sunlit piazza in Siracusa.

Rudy moved to New York in 1935 where he has lived ever since, despite his frequent rambles. Rudy and Edwin's next-door neighbor on 21st Street was Willem de Kooning, and the three became fast friends. Rudy and Edwin bought his paintings, and de Kooning painted Rudy's portrait. Rudy and Edwin went to Haiti, and there began Rudy's first love affair, with a beautiful Haitian woman named Germaine, whom he photographed—the first of a lifelong series of portraits of women. Rudy documented his travels—to Haiti, Morocco, Peru—not only in photographs and 16mm films, but

also in perspicuous journals. He lived with Germaine for nine months, entering into the life of the Haitians in such a way as to enable him to create images of uncommon generosity. Far from stealing the souls of his subjects, Rudy reveals their moments of joy or solemn introspection in the context of shared experience. Whether out of romantic intrigue, aesthetic desire, or anthropological curiosity, Rudy has constantly pursued what we might define as "enlightenment."

When I read Rudy's journals, published in the long-out-of-print *Mobile Homes* (Z Press, Calais, 1979), I realize how much he has seen and experienced. He served in both the Swiss and the U.S. armies; in World War II, he applied for a position as a Signal Corps photographer in Trinidad and spent most of his stint there, evading the turmoil of the front. In Tangiers, in 1955, Rudy made the following entry in his

journal, *I had a glass of wine in a well-kept French establishment decorated in modern Moorish style. Some men were just about to leave, and the girls were kissing them good-bye pleasantly. It was very French and very business-like, and I could feel the iron rule of the Madam. "And now to your places, girls," she said just then, but I left and went inside with a quiet, rather sad Spanish girl instead, who was standing in a doorway down a darker side street.*

Nowadays, Rudy divides his time between New York and Searsmont, Maine, where he has had a house for thirty years. At eighty-two, Rudy, who still works primarily in photography and film and delights in his small, erotic, "postcollages," has also made a breakthrough in painting, moving beyond scenes to startling close-up views. Rudy has made over seventy films, including brilliantly poetic accounts of snow falling on New York fire escapes, set to Haydn; crazy scenes

RUDY BURCKHARDT, HERALD SQUARE, NEW YORK, 1947.

of traffic, and Times Square at night in the 1960s (in color) set to The Supremes. Rudy has always had a great feel for music, whether classical or pop, country and western, Haitian, or rock'n'roll. In the film MOBILE HOMES (1979), there is a sequence of Rudy's son Tom, skateboarding. The accompanying soundtrack is a song by Blondie. Rudy never seems like he's trying to be hip; it's just suddenly there, startling and natural, like a black-eyed Susan bobbing in the breeze.

Rudy has the ability to make everyone he photographs look beautiful. This is very difficult to do. He achieves this because he sees and appreciates people as they are. Some of Rudy's films are narrative, but the majority are not. Neither are they documentary. They are film poems, rhythmic developments of delicate images. He does not start out with a preconceived idea but simply shoots things—usually people—and, later, lets what he has shot determine the shape of the film. Similarly, his films are characterized by their exquisite form, but the form is not imposed on the subject; rather, the subject determines the formal path taken. His work is classical, revealing a profound sense of balance and proportion, not just in visual terms, but in the relation of sound to image, silence, rhythm. There is often great variation in his films, from scenes that go by in real time, to fast edits that produce an effect like animation, to actual animation, to time-lapse animation (as in the beginning of MOBILE HOMES, where we see a bunch of bananas on a window sill ripen over several days in several minutes). His technique is also humanizing, in its preference for hand-held camerawork.

There is a tendency in contemporary art to want to separate oneself from the rest of humanity, but Rudy's tendency is exactly the opposite. He seems to want to connect with as much of humanity as possible. It is a tendency that has kept him open and youthful.

Rudy Burckhardt has had a charmed life, and, though it would sometimes seem that he does everything casually, without a thought, it is in fact not by luck but by shrewd and forceful decision that he extricated himself from the comfort and safety of his upbringing to make that leap into the void and become an artist.

Leaving Rudy's building on a warm September evening, the sky still retaining vestiges of light, night coming on, I look up and see a picture-perfect shot of the Empire State Building, close-up, foreshortened. Despite its gaudy colors, it makes me glad to be a New Yorker, at least one more time. Rudy has allowed me that glimpse.

RUDY BURCKHARDT, CORNER, LONDON, 1933 / STRASSENECKE.

RUDY BURCKHARDT, A VIEW FROM ASTORIA, NEW YORK, 1940.

VINCENT KATZ

RUDY BURCKHARDT
Eine biographische Skizze

Rudy Burckhardt wurde in Basel als ältester Sohn eines Seidenbandfabrikanten geboren und entstammt der Familie des berühmten Kultur- und Kunsthistorikers Jacob Burckhardt. Einerseits erhielt er eine strenge schweizerische Erziehung und genoss andererseits eine Kindheit, in der die Freiheit zu träumen durch die Produktion von Seidenbändern gesichert war. Mit Griechisch und Latein bereitete er sich in der Schule zunächst auf ein Medizinstudium vor, begann aber bereits damals gelegentlich in und um Basel zu photographieren.

Eine Reise nach London im Jahre 1933 änderte alles. Angeblich fuhr er dorthin, um zu studieren, nach ein paar Vorlesungen gab er das Studium jedoch auf und flanierte statt dessen in London herum und photographierte. Dabei entstand die erste seiner «Stadtserien», von denen noch viele weitere folgen sollten. Rudy ist ein ausgesprochener Stadtmensch, der sich in der

Hitze der Grossstadt entfaltet, getrieben von der Energie des kollektiven Begehrens. Selbst als er in den 50er Jahren regelmässig den Sommer auf der Insel Deer in Maine verbrachte, verliess er immer wieder Frau und Kind, um sich auf den langen Weg zurück ins heisse New York zu machen. Wahrscheinlich tat er dies nur, um an einer Strassenecke zu stehen, die Autos hupen zu hören und den vorbeigehenden Leuten zuzuschauen.

Die Photos aus London sind kaum gezeigt worden. Ich selbst habe den grössten Teil davon in diesem Jahr zum ersten Mal gesehen. Kein Wunder, denn Rudy kümmert sich nicht sonderlich um sein Werk, lässt Negative jahrelang in Schubladen liegen, macht nur gelegentlich von einigen wenigen Aufnahmen Abzüge. Von London fing er die Schattenseiten der Stadt ein. Bis auf eine Aufnahme vom Piccadilly Circus sehen wir immer düsterer werdende Strassenzüge, unwirtliche Backsteinreihenhäuser oder einsame Strassenkreuzungen. Die verrotteten Formen der Gebäude und Brücken

sind anrührender als die erbärmlichen Geschichten, die sich hinter dieser Fassade verstecken. Rudy zeigt die reale Welt ohne Einschränkung durch Gesellschaftskritik. Er enthüllt die Vielschichtigkeit des Alltäglichen, die Schönheit des Hässlichen. Im Werk dieses 19jährigen Mannes erhebt das Unauffällige leise seine Stimme, und auch Rudy als Person kommt zum Vorschein, als Stammgast in der Einsamkeit der Aussenseiter, ein streunender Flaneur. Bei einem Besuch in Paris trieb Rudy 1934 seine photographischen Ambitionen weiter voran. Die ersten Nahaufnahmen von Menschen entstanden, Pariserinnen in Strassenbahnen oder auf dem Karussell. Zu diesem Zeitpunkt hatte er bereits die Grundzüge seines späteren, ausgereiften Stils entwickelt: eine ungekünstelte Leichtigkeit in der Textur seiner Strassen oder Himmel und ein kritischer Humanismus, der es ihm ermöglichte, Menschen in allen Lebenslagen ins rechte Licht zu setzen.

Nachdem Rudy nach Basel zurückgekehrt war, entdeckte ihn dort Edwin

VINCENT KATZ ist Schriftsteller und Verleger. Er lebt in New York.

RUDY BURCKHARDT, TARTINETTE, PARIS, 1934.

RUDY BURCKHARDT, WILLEM DE KOONING, NEW YORK, 1938.

RUDY BURCKHARDT, GERMAINE, HAITI, 1938.

RUDY BURCKHARDT, LADY WAITING, PARIS, 1934 / WARTENDE FRAU.

Denby, der amerikanische Tanzkritiker und Dichter, der an einem Wintertag zu ihm kam, um ein Passphoto anfertigen zu lassen. In der Folge blieben sie fast fünfzig Jahre lang Freunde, lebten, reisten und arbeiteten zusammen. Denby führte Burckhardt in die erlesene Kunstwelt ein – zu seinem Freundeskreis gehörten Jean Cocteau, Virgil Thomson, Aaron Copland, Kurt Weill, Lotte Lenya und die ganze New Yorker Szene. In den 50er Jahren arbeiteten Denby und Burckhardt zusammen an *Mediterranean Cities,* einer Arbeit, in der sich Denbys knappe, schwierige Sonette mit Burckhardts mitteilsamer und fesselnder Photographie paarten; dort erscheint auch die Bildfolge mit den Fussgängern, die wie choreographiert im gleissenden Raum einer sonnenüberfluteten Piazza in Syrakus zu schweben scheinen.

1935 zog Burckhardt nach New York, wo er bis heute lebt, wenngleich er sich auf seinen Streifzügen immer wieder von diesem Zentrum entfernt. Rudy und Edwin wohnten in der 21. Strasse Tür an Tür mit Willem de Kooning, und die drei wurden gute Freunde. Rudy und Edwin kauften de Koonings Bilder, er malte Rudys Porträt. Auf einer Reise von Rudy und Edwin nach Haiti begann Rudys erste Liebesgeschichte mit der schönen Haitianerin Germaine; er photographierte sie und machte damit den Anfang einer Frauenporträtserie, die sich durch sein ganzes Leben ziehen sollte. Seine Reisen nach Haiti, Marokko oder Peru hielt Rudy nicht nur auf Photos und 16-mm-Filmen fest, sondern auch in scharfsichtigen Tagebüchern. Neun Monate lang lebte er mit Germaine zusammen und gewann dabei einen Zugang zum Leben der Haitianer, der es ihm ermöglichte,

Bilder von ungewohnter Freizügigkeit zu schaffen. Weit davon entfernt, den photographierten Personen die Seele zu entreissen, stellt Rudy ihre Augenblicke des Glücks oder ihr ernstes Insichgekehrtsein im Kontext der gemeinsamen Erfahrung dar. Ob aus einer romantischen Anwandlung heraus, aus Sehnsucht nach dem Schönen oder schlicht aus unstillbarer Neugier auf die Lebensweise anderer Menschen, immer ging es Rudy darum, etwas zu erhellen, um «Aufklärung».

Lese ich Rudys Tagebücher, die in den seit langem vergriffenen *Mobile Homes* (Z Press, Calais 1979) veröffentlicht wurden, dann wird mir klar, wieviel er gesehen und erfahren hat. Er diente sowohl in der Schweizer Armee wie in der US-Armee; im Zweiten Weltkrieg erhielt er den Posten des Photographen bei der Fernmeldetruppe in Trinidad, wo er den grössten Teil seines Dienstes ableistete und so den Kriegswirren entkam. 1955 schrieb er in Tanger folgenden Tagebucheintrag: *Ich trank ein Glas Wein in einem gut geführten französischen Etablissement, das in modern-maurischem Stil ausgestattet war. Ein paar Männer brachen gerade auf, und die Mädchen küssten sie freundlich zum Abschied. Es war sehr französisch und sehr geschäftsmässig, und man spürte das strenge Regiment von «Madame». «Jetzt aber zurück auf eure Plätze», sagte sie. Da stand ich auf und ging statt dessen mit einem stillen, traurig wirkenden spanischen Mädchen mit, das in einer dunkleren Seitenstrasse in einem Eingang stand.*

Heute lebt Rudy zu gleichen Teilen in New York und Searsmont, Maine, wo er seit dreissig Jahren ein Haus besitzt. Mit seinen zweiundachtzig Jahren macht er immer noch vorwiegend Photographien und Filme und hat seine helle Freude an kleinen, erotischen «Postcollagen». Auch mit seiner Malerei erlebte er einen Durchbruch, er löste sich dort vom Szenenbild, um überraschende Nahsichten zu malen. Über siebzig Filme hat er produziert, darunter brillante und poetische Ansichten von New Yorker Feuerleitern bei Schneefall, begleitet von Haydn-Musik; verrückte Verkehrs-Szenen, und in den 60er Jahren den Times Square bei Nacht in Farbe, vertont mit Musik von *The Supremes*. Rudy hat eine starke Antenne für Musik, egal ob Klassik oder Pop, Country und Western, haitianische Musik oder Rock'n'Roll. Im Film MOBILE HOMES kommt eine Szene vor, in der Rudys Sohn Tom Skateboard fährt; dazu läuft ein Blondie-Song. Dabei scheint Rudy nie hip sein zu wollen; es passiert ihm einfach, überraschend und natürlich, wie einer zarten Blume, die sich im Wind bewegt.

Er verfügt über die Fähigkeit, jeden, den er porträtiert, schön aussehen zu lassen; was äusserst schwierig ist. Es gelingt ihm, weil er die Menschen so sieht und schätzt, wie sie sind. Vielleicht mit der Ausnahme des Films aus Haiti sind seine Filme keine Dokumentarfilme. Er geht nicht von einer bestehenden Idee aus, sondern photographiert etwas, meistens Menschen, und lässt die Form des Films dann aus den Aufnahmen hervorgehen. In Rudys Filmen herrscht eine prägnante Form, die jedoch dem Thema nie aufgezwungen wird. Vielmehr bestimmt das Thema die Richtung. Seine Arbeit ist in gewisser Weise klassisch und verrät einen ausgeprägten Sinn für Ausgewogenheit und Proportion, und dies nicht nur auf der visuellen Ebene, sondern auch im Verhältnis zwischen Ton, Bild, Stille und Rhythmus. Seine Filme sind technisch sehr vielfältig, da gibt es alles, von der Szene in Realzeit über schnelle Schnitte, die wie Zeichentrick wirken, bis hin zur tatsächlichen Animation und zum Zeitraffer (etwa zu Beginn von MOBILE HOMES, wo wir innerhalb weniger Minuten den mehrtägigen Reifungsprozess einiger Bananen auf dem Fensterbrett beobachten können). Seine Technik hat darüberhinaus etwas sehr Menschliches, weil die Kamera oft von Hand gehalten wird.

In der zeitgenössischen Kunst gibt es eine Tendenz, sich von den übrigen Menschen absondern zu wollen, sich für besser und fortschrittlicher als andere zu halten. Rudy Burckhardt tut genau das Gegenteil und tritt mit so vielen Leuten wie möglich in Kontakt. Diese Neigung hat ihn offen und jung erhalten. Er hat bis jetzt ein wunderbares Leben gehabt. Und selbst wenn es manchmal scheint, als geschähe bei ihm alles rein zufällig, ohne Überlegung, so war es doch eine ebenso scharfsinnige wie folgenschwere Entscheidung, mit der er sich von der bequemen Sicherheit seiner Herkunft verabschiedete, um Künstler zu werden.

Als ich an einem warmen Septemberabend aus Rudys Haus trete, noch Spuren von Licht am Himmel, die Nacht im Anzug, blicke ich auf und sehe ein zum Photographieren schönes *Empire State Building*, Nahaufnahme, perspektivisch verkürzt. Und trotz der kitschigen Farben schätze ich mich einmal mehr glücklich, ein New Yorker zu sein. Rudy hat mir diesen Blick ermöglicht.

(Übersetzung: Nansen)

Martin Disler 1949–1996

«As Lost as Safe.» Diese labile Gleichung für den inneren Frieden schrieb Martin Disler 1983 auf Papier. Wir haben den Satz damals abgedruckt, als «Parkett» Nr. 3 in Collaboration mit ihm entstand.

Dieses Blatt ist insofern programmatisch für sein Tun, als er im Zeichnen, Malen und Schreiben auch jenes Benennen erkannte, das Gleichgewicht herstellt und eine grundsätzliche Verlorenheit zu überdecken versteht. Die Kultur ist eine grosse Besänftigungsmaschine, und Dislers Wunsch, diese aufzubrechen, war mitreissend. Unvergesslich für alle, die sie gesehen haben: seine Ausstellung 1980, «Invasion durch eine falsche Sprache», welche die Kunsthalle Basel in einen «River of No Return» verwandelte. Von seiner Aufbruchsenergie angesteckt, entstand um ihn ein Klima, das uns schliesslich auch zur Gründung von «Parkett» verleitete. Martin Disler starb am 27. August 1996 an den Folgen eines Hirnschlags.

"As Lost as Safe." This fragile equation of inner peace was committed to paper by Martin Disler in 1983. We printed the phrase in the third issue of "Parkett", which was published in collaboration with him in 1984.

It exemplifies his oeuvre in as much as it reveals his realization that the acts of drawing, painting, and writing are in effect acts of naming that produce an equilibrium and disguise a profound sense of abandonment. Culture is a huge mollification machine, and Disler's desire to gum up the works was electrifying. Unforgettable his exhibition of 1980: "Invasion of a False Language," in which he transformed the Kunsthalle in Basel into a "River of No Return." His irrepressible energy created an infectious atmosphere that ultimately inspired us to launch «Parkett». Martin Disler died of a stroke on August 27, 1996.

CUMULUS

Aus Europa

IN JEDER AUSGABE VON PARKETT PEILT EINE CUMULUS-WOLKE AUS AMERIKA UND EINE AUS EUROPA DIE INTERESSIERTEN KUNSTFREUNDE AN. SIE TRÄGT PERSÖNLICHE RÜCKBLICKE, BEURTEILUNGEN UND DENK- WÜRDIGE BEGEGNUNGEN MIT SICH – ALS JEWEILS GANZ EIGENE DAR- STELLUNG EINER BERUFSMÄSSIGEN AUSEINANDERSETZUNG.

IN DIESEM HEFT ÄUSSERN SICH NADIA SCHNEIDER, STUDENTIN DER KUNST- GESCHICHTE UND MITGLIED DER KOMBIRAMA-GRUPPE IN ZÜRICH, IM GESPRÄCH MIT DER KÜNSTLERIN ANGELA BULLOCH AUS LONDON, SOWIE DER PUBLIZIST, FILM- UND VIDEO-PROGRAMMGESTALTER GRAHAM LEGGAT AUS NEW YORK.

Pillow Talk in Public Space

NADIA SCHNEIDER & ANGELA BULLOCH

Kombirama is a noncommercial contemporary art space which opened this summer in Zurich. Kombirama wants to combine the spheres of cultural and everyday life to generate a new platform for communication and experimental artistic interventions. It functions as a laboratory, a playground, and a hangout for people who are interested in open-ended contact with contemporary art forms. Art history student Nadja Schneider is a member of the Kombirama group. She conducted the following talk by telephone with British artist Angela Bulloch on September 9th, 1996.

Nadia Schneider: During the installation of your exhibition at the Galerie Walcheturm in Zurich, you happened to come to Kombirama on a Sunday night. We were sitting at a long table at the back of the room discussing internal problems of the group; we didn't expect guests that night. I was surprised by your instant openness, so I guessed you were familiar with group activities of this kind.

Angela Bulloch: Yes, I understood that this was a group of artists who are trying to bring things together, and of course this leads to discussions. In London I am involved in different sorts of groups: one is to do with my studio, where we have to discuss a lot of things like you were; another I'm just starting to be involved with is a kind of women's group (which was mostly full of men at the first meeting). Another important occurrence is less formal, more social meetings of a group of friends centred around an event of some kind—like showing someone's videos or going to some music perfor-

Kombirama, Zurich, July 1996.
(PHOTO: BAYARD HOOVER, ZÜRICH)

mance together. Usually the discussion is better if there is something to focus on, rather than just being in a pub or a party atmosphere.

N S : These ideas are very close to the concept of Kombirama.

A B : I had a discussion about Kombirama at Eva Presenhuber's place, where we talked about groups in which the effort of creating a venue or forum is made. They are special because the effort is made in their own interest, and it means that discussions happen that would otherwise not take place or have any far-reaching developments or effects. These discussions can be really generative and useful in many ways. The thing about Kombirama that I was also interested in is that those who are involved make something happen for themselves as well as for a more general public.

N S : Kombirama is a public space, but the private aspect is always present. In the first month after its opening in July of this year we wanted to give Kombirama a familiar ambience. Tak-

ing the colour green as the theme for all the events that first month, we made the room's olive green carpet—a more or less tasteful remnant of the seventies—our ironic symbol. During this time Kombirama functioned as a sort of hothouse for exotic interventions and events. The room was equipped with hydroponic plants, green cushions, a bar on the floor, and a big orange tent—something between a garden centre, a playground, and an installation. We held performances, a B-movie night, a culinary event, speeches about nature in the city and the deconstruction of nature. People could play badminton or look at educational videos about natural phenomena. Last, but not least, there were always DJs mixing or creating their own electronic music. Experimental electronic music is almost always a feature of Kombirama events. I noticed that you were very interested in Stefan Altenburger's record collection. Is music important for you?

A B : In about 1989, I ran a club myself with a friend, and I was very involved in the London club scene. I have been away from that scene for a while and I just started to get back into it more recently. It's a very different world, but the exciting thing is, that because of new technology almost anybody can make this kind of experimental music. It's quite an explosion. I didn't really expect to find an active techno scene in Zurich.

N S : Is techno more than just dance music for you?

A B : Oh, yes. I like the alien sensibility of electronic sounds. I use these kinds of sounds in my work although I'm not trying to make music. Some years ago I was really interested in groups like Kraftwerk, and I think their music was important for the development of techno. Ideas that are mediated in an electronic form—there are similarities to this approach in my work.

N S : At the Galerie Walcheturm, one of your installations was called FOR-

MATION DANCING BENCH (VIRTUAL HMMM), a bench with a red rectangular cushion on it. When you sit down you can hear a techno dance track. But when you felt like standing up to dance, the music would instantly stop.

A B : Of course, that's a contradiction. The piece is more about thinking about dancing. Because it's a bench, there is room for more than one person, and there are some socks; so you can sit, maybe put the socks on and think about your moves.

N S : Two other pieces at your exhibition involve a video, AUDIO VIDEO TECHNO BENCH (JOSO NEW TOWN), and some books, LIGHT READING BENCH (SNOW CRASH). Are this video and this novel your current favourites?

A B : Yes, *Snow Crash* is my current favourite science fiction book; the choice could be changed later on. The video is the one I made recently in Japan.

N S : The first time I went through the exhibition I enjoyed the aspect of play, of interaction between public and art work. But I quickly realised that it's only an apparent interaction, that the public is the medium that brings the predetermined plans to fulfilment. You say you want to create structures and rules as society does. Was I trapped in your system, accepting your rules?

A B : Well, I think there are rules and there are systems and structures, but there's always room to play within them. Take, for example, my drawing machine BETAVILLE (1995). It draws a vertical line, and if you are sitting on the bench the line will be horizontal. But if you sit up and down repeatedly, it makes a diagonal line, more or less. If you break the rules, you alter the system. When you make a structure, it becomes a bit like a game about trying

to find ways around it, or ways to use it that suit you better. It's not a game predicated upon your doing it precisely the way that it's set up. There's room for interpretation. Working within a structure is as subjective for you, the viewer, as it is for me, the artist. I try to focus on the possible actions within systems, rather than on just the object or structure itself, which usually means that the work is time-based and that the reactions of people to the work become part of it. The viewer is part of the "switch" that activates the piece.

N S : There are many Japanese elements in your exhibition at Walcheturm. Can you tell me something about that?

A B : I spent two months in Japan doing a residency, and I made a video and took many photos there. There are four groups of four photographs, each group relating to some kind of activity or structure. One group was taken during visits to the National Mechanical Research Laboratory in Tskuba and is more or less a portrait of the employees and the machines they make. Another group consists of stills from the making of the video JOSO NEW TOWN. One of them is a TV set on a large blue tarpaulin, set into a very large dirt bunker. We tested if the TV set would really explode—like some pyrotechnic film effect—when rocks were thrown at it. It's something I'd always wanted to see done. The man we got to throw the stones was a good pitcher, but it took him a long time to break the TV, and of course it didn't explode. We saw how things which may look extreme in a pop video—like throwing a TV out of the window or a TV exploding—turn out not to be quite like that. It's a constructed, controlled explosion. The students who were in

the video really enjoyed being able to do something like that.

N S : Who are these people in the video? How did you choose them?

A B : They were a mixed group of young people, about fifteen or sixteen years old. They had their school uniforms on, but each uniform was personalised in some way. Another of these groups of photographs is from a famous place in Tokyo called Harajuku. On Sundays a lot of different bands set up and play there. Some of these bands have a following of younger Japanese fans.

N S : It looks like they're dancing special steps they learned together, like some kind of ritual.

A B : A lot of the girls are wearing the same white socks, which stop halfway up the leg, and they're doing a special formation dancing. They do it to specific songs. It's a unifying behaviour. These are the details I'm interested in.

N S : Why are you interested in Japan?

A B : Technical reasons, really. I wanted to be in a place where the societal structures are very different from the ones I know.

N S : On the cover of your video cassette there is a picture of some of the girls in the video sitting on a large red piece of... let's say, furniture. As far as I know this is also a piece of yours.

A B : The cover is a photograph of some girls watching themselves in the video for the first time. They're sitting on one of these sculptures I made as an edition, called HAPPY SACKS. I used these as parts of other sculptures, other situations. For example, if somebody wishes to view the work or to be part of it, s/he has to be more or less lying down, or together with other people on the same structure. Basically I see the HAPPY SACK as a piece of furni-

ture, but in another way it's a social structure. It's amazing what kind of situations it creates just in terms of discussion, because you can have ten or more people sitting on the same HAPPY SACK. That makes a relaxed, informal context where people are comfortable enough to speak in a much more open way than they normally would.

N S : Perhaps you noticed the green cushions we had in the Kombirama during your visit? Usually we had them spread over the carpet and people would sit or lie on them. But that night we had them arranged around one of the pillars and people probably thought it was an installation.

A B : So nobody touched it! I remember I saw the green cushions and I thought, what they really need is a HAPPY SACK.

N S : I wasn't sure either if I was allowed to sit on your benches at the Walcheturm Gallery. The traditional taboo against touching works of art is difficult to overcome, even if the artist wants you to do so.

A B : I play on this fear a lot in my work... So, what will Kombirama do next?

N S : In September we will organise an Internet seminar. During the day there will be a workshop for people interested in the practical aspects. We'll teach them how to use the programs and how to make their own homepages, without charging a fortune. In the evening we'll invite guests, like Heath Bunting, Patrice Riemens, Eva Wohlgemuth and Kathy Rae Huffman, to talk about their own projects on the Net, or about artistic and economic strategies related to the use of the Net. (A Kombirama online magazine will be available soon at http://www.kombi-

rama.ch.) From the end of October until the beginning of December we'll have a project called "6½ weeks. A space research project." Six artists— one artist per week—from Switzerland, Austria and England are invited to redefine the room. This research project is based on the idea that Kombirama, located in the industrial area of Zurich, has itself redefined space by moving into a room originally intended for commercial purposes. And what are y o u r next projects?

A B : I'm working on an exhibition for the Robert Prime Gallery in London. I'm also developing a project called PANORAMA ISLAND. There is a constructed island in the river Thames, which used to be the loading pier for Bankside Power Station where the new

Tate will be built. I contacted the local council and made an application to change the name. Now it is called "Panorama Island."

N S : What is PANORAMA ISLAND going to be like?

A B : There are a lot of different ideas as to what the Tate should do with it. I'm working on a proposal with an architect, Jonathan Kaplans. But it will be years before it can be fully realised.

N S : What function should the island have?

A B : So far I've projected a new name onto it. As there is no public access to it, I would like to permanently install one work to be remote-controlled by people on the shore. I've thought of other events as well. It should be a platform for art.

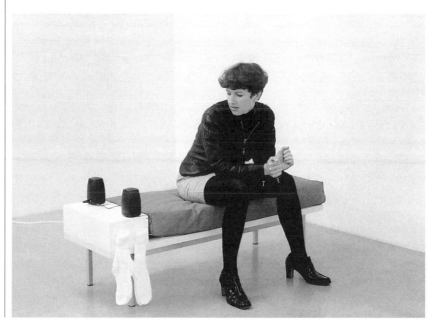

Öffentliches

Kissengeflüster

NADIA SCHNEIDER & ANGELA BULLOCH

Kombirama ist ein nicht kommerzieller Ausstellungsraum für zeitgenössische Kunst in Zürich, der diesen Sommer neu eröffnet wurde. Das Ziel von Kombirama ist es, Kultur und Alltag so zu vereinen, dass eine neue Plattform für künstlerische Experimente und Kommunikation entsteht. Es soll Labor, Spielplatz und auch einfach ein Treffpunkt für Leute sein, die sich für den spielerischen Umgang mit Formen der zeitgenössischen Kunst interessieren. Das folgende Telephongespräch fand am 9. September 1996 statt.

Nadia Schneider: Während der Einrichtung deiner Ausstellung in der Galerie Walcheturm in Zürich schautest du an einem Sonntagabend im Kombirama vorbei. Wir sassen gerade an einem langen Tisch, ganz hinten im Raum, und diskutierten einige interne Probleme, da wir an diesem Abend keine Besucher erwarteten. Ich war überrascht, wie offen du uns sofort begegnet bist, und dachte, dass du wohl mit dieser Art von Gruppen vertraut wärst.

Angela Bulloch: Ja, ich sah, dass da eine Gruppe von Künstlern etwas auf die Beine zu stellen versuchte, und das führt natürlich zu Diskussionen. In London habe ich mit verschiedenen Gruppen zu tun: Eine hat mit meiner Ateliersituation zu tun, da gibt es immer viel Praktisches zu klären, wie bei euch auch; eine andere, zu der ich eben erst Kontakt aufgenommen habe, ist eine Art Frauengruppe (die allerdings beim ersten Meeting vorwiegend aus Männern bestand). Wichtig sind für mich auch eine Reihe eher geselliger Treffs, wo sich einige Freunde zu einem gemeinsamen Anlass einfinden, sei es dass jemand seine Videos zeigt, oder dass wir gemeinsam eine Musikveranstaltung besuchen. Meist ist die Diskussion ergiebiger, wenn es um etwas Bestimmtes geht, als wenn man einfach in einer Beiz oder an einer Party zusammenhockt.

NS: Aus ähnlichen Überlegungen ist auch das Konzept von Kombirama entstanden.

AB: In Eva Presenhubers Galerie haben wir über Kombirama und andere Gruppen gesprochen, denen es darum geht, einen Treffpunkt oder ein Diskussionsforum zu schaffen. Das Besondere daran ist, dass sich im und dank dem Interesse solcher Gruppen tatsächlich etwas bewegt: Es finden Diskussionen statt, die sich sonst nie ergeben würden, geschweige denn etwas bewirken könnten. An Kombirama gefällt mir auch, dass die Gruppe sowohl für sich selbst als auch für ein breiteres Publikum etwas bewegt.

NS: Kombirama ist ein öffentlicher Raum, aber das Private spielt natürlich mit hinein. Gleich im Monat nach der Eröffnung, im Juli, wollten wir im Kombirama eine öffentliche und gleichzeitig familiäre Atmosphäre schaffen. Ausgehend von dem bereits vorhandenen olivgrünen Spannteppich, einem mehr oder weniger geschmackvollen Relikt aus den 70er Jahren, machten wir Grün zur ironischen Symbolfarbe aller Veranstaltungen dieses Monats. Kombirama wurde zu einer Art Treibhaus für exotische Aktionen und Anlässe. Der Raum wurde mit Hydrokultur-Pflanzen, grünen Kissen, einer Bar auf dem Boden und einem grossen orangefarbenen Zelt ausgestattet. Es sah aus wie eine Mischung aus Gartencenter, Spielplatz und Installation. Vor dieser Kulisse fanden die Veranstal-

158

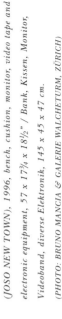

ANGELA BULLOCH, AUDIO VIDEO TECHNO BENCH (JOSO NEW TOWN), 1996, bench, cushion, monitor, video tape and electronic equipment, 57 x 17¾ x 18½" / Bank, Kissen, Monitor, Videoband, diverse Elektronik, 145 x 45 x 47 cm.
(PHOTO: BRUNO MANCIA & GALERIE WALCHETURM, ZÜRICH)

tungen statt: eine B-Movie-Kinonacht, ein Ess-Spektakel, Vorträge über die Natur in der Stadt und die Dekonstruktion der Natur. Die Leute konnten Federball spielen oder sich lehrreiche Videos über irgendwelche Naturphänomene angucken. Last, but not least war immer ein DJ da, der seine eigene elektronische Musik machte oder mixte. Experimentelle elektronische Musik gehört bei den Veranstalungen im Kombirama fast immer mit dazu. Mir ist aufgefallen, dass du dich sehr für Stefan Altenburgers Plattensammlung interessiert hast. Ist Musik und besonders Techno-Musik wichtig für dich?
A B : So um 1989 hatte ich zusammen mit einem Freund selbst einen Club und war sehr aktiv in der Londoner Club-Szene. Dann hat sich vieles in meinem Leben verändert, und ich ging einige Zeit weg. Erst seit kurzem habe ich mich wieder für solche Sachen zu interessieren begonnen. Es ist eine Welt für sich, aber das Spannende ist,

dass jetzt dank der neuen Technologie beinahe jeder seine eigenen Versuche mit dieser Art von experimenteller Musik machen kann. Es ist ein richtiger Boom. Eigentlich habe ich nicht erwartet, in Zürich auf eine aktive Techno-Szene zu stossen.
N S : Ist Techno für dich mehr als Musik zum Tanzen?
A B : O ja. Ich mag das Überirdische, Verletzliche der elektronischen Klänge. Ich verwende diese Art Sound in meinen Arbeiten, obwohl ich eigentlich keine Musik machen will. Vor einigen Jahren habe ich mich ernsthaft für Gruppen wie *Kraftwerk* interessiert, und ich glaube, ihre Musik war wichtig für die Entwicklung des Techno. Ideen werden mit Hilfe von Elektronik zum Ausdruck gebracht – so was kommt in meiner Arbeit natürlich auch vor.
N S : Eine deiner Installationen in der Galerie Walcheturm hiess FORMATION DANCING BENCH (VIRTUAL HMMM), eine Bank mit einem rechteckigen

roten Kissen drauf. Wenn man sich hinsetzt, hört man ein Techno-Tanzstück. Sobald man aber aufsteht und tanzen will, verstummt die Musik.
A B : Ja, das ist natürlich ein Widerspruch. Aber es geht in dieser Arbeit mehr um die Vorstellung vom Tanzen als ums Tanzen selbst. Auf der Bank ist Platz für mehr als nur eine Person, und dann sind da auch noch Socken: Man kann sich hinsetzen, in die Socken schlüpfen, wenn man will, und sich in Gedanken bewegen.
N S : Als Teil von zwei anderen Werken von dir sieht man ein Video, AUDIO VIDEO TECHNO BENCH (JOSO NEW TOWN), und Bücher, LIGHT READING BENCH (SNOW CRASH). Sind das jene, die dir im Moment am liebsten sind?
A B : Ja, *Snow Crash* ist momentan mein liebstes Science-fiction-Buch, aber das kann mit der Zeit ändern, die Bücher können gegen andere ausgetauscht werden. Das Video dagegen

habe ich selbst erst kürzlich in Japan gedreht.

NS: Es gibt viele japanische Elemente in deiner Zürcher Ausstellung. Erzähl mir doch etwas darüber!

AB: Während meines zweimonatigen Stipendienaufenthalts in Japan habe ich dieses Video gedreht und viel photographiert. In der Ausstellung sind vier Gruppen zu je vier Photographien zu sehen. In jeder Gruppe geht es um eine bestimmte Art von Aktivität oder Struktur. Eine davon ist aus Besuchen im *National Mechanical Research Laboratory* in Tskuba hervorgegangen und ist mehr oder weniger ein Porträt der Männer dort und der Maschinen, die sie herstellen. Eine andere besteht aus Stills von den Dreharbeiten zum Video JOSO NEW TOWN. Eines davon zeigt einen Fernsehapparat auf einer grossen blauen Blache in einer Erdmulde. Wir wollten ausprobieren, ob der Fernseher – wie bei einem pyrotechnischen Spezialeffekt – wirklich explodierte, wenn man ihn mit Steinen bewarf. Das wollte ich schon längst einmal sehen. Wir trafen alle möglichen Sicherheitsvorkehren. Der Mann, der die Steine warf, war ein guter Baseballwerfer, aber er brauchte eine Ewigkeit, um den Apparat zu zerschmettern, und natürlich explodierte er nicht. Es war eine Möglichkeit, sich darüber klar zu werden, dass Dinge, die in einem Popvideo aufsehenerregend wirken – wie ein explodierender oder aus dem Fenster geworfener Fernseher –, in Wirklichkeit etwas anders aussehen. Natürlich ist so eine Explosion konstruiert und kontrolliert. Die Studenten im Video haben bei all dem natürlich mit grösstem Vergnügen mitgemacht.

NS: Was sind das für Leute im Video? Wie hast du sie ausgewählt?

AB: Es sind einfach ein paar bunt

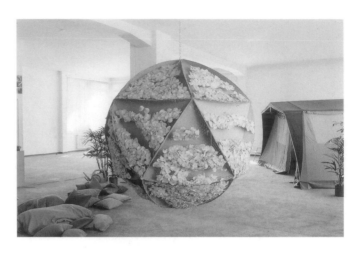

Kombirama, Zürich: MARTINA EBERLE, CHIPS PLANET, 1996, food event.
(PHOTO: STEFAN ALTENBURGER, ZÜRICH)

zusammengewürfelte junge Leute, so um die fünfzehn, sechzehn Jahre alt. Sie tragen Schuluniform, aber jede Uniform hat einen kleinen individuellen Touch. Eine weitere Gruppe der Photographien entstand an einem bekannten Platz in Tokio namens Harajuku. An Sonntagen treten dort verschiedene Musikbands auf und spielen. Manche von ihnen sind ziemlich bekannt und haben eine treue, junge japanische Fangemeinde.

NS: Es sieht aus, als ob sie einige ganz besondere, zusammen einstudierte Schritte und Bewegungen tanzten, eine Art Ritual.

AB: Viele Mädchen tragen die gleichen weissen Kniesocken und tanzen einen speziellen Formationstanz. Das machen sie zu bestimmten Liedern. Es ist ein vereinheitlichendes Verhalten, wo jede genau dasselbe tut. Solche Details interessieren mich.

NS: Weshalb interessierst du dich für Japan?

AB: Vor allem aus technischen Gründen, aber auch, weil die gesellschaftlichen Strukturen da wirklich ganz anders sind: Der Aufenthalt an einem fremden Ort macht einen objektiver gegenüber seiner vertrauten Umgebung.

NS: Auf dem Cover deiner Videokassette sieht man einige Mädchen aus dem Video auf einem grossen ... sagen wir, Sitzmöbel. Dieses ist, soviel ich weiss, auch eine Arbeit von dir.

AB: Das Cover zeigt ein Photo von einigen Mädchen, die sich zum ersten Mal selbst auf dem Video sehen. Sie sitzen auf einer dieser Skulpturen, die ich als Edition gemacht habe, sie heissen HAPPY SACKS. Ich verwendete sie dann wieder als Teil anderer Skulpturen oder Situationen. Eine Herausforderung für jeden Betrachter dieser Werke: Er muss sich sozusagen hinlegen oder ihn sich mit anderen Leuten teilen. Eigentlich verstehe ich den HAPPY SACK als einen Einrichtungsgegenstand, aber er wirkt auch irgendwie sozial strukturierend. Es ist verrückt, welche Gesprächssituationen sich ergeben, wenn zehn oder mehr Leute auf demselben HAPPY SACK sitzen. Das Ganze wirkt dermassen ent-

spannt und ungezwungen, dass die Leute sich unverschämt wohl fühlen und viel offener reden, als sie das sonst tun würden.

N S : Vielleicht hast du am Abend nach deiner Vernissage bei Eva Presenhuber die grünen Kissen im Kombirama bemerkt? Normalerweise waren sie im ganzen Raum verteilt, und die Leute sassen und lagen darauf. Aber an diesem Abend hatten wir sie um eine der Säulen herum angeordnet, und die Leute dachten wahrscheinlich, es wäre eine Installation.

A B : Also rührte sie keiner an! Ich erinnere mich an die Kissen und daran, dass ich dachte, eigentlich wäre ein HAPPY SACK hier das richtige.

N S : Ehrlich gesagt, war ich auch unsicher, ob ich mich auf deine Bänke in der Galerie Walcheturm setzen durfte. Wenn man von klein auf eingetrichtert bekommt, dass Kunstwerke nicht berührt werden dürfen, wird man eine gewisse Scheu nie los, wenn man diese Regel verletzt. Auch wenn der Künstler oder die Künstlerin genau dies erwartet.

A B : Ich spiele oft mit dieser Berührungsangst in meinen Arbeiten. Aber erzähl mir was über die nächsten Projekte von Kombirama!

N S : Im September veranstalten wir ein Internet-Seminar. Tagsüber gibt es einen Workshop für Leute, die sich für den praktischen Umgang mit Internet interessieren. Sie werden lernen können, wie man z. B. eine eigene Homepage erstellt, ohne die üblichen überrissenen Kursgebühren bezahlen zu müssen. Am Abend werden Gäste wie Heath Bunting, Patrice Riemens, Eva Wohlgemuth und Kathy Rae Huffman über ihre eigenen Internet-Projekte sprechen, oder auch über künstlerische und wirtschaftliche Aspekte im Umgang mit dem Netz. Übrigens wird demnächst eine Kombirama-Online-Publikation abrufbar sein unter http://www.kombirama.ch. Von Ende Oktober bis Anfang Dezember läuft das Projekt «6½ Weeks. Ein Raumforschungsprojekt». Sechs Kunstschaffende und Künstlergruppen aus der Schweiz, Österreich und England werden eingeladen, je eine Woche im Kombirama zu arbeiten und den Raum neu zu definieren. Dieses Projekt entstand aus der Überlegung, dass Kombirama selbst, im Zürcher Industriequartier gelegen, eine Neudefinition des Raumes vornahm, als es eine Lokalität bezog, die ursprünglich als Büro- oder Gewerberaum gedacht war. Und was hast du als nächstes vor?

A B : Im Moment bereite ich eine Ausstellung in der Robert Prime Gallery in London vor. Ausserdem arbeite ich an einem Projekt namens PANORAMA ISLAND, das ist eine künstliche Insel in der Themse. Sie diente früher als Ladepier für das Bankside Kraftwerk, dort wo jetzt die neue Tate Gallery gebaut werden soll. Ich habe die lokalen Behörden kontaktiert und einen Antrag auf Namensänderung eingereicht. Jetzt heisst es wirklich «Panorama Island».

N S : Wie wird PANORAMA ISLAND aussehen?

A B : Das Projekt steht im Zusammenhang mit verschiedenen Plänen und Aktivitäten der Tate Gallery. Ich arbeite zusammen mit dem Architekten Jonathan Kaplans an einem Bauprojekt. Alles ist noch im Entwicklungsstadium, und die vollständige Realisierung wird Jahre in Anspruch nehmen.

N S : Was für eine Funktion soll die Insel haben?

A B : Bis jetzt habe ich ihr nur einen neuen Namen gegeben. Da sie nicht öffentlich zugänglich ist, würde ich gern eine permanente Installation darauf einrichten, welche die Leute vom Ufer aus fernbedienen könnten. Aber es sind auch noch ganz andere Veranstaltungen vorstellbar. PANORAMA ISLAND soll zu einer eigentlichen Plattform für Kunst werden.

(Übersetzung: Wilma Parker)

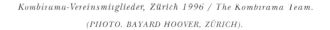

Kombirama-Vereinsmitglieder, Zürich 1996 / The Kombirama Team.
(PHOTO. BAYARD HOOVER, ZÜRICH).

161

CUMULUS

From America

IN EVERY EDITION OF PARKETT, TWO CUMULUS CLOUDS, ONE FROM AMERICA, THE OTHER FROM EUROPE, FLOAT OUT TO AN INTERESTED PUBLIC. THEY CONVEY INDIVIDUAL OPINIONS, ASSESSMENTS, AND MEMORABLE ENCOUNTERS—AS ENTIRELY PERSONAL PRESENTATIONS OF PROFESSIONAL ISSUES.

OUR CONTRIBUTORS TO THIS ISSUE ARE GRAHAM LEGGAT, A WRITER WHO LIVES IN NEW YORK, NADIA SCHNEIDER, A STUDENT AT THE UNIVERSITY AND MEMBER OF THE KOMBIRAMA GROUP IN ZURICH, AND THE ARTIST ANGELA BULLOCH, WHO LIVES IN LONDON.

ALL OF THESE AND NONE OF THESE

GRAHAM LEGGAT

THE 1996 NEW YORK VIDEO FESTIVAL*

For the first four years, the New York Video Festival was presented as a special event of the venerated New York Film Festival. This led to unfortunate comparisons—unfortunate since, despite their surface similarities, film and video are quite dissimilar. They belong within vastly different production, distribution, and exhibition economies; they have radically different histories; they capture and release images using entirely different technologies, one photographic, the other electronic; and they deploy, in most cases, different visual grammars—by which I mean that the general shot selection, mise-en-scène, lighting, camera movement, and visual texture of one can only with great effort be made to convincingly resemble the other. Moreover, the two media tend to affect their material in markedly different ways: in film the subjects are "gilded," given the authority and evanescence of dreams or myths, endowed with an aura of immortality; in video the subject remains resolutely mortal, noticeably lacks authority, and is limned in almost all cases by its own banality.

It was beneficial, then, that this past year the video festival ran as part of the Lincoln Center Festival 96, a summer jamboree of opera, theater, concerts, and other live performances. Inasmuch as this was a more diverse series of programs, the move suited

the video festival; it loosened the ready but wrongheaded associations of video with film and made more apparent video's sympathies with performance. A short inventory of these might include the historic and ongoing use of video as the medium of choice for the documentation of performance; the emergence of video genres marked by direct address to the camera, be they diaristic, confessional, journalistic, or theatrical; and the overall effect of the medium, alluded to earlier, through which the subject is not ennobled but, rather, rendered more transparently—an actor, for example, is more noticeably "on stage" on video, and the viewer's disbelief is thus only barely suspended, if at all.

The main benefit of the switch of venues, though, lay not in replacing one set of questionable associations with another. To sustain an equivalence of video and performance in the public mind would be pointless, for in the final analysis video is no more like performance than it is like film. Nor, despite the persistent tendency to think of video as an arty version of big-screen TV, is the viewing of a video festival the same as watching something on the box, seeing single- or multichannel work in a gallery, or, for that matter, traversing interactive landscapes or waiting for Web pages to compose themselves on a computer screen. While video can be made to resemble any of

these media or experiences at any given moment, its signal characteristic is that it entails a conflation of media: film, performance, television, the plastic arts, digital work, etc. More precisely, it is all of these and none of these, for in its subtlest and perhaps truest forms, video is scarcely an art at all. It might best be described as a demi-art. (Whether this is something inherent in the medium or, instead, a benchmark in its development is hard

was to survey the aesthetic territories through which video runs; the second was to find out what video was when it wasn't something else—what it did best, so to speak, when it was being itself.

Over ten days in late July and early August, we screened more than eighty works, organized into fifteen programs and featuring some sixty artists from Europe, Asia, and the United States. We covered every genre and form possible. The most common remark

DOUG AITKEN, AUTUMN, 1994, video still.

to say.) As such its reception is often marked by false expectations, bafflement, or animosity. This is a great shame since video's "half-nature," elusive and incomplete, is compelling and open to all manner of speculation and exploration.

It was this spirit that guided us in the programming of the 1996 New York Video Festival. Aside from presenting the best material we could find, we undertook two key tasks. The first

in printed reviews was, "It's a little of everything." Even when it was meant favorably, this comment infused our intentionally catholic selection with a dilettantish air. In fact, we had picked works as if we were engaged in the crucial but impossible task of rounding up the animals for the ark. It all had to be there because video is profligate and promiscuous. To have had fewer or less varied works would have misrepresented the medium. Our festival,

* The selection committee for the 1996 New York Video Festival was Marian Masone, associate programmer, Film Society of Lincoln Center; Gavin Smith, associate editor, Film Comment; and the author of this article, Graham Leggat, a writer and film and video programmer who edits *The Journal of Temporary Art*.

then, was not a laissez-faire anthology. It was an explosion run backwards, the sudden coming together of disparate things.

It included MEDEA (1988), a seldom-seen television work by Danish film director Lars van Trier; THE WOLVES (1995), an astonishingly beautiful and dreamlike feature-length experimental video by Spain's Francisco Ruiz de Infante; an evening of music videos by Germany's Marcus Nispel, who presented and discussed his work with critic Armond White; single-channel works by artists Alex Bag (USA), Gillian Wearing (England), and Grazia Toderi (Italy); political documentaries on Russian nationalist Vladimir Zhirinovsky and the Red Brigades by, respectively, Pawel Pawlikowski (UK) and Marco Bellochio (Italy); highly manipulated, effects-laden work by John Maybury (England);

personal explorations of gay life by Tsai Ming-liang (Taiwan) and Jay Corcoran (USA); and many other pieces.

Wide-ranging as our choices were, we felt it was important to have coherent programs organized around specific themes. We presumed that the straightforwardness of these themes— FAMILY LIFE was about family life; ATTITUDE ADJUSTMENT examined the uneasy intersection of the personal and the social, and so on—would provide a center of gravity for several diverse pieces. We had no preconceived ideas about these programmatic categories prior to reviewing submissions. Instead we responded directly to what we saw together, working combinations of tapes until we hit on the right one. Early ideas for programs like Bad Religion, Girls! Girls! Girls!, and Old Men and Cars quickly fell away, and their con-

stituents (i.e. Bob Paris's THE HEALING; Doug Aitken's AUTUMN and Elizabeth Subrin's SWALLOW; and Tony Mendoza's MY FATHER'S LUNCH, respectively) were reconfigured into more sophisticated categories.

Sometimes a group of three or four tapes suggested a promising direction, so we would then search for, and re-examine, others to flesh out the theme. SINK/NECK/TEAR/FIST/MOUTH by Adam Ames, CONSPIRACY OF LIES by Nelson Hendricks, and STANLEY by Tim Matheson formed the early nucleus of the nine-tape slate Twisted, "a lexicon of lunacy, a miscellany of madness." And the ten-tape program Public Domain, which explored "the psychosocial implications of our experience of public space and the ways in which surveillance and spectatorship affect our relationship to it,"

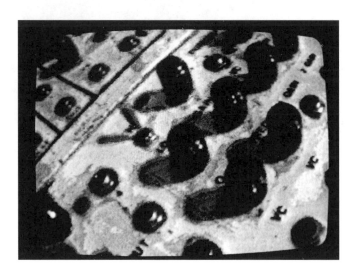

KRISTIN LUCAS, CABLE XCESS, 1996, video still.

164

LAURA WADDINGTON, ZONE, video still.

gathered around Chris Petit's SUR-VEILLANCE, The Bureau of Inverse Technology's SUICIDE BOX, and Laura Waddington's ZONE.

In at least one other case we built a whole car around a steering wheel that delighted us: Mark Bain's astonishing ROTODYNAMICS IN 3-D drew in seven more works, including Kristin Lucas's superb WATCH OUT FOR INVISIBLE GHOSTS, to form the eight-tape OVER-LODE, a "travelogue for cyborgs, or a self-help manual for those troubled (or excited) by the prospect of their imminent disappearance inside their own technology."

Though we had been reviewing tapes for some months, most of the curatorial activity took place over five days. The process was intensive yet supple and conversational, and during

it, two significant developments took place. First, we abandoned the tendency—inherited, I think, from programming film—to rely on one or two long works to carry a program. Instead we created a hive of works, alive with meaning. Second, all at once we saw how absolutely brilliant very short video work can be, revealing, among other things, the unassuming artlessness with which video captures the surrealism of everyday life. More than sixty of the eighty-plus tapes in the program were less than twenty minutes long, and at least half of these were less than ten minutes long. Many were so simple and lovely that they were like great hit singles: the best three-and-a-half minutes of your life. Even better, they had the intrinsic appeal of found objects. And, like found objects, they defeated

in large part any impulse to wholesale commodification. Outside of the realm of video festivals—a marginalized circuit if ever there was one—there is little call for one-off short videos, especially works like Ann MacGuire's JOE DiMAGGIO 1,2,3 and Tracy Wohlgenant's MEXICAN BABY DREAMS that make transparent the material conditions of their production.

Video is cheap and many of these short works obviously cost very little to make. As commodities, they are worthless. In almost every other aspect, they are sublime. They constitute video at its best: something that belongs in no rational, much less lucrative, economy and that bears only passing resemblance to established art forms. Something gorgeous, useless, and as yet undefined.

ALLEN ÄHNLICH, KEINEM GLEICH

GRAHAM LEGGAT

DAS NEW YORK VIDEO FESTIVAL 1996*

In den ersten vier Jahren wurde das *New York Video Festival* im Sonderprogramm des angesehenen *New York Film Festival* gezeigt. Das hatte zur Folge, dass ziemlich unglückselige Vergleiche angestellt wurden, denn Film und Video sind zwei Paar Stiefel, auch wenn sie auf den ersten Blick manches gemeinsam haben: Sie unterscheiden sich, was Produktion, Vertrieb und Präsentation betrifft; sie haben eine grundlegend andere Geschichte; sie bedienen sich je völlig verschiedener Technologien – Photographie und Elektronik –, um Bilder einzufangen und wiederzugeben, und auch die Grammatik ihrer Bildsprachen ist verschieden, d. h. Bildauswahl, Komposition, Beleuchtung, Kamera-

bewegung und visuelle Textur des einen Mediums können nur mit grösster Anstrengung überzeugend denen des anderen angeglichen werden. Ausserdem gehen die beiden Medien grundsätzlich anders mit ihrem Material um: Während im Film die Sujets dank der Macht und der Flüchtigkeit von Träumen oder Mythen «vergoldet» und mit einer Aura der Unsterblichkeit umgeben werden, bleiben die Helden des Videos ganz gewöhnliche Sterbliche und besitzen vor allem auch keinerlei Autorität, im Gegenteil, meistens zeichnen sie sich gerade durch ihre Alltäglichkeit aus.

Es war deshalb nur zu begrüssen, dass das *Video Festival 1996* ins *Lincoln Center Festival* integriert wurde, in ein Sommer-Potpourri aus Oper, Theater, Konzerten und anderen live performances, ein sehr viel abwechslungsreicheres Programm also, was dem Video-Festival nur zugute kam. Die naheliegenden, aber irrigen Vergleiche mit dem Film drängten sich weniger auf, während die Affinitäten des Videos zur Performance stärker

hervortraten. Zu nennen wäre da der von jeher beliebte Einsatz des Videos zur Dokumentation von Performances; ferner die Entwicklung eigentlicher Video-Genres als Folge dieser direkten Konfrontation mit der Kamera, etwa des Videotagebuchs, des Bekennervideos, der Reportage oder der dramatischen Inszenierung; und schliesslich die bereits erwähnte Eigenart dieses Mediums, sein Sujet nicht zu überhöhen, sondern transparent zu machen. Ein Schauspieler, zum Beispiel, bleibt im Video viel deutlicher als solcher erkennbar, und der Zuschauer gibt daher seine kritische Distanz nicht so leicht auf.

Aber allein die Tatsache, dass eine Sorte fragwürdiger Assoziationen durch eine andere ersetzt wurde, machte den neuen Schauplatz noch nicht zur glücklichen Fügung. Dem Publikum die Gleichwertigkeit von Video und Performance suggerieren zu wollen, wäre witzlos, denn schliesslich hat Video mit Performance nicht mehr zu tun als mit Film. Und trotz der hartnäckig sich behauptenden Ten-

* Zum Auswahlkomitee des *New York Video Festival 1996* gehörten Marian Masone, Mitprogrammgestalter der Film Society des Lincoln Center, Gavin Smith, Mitherausgeber von *Film Comment,* sowie der Autor dieses Artikels, Graham Leggat, Film- und Videoprogrammgestalter und Herausgeber des *Journal of Temporary Art.*

LARS VAN TRIER, MEDEA, 1988, Videostill.

denz, Video als künstlerische Version des grossformatigen Fernsehens zu betrachten – was das Video-Festival bietet, hat nichts mit Fernsehen zu tun; auch nichts mit irgendeiner Ein- oder Mehrkanal-Installation in einer Galerie, mit einem Spaziergang durch interaktive Landschaften oder mit dem Warten auf das Erscheinen einer Web-Seite auf dem Computerbildschirm. Video kann zwar jederzeit in die Nähe dieser Medien oder Erfahrungen geraten – eines seiner charakteristischen Merkmale ist ja gerade die Verschmelzung verschiedener Medien: Film, Performance, Fernsehen, Plastik, digitale Kunst, usw. Video hat von allen etwas und ist doch mit keinem gleichzusetzen, denn in seiner subtilsten und vielleicht ehrlichsten Form ist Video eigentlich gar keine Kunst. Am zutreffendsten wäre wohl die Bezeichnung Semi-Kunst. (Ob das im Medium selbst begründet ist, oder nur einen augenblicklichen Stand der Entwicklung markiert, ist schwer zu sagen.) Es weckt häufig falsche Hoffnungen oder stösst auf Unverständnis, ja Feindseligkeit. Das ist um so be-

klagenswerter, als das «Zwischending» Video, flüchtig und unfertig wie es ist, sich als ein faszinierendes und für alle Arten von Spekulationen und Explorationen offenes Medium erwiesen hat.

Von diesen Überlegungen liessen wir uns bei der Programmgestaltung des *New York Video Festival* leiten. Neben der Präsentation der besten verfügbaren Arbeiten steckten wir uns zwei weitere Ziele: erstens, einen Überblick zu vermitteln über die ästhetischen Bereiche, die das Video für sich erschlossen hat; zweitens, herauszufinden, was Video war, als es noch nicht alles mögliche sein konnte, wozu es fähig war, als es noch «es selbst» war.

Von Ende Juli bis Anfang August sahen wir uns zehn Tage lang mehr als achtzig Arbeiten von ungefähr sechzig Künstlern aus Europa, Asien und den USA an, die in fünfzehn Themenkreise eingeteilt wurden. Wir berücksichtigten jedes Genre und jede Form. Die Bemerkung, die am häufigsten in den Kritiken auftauchte, lautete: «Es hat von allem etwas.» Auch wenn er positiv gemeint war, verlieh dieser Kommen-

tar unserem Anspruch auf Universalität den Anschein des Dilettantismus. Tatsächlich gingen wir bei der Auswahl so vor, als gälte es, für die Arche Noah von jeder Tierart ein Exemplar einzufangen, eine ebenso entscheidende wie unmögliche Aufgabe. Alles musste vertreten sein, denn das Ausufernde und Promiskuitive gehören nun mal zum Video. Mit weniger oder nicht so breit gestreuten Arbeiten wäre das Medium nicht adäquat repräsentiert worden. Unser Festival war also keineswegs ein zufälliges Sammelsurium, sondern eine rückwärts abgespulte Explosion: die plötzliche Vereinigung völlig disparater Dinge.

Vertreten waren: MEDEA (1988), eine selten gezeigte Arbeit des dänischen Filmregisseurs Lars van Trier fürs Fernsehen; DIE WÖLFE (1995), ein erstaunlich ästhetisches, traumähnliches Experimental-Video in Spielfilmlänge des Spaniers Francisco Ruiz de Infante; abendfüllende Musikvideos des Deutschen Marcus Nispel, der seine Arbeiten selbst vorstellte und mit dem Kritiker Armond White diskutierte;

Einkanal-Videos der Künstler Alex Bag (USA), Gillan Wearing (England) und Grazia Toderi (Italien); politische Dokumentarvideos über den russischen Nationalisten Wladimir Schirinowski und die Roten Brigaden, von Pawel Pawlikowski (Ukraine) bzw. Marco Bellochio (Italien); die mit allen Tricks und Spezialeffekten ausgestatteten Arbeiten von John Maybury (England); die persönlichen Erkundungen schwuler Lebensweisen von Tsai Ming-liang (Taiwan) und Jay Corcoran (USA) und viele andere Arbeiten.

Da unsere Auswahl ein so breites Spektrum umfasste, hielten wir es für wichtig, zusammenhängende Programme zu spezifischen Themenkreisen zu erstellen. Wir gingen davon aus, dass das Weitgefasste dieser Themen – *Family Life* hatte das Familienleben zum Gegenstand, *Attitude Adjustment* untersuchte den Konfliktbereich zwischen Individuum und Gesellschaft usw. – unterschiedliche Arbeiten in sich vereinen könnte.

Wir liessen uns bei diesen Programmkategorien nicht von Vorstellungen leiten, die wir bereits vor der Auswahl entwickelt hatten. Wir reagierten vielmehr auf das, was wir uns zusammen anschauten, und probierten dann so lange verschiedene Kombinationen von Bändern aus, bis wir auf die richtige stiessen. Frühere Programmideen wie *Bad Religion, Girls! Girls! Girls!* oder *Old Men and Cars* fielen schnell wieder weg, und die Arbeiten, die darunter fielen (Bob Paris' THE HEALING, Doug Aitkens AUTUMN, Elizabeth Subrins SWALLOW und Tony Mendozas MY FATHER'S LUNCH u.a.), wurden unter differenzierteren Kategorien eingeordnet.

Manchmal wies uns eine Gruppe von drei oder vier Bändern in eine vielversprechende Richtung, so dass wir unter diesem neuen Gesichtspunkt andere Bänder suchten und überprüften, um das Thema auszugestalten. SINK / NECK / TEAR / FIST / MOUTH von Adam Ames, CONSPIRACY OF LIES von Nelson Hendricks und STANLEY von Tim Matheson bildeten den Kern, der aus neun Filmen bestehenden Kategorie *Twisted* – ein «Lexikon der Geistesverwirrung, ein Potpourri von Verrücktheiten». Und der zehn Bänder umfassende Themenkreis *Public Domain*, der «die psychosozialen Implikationen unserer Erfahrung des öffentlichen Raums erforscht und der Frage nachgeht, wie sich unsere Beziehung zu ihm durch Überwachung und durch unseren Zuschauerstatus verändert», bildete sich um SURVEILLANCE von Chris Petit, SUICIDE BOX von *The Bureau of Inverse Technology* und ZONE von Laura Waddington herum.

In einem Fall bauten wir auch «ein ganzes Auto um ein Lenkrad herum, das unsere Begeisterung geweckt hatte»: Mark Bains erstaunliches 3-D-Video ROTODYNAMICS zog sieben weitere Arbeiten nach sich, unter anderem Kristin Lucas' hinreissendes WATCH OUT FOR INVISIBLE GHOSTS, um schliesslich das aus acht Bändern bestehende Thema *Overload* zu bilden, einen «Reisebericht für Cyborgs oder eine Anleitung zur Selbsthilfe für solche, die die Aussicht auf ihr drohendes Verschwinden in den eigenen Technologien erschreckt (oder begeistert)».

Obwohl wir uns einige Monate lang unentwegt Bänder angeschaut hatten, beschränkte sich die organisatorische Arbeit im wesentlichen auf fünf Tage. Der Prozess war intensiv, lebendig und kommunikationsorientiert. Zwei wichtige Entwicklungen fanden dabei statt: Zunächst verabschiedeten wir uns von der – wohl von der Filmprogrammgestaltung übernommenen – Tendenz, ein Programm auf ein, zwei längeren Arbeiten aufzubauen. Statt dessen bündelten wir einen ganzen Schwung von Arbeiten zu einem prallen Packen voller Bedeutung. Zweitens entdeckten wir plötzlich, wie faszinierend ganz kurze Videoarbeiten sein können, da sie u.a. zeigen, mit welcher Leichtigkeit sich die Absurditäten des Alltags einfangen lassen.

Mehr als sechzig der über achtzig Bänder im Programm waren kürzer als zwanzig Minuten, und gut die Hälfte davon war nicht einmal zehn Minuten lang – manche waren so einfach und überzeugend wie ein grosser Single-Hit: die besten dreieinhalb Minuten deines Lebens. Noch interessanter war, dass sie den Charme eines *objet trouvé* besassen. Und wie ein solches widersetzten sie sich allfälligen Regungen, sie *en gros* zu vermarkten. Ausserhalb von Video-Festivals, die wahrhaftig selten genug sind, besteht so gut wie kein Bedarf an einzelnen Kurzvideos, an Arbeiten wie Ann MacGuires JOE DiMAGGIO 1,2,3 oder Tracy Wohlgenants MEXICAN BABY DREAMS, die die materiellen Bedingungen ihrer Entstehung transparent machen.

Video ist ein billiges Medium, und viele dieser kurzen Arbeiten haben offensichtlich nicht viel gekostet. Als Ware sind sie wertlos. Doch in jeder anderen Beziehung sind sie unschlagbar. Sie zeigen Video von seiner besten Seite: als etwas, was nicht den rationalen, und schon gar nicht den gewinnorientierten Gesetzen der Wirtschaft folgt und nur flüchtige Ähnlichkeit mit etablierten Kunstformen hat. Etwas Grossartiges, Unnützes und bis heute nicht eindeutig Definiertes.

(Übersetzung: Uta Goridis)

168

BALKON

Vom Art- zum Lifestyle... und wieder zurück

CHRISTOPH DOSWALD

Seit sechs Jahren arbeitet der Schweizer Künstler Ian Anüll (49) kontinuierlich an einer bis heute nicht abgeschlossenen Werkgruppe mit dem Titel STYLE. Dem Zyklus kommt vor allem im Zusammenhang mit den auseinanderdriftenden Interpretationsmustern, mit denen sein Schaffen bislang bedacht wurde, exemplarische Bedeutung zu. Das STYLE-Projekt verkörpert gewissermassen prototypisch die Anüllsche Kunstpraxis zwischen Performance, Aktion, Appropriation und kontextualisierender Strategie.

Die Verschränkung alltags- und hochkultureller Grenzzonen und die Hinterfragung diesbezüglicher systemimmanent-marktpolitischer Mechanismen stehen im Vordergrund der von Anüll betriebenen künstlerischen Untersuchungen. Ohne zu moralisieren, legt er seinen Finger präzise – und oftmals mit slapstickhaftem Schalk – auf die Wunde jener aufklärerischen

CHRISTOPH DOSWALD ist Kunstkritiker und Ausstellungsmacher. Er lebt in Baden, Schweiz.

Kunstauffassung, die durch die gängige Marketing-Ästhetik[1] der späten 80er Jahre in ihren Grundfesten erschüttert wurde. Sei es das eingezirkelte R der *Registered Trademark* (®) als Freilegung des «immanenten Logozentrismus von Produkten der Kulturindustrie»,[2] sei es das zum Warenzeichen avancierte Symbol des gekreuzigten Christus, INRI,[3] oder das Kunstwerk, das sich prononciert als PRODUKT zu erkennen gibt – Anüll gelingt mit seiner assoziativen Dialektik eine neue Sicht auf Werte, Stereotype und Mechanismen, welche die (Kunst-) Gegenwart prägen. Dass sich Anüll der Vokabel *Style* annimmt, erscheint in diesem Zusammenhang als folgerichtige Fortsetzung seiner vorangegangenen Untersuchungen. Die Verschmelzung der aktuellen kunstkritischen Irrelevanz mit der alltags- und werbesprachlichen Beliebigkeit und Beliebtheit der Vokabel legt den diffundierenden Regelkreis von Hoch- und Alltagskultur offen –

vom Art- zum Lifestyle und wieder zurück.

Das Reisen als berufsspezifische Künstlertätigkeit wie auch als «prägende Voraussetzung für Anülls Schaffensweise»[4] markiert den beiläufigen, aber dennoch bewusst gewählten Ausgangspunkt seiner prozesshaften Stilstudie. Immer wenn Anüll die Koffer packt, um irgendwo auf dieser Welt seine Werke auszustellen, fertigt er vorher eine kleine Leinwand, die gerade noch in seinem Handgepäck Platz findet. Darauf malt er – in wechselnder typographischer Form und dem Idiom der Destination entsprechend – das Wort «Stil». Im jeweiligen Land angekommen (bis heute besuchte er die USA, Australien, Frankreich, Kanada, England, Thailand, Brasilien, Island, Italien, Deutschland, Bolivien und Indien), begleitet die bemalte Leinwand den Künstler auf seinen Spaziergängen. Beim Durchstreifen der Strassen, Plätze, Wohnungen, Bars, Ämter und Landschaften sucht er systematisch nach dem präzisen Ort für das Bild, wo dann die aus dem Atelier kommende

Stilstudie plaziert, rekontextualisiert und in dieser vom Künstler explizit ausgewählten Umgebung photographiert wird. Die Leinwand verbindet sich mit dem situativen Kontext zu einer gezielt herbeigeführten, nur Sekunden dauernden Performance im öffentlichen Raum, um – als photographische Inszenierung, die via Laser-Kopierer auf eine Leinwand projiziert wird – dem ursprünglichen Medium und dem Warenkreislauf der Kunst wieder zugeführt zu werden. Das derart erstellte Kunst-Endprodukt birgt in seiner unverdächtigen, weil klassischen Erscheinungsform – Farbe auf Leinwand mit Chassis – ein verdichtetes Kondensat der ephemeren künstlerischen Praxis, wie sie Ian Anülls Werk auszeichnet.

Aus dem von Aggregatszustand zu Aggregatszustand pendelnden Verfahren spricht der Wille, Genregrenzen und die Limiten der Technik wie auch der hergebrachten Repräsentationsformen von Kunst zu durchbrechen. So besuchte Anüll im Sommer 1995 einen Londoner Vorort. Die Fassaden der Backsteinhäuser waren heruntergekommen, das Ambiente trist. Die blaue Leinwand mit weisser Typographie plazierte der Künstler dort, wo ursprünglich wohl eine Hinweistafel hing. Trotz materieller Absenz ist die instruktive Anweisung für die Öffentlichkeit noch spürbar – ein ausgeleierter, verblichener Holzrahmen legt relikthaft Zeugnis ab. Daneben verkündet ein Plakat mit weissen Lettern auf schwarzem Grund: YOU CAN'T BUY CREDIBILITY (Glaubwürdigkeit kann man nicht kaufen). In der Konfrontation der formal analogen, inhaltlich jedoch komplementären Botschaften schafft Anüll ein intensives Moment paradoxer Spannung, das die Trauer um den Verlust idealistischer Weltbilder und das Wissen um das Verschwinden auratischen Kunstschaffens auf den Punkt bringt.

Das Projekt ART IN SAFE (1989) verdeutlicht Anülls Intention, die dem Kunst-Warencharakter eingeschriebenen Repräsentations- und Rezeptionsmuster zu konterkarieren. In den Tresorräumen einer Genfer Bank deponierte er dem Format der Privatsafes entsprechende Werke von Joseph Beuys, Guillaume Bijl, Daniel Buren, Les Levine, Hermann Nitsch, Dennis Oppenheim, Meret Oppenheim und Franz Erhard Walther. Ausstellungsbesucher, welche die in der Galerie Ruine angekündigten Werke besichtigen wollten, mussten sich mit den dort vorhandenen Safeschlüsseln zur Bank begeben, um die Kunst im Beisein eines Bankbeamten einzusehen. Wollte jemand eines der Werke erwerben, wurde ihm nicht die Kunst, sondern stellvertretend dafür der Schlüssel ausgehändigt. Sowohl die Praxis des Ausstellens – die mit dem Schaffen von Öffentlichkeit verbunden ist – wie jene des Kunstsammelns und des Kunstinvestment – die sich durch Diskretion und Geheimniskrämerei auszeichnet – wurden durch diese De- und Rekontextualisierung physisch erfahrbar.

Mit seinen subversiven Appropriationen und dem oftmaligen Verwenden von gängigen Typographien oder Signeten verweigert sich Anüll der künstlerischen Handschrift. Mit Vorliebe bearbeitet er die Logotypen verbreiteter Markenzeichen, wie etwa jenes der Schweizer Detailhandelskette Migros. Oder er orakelt mit gängigen Abkürzungen aus dem Wissenschafts- oder Soziologenjargon. LSD, das Kürzel einer Droge, welche einer ganzen Generation – zu der auch Anüll zählt – zum Inbegriff der Erweiterung der Kreativitätsgrenzen geworden war, erfährt in Anülls aktualisierender Lesart (LAUSANNE SANS DOMICILE) im Gegensatz zu jener der Beatles (Lucy in the Sky with Diamonds) eine ernüchternde, sozialkritische Neudeutung. Mit dem Hinterfragen und Aktualisieren der Begriffsbedeutung – vom ehemaligen Medikament in den schwärmerischen Dunstkreis der Popkultur und von da in die Niederungen der gesellschaftlichen Randzonen – zeigte Anüll schon lange vor dem Fall der Berliner Mauer auf, dass frommen Heilsversprechen und utopischen Lehren im Rahmen einer immer komplexeren Alltagswirklichkeit nur mit spielerisch assoziativen Strategien begegnet werden kann und dass in der gescheiten, manchmal humorvollen Differenz der Wahrnehmung eine mögliche (Über-)Lebensmaxime zu orten wäre.

1) *Marketing esthetic* ist ein Begriff, den Anüll mit einer Werkgruppe 1987 prägte. Rot übermalte Dollarnoten verdeutlichten den zunehmenden Warencharakter von Kunst im Rahmen des Kunstmarktbooms der 80er Jahre.
2) Hans Rudolf Reust; «Art in Safe», in: *Ian Anüll*, Ausstellungskatalog, 21. Biennale São Paulo 1991, S. 82.
3) Anüll benutzte die religiös-typographische Ikone Mitte der 80er Jahre in unterschiedlichem Kontext. Einerseits übermalte er damit gefundene Devotionalienbilder vom Flohmarkt und erzeugte mit der doppelten Konnotation einen Effekt der zynischen, weil überzogenen Affirmation; anderseits provozierte er einen Prozess der wechselseitigen Dekontextualisierung, indem er handelsübliche Waren wie beispielsweise einen mit Blumenmuster bedruckten Stoff dem christlichen Logotyp gegenüberstellte.
4) Bernhard Bürgi, «Ian Anüll», in: *Ian Anüll*, Ausstellungskatalog, 21. Biennale São Paulo 1991, S. 8.

IAN ANÜLL, STIL / STYLE:
Furka, 1995.

Bratislava, 1995.

Panjim, 1991

London, 1995.

Buffalo, 1996.

Los Angeles, 1995.

From Art to Lifestyle...
and Back Again

CHRISTOPH DOSWALD

Six years ago Swiss artist Ian Anüll embarked on a series of works entitled STYLE. This series might be said to stand for his oeuvre as a whole, especially in view of the widely divergent interpretations to which his work has been subjected in the past. The STYLE project prototypically embodies Anüll's art practice, situated between performance, action, appropriation, and contextualizing strategies.

Disregard of the border between popular and high culture and exposure of attendant system-immanent marketing and political mechanisms are the driving issues behind Anüll's artistic investigations. Without moralizing, he puts his mischievous finger precisely on the wound of the enlightened artistic attitude that was thoroughly shattered by the "marketing esthetic"[1] of the late eighties. Whether it is the encircled "R" of the Registered Trademark that exposes the "immanent logocentrism of the products of the culture industry,"[2] or the symbol of Christ crucified promoted to a trademark (IN-RI)[3], or the work of art that makes

a pointed appearance as a "PRODUKT," Anüll's associative dialectic always succeeds in casting new light on the defining values, stereotypes, and mechanisms of (art) today. In this context, his adoption of the term "style" follows as a logical consequence of earlier investigations. The merging of current art-critical irrelevance with the arbitrariness and popularity of the term in the vernaculars of daily life and advertising reveals the diffusive circuit of high and low culture—from art to lifestyle ... and back again.

Traveling as an occupational, artistic activity and as a "defining prerequisite of Anüll's method"[4] is the casual yet conscious point of departure of the artist's process-oriented studies in style. Every time Anüll packs his bags to present his work somewhere on this planet, he takes along a canvas the size of his hand luggage, on which he has painted the word "style" in a typography and language appropriate to his destination. So far he has been to the United States, Australia, France, Canada, England, Thailand, Brazil, Iceland, Italy, Germany, Bolivia, and

India. Wherever he goes, the canvas is his constant companion. Roaming the streets, wandering through squares, apartments, bars, government offices, and landscapes, he systematically seeks the perfect site for his studio-made study of style. The picture is then placed, recontextualized, and photographed in the surroundings that he has chosen for it. Having joined forces with the situational context for the few seconds of its consciously generated performance in public space, the canvas is then repossessed by the original medium; in other words, it is converted into a photographic scenario on canvas, via Laser copier, and thus returned to the commodity loop of art. The innocuous, classical appearance of the artistic endproduct—colors on a canvas with a support—yields a compressed condensation of the ephemeral artistic practices that typify Ian Anüll's oeuvre.

This procedure of moving from aggregate state to aggregate state speaks of the desire to explode the restrictions of genre, the limitations of technique, and the traditional forms of representation in art. In the summer of 1995, for example, Ian Anüll visits a suburb of London. The facades of the

CHRISTOPH DOSWALD is an art critic and curator who lives in Baden, Switzerland.

PARKETT 48 1996

172

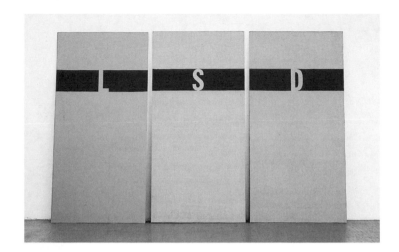

IAN ANÜLL, LSD (LAUSANNE SANS DOMICILE),
1994, Acryl und diverse Materialien auf
3 Tafeln zu je 190 x 90 cm / acrylic and mixed media
on 3 panels, 47¾ x 35½" each.
(PHOTO: PATRICK ROY, LAUSANNE)

brick houses are dilapidated; the atmosphere is dreary. The artist places his blue canvas with the white lettering in a spot where another sign must once have hung. Despite its physical absence, the directive for the public is still tangible—in the shape of a twisted and faded wooden frame. Next to it, a poster with white letters on a black background proclaims: YOU CAN'T BUY CREDIBILITY. By confronting messages that are analogous in form but complementary in content, Anüll creates an intense moment of paradoxical tension that pinpoints the lamentable loss of idealistic world images and the realization that auratic art is on its way out.

ART IN SAFE (1989) demonstrates Anüll's intention of counteracting patterns of representation and reception that are inscribed in the commodity-character of art. In the safe of a bank in Geneva, the artist placed safe-deposit-sized works by Joseph Beuys, Guillaume Bijl, Daniel Buren, Les Levine, Hermann Nitsch, Dennis Oppenheim, Meret Oppenheim, and Franz Erhard Walther. Visitors who wanted to see the works announced at the Ruine Gallery had to pick up the safe-deposit key at the gallery, go to the bank, and look at

them in the presence of a bank employee. People who wanted to buy one of the works were not given the work but rather the key by way of proxy. Thus, through decontextualization and recontextualization, the practices of art display—closely associated with the creation of a presence in public—as well as those of art collection and art investment—characterized by discretion and secrecy—became a physical experience.

Through subversive acts of appropriation and the frequent use of conventional typographies and logos, Anüll forfeits an artistic signature. He often works with familiar logos such as that of the Swiss chain store, Migros, and plays the oracle with standard scientific or sociological abbreviations. LSD, the quintessential mind-blowing liberator of creative energy for the generation to which Anüll belongs, is soberingly revamped as LAUSANNE SANS DOMICILE (Homeless in Lausanne)—a great contrast to the Beatles' version, *Lucy in the Sky with Diamonds.* Long before the Berlin wall came down, Anüll's critical, socially conscious reinterpretation of the concept—from pop culture's rapturous consumption

of the substance to the depths of marginal society—demonstrated that pious promises of salvation and utopian visions can only be encountered with playful, associative strategies in the ever more complex context of daily reality, and that a potential philosophy of life(-saving) can, in fact, be sighted in clever and sometimes humorous differences of perception.

(Translation: Catherine Schelbert)

1) "Marketing esthetic" is a term used by Anüll in a series of works from 1987. Dollar bills overpainted in red demonstrated the increasing commodification of art during the art-market boom of the eighties.
2) Hans Rudolf Reust, "Art in Safe" in: *Ian Anüll,* ex. cat., 21st Biennale São Paulo, 1991, p. 82.
3) Anüll used religious, typographical icons in several contexts in the eighties. He overpainted religious pictures bought at flea markets—an act of cynical affirmation through the double connotation of overpainting. On the other hand, he provoked a process of mutual decontextualization by juxtaposing commercial goods, such as a flower-print fabric, with the Christian logotype.
4) Bernhard Bürgi, "Ian Anüll" in: *Ian Anüll,* ex. cat., 21st Biennale São Paulo, 1991, p. 8.

Who's afraid of Wall, Sherman & Ruff?

Banque Bruxelles Lambert (Suisse) S.A., Genève.
(PHOTO: SERGIO ANELLI)

Beinahe wäre es wahr geworden: Eine Bank in einem klar symmetrisch gegliederten, feinen Gebäude von Mario Botta, das seine Besucher konfrontiert mit dem Besten, was heute Künstler an Photographie produzieren. Am Eingang ein Diptychon von Jeff Wall – SOME BEANS (Einige Bohnen, 1990) und AN OCTOPUS (Eine Krake, 1990); in den um einen elliptischen Innenhof herum angeordneten Gängen Kunst von Robert Frank, Cindy Sherman, Hiroshi Sugimoto, Richard Prince, Nan Goldin, Sigmar Polke und anderen; in einem Sitzungszimmer grosse Porträts von Thomas Ruff und Hundebilder von Rosemarie Trockel; in einem andern, im Dachgeschoss, die Nachtansichten der Stadt Athen von Andreas Gursky, in Beziehung gebracht mit der Aussicht auf die Stadt Genf.

Wieviel Wirklichkeitsbezug ist Kundschaft und Belegschaft einer Bank zumutbar? Eine Frage, die den ängstlichen neuen Generaldirektor und die engagierte, sich auf keine lauen Kompromisse einlassende Sammlerin Marion Lambert, Gattin des Verwaltungsratspräsidenten, entzweite und das schöne Projekt zunichte machte. Es hätte ein strahlendes Beispiel sein können.

Pikantes Detail: Auf des Direktors Zensurliste war auch Louise Lawlers Photographie eines Genfer Salons mit Bild von Ferdinand Hodler (DIE LIEBE, 1908), das als zu obszön empfunden wurde.

B. C.

It almost came true: A bank housed in a refined, clearly symmetrical building by Mario Botta that confronts its visitors with the very best in contemporary photography. In the lobby, a diptych by Jeff Wall, SOME BEANS (1990) and AN OCTOPUS (1990). In the corridors around an elliptical atrium works by Robert Frank, Cindy Sherman, Hiroshi Sugimoto, Richard Prince, Nan Goldin, Sigmar Polke, and more. In a conference room, Thomas Ruff's large-format portraits and Rosemarie Trockel's pictures of dogs. In a penthouse conference room, Andreas Gursky's night views of Athens making contact with the view overlooking the city of Geneva.

How much reference to reality can the clients and staff of a bank cope with? This question divided the anxious new director and the committed, uncompromising collector, Marion Lambert, whose husband presides over the Board of Directors—and dashed the project. It could have been a shining example.

A choice tidbit: The director's list of censored works included Louise Lawler's photograph of a Genevan salon because it shows an indecent painting on the wall: L'AMOUR (1908) by Ferdinand Hodler.

B. C.

LOUISE LAWLER, SALON HODLER,
1992/93,
cibachrome, 49¼ x 58¼" / 125 x 147,9 cm

Für weitere Informationen / For additional information, contact: Collection LAC, Genève, Fax: ++41 22 346 20 92.

IES IST KEINE SPITALTÜR, son-
rn die Tür zum Lift im Parkett Ver-
g, Zürich / THIS IS NOT A HOSPI-
AL DOOR but the door to the ele-
tor at Parkett Publishers, Zurich.
HOTO: WILMA PARKER)

Robert Frank als Szenen-Photograph während der Dreharbeiten
zum Film Steibruch (mit Heiri Gretler und Maria Schell), 1942,
im Römersteinbruch von Würenlos, wo Emma Kunz im selben
Jahr ihr Heilgestein entdeckte (vgl. Parkett 47, S. 7 ff.).
Robert Frank shooting stills in 1942, for the film Steibruch, (with
Heiri Gretler and Maria Schell) on the set in the Roman quarry of
Würenlos, where Emma Kunz found her healing rock formation
that same year (see Parkett 47, pp. 14–18).

Silver gelatin print.
(PHOTO: NATIONAL GALLERY OF ART, WASHINGTON,
ROBERT FRANK COLLECTION, GIFT OF ROBERT FRANK)

Garderobe
'gär-,drōb

Letter to The Editor
Congratulations!

An encouraging development notice-
able in the last few issues of Parkett has
converted me from a faithful to an avid
reader of your publication. More and
more contributors are intrepid enough
to speak up without the seemingly man-
datory quotation of the distinguished
thinkers in our fast dying century.
Roberta Cavutt, Dallas, Texas.

Eine Lanze für das Zitat

m schwierigen Metier des brillanten Kritikers gehört es, brillant zu schrei-
n, aber auch brillant zu zitieren und brillant Zitiertes zu zitieren.
r Internationale Quotelovers Club (IQC) empfiehlt folgende Checklist:
Habe ich mindestens einen der «Grossen Drei» (Barthes, Lacan, Virilio)
iert?
Wenn nicht, habe ich ersatzweise wenigstens zwei der folgenden Autoren
wähnt: Adorno, Bachelard, Barthes, Baudrillard, Benjamin, Deleuze, Der-
da, Freud, Heraklit, Nietzsche, Marshal McLuhan, Sartre, Sontag, Wittgen-
in?
Habe ich mich als Kenner der schöngeistigen Literatur ausgewiesen? Hier
npfehlen sich wahlweise Zitate von Rainer Maria Rilke, Thomas Wolfe,
alker Percy, José Luis Borges, Walt Whitman, Herman Melville, Henry
mes sowie (insbesondere für amerikanische Autoren): Albert Camus,
scar Wilde, Charles Baudelaire oder – besonders fein – ein deutscher Ro-
antiker (Chamisso, Eichendorff, E.T.A. Hoffmann).
Enthält mein Text mindestens ein wirklich brillantes Zitat zweiter oder
itter Hand, dessen Eruierung im Original eine echte Herausforderung für
bersetzerin und Redaktion darstellt?
itzliche Hinweise, Ergänzungen und Kommentare zu dieser Checklist er-
ichen den Quotelovers Club unter:
hiffre FY10X, Parkett Verlag, Quellenstr. 27, CH-Zürich.
x 0041 1272 4301

Quotelibet

To do justice to an exacting métier, the scintillating critic must not only pro-
duce scintillating writing but also scintillating quotations and above all quota-
tions of others' scintillating quotations.
The International Quotelovers Club (IQC) recommends the following check-
list:
1. Have I quoted one or more of the "Three Greats"—Barthes, Lacan, Virilio?
2. If not, have I managed to mention at least two of the following writers:
Adorno, Bachelard, Barthes, Baudrillard, Benjamin, Deleuze, Derrida, Freud,
Heraclitus, Marshal McLuhan, Nietzsche, Sartre, Sontag, Wittengstein?
3. Have I demonstrated my profound knowledge of belles lettres? Proof of the
pudding is a selective smattering of the following quotable notables: Rainer
Maria Rilke, Thomas Wolfe, Walker Percy, José Luis Borges, Walt Whitman,
Herman Melville, Henry James and—for American critics in particular—Al-
bert Camus, Oscar Wilde, Charles Baudelaire or, quintessentially, a German
Romantic (Chamisso, Eichendorff, E.T.A. Hoffmann).
4. Does my article contain at least one scintillating second or third hand quo-
tation that poses a near unsurmountable challenge to translator and editor in
researching the original?
The IQC welcomes suggestions, addenda and comments.
Write to
Box FY10X, Parkett Publishers, Quellenstrasse 27, CH-8005 Zurich,
Switzerland. Fax: 0041 1272 4301.

COMPLETE YOUR PARKETT LIBRARY
VERVOLLSTÄNDIGEN SIE IHRE PARKETT-BIBLIOTHEK

OUT OF PRINT / VERGRIFFEN: NO. 1 ENZO CUCCHI, NO. 2 SIGMAR POLKE, NO. 3 MARTIN DISLER, NO. 4 MERET OPPENHEIM, NO. 5 ERIC FISCHL, NO. 6 JANNIS KOUNELLIS, NO. 7 BRICE MARDEN, NO. 8 MARKUS RAETZ, NO. 9 FRANCESCO CLEMENTE, NO. 10 BRUCE NAUMAN, NO. 13 REBECCA HORN, NO. 16 ROBERT WILSON, NO. 19 JEFF KOONS, MARTIN KIPPENBERGER, NO. 27 LOUISE BOURGEOIS, ROBERT GOBER, NO. 30 SIGMAR POLKE, NO. 31 DAVID HAMMONS, MIKE KELLEY, NO. 35 GERHARD RICHTER

For out-of-print issues you can register your name and address with Parkett and you will be notified, if your issue(s) become(s) available on the secondary market / Für vergriffene Bände nimmt der Verlag gerne Ihren Suchauftrag entgegen und macht Ihnen bei allfälliger Verfügbarkeit im Handel ein Angebot.

COLLABORATIONS

LAURIE ANDERSON
DOUGLAS GORDON
JEFF WALL

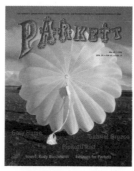

No. 49 - ISBN 3-907509-99-4

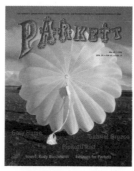

GARY HUME
GABRIEL OROZCO
PIPILOTTI RIST
BOVIER, MUIR, FOGLE, BONAMI
DE ZEGHER, SPECTOR, URSPRUNG
BABIAS, COLOMBO, ANDERSON
INSERT: **RUDY BURCKHARDT**
VINCE LEO: **RUDY BURCKHARDT**
VAN DE WALLE: **CHARLES LONG
& STEREOLAB**
FAYE HIRSCH: **BRUCE CONNOR**
CHRISTOPH DOSWALD: **IAN ANÜLL**
CUMULUS: LEGGAT, SCHNEIDER

No. 48 - ISBN 3-907509-98-6

TONY OURSLER
RAYMOND PETTIBON
THOMAS SCHÜTTE
COOKE, RICHARD, NERI,
LEWIS, GROYS, ALS, RUGOFF,
GOODEVE, SEARLE, MARI, REUST,
WAKEFIELD, LOOCK, JANUS
INSERT: **ZOE LEONARD & CHERYL DUNYE**
JURI STEINER: **EMMA KUNZ**
MAX WECHSLER: **CHRISTOPH RÜTIMANN**
SUSAN MORGAN: **DIANE ARBUS**
CUMULUS: PRINCENTHAL, BOVIER/CHERIX

No. 47 - ISBN 3-907509-97-8

RICHARD ARTSCHWAGER
CADY NOLAND
HIROSHI SUGIMOTO
DEITCHER, SCHAFFNER, FORSTER, MUNIZ
ARMSTRONG, RELYEA, BOGDAN, GOODEVE
NICKAS, BRYSON, RUGOFF, DENSON
INSERT: **JOHN M ARMLEDER**
ROLAND WÄSPE: **ERWIN WURM**
DANIEL BIRNBAUM: **ÖYVIND FAHLSTRÖM**
LES INFOS DU PARADIS: ROBERT FLECK
CUMULUS: MILLER, VETTESE
BALKON: MARTIN HELLER

No. 46 - ISBN 3-907509-96-X

MATTHEW BARNEY
SARAH LUCAS
ROMAN SIGNER
BRYSON, ONFRAY, SEWARD, GOODEVE,
ALTZ, VAN ADRICHEM, SCHORR, FREEDMAN,
JOUANNAIS, BITTERLI, DOSWALD,
VIEWING, WECHSLER, DELAND
INSERT: **ELLIOTT PUCKETTE**
HEIDI GILPIN: **WILLIAM FORSYTHE**
ROBYN McKENZIE: **GEOFF LOWE**
MICHAEL TARANTINO: **CHANTAL AKERMAN**
CUMULUS: McEVILLEY, WAKEFIELD

No. 45 - ISBN 3-907509-95-1

VIJA CELMINS
ANDREAS GURSKY
RIRKRIT TIRAVANIJA
PRINCENTHAL, LEWIS, SILVERTHORNE
SHIFF, CRIQUI, BURCKHARDT, WAKEFIELD
SCHORR, MELO, GILLICK, FLOOD, STEINER
INSERT: **HANS DANUSER**
LES INFOS: LIAM GILLICK & DOUGLAS GORDON
LYNNE COOKE, DAVID DEITCHER
DANIEL KURJAKOVIC: **MARIE JOSÉ BURKI**
NAN GOLDIN: **PETER HUJAR**
NOEMI SMOLIK: **ANDREAS SLOMINSKI**
JASON SIMON: **MARK DION**
LUK LAMBRECHT: **MARK LUYTEN**

No. 44 - ISBN 3-907509-94-3

JUAN MUÑOZ
SUSAN ROTHENBERG
LYNNE COOKE, ALEXANDRE MELO
JAMES LINGWOOD, GAVIN BRYARS
ROBERT CREELEY, INGRID SCHAFFNER
JEAN-CHRISTOPHE AMMANN
MARK STEVENS, JOAN SIMON
INSERT: **ROBERT SMITHSON**
NEVILLE WAKEFIELD
MICHELLE NICOL: **CARSTEN HÖLLER**
HANS-ULRICH OBRIST: **FABRICE HYBERT**

No. 43 - ISBN 3-907509-93-5

LAWRENCE WEINER
RACHEL WHITEREAD
BROOKS ADAMS, FRANCES RICHARD
DIETER SCHWARZ, DANIELA SALVIONI
ED LEFFINGWELL, LANE RELYEA
NEVILLE WAKEFIELD, RUDOLF SCHMITZ
TREVOR FAIRBROTHER, SIMON WATNEY
INSERT: **NAN GOLDIN**
VINCE LEO: **ROBERT FRANK**
CLAUDE RITSCHARD: **MARKUS RAETZ**

No. 42 - ISBN 3-907509-92-7

FRANCESCO CLEMENTE
GÜNTHER FÖRG
PETER FISCHLI / DAVID WEISS
DAMIEN HIRST
JENNY HOLZER
REBECCA HORN
SIGMAR POLKE
HOLLAND COTTER, BORIS GROYS
MAX WECHSLER, DAVID RIMANELLI
JOAN SIMON, GORDON BURN
GILBERT LASCAULT, WERNER SPIES
BICE CURIGER, JEFF PERRONE
G. ROGER DENSON, VIK MUNIZ
DAVE HICKEY

No. 40/41 - ISBN 3-907509-90-0

FELIX GONZALEZ-TORRES
WOLFGANG LAIB
NANCY SPECTOR, SIMON WATNEY,
SUSAN TALLMAN, DIDIER SEMIN,
CLARE FARROW, JEAN-MARC AVRILLA,
THOMAS McEVILLEY
CLAUDE GINTZ: **GABRIEL OROZCO**
WALTER GRASSKAMP: **AXEL KASSEBÖHMER**
NEVILLE WAKEFIELD: **MATTHEW BARNEY**
INSERT: **RONI HORN**
LES INFOS DU PARADIS: **BURT BARR**
CUMULUS: **MEYER VAISMAN**

No. 39 - ISBN 3-907509-89-7

ROSS BLECKNER
MARLENE DUMAS
EDMUND WHITE, SIMON WATNEY
JOSE LUIS BREA, MARINA WARNER
ANNA TILROE, INGRID SCHAFFNER
ULRICH LOOCK
INSERT: **RUDI MOLACEK**
HARTMUT BÖHME
MAX WECHSLER: **ADRIAN SCHIESS**
DORIS VON DRATHEN:
RACHEL WHITEREAD

No. 38 - ISBN 3-907509-88-9

CHARLES RAY
FRANZ WEST
KLAUS KERTESS, CHRISTOPHER KNIGHT
PETER SCHJELDAHL, ROBERT STORR
JAN AVGIKOS, AXEL HUBER
MARTIN PRINZHORN, ELISABETH
SCHLEBRÜGGE, HARALD SZEEMANN,
DENYS ZACHAROPOULOS
INSERT: **PIPILOTTI RIST**
JEAN BAUDRILLARD
HANS RUDOLF REUST: **LUC TUYMANS**
PARKETT INQUIRY:
CHERCHEZ LA FEMME PEINTRE!

No. 37 - ISBN 3-907509-87-0

STEPHAN BALKENHOL
SOPHIE CALLE
NEAL BENEZRA, VIK MUNIZ, MAX KATZ
JEAN-CHRISTOPHE AMMANN
LUC SANTE, JOSEPH GRIGELY
PATRICK FREY, ROBERT BECK
INSERT: **RICHMOND BURTON**
URSULA PANHANS-BÜHLER: **EVA HESSE**
DOUGLAS BLAU: **JON KESSLER**
KIRBY GOOKIN: **LIZ LARNER**
LÁSZLÓ FÖLDÉNYI:
RUDOLF SCHWARZKOGLER

No. 36 - ISBN 3-907509-86-2

ILYA KABAKOV
RICHARD PRINCE
BORIS GROYS, ROBERT STORR
JAN THORN-PRIKKER
CLAUDIA JOLLES, EDMUND WHITE
SUSAN TALLMAN, DANIELA
SALVIONI, KATHY ACKER
INSERT: **TATSUO MIYAJIMA**
GUDRUN INBODEN: **ASTA GRÖTING**
LYNNE COOKE: **GARY HILL**
PATRICK McGRATH: **STEPHEN ELLIS**

No. 34 - ISBN 3-907509-84-6

ROSEMARIE TROCKEL
CHRISTOPHER WOOL
VERONIQUE BACCHETTA,
BARRETT WATTEN,
ANNE WAGNER, JIM LEWIS,
GREIL MARCUS, JEFF PERRONE,
DIEDRICH DIEDERICHSEN
INSERT: **ADRIAN SCHIESS**
MARINA WARNER: **PENIS PLENTY**
G. ROGER DENSON:
DENNIS OPPENHEIM
CAMIEL VAN WINKEL

PARKETT

WOOL
TROCKEL

33

No. 33 - ISBN 3-907509-83-3

No. 32 - ISBN 3-907509-82-X

IMI KNOEBEL
SHERRIE LEVINE
RUDOLF BUMILLER
RAINER CRONE/DAVID MOOS
LISA LIEBMANN, DANIELA SALVIONI
ERICH FRANZ, HOWARD SINGERMANN
INSERT: **DAMIEN HIRST**
SHEENA WAGSTAFF: **VIJA CELMINS**
JIM LEWIS: **LARRY CLARK**
LIAM GILLICK: **BETHAN HUWS**
THOMAS KELLEIN: **WALTER DE MARIA**

FRANZ GERTSCH
THOMAS RUFF
HELMUT FRIEDEL, ULRICH LOOCK
I. MICHAEL DANOFF, AMEI WALLACH
RAINER MICHAEL MASON
MARC FREIDUS, JÖRG JOHNEN
TREVOR FAIRBROTHER/NORMAN BRYSON
INSERT: **LIZ LARNER**
JAMES LEWIS: **RICHARD PRINCE**
DAVID HICKEY:
**THE INVISIBLE DRAGON/
DER UNSICHTBARE DRACHEN**
PAUL TAYLOR: **JAMES ROSENQUIST**

No. 28 - ISBN 3-907509-78-1

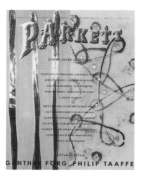

No. 26 - ISBN 3-907509-76-5

GÜNTHER FÖRG
PHILIP TAAFFE
JOHN CALDWELL, CATHERINE QUELOZ
WILFRIED DICKHOFF
JEFF PERRONE, EDMUND WHITE
FRANCESCO PELLIZZI
G. ROGER DENSON
INSERT: **PETER GREENAWAY**
BICE CURIGER: **SIGMAR POLKE**
HANS-ULRICH OBRIST:
ROMAN SIGNER
DAVID LEVI STRAUSS:
JOSEPH BEUYS

KATHARINA FRITSCH
JAMES TURRELL
GARY GARRELS
JULIAN HEYNEN, DAN CAMERON,
JEAN-CHRISTOPHE AMMANN,
DAVE HICKEY, RICHARD FLOOD &
CARL STIGLIANO, TED CASTLE
INSERT: **BEAT STREULI**
PATRICK FREY:
JEAN-FRÉDÉRIC SCHNYDER
DIETER SCHWARZ: **JAMES COLEMAN**
LYNNE COOKE:
RICHARD HAMILTON

No. 25 - ISBN 3-907509-75-7

No. 24 - ISBN 3-907509-74-9

ALIGHIERO E BOETTI
JEAN-CHRISTOPHE AMMANN
GIOVAN BATTISTA SALERNO
RAINER CRONE & DAVID MOOS
FRIEDEMANN MALSCH
JEAN-PIERRE BORDAZ
ALAIN CUEFF
INSERT: **CINDY SHERMAN**
SHEENA WAGSTAFF:
SOPHIE CALLE
HERBERT LACHMEYER/
BRIGITTE FELDERER: **FRANZ WEST**
JUTTA KOETHER. **MIKE KELLEY**

RICHARD ARTSCHWAGER
ARTHUR C. DANTO, GEORG KOHLER,
MARIO A. ORLANDO, JOYCE
CAROL OATES, WERNER OECHSLIN,
ALAN LIGHTMAN, PATRICK
McGRATH, DANIEL SOUTIF,
LASZLO F. FÖLDENYI, JEAN STROUSE
INSERT: **DAVID BYRNE**
RENATE PUVOGEL: **ANDRÉ THOMKINS**
ULRICH LOOCK: **THOMAS STRUTH**
NANCY SPECTOR: **MEREDITH MONK**

No. 23 - ISBN 3-907509-73-0

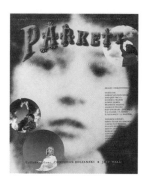

No. 22 - ISBN 3-907509-72-2

CHRISTIAN BOLTANSKI
JEFF WALL
DIDIER SEMIN, GEORGIA MARSH
BÉATRICE PARENT, DAN GRAHAM
JEFF WALL, ARIELLE PÉLENC
INSERT: **CHRISTOPHER WOOL**
DIETER KOEPPLIN:
STEPHAN BALKENHOL
RENATE PUVOGEL:
DAN FLAVIN, DONALD JUDD
WERNER LIPPERT: **VARIOUS SMALL
FIRES IN THE GUTENBERG GALAXY**

ALEX KATZ
JOHN RUSSELL, BROOKS ADAMS,
DAVID RIMANELLI, FRANCESCO
CLEMENTE, MICHAEL KRÜGER,
RICHARD FLOOD, PATRICK FREY,
CARL STIGLIANO, BICE CURIGER,
GLENN O'BRIEN
INSERT: **WILLIAM WEGMAN**
LISA LIEBMAN: **ROBERT GOBER**
JACQUELINE BURCKHARDT:
GIULIO ROMANO

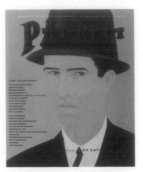

No. 21 - ISBN 3-907509-71-4

TIM ROLLINS + K.O.S.
MARSHALL BERMAN
TREVOR FAIRBROTHER
STATEMENTS, DIALOGUE 5
INSERT: **ANDREAS GURSKY**
MICHAEL NASH: **BILL VIOLA**
STEPHEN ELLIS: **ROSS BLECKNER**
KLAUS KERTESS: **TRISHA BROWN**

No. 20 - ISBN 3-907509-70-6

EDWARD RUSCHA
DAVE HICKEY, DENNIS HOPPER
ALAIN CUEFF, JOHN MILLER
CHRISTOPHER KNIGHT
INSERT: **BOYD WEBB**
JAN THORN-PRIKKER: **WOLS**
LYNNE COOKE: **TONY CRAGG**
BROOKE ADAMS: **JULIAN SCHNABEL**
DER KÜNSTLER ALS EXEM-
PLARISCH LEIDENDER?
EINE UMFRAGE / THE ARTIST AS A
MODEL SUFFERER? AN INQUIRY

No. 18 - ISBN 3-907509-68-4

PETER FISCHLI/
DAVID WEISS
PATRICK FREY, GERMANO CELANT,
KAREN MARTA, BERNHARD
JOHANNES BLUME, JEANNE SILVER-
THORNE, SIDRA STICH
INSERT: **LOUISE BOURGEOIS**
MAX WECHSLER: **IMI KNOEBEL**
PAUL GROOT: **MATT MULLICAN**
KATHY HALBREICH:
WOOSTER GROUP

No. 17 - ISBN 3-907509-67-6

MARIO MERZ
MARLIS GRÜTERICH, JEANNE
SILVERTHORNE, DEMOSTHENES
DAVVETAS, HARALD SZEEMANN,
DENYS ZACHAROPOULOS
INSERT: **GENERAL IDEA**
MAX KOZLOFF: **GILLES PERESS**
FRIEDEMANN MALSCH:
GEORG HEROLD
BRUNELLA ANTOMARINI:
FRANCESCA WOODMAN

No. 15 - ISBN 3-907509-65-X

GILBERT & GEORGE
DUNCAN FALLOWELL, MARIO
CODOGNATO, JEREMY COOPER,
DEMOSTHENES DAVVETAS,
WOLF JAHN
INSERT: **ROSEMARIE TROCKEL**
ROBERT STORR: **NANCY SPERO**
HAIM STEINBACH: **MANIFESTO**
JÖRG ZUTTER: **THOMAS HUBER**

No. 14 - ISBN 3-907509-64-1

ANDY WARHOL
STUART MORGAN, GLENN O'BRIEN,
REMO GUIDIERI, ROBERT BECKER
INSERT: **GÜNTER FÖRG**
LYNNE COOKE: **BILL WOODROW**
AMINE HAASE:
JÜRGEN PARTENHEIMER
PATRICK FREY: **REINHARD MUCHA**

No. 12 - ISBN 3-907509-62-5

GEORG BASELITZ
REMO GUIDIERI, DIETER
KOEPPLIN, ERIC DARRAGON,
RAINER MICHAEL MASON, FRANZ
MEYER, JOHN CALDWELL
INSERT: **BARBARA KRUGER**
GRAY WATSON: **DEREK JARMAN**
CAROL SQUIERS:
PHOTO OPPORTUNITY
ROSETTA BROOKS:
TROY BRAUNTUCH

No. 11 - ISBN 3-907509-61-7

Each volume of PARKETT is created in collaboration with artists, who contribute an original work specially made for the readers of PARKETT. The works are available in a signed and numbered Special Edition. Prices are subject to change. Postage is not included.

EDITIONS FOR PARKETT

Jeder PARKETT-Band entsteht in Collaboration mit Künstlern, die eigens für die Leser von PARKETT Originalbeiträge gestalten. Diese Vorzugsausgaben sind als numerierte und signierte Editionen erhältlich. Preisänderungen vorbehalten. Versandkosten und MwSt. (Schweiz) nicht inbegriffen.

Dear Parkett Subscriber, dear Reader,

It gives us great pleasure to present the latest survey of all artists' editions currently available. Following exhibitions in Tokyo and at the Louisiana Museum in Denmark, the editions will be on view throughout 1997 in museums and galleries in Los Angeles, Madrid, Geneva and Vienna.
All artists' editions made for Parkett, including those out of print, are fully documented in the catalogue raisonné *Silent & Violent* (see below). Beatrice Fässler at our Zurich office will be happy to answer any questions you may have regarding our small "Musée en Appartement." Orders may be placed using the attached form.

Yours Sincerely,

Sehr geehrte Abonnentin, sehr geehrter Abonnent, liebe Parkett-Leser,

Wir freuen uns, Ihnen auf den folgenden Seiten den neuesten Überblick über die gegenwärtig erhältlichen Künstlereditionen zu geben. nach den Ausstellungen in Tokio und im Louisiana Museum in Dänemark sind 1997 Museums- und Galeriepräsentationen der Editionen in Los Angeles, Madrid, Genf und Wien geplant.
Die von Künstlerinnen und Künstlern für Parkett geschaffenen Werke, Multiples und Grafiken sind im unten beschriebenen Werkverzeichnis *Silent & Violent* umfassend dokumentiert. Für Ihre Fragen zu unserem «Musée en Appartement» steht Ihnen Beatrice Fässler in Zürich jederzeit gerne zur Verfügung. Für Bestellungen können nen Sie auch den beigehefteten Antwortschein verwenden.

Mit freundlichen Grüssen,

Dieter von Graffenried

Dieter von Graffenried
Publisher/Verleger

Bice Curiger

Bice Curiger
Editor in Chief/Chefredaktorin

SILENT & VIOLENT
CATALOGUE RAISONNÉ OF ALL
PARKETT ARTISTS' EDITIONS
from No. 1–44, 183 pages, 144 in color
text by Susan Tallmann,
short biographies of all artists
WERKVERZEICHNIS ALLER
PARKETT-KÜNSTLER-EDITIONEN
von Nr. 1–44, 183 Seiten,
davon 144 in Farbe
Text von Susan Tallmann,
Kurzbiographien der Künstler

ISBN 3-89322-796-3 (engl.)
ISBN 3-89322-787-3 (dt.)

PARKETT-POSTCARD SET
featuring 36 artists' editions
made for Parkett

PARKETT-POSTKARTEN-SET
mit 36 Editionen, die von Künstlern
für Parkett geschaffen wurden.

Oneness and plurality. Particles of light fluttering in a tangle of leaves and twigs, electronically filtered and reinvented.

Einheit und Vielfalt. Im Blättergewirr flirrende Lichtpartikel elektronisch gefiltert und wieder ins Bild gestreut.

PARKETT 48

GABRIEL OROZCO
LIGHT THROUGH LEAVES, 1996
Iris computer print,
archival water-based ink on paper
(500 gsm Somerset Satin 100% cotton rag),
produced by Cone Laumont Editions, New York,
20 x 30⅛" (image size), 22 x 32⅛" (paper size),
Ed. 60, signed and numbered, **US$ 680**

LICHT DURCH LAUB, 1996
Iris Computerprint,
lichtechte Druckfarbe auf holzfreiem Somerset.
Satin-Papier (500 gm²),
gedruckt bei Cone Laumont Editions, New York,
50,8 x 76,5 cm (Bildgrösse),
55,9 x 81,6 cm (Papierformat),
Ed. 60, signiert und numeriert, **sFr. 850.–**

Impervious to warmth and weather:
a bold and bonny snowman aglow against a soft,
sunset pink.

Immun gegen Hitze, Hetze und Schmelze:
ein praller, kühn glühender Schneemann

PARKETT 48

GARY HUME
SNOWMAN, 1996
Silkscreen on red felt,
printed by Print Workshop, London, 12 x 12",
Ed. 55, signed and numbered, **US$ 600**

SCHNEEMANN, 1996
Siebdruck auf rotem Filz,
gedruckt bei Print Workshop, London,
30,5 x 30,5 cm
Ed. 55, signiert und numeriert, **sFr. 750.–**

Zipzap. Vorhang auf für das Spektakel vor der Kiste.

Peeping tomboy.
Are you lonesome tonight?

PARKETT 48

PIPILOTTI RIST

ICH HABE NUR AUGEN FÜR DICH – (PIN DOWN JUMP UP GIRL), 1996

Dreidimensional erscheinendes Bild, Farbphotographie unter Lenticularrasterfolie, auf flexiblen Kunststoff
aufgezogen, rückseitig vier Saugnäpfe, mit denen das Bild am «schlafenden» Fernsehschirm befestigt werden kann.
Photographiert von Rita Palanikumar. 21 x 28 cm.
Ed. 80, signiert und numeriert, **sFr. 650.–**

I'VE ONLY GOT EYES FOR YOU—(PIN DOWN JUMP UP GIRL), 1996

3-D image, color photograph under lenticulated film, mounted on flexible plastic with four suction cups, to be attached
to TV screen when not in use. Photograph by Rita Palanikumar. 8¼ x 11".
Ed. 80, signed and numbered, **US$ 520**

Hell, bunt und schwerelos ist diese Tapete in ihrer Heimatlosigkeit zum
fliegenden Teppich geworden – auf der Suche nach Menschen und
Räumen.

Rainbow bright. Lighthearted wallpaper, about to float away like a
magic carpet, inspires flights of fancy on tapestries, spaces, and the
people who live with them.

PARKETT 47

THOMAS SCHÜTTE

OLGA'S WALLPAPER, 1996 (1977)

Lithographie vom Stein, 5-farbig, gedruckt von Felix Bauer, Köln,
auf Indisches Handbütten, 250 g, ca. 102 x 68,5 cm
Ed. 60, signiert und numeriert, **sFr. 850.–**

OLGA'S WALLPAPER, 1996 (1977)

Lithograph, stone-pulled, 5 colors, printed by Felix Bauer, Cologne,
on handmade Indian Vellum, 250 g, approx. 40⅛ x 27"
Ed. 60, signed and numbered, **US$ 750**

Force of dramatic character is transformed into pure energy. The light source, correlated to a sound organ, waxes and wanes according to the fluctuating intensity of the performed text.

Körperloses Aufflackern eines Bewusstseinsfunkens in der virtuellen Welt der Elektronik. Ein Son-et-lumière zur ephemeren Befindlichkeit des heutigen Menschen.

PARKETT 47

TONY OURSLER
TALKING LIGHT, 1996
CD of original script written and performed by the artist (running time approx. 15 minutes), standard 40 watt light bulb, sound organ kit (the light bulb reacts to the frequency of the voice on the CD); installation manual.
Ed. 60, approx. **US$ 850**

TALKING LIGHT, 1996
CD mit der Stimme des Künstlers (Dauer ca. 15 Minuten), 40-Watt-Glühbirne, Tonverstärker mit Zubehör (die Glühbirne reagiert auf die Frequenzen der Stimme auf CD); Installationsanleitung.
Ed. 60, ca. **sFr. 1000.–**

Riding the waves. A swell of words and images. Whooping with joy, seeking to maintain a precarious balance, persevering in focused silence.

Eine Welle von Worten und Bildern. Aufjauchzen, ums Gleichgewicht bangen, Labiles aushalten, still werden – kurz: Wellenreiten.

PARKETT 47

RAYMOND PETTIBON
UNTITLED
(JUSTLY FELT AND BRILLIANTLY SAID), 1996
Silkscreen, hand-written texts by the artist which vary in each edition, pressed flower, printed by Lorenz Boegli, Zurich, on Arches 120 g, approx. $9\frac{5}{8}$ x $7\frac{5}{8}$", a 10-part foldout, full length $9\frac{5}{8}$ x $76\frac{3}{4}$".
Edition: 60, signed and numbered, **US$ 750**

OHNE TITEL
(JUSTLY FELT AND BRILLIANTLY SAID / RICHTIG EMPFUNDEN UND BRILLANT FORMULIERT), 1996
Siebdruck, mit handgeschriebenen Texten des Künstlers, die von Edition zu Edition variieren, gepresste Blume, gedruckt bei Lorenz Boegli, Zürich, auf Arches 120 g, ca. 24,5 x 195 cm (als 10teiliges Leporello gefalzt auf 24,5 x 19,5 cm).
Auflage: 60, signiert und numeriert, **sFr. 850.–**

Sparkling, silvered stocks—
hinting perhaps at the crumbling elegance
of pilloried lives?

Ein schillernder Pranger aus Pappe –
Hinweis auf die schalen Zwänge
gebeutelten Lebens?

PARKETT 46

CADY NOLAND
(NOT YET TITLED), 1996
cardboard, lacquer-based sanding sealer and aluminum enamel spray paint
(please note: surface inflections differ from one piece to another) 56 x 54"
Ed. 60, signed and numbered, **US$ 750**

(NOCH OHNE TITEL), 1996
Pappkarton, Lackgrund und Aluminium-Farbspray (Bitte beachten: Falt-
und Biegespuren sind von Stück zu Stück verschieden), ca. 142 x 137 cm
Ed. 60, **sFr. 900.–**

Yang and yang. Brass balls or lead balloons, a
rude trophy, cast as heroic kitsch or mortal
weight.

Yang und Yang – Messingeier oder Bleisack, ein
Schambeutel als Trophäe, so runzlig wie rüd.

PARKETT 45

SARAH LUCAS
LION HEART, 1995
cast metal, 50 pieces of cast lead, 50 pieces of
cast brass, produced at the Jäger Brothers Foundry,
Pfäffikon SZ, Switzerland,
approx. 2¾ x 2¾ x 1¾" each.
Ed. 100: No 1–50 (brass), No 51–100 (lead),
signed and numbered, **US$ 650**

LÖWENHERZ, 1995
Metallguss, 50 Exemplare in Bleilegierung,
50 Exemplare in Messing, gegossen durch
die Kunstgiesserei Gebrüder Jäger,
Pfäffikon SZ, Schweiz, je ca. 7 x 7 x 4,5 cm
Ed. 100: Nr. 1–50 (Messing), Nr. 51–100 (Blei),
signiert und numeriert, **sFr. 750.–**

Red alert. A fireman's protective glove plays an active role as a mock traffic signal.

Stopp – ein rotsilberner Handschuh. Schutz vor Signers poetischem Feuerregen? Nein, Kampfhandschuh zum Einsatz im täglichen Strassenverkehr.

PARKETT 45

ROMAN SIGNER
FEUERWEHRHANDSCHUH MIT PHOTO, 1995
Handfläche aus hitzebeständigem Spezialspaltleder, Handrücken
aus hitzereflektierendem, aluminisiertem KEVLAR-Gewebe 550 g/m^2,
isolierendes Wollfutter, Länge 35 cm,
Photographie aus einem Video von Aleksandra Signer, ca. 13 x 18 cm
Ed. 80, signiert und numeriert, **sFr. 600.–**
FIREMAN'S GLOVE WITH PHOTOGRAPH, 1995
Standard fireman's glove with heat-resistant red suede palm, heat-reflecting,
aluminized KEVLAR back, 550 g/m^2, insulating woolen lining, length 13¾",
still from a video by Aleksandra Signer, approx. 5⅛ x 7⅛".
Ed. 80, signed and numbered, **US$ 520**

Instrument of heightened perception. A self-portrait perhaps or a picture of the part played by the artist as he brings into focus the daily chores blurred by habit.

Instrument der geschärften Wahrnehmung. Vielleicht ein Selbstporträt oder ein Bild der Rolle des Künstlers, der alltägliche Abläufe, die in der Unschärfe der Routine verschwinden, in den Brennpunkt zurückholt.

PARKETT 44

RIRKRIT TIRAVANIJA
UNTITLED, 1995 (450/375)
Gold-rimmed Ray Ban glasses with engraving on the lenses:
LONG RIVER A SINGLE LINE
ORANGE SAFFRON AT TWILIGHT
Ed. 80, numbered, with signed certificate, **US$ 780**

OHNE TITEL, 1995 (450/375)
Metallbrille Ray Ban mit Gravur auf den Gläsern:
LONG RIVER A SINGLE LINE
ORANGE SAFFRON AT TWILIGHT
Ed. 80, numeriert, mit signiertem Zertifikat, **sFr. 900.–**

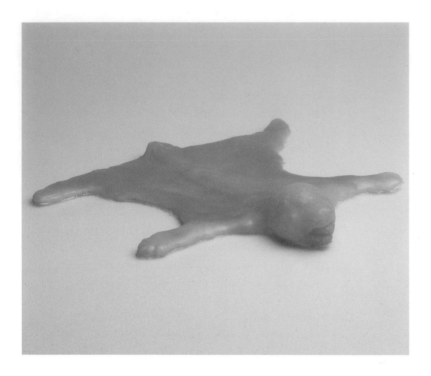

Ursa Minor. A miniature pelt as talisman rather than trophy.

Ursa minor. Vom Himmel geholt, Trophäe der Verletzlichkeit.

PARKETT 43

SUSAN ROTHENBERG
BEAR SKIN RUG 1995
Synthetic latex, $12\frac{1}{4}$ x $12\frac{1}{2}$ x 2"
Ed. 70, signed and numbered, **US$ 830**

BÄRENHAUT TEPPICH, 1995
Synthetischer Latex, 31 x 32 x 5 cm
Ed. 70, signiert und numeriert, **sFr. 950.–**

Vanishing point. An image as tenuous and fugitive as breath on a pane of glass.

Conditio humana. Oh Augenblick, verweile, du bist so unergründlich.

PARKETT 43

JUAN MUÑOZ
AUGENBLICK (GLIMPSE), 1995
Hand-etched glass. The image becomes momentarily visible by breathing on the glass.
$4\frac{3}{4}$ x $3\frac{1}{2}$ x $\frac{1}{8}$"
Ed. 70, signed and numbered, **US$ 830**

AUGENBLICK, 1995
Hand-Radierung auf Glas. Das Bild wird sichtbar durch Anhauchen des Glases. 12 x 9 x 0,3 cm
Ed. 70, signiert und numeriert, **sFr. 950.–**

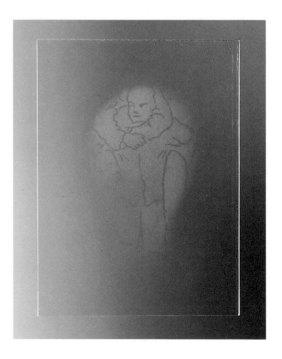

The meaning that comes away from the work of art. Berlin's historic street transforms—through the act of translation—into a metaphor of poetry and nature.

Bedeutungswandel. Der geschichtsträchtige Strassenname Berlins wird in der Übertragung zur romantisch poetischen Formel.

PARKETT 42

LAWRENCE WEINER
UNTER DEN LINDEN – UNDER LIME TREES, 1994
Stamp 7⅜ x 3¾ x 3½" with red ink pad
in silkscreened cardboard box.
Ed. 80, signed and numbered, US$ 740
UNTER DEN LINDEN – UNDER LIME TREES, 1994
Stempel 19,5 x 9,5 x 9 cm mit
rotem Stempelkissen in Kartonschachtel,
Feinrastersiebdruck.
Ed. 80, signiert und numeriert, **sFr. 850.–**

Persönlicher geht's nicht mehr, wenn auf den Überdrucken von Parkett der Zufall zuschlägt und uns gezeigt wird, wo der Meisterschütze den Apfel traf und wie die Währung gefährlich mitspielt.

Master marksman. Chance hits the mark on overprint paper in a fireworks of acrobatic multi-meaning.

PARKETT 40/41

SIGMAR POLKE
OHNE TITEL, 1994
Parkett-Band aus Überdruck-Makulatur, 25,5 x 21 cm, Ed. 25,
signiert und numeriert, **sFr. 2000.–**
UNTITLED, 1994
Volume of Parkett made of overprint paper, 10 x 8¼", Ed. 25
copies, signed and numbered, **US$ 1740**

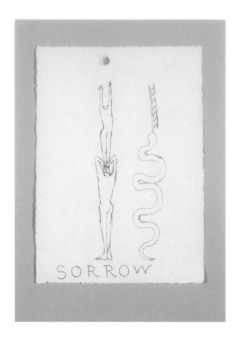

Im schwindelerregenden Balanceakt nach
dem Mond greifen zu wollen und dabei zu
scheitern ist die sich lohnende Wehmut aller.

Balancing act. A whimsical lyricism counter-
weighted by an aura of impossibility haunts
these simple figures.

PARKETT 40/41

FRANCESCO CLEMENTE
SORROW, 1994
Tiefdruck mit Photoätzung, 29 x 20,5 cm,
gedruckt bei Peter Kneubühler, Zürich,
auf handgeschöpftem Bütten-Papier,
Ed. 60, signiert und numeriert, **sFr. 1500.–**
SORROW, 1994
Photo-etching, printed by Peter Kneubühler
on handmade Vellum, 11⅛ x 8⅛", Ed. 60,
signed and numbered, **US$ 1300**

Der Spiegel und die Kupferplatte, beide im Parkettformat, stehen in einem der
spannendsten Kunst-Diskurse: gespiegelte Realität des Betrachters und seiner
Architektur versus abstrakte Malerei, versinnbildlicht durch die Oxyda-
tionsflecken des Kupfers.

Reality abstracted. Lightning strikes between mirrored reality and the abstract
pattern of oxidation on a copperplate, both in Parkett format.

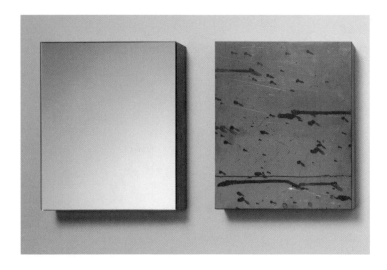

PARKETT 40/41

GÜNTHER FÖRG
OHNE TITEL (FÜR PARKETT), 1994
Zweiteiliges Objekt mit je einem Spiegel und
einer Kupferplatte, auf Holz montiert, im
Parkett-Format, je 25,5 x 21 x 3,2 cm,
Ausführung Jürgen Zimmermann, Karlsruhe,
Ed. 45, signiert und numeriert, **sFr. 2200.–**
UNTITLED (FOR PARKETT), 1994
Two-part object, consisting of one mirror and
one copperplate each mounted on wood in
Parkett format, each 10 x 8¼ x 1¼",
produced by Jürgen Zimmermann, Karlsruhe,
Ed. 45, signed and numbered, **US$ 1910**

Wie durchlässig sind die Ränder unseres kollektiven Daseins? Felix Gonzalez-Torres hat ein gigantisches Bild geschaffen, das zugleich den Anspruch stellt, das stille «Bei-sich-Sein» wie das öffentliche «Nach-aussen-Dringen» zu symbolisieren.

Emotional propaganda. Ephemeral footprints in sand become an advertisement for the ineffable in a gigantic billboard.

PARKETT 39

FELIX GONZALEZ-TORRES
OHNE TITEL (FÜR PARKETT), 1994
Plakat in 8 Blätter unterteilt, Siebdruck auf imprägniertem (Appleton-)Papier, 317,5 x 690,9 cm,
Ed. 84, signiert und numeriert, **sFr. 1500.–**
UNTITLED (FOR PARKETT), 1994
8-sheet billboard, silkscreen on Appleton coated stock, 125 x 272",
Ed. 84, signed and numbered, **US$ 1300**

Wolfgang Laib sucht sich einen Berg des europäischen Kontinents aus, um dort einen öffentlichen Ort der persönlichen Einkehr zu schaffen, und will ihn mit jenem «energetischen Gold überziehen, das Wachs heisst» (Jean-Marc Avrilla).

Trace elements. A delicate rendering in golden wax of a secluded place in the future, a mountain sanctuary to be built by the artist in the Pyrenees.

PARKETT 39

WOLFGANG LAIB
A WAX ROOM FOR A MOUNTAIN, 1994
Vom Künstler mit Ölstift überarbeiteter Siebdruck auf Rivoli SK2 (240 g), gedruckt bei Lorenz Boegli, Zürich, 49,3 x 41 cm,
Ed. 75, signiert und numeriert, **sFr. 900.–**
A WAX ROOM FOR A MOUNTAIN, 1994
Silkscreen, oilstick on Rivoli SK2 (240 g), printed by Lorenz Boegli, Zurich, 19½ x 16⅛",
Ed. 75, signed and numbered, **US$ 780**

Augenzwinkernde Vorurteilsbewältigung als drucktechnische Rhapsodie.

Archetypical exorcism. The crude silhouettes of street graffiti meet the painstaking processes of the handmade print, transforming familiar stereotypes into a luxurious triptych.

PARKETT 38

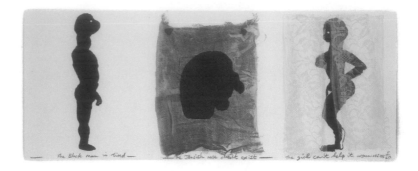

MARLENE DUMAS
THE BLACK MAN, THE JEW, AND THE GIRL, 1993
Triptych printed by Marcel Kalksma, Amsterdam, in three processes on 250 grs Arches: Blockprint in one color, two transfer lithographs from one stone rendered in two colors, inked and inscribed by hand, with eyes and organs scratched out, folded zigzag, 10 x 24¾",
Ed. 60, signed and numbered, **US$ 1040**
THE BLACK MAN, THE JEW, AND THE GIRL, 1993
Gefaltetes Triptychon, hergestellt bei Marcel Kalksma, Amsterdam, in drei Durchgängen auf Arches (250 g): einfarbiger Holzschnitt (Silhouetten), zweifache Umdrucklithographie von einem Stein in zwei Farben, mit Tinte markiert, Augen und Geschlechtsteile ausgekratzt, handschriftlicher Text, 25,5 x 63 cm, Ed. 60, signiert und numeriert, **sFr. 1200.–**

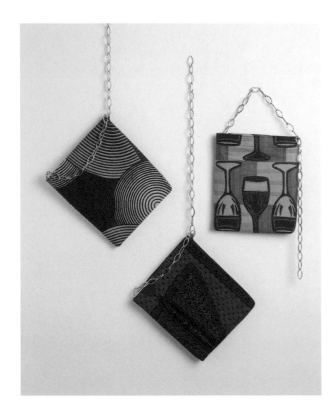

Franz Wests «Sackerl» bietet einen hintersinnigen Kommentar zum euroamerikanischen Zentrismus von Parkett.

Totem tote. A Parkett-sized pouch fashioned from hand-printed African fabric is a useful article for a specific purpose.

PARKETT 37

FRANZ WEST
ETUI FÜR PARKETT, 1993
Bedruckte afrikanische Baumwollstoffe, Kette,
Ed. 180, signiert und numeriert, **sFr. 300.–**
POUCH FOR PARKETT, 1993
Printed African fabric, chain, Ed. 180,
signed and numbered, **US$ 260**

Ein Bild mit Gewicht. In weiches, schweres Blei gegossen ist ein Mann flankiert von zwei mannshohen Echsen – Mensch und Tier vereint ohne Furcht und Hierarchie.

Graven image. A triumvirate of a man and two lizards cast in lead— a substance at once elemental and endearing—man coexists with beast, devoid of fear or hierarchy.

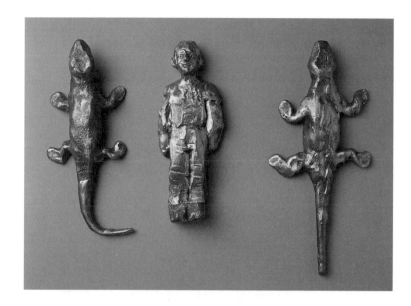

PARKETT 36

STEPHAN BALKENHOL
ZWEI ECHSEN MIT MANN, 1993
Dreiteilige Figurengruppe, gegossen in
Bleilegierung durch Giesserei Bärtschi, Aefligen,
Schweiz, je ca. 30 x 13 x 4 cm, Gewicht je ca. 2 kg,
Ed. 85, signiert und numeriert, **sFr. 1900.–**
TWO LIZARDS AND A MAN, 1993
Group of three cast lead figurines, produced
at the Bärtschi Foundry, Aefligen, Switzerland,
each figure approx. $11\frac{7}{8}$ x $5\frac{1}{8}$ x $1\frac{1}{2}$", weighing
approx. 4.5 lbs, Ed. 85, signed and
numbered, **US$ 1650**

Eine Seidenkrawatte war das erste von mehreren Kleidungsstücken, die Sophie Calle anonymerweise einem heimlich beobachteten Unbekannten zukommen liess. Die Geschichte dieser imaginären Beziehung ist auf der Krawatte niedergeschrieben.

Autobiographical story. A silken tie not only represents the first episode of a story in which a number of tasteful articles of clothing are sent to a badly dressed but attractive man; it also becomes the page on which the story itself is told.

PARKETT 36

SOPHIE CALLE
THE TIE, 1993
Krawatte mit aufgedruckter Kurzgeschichte
«I saw him», Crêpe de Chine,
braun mit blauem Text, hergestellt durch
Fabric Frontline, Zürich, Ed. 150,
signiert und numeriert, **sFr. 280.–**
THE TIE, 1993
Pure silk crepe-de-chine man's tie, printed
with an autobiographical story,
produced by Fabric Frontline, Zurich,
Ed. 150, signed and numbered, **US$ 243**

Greatest hits. Der Meister der Fiktion krönt sich selber mit der höchsten
Auszeichnung der Unterhaltungsindustrie – die goldene Schallplatte –
und fügt ihr ein Muster seiner Erzählkunst bei.

Greatest hits. A weaver of fictions awards himself the industry's highest
accolade—a gold record—complete with winning cover design and
haunting "lyrics."

PARKETT 34

RICHARD PRINCE
GOOD REVOLUTION, 1992
Goldene Schallplatte und graviertes Metallschild auf C-Print, montiert und
gerahmt. Enthält zusätzlich eine beidseitig abspielbare Vinylplatte des Künstlers.
«Good Revolution» (1,46 Min.) und «Don't Belong» (1,46 Min.) arrangiert und
interpretiert von Richard Prince. Aufgenommen und gemischt auf der
Harmonic Ranch von Mark Degliantoni, September 1992. 52 x 41,9 cm.
Ed. 80, signiert und numeriert, **sFr. 1100.–**
GOOD REVOLUTION, 1992
Presentation gold record with engraved plaque mounted on C-Print, framed.
Includes a playable vinyl record by the artist, recorded on both sides.
"Good Revolution" (1:46) and "Don't Belong" (1:46), arranged and
performed by Richard Prince. Recorded and mixed at Harmonic Ranch
by Mark Degliantoni, September 1992. 20½ x 16½" (52 x 41,9 cm),
Ed. 80, signed and numbered, **US$ 960**

In den 16 cm kleinen Kinderschuhen vereinen sich Vor-
stellungen von Niedlichkeit und früher Uniformierung, von
Androgynität und Standfestigkeit – als Bild der Einprobung
in unsere Welt.

A new pair of shoes. Many years ago, Sherrie Levine found
and sold pairs of small shoes in a gallery in New York. A
refined version, handmade in Italy from softest leather
and suede, retraces the artist's first steps.

PARKETT 32

SHERRIE LEVINE
2 SCHUHE, 1992
Ein Paar Kinderschuhe, braunes Leder, je ca. 16 x 6 x 6 cm,
Ed. 99, signiert und numeriert, **sFr. 830.–**
2 SHOES, 1992
Pair of shoes, brown leather, each 6½ x 2½ x 2½"
(16 x 6 x 6 cm), Ed. 99, signed and numbered, **US$ 720**

PARKETT 28

FRANZ GERTSCH
CIMA DEL MAR (AUSSCHNITT), 1990/91
Holzschnitt (Kobalttürkis und Ultramarin, halb und halb) auf
Heizoburo-Japanpapier, 25,4 x 41,6 cm, gefaltet, nicht eingebunden,
Ed. 80, signiert und numeriert, **sFr. 1350.–**
CIMA DEL MAR (DETAIL), 1990/91
Woodcut (cobalt turquoise and ultramarine, half and half) on
Heizoburo Japan paper, 10 x 16⅜" (25,4 x 41,6 cm), folded, not bound
in the magazine, Ed. 80, signed and numbered, **US$ 1170**

Detail aus einem über zwei Meter hohen Holzstock, an dem Franz
Gertsch ein Jahr lang gearbeitet hat.

Ein Monster, gedruckt auf feinste Seide, quillt
aus einem Goldrahmen.

The little house of horrors. A silken greasepaint
grotesque rendered in startling 3-D threatens
to burst from its keepsake frame.

Against the grain. Every point of light on this minutely described
surface corresponds to the removal of a sliver of wood. This fragment
was taken from a gigantic woodcut measuring more than 5 x 6 feet
(170 x 152 cm).

Basketball ist eine der Möglichkeiten für einen Afro-Amerikaner,
reich zu werden. So trägt die Photographie des Objet trouvé den
Titel «Geldbaum».

Readymade magic. A basketball hoop fashioned from the rim of a
bicycle tire, embedded in a living tree in a Charleston backyard,
testifies to the ingenuity of its anonymous maker.

PARKETT 29

CINDY SHERMAN
OHNE TITEL, 1991
Bedruckte Seide, gepolstert, in goldfarbenem
Holzrahmen, 15 x 11,5 cm (Bild),
21,3 x 17,4 cm (Rahmen), Ed. 100, signiert
und numeriert, **sFr. 1380.–**
UNTITLED, 1991
Printed silk, padded, in gilded wooden
frame, 8⅜ x 6⅞" (21,3 x 17,4 cm), with frame,
Ed. 100, signed and numbered, **US$ 1200**

PARKETT 31

DAVID HAMMONS
GELDBAUM, 1992
Sepia-Print-Photographie,
42 x 28 cm, Ed. 70,
signiert und numeriert,
sFr. 890.–
MONEY TREE, 1992
Sepia Print photograph,
16½ x 11" (42 x 28 cm),
Ed. 70, signed and
numbered, **US$ 770**

Teilen Sie mit Rosemarie Trockel die geheime Perspektive auf ihr Atelier als Hirnsicht durch die linke Augenhöhle.

Mind's eye view. An intimate perspective of the studio that places the viewer inside the secret cave of the artist's left eye.

PARKETT 33

ROSEMARIE TROCKEL
STUDIO VISIT, 1992
Photogravure in Strohpappe-Passepartout mit Prägedruck, säurefreies Folienfenster, auf Holz montiert mit Aufhänger, Bild: 21 x 21 cm, Rahmen: 38 x 33 x 0,9 cm, Ed. 80, signiert und numeriert, **sFr. 850.–**
STUDIO VISIT, 1992
Photoetching and acid-free transparent foil in embossed strawboard matte, mounted on wood with hanger, image: 8¼ x 8¼", frame: 15 x 13 x ⅜", Ed. 80, signed and numbered, **US$ 740**
Printed by Peter Kneubühler

Ruffs Sternenhimmel für einmal als Negativprint. Im Zentrum steht ein astronomisch bestimmter Stern.

Milky ways. Phantasmagoric photographs of the night sky and its galaxies are reversed into peppered white fields upon which a single lodestar is pinpointed by its astronomical data.

PARKETT 28

THOMAS RUFF
C-PRINTS, 1991
2 C-Prints (Photos: ESO), je 50 x 50 cm, in Transparenthüllen, astronomische Daten in Siebdruck beidseitig auf Hüllen gedruckt, Ed. je 50, signiert und numeriert, **sFr. 1200.–**
C-PRINTS, 1991
Two c-prints (Photos: ESO), each 19½ x 19½" (50 x 50 cm), with astronomic data silk-screened on front and back of transparent wrappers, Ed. of 50 each, signed and numbered, **US$ 1040**

Klang- und Geräuschskulpturen, Er-
innerungsbilder aus dem kollektiven
Gedächtnis formen sich aus Ihren
Lautsprechern heraus.

Music for the eyes. A set of three re-
cords, each pressed with a single
ambient sound from the artist's aural
memory—toads croaking, a water-
mill churning, a local ambulance
siren wailing—and sealed with a cor-
responding emblematic color.

PARKETT 25

KATHARINA FRITSCH
MÜHLE / KRANKENWAGEN /
UNKEN, 1990
Drei Single-Schallplatten, Ed. je 2000,
unsigniert, zusammen: **sFr. 45.–**
MILL / AMBULANCE / TOADS,
1990
Set of three single records, Ed. of 2000
sets, unsigned, for set of three: **US$ 39**

Licht materialisiert sich zu geometrischen Körpern; für einmal nicht in einer
von Turrells Rauminstallationen, sondern in einem traditionsgemäss für
Hell-Dunkel-Effekte geschaffenen Medium.

Speed of light. These experimental forays into the medium of etching yield
light as material, not illusion, in the contours of the printed image.

PARKETT 25

JAMES TURRELL
SQUAT, CARN, JUKE, ALTA, 1990
Aquatinta-Editionen auf Zerkall 250 g, je 25,5 x 21 cm, in Parkett
eingebunden, Sonderedition: 10 Editionen mit allen vier Aquatintae,
signiert und numeriert, **sFr. 3900.–**
SQUAT, CARN, JUKE, ALTA, 1990
Aquatint editions on Zerkall 250 g, each 10 x 8¼"
(25,5 x 21 cm), bound in the magazine. Special edition: Ed. of 10 with all four
aquatints, signed and numbered, **US$ 3200**

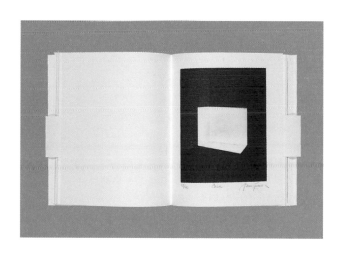

Eine poetische Symmetrie oszilliert zwischen Flächigkeit, Stilisierung und Abbild der Natur.

Artificial nature. A deft exercise in Katz's ongoing exploration of pictorial flatness and poetic symmetry, this stylized woodcut on the most delicate of papers is a quiet moment of reflection from a preternatural world.

PARKETT 21

ALEX KATZ
SCHWARZER TEICH, 1989
Holzschnitt auf Goyu-Papier, 29,5 x 46 cm,
Ed. 100, signiert und numeriert, **sFr. 950.–**
BLACK POND, 1989
Woodcut on Goyu paper,
11⅝ x 18⅛" (29,5 x 46 cm),
Ed. 100, signed and numbered, **US$ 830**

Der Künstler begibt sich auf die Spur von Verdoppelungen, lässt von zwei verschiedenen Händen die zweifache Ausgabe von Newsweek – die nationale und die internationale – abzeichnen.

Double trouble. A perennial obsession with dual identities and symmetry is manifested in the systematic rendering of twin subjects by two detectably different hands. A hand-applied flash of vicious scarlet completes this doubly complex Rorschach test.

PARKETT 24

ALIGHIERO E BOETTI
AUF DEN SPUREN DER GEHEIMNISSE
EINES DOPPELLEBENS, 1990
Lichtdruck (Granolitho), von Hand rot übermalt,
50 x 70 cm, Ed. 100, signiert und numeriert, **sFr. 1200.–**
PROBING THE MYSTERIES
OF A DOUBLE LIFE, 1990
Collotype (Granolitho), overpainted by
hand in red, 19⅝ x 27½" (50 x 70 cm),
Ed. 100, signed and numbered, **US$ 1040**

Mit minimalsten Licht- und Architekturakzenten öffnen sich traumhafte Bühnenräume, wie sie nur ein Robert Wilson erdenken kann.

The director's notebook. This animated three-part lithograph is a reminder that every one of Wilson's dramatic theater works has its genesis in a powerful, light-filled drawing.

PARKETT 16

ROBERT WILSON
A LETTER FOR QUEEN VICTORIA, 1988
Lithographie auf Rives, 25,5 x 61 cm, in Parkett eingebunden,
Ed. 80, signiert und numeriert, **sFr. 800.–**
Lithograph on Rives, 10 x 24", (25,5 x 61 cm), bound in the magazine,
Ed. 80, signed and numbered, **US$ 690**
Printed by Champfleury

Eindringlich und dramatisch spielt das Licht auf den Gesichtern von Gilbert & George im Photo-Diptychon zum Aufstellen auf Ihrem Schreibtisch oder Bücherschrank.

Memorabilia from an art world Hall of Fame. A provocative reshoot of the classic wedding photo, the alumni portrait, the religious diptych, Gilbert & George's stand-up self-portrait will be an asset to the mantelpiece of any self-respecting amateur.

PARKETT 14

GILBERT & GEORGE, 1987
Photographie auf Karton aufgezogen,
in der Mitte faltbar, 25,5 x 42 cm,
Ed. 200, signiert und numeriert, **sFr. 1200.–**
Photograph, mounted on cardboard
folded in the middle, 10 x 16½" (25,5 x 42 cm),
Ed. 200, signed and numbered, **US$ 1040**

PARKETT IN BUCHHANDLUNGEN / *BOOKSHOPS*

AUSKUNFT UND ABONNEMENTS / *INFORMATION AND SUBSCRIPTIONS:*

PARKETT VERLAG AG, QUELLENSTRASSE 27, CH-8005 ZÜRICH, TEL. 01/271 81 40, FAX 272 43 01; TANNENWALDALLEE 17, D-61348 BAD HOMBURG, FAX 06172/937 444

PARKETT, 155 AVENUE OF THE AMERICAS, 2ND FLOOR, NEW YORK, N.Y. 10013, PHONE (212) 673-2660, FAX 271-0704

SCHWEIZ

VERTRIEB
B + I BUCH UND INFORMATION AG
OBFELDERSTR. 35
8910 AFFOLTERN A. A.
BASEL
BUCHHANDLUNG STAMPA, SPALENBERG 2
BÜCHERSTAND STAMPA, KUNSTHALLE BASEL
W. JAEGGI AG, FREIESTR. 32
BERN
HANS HUBER AG, MARKTGASSE 59
BUCHHANDLUNG SCHERZ, MARKTGASSE 25
BUCHHANDLUNG STAUFFACHER, NEUENGASSE 25
BUCHHANDLUNG STAUFFACHER
IM KUNSTMUSEUM BERN, HODLERSTR.12
GENÈVE
LIBRAIRIE DESCOMBES, 6, RUE DU VIEUX-COLLÈGE
LIBRAIRIE PAYOT, 5, RUE DE CHANTEPOULET
LIBRAIRIE WEBER, 13, RUE DE MONTHOUX
LAUSANNE
LIBRAIRE BERNARD LETU,
MUSÉE D'ART CONTEMPORAIN
LIBRAIRIE PAYOT, 1, RUE DE BOURG
SCHAFFHAUSEN
BÜCHER-FASS, WEBERGASSE 13
ST. GALLEN
BUCHHANDLUNG COMEDIA, KATHARINENGASSE 20
ZÜRICH
BUCHHANDLUNG ZUM ELSÄSSER, LIMMATQUAI 18
BUCHHANDLUNG CALLIGRAMME, HÄRINGSTR. 4
SCALO BOOKS & LOOKS, WEINBERGSTRASSE 22 A
HEINIMANN & CO, KIRCHGASSE 17
BUCHHANDLUNG HOWEG, WAFFENPLATZSTR. 1
BUCHHANDLUNG AM KUNSTHAUS AG, RÄMISTR. 45
BUCHHANDLUNG KRAUTHAMMER, OBERE ZÄUNE 24
KUNSTKIOSK, LIMMATQUAI 31/HELMHAUS
ORELL FÜSSLI, FÜSSLISTR. 4
SEC 52, JOSEFSTR. 52

DEUTSCHLAND

VERTRIEB
GWP VERLAGSAUSLIEFERUNG
BEIENRODER HAUPTSTR. 3
38154 KÖNIGSLUTTER
BERLIN
BÜCHERBOGEN, AM SAVIGNYPLATZ
GALERIE 2000, KNESEBECKSTR. 56–58
WASMUTH GmbH & CO., HORDENBERGSTR. 9A
WERNER GmbH, EHRENBERGSTR. 29
BONN
CARL KAYSER, POSTSTR. 16
GALERIE PUDELKO, HEINRICH-VON-KLEIST-STR.
BREMEN
ANTIQUARIAT, BEIM STEINERNEN KREUZ 1
JOHS. STORM, LANGENSTR. 10
KUNSTBUCH, SPITZENKIEL 16/17
B. SIEBRECHT, PANORAMA, VOR DEM STEINTOR 136
KUNST UND BUCH,
AM NEUEN MUSEUM, WESERBURG, TEERHOF 20
BREMERHAVEN
KABINETT FÜR AKTUELLE KUNST, KARLSBURG 4

DÜSSELDORF
M. + R. FRICKE, POSTSTR. 3
WALTHER KÖNIG, HEINRICH-HEINE-ALLEE 15
MÜLLER & TILLMANNS, NEUSTR. 38
FRANKFURT
HUGENDUBEL, STEINWEG 12
KARL MARX BUCHHANDLUNG, JORDANSTR. 11
PETER NAACHER, SCHWEIZERSTR. 57
SCHUMANN & COBET, BÖRSENSTR. 2–4
WALTHER KÖNIG, DOMSTR. 6
HAMBURG
H. VON DER HÖH, GROSSE BLEICHEN 21
SAUTTER UND LACKMANN
ADMIRALITÄTSSTRASSE 71/72
PPS, FELDSTR. / HOCHHAUS
HANNOVER
BUCHHANDLUNG IM SPRENGELMUSEUM
KURT-SCHWITTERS-PLATZ
HEIDELBERG
KUNSTHANDLUNG W. WELKER, HAUPTSTR. 106
KARLSRUHE
KUNSTBUCHHANDLUNG JUST, WALDSTR. 85
KIEL
GALERIE + EDITION KOCH, HOLSTENTÖRNPASSAGE
KÖLN
WALTHER KÖNIG, EHRENSTR. 4
MÜNCHEN
ILKA KÖNIG, AM KOSTTOR 1
H. GOLZ, TÜRKENSTR. 54
L. WERNER, RESIDENZSTR. 18
INT. BAHNHOFSBUCHHANDLUNG, BAHNHOFSPLATZ 2
MAX SUSSMANN GmbH, ARNULFSTR. 1/II
BASIS ANTIQUARIAT, ADALBERTSTR. 43
MÜNSTER
HEINRICH POERTGEN
HERDERSCHE BUCHHANDLUNG, HÖLTENWEG 51
NÜRNBERG
HEINRICH HUGENDUBEL, LUDWIGSPLATZ 1
OSNABRÜCK
H. TH. WENNER GmbH, GROSSE-STR. 69
REUTLINGEN
FETZER BUCH, WEINGÄRTNERSTR. 7
SAARBRÜCKEN
BOCK & SEIP, FUTTERSTR. 2
STUTTGART
WENDELIN NIEDLICH, SCHMALESTR. 9
GALERIE VALENTIEN, KÖNIGSBAU
TÜBINGEN
HUGO FRICK, NAUKLERSTR. 7
ULM
BUCHHANDLUNG UND GALERIE HOLM
HAFENBAD 11

ÖSTERREICH

VERTRIEB
LECHNER + SOHN, HEIZWERKSTRASSE 10, 1232 WIEN
GRAZ
BUCHHANDLUNG GALERIE
VERLAG DROSCHL, BISCHOFPLATZ 1
INNSBRUCK
PARNASS, SPECKBACHERSTR. 21

WAGNERSCHE UNIVERSITÄTSBUCHHANDLUNG
MUSEUMSTR. 4
LINZ
ALEX STELZER, HAUPTPLATZ 17
WIEN
JUDITH ORTNER, SONNENFELSGASSE 8
SHAKESPEARE & COMPANY
BOOKSELLERS, STEINGASSE 2

HOLLAND

DISTRIBUTION
IDEA BOOKS, NIEUWE HERENGRACHT 11
1011 RK AMSTERDAM
AMSTERDAM
ART BOOK, PRINSENGRACHT 645
ATHENAEUM NIEUWSCENTRUM, SPUI 14–16
MENEER KEES, PC HOOFSTRAAT 64-66
NIJHOF & LEE, STAALSTRAAT 13 A
PREMSELA, VAN BAERLESTRAAT 78
VERBEELDING, UTRECHTSESTRAAT 40
ARNHEM
HIJMAN, GROTE OORD 15
ARNHEMS GEMEENTEMUSEUM, UTRECHTSEWEG 87
BREDA
VAN KEMENADE & HOLLAERS, GINNEKENWEG 330
DORDRECHT
BENGEL, VOORSTRAAT 283
EINDHOVEN
MOTTA BERGSTRAAT 35
VAN ABBEMUSEUM, BILDERDIJKLAAN 10
ENSCHEDE
BROEKHUIS, MARKTSTRAAT 12
GRONINGEN
SCHOLTENS/WRISTERS, GULDENSTRAAT 20
HENGELO
BROEKHUIS, ENSCHEDESTRAAT 19
LEIDEN
GINSBERG, BREESTRAAT 127
MAASTRICHT
TRIBUNE, KAPOENSTRAAT 8
VELDEKE, KLEINE STAAT 14
ROTTERDAM
DONNER, LIJNBAAN 150
VAN GENNEP, OUDE BINNENWEG 131B
THE HAGUE
ULYSSES, DENNEWEG 108
TILBURG
DE PONT STICHTING, WILHELMINAPARK 1
UTRECHT
CENTRAAL MUSEUM, AGNIETENSTRAAT 1

BELGIQUE

ANTWERPEN
BRAMANTE, KOEPORTBRUG 4
F.N.A.C. GROENPLAATS
LANDSCHAP, WIJNGAARDSTRAAT 12
STANDAARD, HUIDEVETTERSTRAAT 57
BRUXELLES
PEINTURE FRAÎCHE, 10 RUE DU TABELLION
POST-SCRIPTUM, 37 RUE DES ÉPERONNIERS
TROPISMES, GALERIE DES PRINCES 11

GENT
COPYRIGHT JAKOBIJNENSTRAAT 8
INTELLECT, KALANDESTRAAT 1
KORTRIJK
THEORIA, ONZE LIEVE VROUWESTRAAT 22

ESPAÑA
BARCELONA
NOA NOA, CENTRE CULTURAL DE LA FUNDACIÒ
CAIXA, PASSEIG DE SANT JOAN, 108
NOA NOA LIBRES D'ART
CENTRE D'ART STA. MONICA
RAMBLA STA. MONICA 7
MADRID
LIBROS ARGENSOLA, DOCTOR MATA, 1
CENTRO REINA SOFIA, STA. ISABEL 52

FRANCE
AIX-EN-PROVENCE
LIBRAIRIE VENTS DU SUD, 7, RUE MARÉCHAL FOCH
BORDEAUX
LIBRAIRIE DU MUSÉE CAPC, ENTREPÔT LAINÉ
LIBRAIRIE MOLLAT, 9–15, VITAL CARLES
LYON
LIBRAIRIE LE RÉVERBÈRE, 4, RUE NEUVE
PARIS
LA HUNE, 170 BLVD ST-GERMAIN
«FLAMMARION 4», CENTRE GEORGES POMPIDOU
PLATEAU BEAUBOURG
LIBRAIRIE DU MUSEE D'ART MODERNE
9, RUE FERRIÈRE
GALERIE NATIONALE DU JEU DE PAUME
PLACE DE LA CONCORDE
TOULOUSE
LIBRAIRIE OMBRES BLANCHES, 50, RUE GAMBETTA

ISRAEL
TEL AVIV
BOOKWORM, 30 BASEL ST.

ITALIA
MILANO
A&M BOOKSTORE, VIA PLINIO 15
MILANO LIBRI, VIA G. VERDI 2
MODENA
LOGOS IMPEX
VIA CURTATONA, 5/F, 41010 SAN DAMASO/MODENA
ROMA
FELTRINELLI, VIA DEL BABUINO 41
GALLERIA PRIMO PIANO, VIA PANISPERNA 203

PORTUGAL
LISBOA
COMICOS ESPAÇO INTER-MEDIA
RUA TENENTE RAUL CASCAIS 1B

SVERIGE
STOCKHOLM
BOK & BILD, KULTURHUSET, SERGELSTORG 3
NORDENFLYCHTSVÄGEN 70

GREAT BRITAIN
DISTRIBUTOR
CENTRAL BOOKS, 99, WALLIS RD. LONDON E9 5LN
LONDON
HAYWARD GALLERY BOOKSHOP, SOUTH BANK
ICA BOOKSHOP, NASH HOUSE
12, CARLTON HOUSE TERRACE
LIBERTY, BOOK DEPT., 210 REGENT STREET

USA
DISTRIBUTOR
D. A. P. (DISTRIBUTED ART PUBLISHERS)
636 BROADWAY, RM 1208 NEW YORK, NY 10012

ANN ARBOR, MI
MAIN STREET NEWS, 220 S. MAIN
AUSTIN, TX
BOOK PEOPLE, 603 N. LAMAR
BERKELEY, CA
CODY'S BOOKS, 2454 TELEGRAPH AVENUE
UNIVERSITY ART MUSEUM, 2625 DURANT AVENUE
BOSTON, MA
MIT PRESS BOOKSTORE, 292 MAIN STREET,
CAMBRIDGE, MA 02142
TRIDENT BOOKSELLERS, 338 NEWBURY STREET
BUFFALO, NY
TALKING LEAVES, 3158 MAIN STREET
CHICAGO, IL
THE ART INSTITUTE OF CHICAGO,
104 EAST CHICAGO AVENUE
MUSEUM OF CONTEMPORARY ART
220 EAST CHICAGO AVENUE
COLUMBUS, OH
WEXNER CENTER, 30 W. 15TH AVENUE
DALLAS, TX
MCKINNEY AVENUE CONTEMPORY
3120 MCKINNEY AVENUE
HOUSTON, TX
BRAZOS BOOK STORE, 2421 BISSONNET
CONTEMPORARY ARTS MUSEUM SHOP
5216 MONTROSE AVENUE
MENIL COLLECTION BOOKSTORE, 1520 SUL ROSS
KANSAS CITY, MO
WHISTLER'S BOOKS, 427 WESTPORT ROAD
LOS ANGELES
BOOKSOUP, 8818 SUNSET BOULEVARD
MUSEUM OF CONTEMPORARY ART, 250 S. GRAND
UCLA/ARMAND HAMMER MUSEUM OF ART
10899 WILSHIRE BOULEVARD
MIAMI, FL
BOOKS & BOOKS, 296 ARAGON AVENUE,
CORAL GABLES, FL 33134
MOCA MUSEUM SHOP, 770 N.E. 125TH STREET
NORTH MIAMI, FL 33161
MINNEAPOLIS
WALKER ART CENTER, VINELAND PLACE
NEW YORK
BOOKS AND COMPANY, 939 MADISON AVENUE
GUGGENHEIM MUSEUM, 575 BROADWAY
RIZZOLI BOOKSTORES, 300 PARK AVENUE SOUTH
SAINT MARKS BOOKSHOP, 31 THIRD AVENUE
OAKLAND, CA
DIESEL, A BOOKSTORE, 5433 COLLEGE AVENUE
OMAHA, NE
JOSELYN ART MUSEUM, 2200 DODGE STREET
PHILADELPHIA, PA
WATERSTONE'S BOOKSELLERS, 2191 HORNIG ROAD
PITTSBURGH, PA
CARNEGIE INSTITUTE, 4400 FORBES AVENUE
PORTLAND, OR
POWELL'S BOOKS, 7 NW 9TH STREET
PROVIDENCE, NY
ACCIDENT OR DESIGN, 128 N. MAIN STREET
RHODE ISLAND SCHOOL OF DESIGN
30 N. MAIN STREET
SAN FRANCISCO, CA
CITY LIGHTS BOOKSHOP, 261 COLUMBUS AVENUE

JACK HANLEY GALLERY, 41 GRANT AVENUE
MUSEUMBOOKS SFMOMA, 151 3RD ST., 1ST FLOOR
ST. LOUIS, MO
LEFT BANK BOOKS, 399 NORTH EUCLID
SANTA MONICA, CA
ARCANA, 1229 3RD ST. PROMENADE
MIDNIGHT SPECIAL BOOKSTORE
1318 3RD ST. PROMENADE
SEATTLE, WA
UNIVERSITY BOOK STORE
4326 UNIVERSITY AVENUE
WASHINGTON, D.C.
FRANZ BADER BOOKSTORE, 1911 "I" STREET, NW
NATIONAL GALLERY OF ART
6TH & CONSTITUTION AVENUE, NW

CANADA
CALGARY
TREPANIER BAER GALLERY, 999 8TH STREET
MONTREAL
ARTEXTE, 3575 ST. LAURENT
TORONTO
ART METROPOLE, 788 KING STREET WEST
ART GALLERY OF ONTARIO, BOOKSTORE
317 DUNDAS ST. WEST
EDWARDS BOOKS & ART, 356 QUEEN ST. WEST
DAVID MIRVISH BOOKS ON ART, 596 MARKHAM ST.
VANCOUVER
ART GALLERY STORE, 750 HORNBY ST.

AUSTRALIA
DISTRIBUTORS
MANIC EX-POSEUR, WORLD TRADE CENTER
MELBOURNE 3005
THE ARTS BOOKSHOP, 1067 HIGH STREET
ARMADALE, VICTORIA 3143
VICTORIA
HARTWIGS BOOKSHOP
245 BRUNSWICK STR., VICTORIA 3182

NEW ZEALAND
DISTRIBUTOR
PROPAGANDA, 44 COLLEGE HILL, AUCKLAND

HONG KONG
PUBLISHERS MARKETING LTD.
TUNG ON BUILDING, 171, PRINCE EDWARD ROAD
KOWLOON
TAI YIP ART BOOK CENTRE
HONG KONG MUSEUM OF ART
TSIM SHA TSUI, KOWLOON

JAPAN
TOKIO
EUROPA ART GmbH, KAMIOGI 4-16-4, SUGINAMI-KU
ON SUNDAYS, 3-7-6 JUNGUMAE, SHIBUYA-KU
AOYAMA BOOKCENTER, ROPPONGI STORE
MINATO-KU
HAKUO TRADING COMPANY
KOJIMACHI SHINE BLD., 8F, CHIYODA-KU
SANSEIDO BOOKSTORE, 7-11-8 KOHAKU, ADACHI-KU
MY BOOK SERVICE, AOI BLD. 5-8, SARUGAKU-CHO

E X H I B I T I O N S

ZÜRICH

THOMAS AMMANN FINE ART	Restelbergstrasse 97 P.O. Box 922 8044 Zürich Tel. 01 252 90 52	IMPRESSIONISTS & 20TH CENTURY MASTERS by appointment only	
ARS FUTURA	Bleicherweg 45 8002 Zürich Tel. 01 201 88 10	YUKINORI YANAGI	17.1.–1.3.97
BRANDSTETTER & WYSS	Limmatstrasse 270 8005 Zürich Tel. 01 440 40 18	ANDREA ALTENEDER, KLAUS G. GAIDA, FRANK GERRITZ, RAIMUND GIRKE, ASTRID KLEIN, GASPARE O. MELCHER, BARBARA MÜHLEFLUH, THOMAS MÜLLENBACH, MARIO SALA, LAURENT SCHMID, GIUSEPPE SPAGNULO, WINFRIED VIRNICH, STEPHEN WILLATS	
PETER KILCHMANN	Limmatstrasse 270 8005 Zürich Tel. 01 440 39 31	RITA ACKERMANN, STEFAN ALTENBURGER, BALTHASAR BURKHARD, JOHN COPLANS, WILLIE DOHERTY, LUCAS DUWENHÖGGER, JONATHAN HAMMER, FELIX STEPHAN HUBER, BRUNO JAKOB, SUZANNE LAFONT, CLAUDIA & JULIA MÜLLER, HANNAH VILLIGER	
MAI 36 GALERIE	Rämistrasse 37 8024 Zürich Tel. 01 261 68 80	PIA FRIES	29.11.96–18.1.97
		CHRISTOPH RÜTIMANN	23.1.–1.3.97
		TROY BRAUNTUCH	6.3.–18.4.97
MARK MÜLLER	Gessnerallee 36 8001 Zürich Tel. 01 211 81 55	JOACHIM BANDAU + DUANE ZALOUDEK	23.11.96–4.1.97
		BEAT ZODERER + CARTE BLANCHE	11.1.–22.2.97
		CECILE BART + CHRISTOPH HAERLE	1.3.–12.4.97
SEMINA RERUM IRÈNE PREISWERK	Cäcilienstrasse 3 8032 Zürich Tel. 01 251 26 39	PIA GAZZOLA FOSSILI – SEITEN/STEINE	23.11.96–18.1.97
		IM DUNKELN ZUM LICHT: AGNES FUCHS, HANS DANUSER, SILVIA GERTSCH, MIREILLE GROS, JAN JEDLICKA, THOMAS SCHLIESSER ERIK STEFFENSEN, F.v. STOCKHAUSEN, ANNELIES STRBA, CÉCILE WICK	JAN./FEBR. 97

EXHIBITIONS

BOB VAN ORSOUW	Limmatstrasse 270 8005 Zürich Tel. 01 273 11 00	PHILIP AKKERMAN, HANSPETER AMMANN, NOBUYOSHI ARAKI, JEAN-MARC BUSTAMANTE, RINEKE DIJKSTRA, SYLVIE FLEURY, PAUL GRAHAM, FABRICE GYGI, CALLUM INNES, KARIN KNEFFEL, CLAUDIO MOSER, JULIAN OPIE, DAVID REED, ALBRECHT SCHNIDER, THOMAS STALDER, MITJA TUSEK, ALAN UGLOW, JUAN USLÉ, JOEP VAN LIESHOUT, BERNARD VOÏTA	
ANNEMARIE VERNA	Neptunstrasse 42 8032 Zürich Tel. 01 262 38 20	ROBERT MANGOLD DAVID RABINOWITCH REE MORTON SYLVIA PLIMACK MANGOLD	31.10.–21.12.96 16.1.–1.3.97 6.3.–26.4.97 29.4.–28.6.97
JAMILEH WEBER	Waldmannstrasse 6 8001 Zürich Tel. 01 252 10 66	CHRISTIAN HERDEG «NEUE ARBEITEN» BASELITZ, CHAMBERLAIN, DE MARIA, JUDD, LICHTENSTEIN, LEE, MARDEN, RAUSCHENBERG, SCULLY, SERRA, STELLA – A GROUP SHOW	 23.11.96–18.1.97 24.1.–29.3.97

BERN

GALERIE **ERIKA + OTTO** **FRIEDRICH**	Junkerngasse 39 3011 Bern Tel. 031 311 78 03	GÄSTE / GUESTS 3: KONRAD BITTERLI ZEIGT MATTHEW McCASLIN DOMINIQUE LÄMMLI GÄSTE / GUESTS 4: DANIEL KURJAKOVIC ZEIGT MARIE JOSÉ BURKI, JOS NÄPFLIN, JULIAN OPIE, VITTORIO SANTORO	 15.12.96–31.1.97 7.2.–8.3.97 14.3.–19.4.97

GENÈVE

DANIEL VARENNE	8, rue Toepffer 1206 Genève Tel. 022 789 16 75	PAINTINGS AND DRAWINGS 19TH AND 20TH CENTURY	

ST. GALLEN

WILMA LOCK	Schmidgasse 15 9000 St. Gallen Tel. 071 222 62 52	STEPHEN WESTFALL NEW PAINTINGS	 16.11.96–11.1.97

GARY HILL

DECEMBER

VITO ACCONCI

JANUARY – FEBRUARY

ILYA KABAKOV

MARCH

NEW ADDRESS

BARBARA GLADSTONE

515 WEST 24TH STREET NEW YORK 10011
TEL 212.206.9300 FAX 212.206.9301

GIOVANNI ANSELMO
JOSEPH BARTSCHERER
LOTHAR BAUMGARTEN
CHRISTIAN BOLTANSKI
MARCEL BROODTHAERS
JAMES COLEMAN
TONY CRAGG
RICHARD DEACON
DAN GRAHAM
REBECCA HORN
ANSELM KIEFER
JANNIS KOUNELLIS
JUAN MUÑOZ
MARIA NORDMAN
GABRIEL OROZCO
GIULIO PAOLINI
GIUSEPPE PENONE
GERHARD RICHTER
THOMAS SCHÜTTE
THOMAS STRUTH
NIELE TORONI
JEFF WALL
LAWRENCE WEINER

MARIAN GOODMAN GALLERY

24 WEST 57TH STREET NEW YORK, NY 10019 TEL 212 977-7160

FAX 212 581-5187 E-MAIL: MGOODGAL@AOL.COM

Rodney Graham
Simon Linke

23rd November 1996 – 11th January 1997

John McCracken

22nd January – 22nd February 1997

LISSON GALLERY

52–54 Bell Street London NW1 • Tel: 0171 724 2739 Fax: 0171 724 7124

Gary Hume

Is represented by Matthew Marks Gallery, New York

Exhibition Spring 1997

Winter 1997

Nayland Blake
Peter Cain
Jonathan Hammer
Inez van Lamsweerde 523 West 24th Street

Jean-Marc Bustamante 522 West 22nd Street

Willem de Kooning 1018 Madison Avenue

Matthew Marks Gallery
New York

MAI 36 GALERIE

PIA FRIES

NOVEMBER 29, 1996 – JANUARY 18, 1997

CHRISTOPH RÜTIMANN

JANUARY 23 – MARCH 1

TROY BRAUNTUCH

MARCH 6 – APRIL 18

Rämistrasse 37, CH-8024 Zürich, Tel. 01 261 68 80, Fax 261 68 81

GROUP SHOW

INCLUDING RICHARD ARTSCHWAGER
JONATHAN BOROFSKY, TONY FEHER, ROBERT GOBER
ZOE LEONARD, JOEL SHAPIRO

NOVEMBER 29 – JANUARY 5

RUDOLF STINGEL

JANUARY 15 – FEBRUARY 22

ANDRES SERRANO

MARCH 1 – APRIL 12

TONY SMITH

APRIL 19 – MAY 31

PAULA COOPER GALLERY

534 WEST 21 STREET NEW YORK NY 10011

TEL 212 255 1105 FAX 255 5156

23. November 1996 bis 25. Januar 1997

23 November 1996 to 25 January 1997

Die Galerie bleibt über die Festtage
vom 24. Dezember 1996 bis zum 6. Januar
1997 geschlossen.

The gallery will be closed for the Christmas
break from 24 December 1996 to 6 January
1997.

LOUISE BOURGEOIS

Red Room
Installation / Drawings

GALERIE HAUSER & WIRTH

Galerie Hauser & Wirth AG Limmatstrasse 270 CH-8005 Zürich Tel +41 1 446 80 50 Fax 446 80 55
Öffnungszeiten: Di-Fr 12-18 Uhr, Sa 11-16 Uhr Gallery Hours: Tue-Fri 12-6pm, Sat 11am-4pm

JEAN BERNIER
51 MARASLI STR., GR–106 76 ATHENS, GREECE
TEL. 723 56 57 FAX: 722 61 89

PIA STADTBÄUMER
JANUARY 1997

VANESSA BEECROFT
FEBRUARY 1997

HARALD KLINGELHÖLLER
MARCH 1997

GALERIA ■ HELGA DE ALVEAR

DOCTOR FOURQUET, 12 28012 MADRID TEL. 468 05 06 FAX 467 51 34

JAVIER VALLHONRAT
NOVEMBER - JANUARY

DAN FLAVIN
JANUARY - MARCH

ESTUDIO ▲ HELGA DE ALVEAR

LAWRENCE WEINER
OCTOBER - DECEMBER

JOAN MIRÓ

SCULPTURES - DESSINS - GRAVURES

23. November 1996 31. Januar 1997

GALERIE LELONG ZÜRICH

Utoquai 31, 8008 Zürich, Telefon 01/251 11 20, Fax 01/262 52 85

Öffnungszeiten: DI–FR 11–18 Uhr, SA 11–16 Uhr

GALERIE WALCHETURM

"peter builts"

HUGO MARKL
Januar 17 - Februar 28 1997

Eva Presenhuber

Walchestrasse 6, Am Stampfenbachplatz
CH-8006 Zürich, Phone +41 1 252 10 96, Fax +41 1 252 10 97
Tuesday - Friday 12 - 6.30, Saturday 11 - 4

S.L. Simpson Gallery

515 Queen Street West Toronto, Canada M5V 2B4

Tel 416 504 3738 Fax 416 504 7979

PIPILOTTI RIST & SAMIR

17. November 1996 bis 5. Januar 1997

the Social Life of Roses

Or Why I'm never Sad

Staatliche Kunsthalle Baden-Baden

Lichtentaler Allee 8a 76530 Baden-Baden Telefon 07221-23250 Telefax 07221-38590 Geöffnet täglich außer montags

CINDY SHERMAN

19. Januar bis 13. März 1997

Schwester des Stroms 1993 von **Pipilotti Rist**

Yoghurt on skin - Velvet on TV Installation mit Video von **Pipilotti Rist**
STAMPA / ART 25!94 15.-21.6.94

Emily, I'M Gonna Write Your Name High On The Silverscreen
© 1996 Pipilotti Rist
a tribute to Hot Chocolate

STAMPA Spalenberg 2 CH - 4051 Basel tel +41.61.261 79 10

ATELIER FÜR SIEBDRUCK , LORENZ BOEGLI
Aemtlerstr. 201 CH-8003 Zurich Tel +41 1 493 39 50 Fax +41 1 493 39 65

printed art-books and -reproduktions, brochures in high-quality
References are Parkett Editions Nr. 34 / 39 / 42 / 47

MAURIZIO ARCANGELI

STEPHAN BALKENHOL

MARTINO COPPES

CHIARA DYNYS

CRAGIE HORSFIELD

JULIAN OPIE

GABRIEL OROZCO

MARKUS RAETZ

CAROL RAMA

JEAN-FREDERIC SCHNYDER

BEAT STREULI

THOMAS STRUTH

MONICA DE CARDENAS
Via Francesco Viganò 4 · 20124 Milano
Tel. 39-2-29010068 · Fax 39-2-29005784

DONALDYOUNGGALLERY
1103 EAST PIKE STREET SEATTLE WA 98122 206-860-1651

1997

GARY HILL

(exclusively represented by the Donald Young Gallery)

MARTIN PURYEAR

CHARLES RAY

JOSIAH McELHENY

THE ONLY COMPREHENSIVE BOOK SERIES FEATURING CONTEMPORARY ARTISTS.

DIE EINZIGARTIGE BUCHREIHE MIT GEGENWARTSKÜNSTLERN.

THE PARKETT SERIES WITH CONTEMPORARY ARTISTS

DIE PARKETT-REIHE MIT GEGENWARTSKÜNSTLERN

Kunst- und Ausstellungshalle der Bundesrepublik Deutschland
53113 Bonn · Museumsmeile · Friedrich-Ebert-Allee 4
0228/9171-200 · http://www.kah-bonn.de
Geöffnet dienstags und mittwochs 10 bis 21 Uhr
donnerstags bis sonntags 10 bis 19 Uhr

MedienKunstRaum

Studio Azzurro
Tavoli / Why these hands are touching me
Interaktive Videoinstallation · 13. Dezember 1996 bis 9. Februar 1997

Ulrike Rosenbach
Im Palast der neugeborenen Kinder
Interaktives Environment · 7. März bis 27. April 1997 Foto: Studio Azzurro

Oeuvres de la Stiftung Kunst Heute de Berne
et du Musée cantonal des beaux-arts de Sion

DIALOGUES

Musée cantonal des beaux-arts de Sion
Kantonales Kunstmuseum Sitten

Marina Abramovic, Ian Anüll, John Armleder, Silvia Bächli,
Heinz Brand, Stéphane Brunner, Miriam Cahn, Martin Disler,
Yan Duyvendak, Pierre André Ferrand, Olivier Genoud,
Hervé Graumann, Peter Fischli et David Weiss,
Alex Hanimann, Alois Lichtsteiner, Jean-Luc Manz,
Josef Felix Müller, Guido Nussbaum, Daniela Pellaud, Pipilotti
Rist, Gilles Porret, Adrian Schiess, Jean-Frédéric Schnyder,
Beat Streuli, Gottfried Tritten, Felice Varini, Rémy Zaugg

Musée cantonal des beaux-arts 15, place de la Majorie
CH - 1950 Sion. Du 17 novembre 1996 au 11 mai 1997
Tous les jours 10 - 12 et 14 - 18 heures, sauf le lundi
Tél: 41 (0)27 606 46 70, fax: 41 (0)27 606 46 74

Musée cantonal
des beaux-arts Kantonales
 Kunstmuseum

organisation: attitudes

JAUME PLENSA

FUNDACIÓ JOAN MIRÓ
December 1996 – January 1997, BARCELONA

GALERIE NATIONALE DU JEU DE PAUME
March – April 1997, PARIS

STÄDTISCHE KUNSTHALLE MANNHEIM
May – June 1997, MANNHEIM

MALMÖ KONSTHALL
August – Octobre 1997, MALMÖ

GENTILI ARTE CONTEMPORANEA, FIRENZE TEL/FAX 039 55 240877

Prix d'art contemporain
de la Banque Cantonale de Genève
1996

**Banque Cantonale
de Genève**

Adrian Schiess

Musées
D'ART ET D'HISTOIRE
GENÈVE

Musée d'art et d'histoire, Genève
6 décembre 1996 - 2 mars 1997

Rue Charles-Galland, Genève
Ouvert de 10 à 17 heures
Fermé le lundi,
les mercredis 25 décembre 1996
et 1er janvier 1997

AUSSTELLUNG
WA(H)RE KUNST

KONZEPT: BAZON BROCK, GOTTFRIED FLIEDL, ULRICH GIERSCH, RAINER ZENDRON
6. DEZEMBER 1996 – 14. JANUAR 1997

A-4020 LINZ, DAMETZSTR.30
TEL:+43-(0)732-784178
FAX:+43-(0)732-775684

OFFENES KULTURHAUS
PRODUKTIONS- UND AUSSTELLUNGSHAUS
FÜR ZEITGENÖSSISCHE KUNST

«Basel is contemporary art's most
influential trade fair»
(Newsweek, New York) ★

«Kunst in ihrer besten Art – Unangefochten:
Die 27. Art in Basel»
(Frankfurter Allgemeine, Frankfurt) ★

«La fiera svizzera mantiene suo primato»
(La Repubblica, Roma) ★

«Numéro un mondial des foires»
(Le Figaro, Paris) ★

«Sin lugar a dudas, la feria principal»
(El Mundo, Madrid) ★

★
Art
28'97
Basel 12.–18.6.1997

Messe Basel.
http://www.art.ch

Sponsored by

Swiss Bank
Corporation

Galerien im Löwenbräu, Limmatstrasse 270, 8005 Zürich

Brandstetter & Wyss
tel 01 440 40 18, fax 01 440 40 19
e-mail: brandstetter@access.ch
di–fr 12–18, sa 11–16 uhr

Andrea Alteneder Klaus G. Gaida Frank Gerritz Raimund Girke
Astrid Klein Gaspare O. Melcher Barbara Mühlefluh Thomas
Müllenbach Mario Sala Laurent Schmid Giuseppe Spagnulo
Winfried Virnich Stephen Willats

Peter Kilchmann
tel 01 440 39 31, fax 01 440 39 32
e-mail: kilchmann@access.ch
di–fr 12–18, sa 12–16 uhr

Rita Ackermann Stefan Altenburger Balthasar Burkhard John
Coplans Willie Doherty Lukas Duwenhögger Jonathan Hammer
Felix Stephan Huber Bruno Jakob Suzanne Lafont Claudia & Julia
Müller Hannah Villiger

Bob van Orsouw
tel 01 273 11 00, fax 01 273 11 02
di–fr 12–18, sa 11–16 uhr

Philip Akkerman Hanspeter Ammann Nobuyoshi Araki Jean-Marc
Bustamante Rineke Dijkstra Sylvie Fleury Paul Graham Fabrice
Gygi Callum Innes Karin Kneffel Claudio Moser Julian Opie
David Reed Albrecht Schnider Thomas Stalder Mitja Tušek Alan
Uglow Juan Uslé Joep van Lieshout Bernard Voïta

ROBERT MANGOLD
SEVEN MAXIMS

This important text by Friedrich Hölderlin in a translation by Paul Schmidt with five lithographs by Robert Mangold printed in Paris at the Atelier Franck Bordas. Published June 1996 in an edition of 40 copies plus 10 special editions.

other books from Picaron Editions:
Jean-Charles Blais, James Brown, Markus Lüpertz, Matthew Weinstein, Robert Wilson

Picaron Editions: 46, rue de Sévigné, 75003 Paris, Tel +33-1-42775894, fax 42777427

FRANKFURT

Kunst im Auge des Betrachters

Messe Frankfurt
Halle 1 – Eingang City

Öffnungszeiten:
Sa. bis Mi. 11 bis 20 Uhr
Do. 11 bis 18 Uhr

Infos unter:
Telefon: (0 69) 75 75 - 66 64
Telefax: (0 69) 75 75 - 66 74
Internet:
http://www.messefrankfurt.de/art/

Aktion, Information, Diskussion –
aktuelle Kunst der Gegenwart,
präsentiert von Galerien aus aller
Welt, das Rahmenprogramm, die
Sonderschauen und die in ihrer
Art einmalige Besucherschule
machen die Begegnung mit der
Kunst auf der Art Frankfurt zu
einem inspirierenden Erlebnis.

ART Frankfurt
Die Messe zum Thema Kunst
26. April – 1. Mai 1997

Messe
Frankfurt

LES CAHIERS
DU MUSÉE NATIONAL D'ART MODERNE

ABONNEMENTS ET VENTES : Carole Hubert
tél. 01 44 78 42 88, fax 01 44 78 12 05

Seit 50 Jahren Ihr diskreter Partner für Kunsttransporte

Transport à la carte

1945 – 1995

MAT SECURITAS EXPRESS AG

Kloten-Zürich 01 /814 16 66 Fax 01 /814 20 21
Basel 061/271 43 80 Fax 061/271 43 18
Chiasso 091/683 75 51 Fax 091/683 98 08
Genève 022/827 18 22 Fax 022/827 18 33

Ein Unternehmen der VIA MAT Holding AG

INTERNATIONAL CONTEMPORARY ART FAIR

Parque Ferial Juan Carlos I

ARCO 97

13-18 FEB.

LATINOAMERICA

contents:

Modern and Contemporary Art Galleries
Cutting Edge Programmes
Art Edition and Multiples
Photography
Electronic Art

simultaneously:

Latin america at ARCO
I Cibernetica Biennial
IX International Contemporary Art
Forum
Major collectors at ARCO

Ministerio de Educación y Cultura
Fundación Coca-Cola España
Iberia
Icex

IFEMA
Feria de Madrid

ARCO
Apdo. de Correos: 67.067
Madrid E-28067 Spain
Tel.: (34-1) 722 50 17
Fax: (34-1) 722 57 98
E-mail: arco@sei.es
Internet: www.arco.sei.es

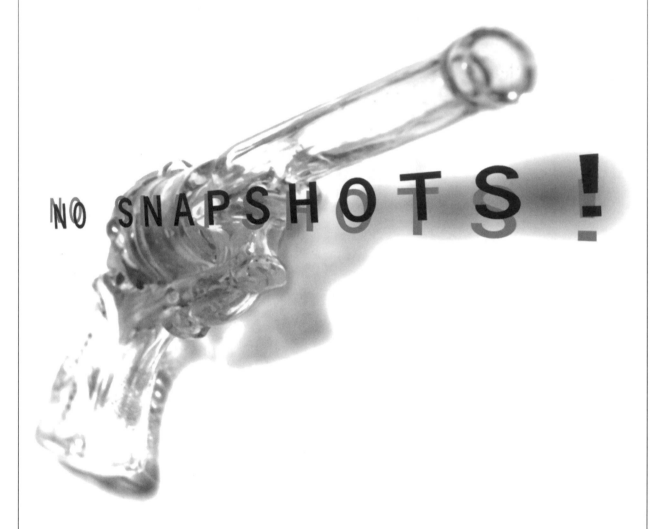

NO SNAPSHOTS!

MODERNE
REKLAME

Hasengasse 5-7 60311 Frankfurt am Main
Telefon +49 69- 20 10 5 │ Telefax +49 69- 29 05 62

BEUYS

BASELITZ

KUNST HEUTE

Gespräche mit zeit-
genössischen Künstlern.

Herausgegeben von
Gisela Neven Du Mont
und Wilfried Dickhoff.

RAUSCHENBERG

LÜPERTZ

CLEMENTE

A. R. PENCK

A. OEHLEN

DAHN

HOLZER

DOKOUPIL

IMMENDORFF

BROODTHAERS

KIRKEBY

SHERMAN

KOUNELLIS

BYARS

ANZINGER

In Ihrer Buchhandlung:
Jeder Band DM 28,-
öS 204,- / sFr 28,-
Im Abonnement:
DM 26,-/öS 190,-/sFr 26,-

Kiepenheuer & Witsch
Rondorfer Straße 5
Telefon 0221/376850

VERLAG
KIEPENHEUER
& WITSCH

Eine zehnjährige
Druck-Collaboration
mit 39 Parkett-Ausgaben:

Zürichsee
Druckereien AG

A printing collaboration
for 10 years and
39 Parkett issues:

Zürichsee
Druckereien AG

MARTIN KIPPENBERGER
RESPEKTIVE 1997-1976

mamco

31 janvier–25 mai 1997

musée d'art moderne et contemporain, 10, rue des vieux-grenadiers, ch-1205 genève, téléphone 022 320 61 22, fax 022 781 56 81

ouvert tous les jours de 12h à 18h sauf le lundi
nocturne le mardi jusqu'à 21h

KUNSTHALLE DÜSSELDORF, GRABBEPLATZ 4, TELEFON 02 11 / 899 62 40

25. JANUAR BIS 13. APRIL 1997

MICHAIL WRUBEL
DER RUSSISCHE SYMBOLIST

HAUS DER KUNST MÜNCHEN, PRINZREGENTENSTRASSE 1,
TELEFON 0 89 / 21 12 70

10. MAI BIS 27. JULI 1997

Louise Bourgeois

December 5th 1996 - February 22nd 1997
Opening Thursday, December 5th, 6 to 9 pm

Xavier Hufkens

Sint-Jorisstraat 8 rue Saint-Georges, 1050 Brussels

Phone +32/2/646 63 30 Fax +32/2/646 93 42

Open Tuesday to Saturday, noon to 6 pm

THOMAS AMMANN FINE ART AG

IMPRESSIONIST & 20TH CENTURY MASTERS

SELECTED WORKS BY MAJOR ARTISTS

ARP
BALTHUS
BEUYS
BOTERO
CALDER
CHILLIDA
COURBET
ERNST
GIACOMETTI
KLEE
DE KOONING
LAURENS
LEGER
LICHTENSTEIN
MANZU
MATISSE
MIRO
MODIGLIANI
MONDRIAN
MOORE
NEWMAN
OLDENBURG
PICASSO
RENOIR
RICHTER
RODIN
ROTHKO
SEGAL
STILL
TWOMBLY
WARHOL

RESTELBERGSTRASSE 97 CH-8044 ZÜRICH
TEL. (411) 252 90 52 FAX (411) 252 82 45

christian herdeg

new works

november 23 - january 18, 1997

georg baselitz
max bill
john chamberlain
nicola de maria
dan flavin
donald judd
roy lichtenstein
catherine lee
brice marden
mimmo paladino
robert rauschenberg
sean scully
richard serra
frank stella

a group show

january 24 - march 29, 1997

galerie jamileh weber

waldmannstrasse 6

ch-8001 zürich

telefon 01 252 10 66

telefax 01 252 11 32